THE CHARTIST MOVEMENT

THE
CHARTIST MOVEMENT

BY

MARK HOVELL

EDITED AND COMPLETED WITH A
MEMOIR BY T. F. TOUT

Augustus M. Kelley · Publishers

New York · 1967

© Manchester University Press

First published 1918
Second Edition 1925
Third Edition 1966 *with a Bibliographical*
Introduction by W. H. Chaloner

First published
in the United States
1967
by AUGUSTUS M. KELLEY · PUBLISHERS
24 East 22nd Street, New York, N.Y. 10010

BIBLIOGRAPHICAL INTRODUCTION TO THE 1966 EDITION

(The place of publication of all books mentioned is Great Britain, unless otherwise indicated.)

EVEN the most ardent admirers of the movement are now constrained to admit that Chartism was a failure,[1] but to judge by the continuing popular interest in this pale British brand of Jacobinism, the " struggle for the Charter " was " l'un des insuccès les plus réussis de l'histoire," as Alfred Cobban has so neatly put it.[2] Mark Hovell told the story of Chartism largely in terms of a national movement, and it is significant that his account, as corrected for the second edition of 1925, has never been superseded, in spite of its sketchy treatment of the period after 1842. Research and publication on Chartism and related movements since the early 1920s has not only deepened our knowledge of what would have been called in 1838–48 " Chartism in the localities," but has also contributed to our understanding of the history of other movements with which Chartism was embroiled or enmeshed. We now have, too, as a result of this research, a clearer view of the working of central and local government in the early nineteenth century.

It is now obvious that Chartist ideas and leaders came, with few exceptions, from members of the middle classes, although

[1] " Chartism was a failure. No amount of special pleading by those anxious to detect the red thread of progress in the history of the labour movement, or to answer the curt ' It achieved nothing ' of old-fashioned text-books, can turn it into anything else " (E. J. Hobsbawm, *New Statesman*, October 31, 1959).
[2] Introduction to 1948 edition of E. Dolléans, *Le Chartisme, 1831–1848*, p. xi.

the mass of adherents came from the artisan and labouring classes. The extent to which the movement found recruits among old-established or decaying crafts is remarkable— handloom weavers, stockingers, and shoemakers, rather than the new factory workers, were the real militants of Chartism. This hardly suggests a " progressive " movement of the whole working class.

GENERAL

Three indispensable reappraisals of the movement have appeared recently : Asa Briggs, " Chartism reconsidered " (*Historical Studies: Papers read before the Third Conference of Irish Historians* (ed. Michael Roberts), 1959, pp. 42-59) ; Asa Briggs, " National Bearings " in *Chartist Studies*, 1959, pp. 288-303, and F. C. Mather, " Chartism : the present position of historical studies " (*Britain and the Netherlands*, ed. J. S. Bromley and E. H. Kossmann, vol. ii, Groningen, Historical Society of Utrecht, 1964, pp. 181-204). E. Dolléans's pioneer study, *Le Chartisme, 1831–1848*, 2 vols., 1912–13, has been re-issued in a revised edition (Paris, Marcel Rivière, 1949). There is now a general study in Italian : L. de Rosa, *Storia del cartismo* (Milan, 1953). A large part (pp. 157-297, 396-424) of S. Maccoby's *English Radicalism, 1832–1852* (1935) is devoted to a rather uninspired short history of Chartism. A useful selection of Chartist poetry, journalism and literary criticism (in English) will be found in Y. Kovalev (ed.), *An Anthology of Chartist Literature* (Moscow, 1956). The introduction by Kovalev is in Russian, but an English translation has been published in *Victorian Studies* (Indiana University, Blooming-ton) vol. ii, no. ii, December 1958, pp. 117-38.

A useful selection of documents relating to Chartism will be found in G. D. H. Cole and A. E. Filson (eds.), *British Working Class Movements: Select Documents*, vol. i (1789–1875), 1951, pp. 345-421. See also M. Morris (ed.), *From Cobbett to the Chartists . . . 1815–1848: Extracts from Contemporary Sources*, 1948, pp. 134-99.

J. L. and B. Hammond, in *The Age of the Chartists, 1832–1854: a study of discontent* (1930) have portrayed the general social and economic background vividly—perhaps too vividly. Much wider in its coverage of the period is *Early Victorian England, 1830–1865*, ed. G. M. Young, 2 vols., 1934. There is a new annotated translation of Friedrich Engels, *The Condition of the Working Class in England*, by W. H. Chaloner and W. O. Henderson (1958), which contains many references to Chartism.

Chapter iii of Hovell's book (" The rise of anti-capitalist economics and social revolutionary theory ") must now be supplemented by the following books and articles :

(a) Sir Alexander Gray, *The Socialist Tradition: Moses to Lenin*, 1st ed., 1946, 3rd revised impression 1948, pp. 262-96 (" The pre-Marxians ").

(b) É. Halévy, *Thomas Hodgskin*, trans. and ed. A. J. Taylor, 1956.

(c) Thomas Hodgskin, *Labour defended against the Claims of Capital*, 1st ed., 1825, reprinted 1922 and 1964.

(d) R. K. P. Pankhurst, *William Thompson, 1775–1833: Britain's Pioneer Socialist, Feminist and Co-operator*, 1954.

(e) Janet Kimball, *The Economic Doctrines of John Gray, 1799–1883*, Washington, 1948.

(f) M. F. Jolliffe, " John Francis Bray," *International Review for Social History*, vol. iv, 1939, pp. 1-36.

(g) M. F. Jolliffe, " Fresh light on John Francis Bray," *Economic History* (supplement to *Economic Journal*, February–May 1939, vol. iii, no. 14, pp. 240-4).

(h) H. J. Carr, " John Francis Bray," *Economica*, new series, vol. vii, 1940, pp. 397-415.

(i) J. F. Bray, *Labour's Wrongs and Labour's Remedy*, 1st ed., 1839, reprinted 1931.

(j) J. F. Bray, *A Voyage from Utopia* (ed. M. F. Lloyd-Prichard, 1957).

(k) G. D. H. Cole, *Robert Owen*, 1925.

(l) M. I. Cole, *Robert Owen of New Lanark*, 1953.

(m) Robert Owen, *A New View of Society and other Writings* (Everyman edition by G. D. H. Cole, 1927).

(n) A. L. Morton, *The Life and Ideas of Robert Owen*, 1962.

(o) W. H. G. Armytage, *Heavens Below: Utopian Experiments in England, 1560–1960*, 1961. Phase II : The Owenite apocalypse, pp. 77-170.

BIOGRAPHICAL

There are now biographies of Feargus O'Connor (*Feargus O'Connor, Irishman and Chartist*, by Donald Read and E. L. H. Glasgow, 1961—a balanced study which has not met with the approval of some left-wing historians) ; of Thomas Cooper (R. J. Conklin, *Thomas Cooper the Chartist (1805–1892)*, Manila, University of the Philippines Press, 1935) ; of Frost (David Williams, *John Frost: a study in Chartism*, 1939) ; of George Julian Harney (A. R. Schoyen, *The Chartist Challenge: a portrait of George Julian Harney*, 1958), and of Ernest Jones (John Saville, introduction, pp. 13-82 to *Ernest Jones: Chartist: Selections from the Writings and Speeches of Ernest Jones . . .* 1952).

O'Connor's agrarian schemes are most fully dealt with by Joy MacAskill, " The Chartist land plan " in *Chartist Studies* (ed. A. Briggs, 1959, pp. 304-41). There is a shorter treatment in W. H. G. Armytage, *Heavens Above*, 1961, pp. 224-37 (" The Chartist land colonies "). John Stuart Mill's favourable remarks about the plan in the first edition of *The Principles of Political Economy*, (1848) should be noted.

The early history of *The Northern Star* (it is an exaggeration to state that O'Connor " founded " it) is dealt with by E. L. H. Glasgow in his article " The establishment of the *Northern Star* newspaper," *History*, new series, vol. xxxix, 1954, pp. 54-67.

G. D. H. Cole's *Chartist Portraits* (1st ed., 1941, 2nd ed., 1965, with new introduction by Asa Briggs) contains useful biographical sketches of nine Chartists (Thomas Attwood, Cooper, Frost, Harney, Jones, William Lovett, James Bronterre O'Brien, O'Connor and Joseph Sturge) and of three men who were not Chartists (John Fielden, Richard Oastler, Joseph

Rayner Stephens) but used Chartist platforms to further the causes in which they were primarily interested—factory reform and agitation against the new Poor Law of 1834.[1] There is now an excellent biography of Oastler by Cecil Driver (*Tory Radical: the Life of Richard Oastler*, 1946) and a shorter study of Stephens (J. T. Ward, " Revolutionary Tory : the Life of Joseph Rayner Stephens of Ashton-under-Lyne (1805–1879)," *Trans. Lancs. and Ches. Antiquarian Soc.*, vol. lxviii, 1959, pp. 93-116). On the other Chartist leaders there are Alfred Plummer, " The place of Bronterre O'Brien in the working-class movements " (*Economic History Review*, January 1929, vol. ii, no. 1, pp. 61-80) and W. H. Chaloner, ed. " The reminiscences of Thomas Dunning, 1813–1894 " (*Trans. Lancs. and Ches. Antiquarian Society*, vol. lix, 1947, pp. 111-22).

LOCAL CHARTISM

On the local level the most convenient source is *Chartist Studies* (ed. Asa Briggs, 1959) which contains chapters on Chartism in Leeds and Leicester,[2] (both by J. F. C. Harrison) in Manchester (by Donald Read), in Suffolk (by Hugh Fearn) and in Somerset and Wiltshire by R. B. Pugh.[3] *Chartist Studies* also contains a chapter by the editor on " The local background of Chartism." There is as yet no adequate study of Chartism in Birmingham, although Conrad Gill, *A History of Birmingham*, vol. i (1952), pp. 241-71, gives a brief account, and there is an article by Trygve R. Tholfsen on " The Chartist crisis in Birmingham " in the *International Review of Social History*, vol. iii, 1958, pp. 461-80. A. C. Wood's long article " Nottingham, 1835–1865 ", *Trans. Thoroton Society*, vol. lix, 1950, pp. 1-83, contains much about Chartism in that town. L. C. Wright, *Scottish Chartism* (1953), should be supplemented for South West Scotland by Alex Wilson's " Chartism in Glasgow " (*Chartist Studies*, ed. A. Briggs, 1959, pp. 249-87). In a

[1] Cole's book also contains a very useful bibliography of Chartist literature (*op. cit.*, pp. 359-66).
[2] Chapters xv to xviii of A. Temple Patterson's *Radical Leicester: a history of Leicester, 1780–1850* (1954), pp. 275-364, contain a fuller study.
[3] See also R. B. Pugh, " Chartism in Wiltshire," *The Wiltshire Magazine*, vol. liv, 1951.

similar manner David Williams's " Chartism in Wales " (*ibid.*, pp. 220-48) supplements the same author's earlier work on John Frost. David Williams, *The Rebecca Riots: a study in agrarian discontent* (1955) is the definitive treatment of this curious phenomenon which is only briefly referred to by Hovell. Rachel O'Higgins's " The Irish influence in the Chartist movement," *Past and Present*, no. 20, November 1961, pp. 83-96, discusses the connection between extreme Irish agrarian nationalism and English extreme radicalism.

CHARTISM AND THE PROBLEMS OF PUBLIC ORDER

In this sphere F. C. Mather, *Public Order in the Age of the Chartists* (1959), and the same author's three articles detailed below are indispensable. They indicate how ramshackle was the machinery of public order and how slight the Governments of the time considered the " threat " of Chartism to be. No British Government of the time was " panic-stricken," as is sometimes stated.

- (*a*) " The railways, the electric telegraph and public order during the Chartist period, 1837–48 " (*History*, new series vol. xxxviii, 1953, pp. 40-53).
- (*b*) " Army pensioners and the maintenance of civil order in early nineteenth-century England," *Journal for the Society of Army Historical Research*, vol. xxxvi, 1958, pp. 110-24.
- (*c*) " The Government and the Chartists " in *Chartist Studies* (ed. A. Briggs, 1959, pp. 372-405).

A. G. Rose's " The Plug Riots of 1842 in Lancashire and Cheshire " (*Trans. Lancs. and Ches. Antiquarian Society*, vol. lxviii, 1957, pp. 75-112) illuminates in great detail this celebrated and controversial episode.

CHARTISM AND THE ANTI-CORN LAW LEAGUE

O'Connor's " social philosophy," if it can be dignified by that description, was opposed to that of the Anti-Corn Law League, so that O'Connorite Chartists (but not, for example,

Scottish Chartists) opposed the activities of the Leaguers. Lucy Brown's article on " The Chartists and the Anti-Corn Law League " (*Chartist Studies*, ed. A. Briggs, 1959, pp. 342-71) supplements Norman McCord, *The Anti-Corn Law League, 1838–1846*, 1958, and G. Kitson Clark, " Hunger and Politics in 1842," *Journal of Modern History*, vol. xxv, no. 4, December 1953, pp. 355-74. McCord's book is particularly valuable in stressing the split between the Manchester Irish, who were split into O'Connellite and O'Connorite factions. P. Searby's *Coventry Politics in the Age of the Chartists*, 1964, should also be noted.

CHRISTIAN SOCIALISM, 1848–1854

Hovell does not mention Christian Socialism, but this middle-class movement was clearly derived in great measure from a fusion between Owenite and Chartist ideas. There is now a large literature on the subject, of which the following items will be found the most important :

(a) C. E. Raven, *Christian Socialism, 1848–1854*, 1920.

(b) John Saville, " The Christian Socialists of 1848," in *Democracy and the Labour Movement* (ed. John Saville, 1955), pp. 135-59.

(c) E. C. Mack and W. H. G. Armytage, *Thomas Hughes*, 1952, pp. 52-75.

(d) N. C. Masterman, *John Malcolm Ludlow: the Builder of Christian Socialism*, 1963.

(e) Torben Christensen, *Origins and History of Christian Socialism, 1848–54*, Acta Theologica Danica, vol. iii, Universitetsforlaget Aarhus, 1962.

<div align="right">W. H. CHALONER</div>

THE UNIVERSITY OF MANCHESTER
February 1965

CONTENTS

Bibliographical Introduction to the 1966
 Edition by W. H. Chaloner iii-ix

Introduction: Mark Hovell. 1888–1916 xxi-xxxvii

CHAPTER I

The Charter and its Origin . . . 1-7

The National Charter—Its preamble—Six Points and minor provisions—Its programme of Parliamentary Reform—Origins of the movement for Parliamentary Reform—The Army debates in 1647 and the Instrument of Government, 1653—The Radical programme in the eighteenth century—Its revival after Waterloo— Dissatisfaction of Radical reformers with the Reform Act of 1832.

CHAPTER II

The Industrial Revolution and its Conse-
 quences 8-27

1815–1840 the critical years of the Industrial Revolution— Large scale production and machinery triumph over small production and domestic organisation—Social and economic difficulties resulting from the change—The transition easier in some industries than others—The worst difficulties were in those trades where the old and new systems long coexisted side by side—Contrast between the spinning and weaving trades—The latter long a transitional industry, remaining partly domestic, but under capitalist control—The long agony of the handloom weavers—Instances of various types—The silk-weavers of Coventry—The cotton-weavers

of Lancashire and the woollen-weavers of Yorkshire—The stock-
ingers and the hosiery trade in the Midlands—Bagmen and frame-
rents—Quarrying and mining—The butty and the gang system—
The employment of women and children—Want of organisation
and care for the welfare of the new industrial population—The
social and economic background of Chartism.

CHAPTER III

THE RISE OF ANTI-CAPITALIST ECONOMICS AND
 SOCIAL REVOLUTIONARY THEORY . . 28-51

Effects of the French Revolution and of the Industrial Revolution
on English political and social ideas—Social dislocation resulting
from Industrial Revolution—Movement and enterprise replace
security as basis of economic life—Practical grievances of the wage-
earners—Beginnings of socialistic literature—Three schools of early
socialism—The agrarians and their revolt against enclosures—
Doctrine of natural right to the land—Thomas Spence—William
Ogilvie—Thomas Paine—The anti-capitalistic critics of the classical
economists—Charles Hall as the link between the first and second
schools—Influence of David Ricardo—His doctrine that Labour
is the source of value—Its development by Thomas Hodgskin to
claim for Labour the whole produce of Industry—The theoretical
Communists—Robert Owen—William Thompson and J. F. Bray—
The new Trades Unionism and Robert Owen—The Grand National
Consolidated Trades Union—Its failure—The London group of
Labour leaders—Special position of the London artisans—Their
reaction from orthodox Owenism and its results—The disillusion
of the Reform Bill.

CHAPTER IV

THE LONDON WORKING MEN'S ASSOCIATION AND
 THE PEOPLE'S CHARTER (1836-1839) . . 52-77

Failure of the earlier working men's societies in London—The
agitation in favour of unstamped newspapers—Its partial triumph
in 1836—The leaders in the agitation—Francis Place—William
Lovett—Henry Hetherington—James Watson—John Cleave—
The same men found the London Working Men's Association—
Two accounts of its origin—Part played by Lovett in it—Its objects,
membership, and proceedings—Its publications, especially The

Rotten House of Commons—Its discussions at Place's house—
Notable new members—Threatened disruption—J. B. Bernard
and the Cambridgeshire Farmers' Association—Rival short-lived
associations—The London Democratic Association—Extension of
Chartist associations over the country—Lovett's missionary zeal—
Addresses to the Queen and to Reformers—Public meeting at
Crown and Anchor—Petition to Commons drawn up—Parliamentary
supporters of the Association—Beginnings of more public propa-
ganda—The prosecution of the Glasgow Cotton Spinners—Support
from the Birmingham Political Union—Committee to draft a Bill
empowered, but does nothing—Place and Lovett draw up the
People's Charter—Failure of the Parliamentary Radicals to give
effective help—Proposal for a National Convention—The elections
for it—Decline in importance of the Working Men's Association.

CHAPTER V

THE AGITATION AGAINST THE NEW POOR LAW
 (1834–1838) 78-98

Importance of Poor Law Amendment Act of 1834—The first
piece of radical legislation and the first-fruits of Benthamism—
Action of Edwin Chadwick and the Poor Law Commissioners—
Growth of resistance to the Act—Real suffering caused by it—
Plight of handloom weavers and stockingers—William Cobbett's
arguments against it—Outdoor relief as the share of the poor in
the spoils of the Church at the Reformation—The opposition of
local interests to centralisation and bureaucracy—The cry of vested
interests—The resistance to the Act in Lancashire and Yorkshire,
1836—John Fielden of Todmorden—Richard Oastler—Joseph
Rayner Stephens—The Methodist spirit and the opposition to the
Act—The coming to the North of Augustus Harding Beaumont
and Feargus O'Connor—The *Northern Liberator* and the *Northern
Star*—Effectiveness of O'Connor as an agitator in the factory
districts—Death of Beaumont—Absorption of the Anti-Poor Law
movement in Chartism.

CHAPTER VI

THE REVIVAL OF THE BIRMINGHAM POLITICAL
 UNION (1837–1838) 98-115

Part played by the Birmingham Political Union in the struggle
for the Reform Bill—Its dissolution in 1834—Beginnings of bad

trade, and setting up in 1836 of a Reform Association—Thomas
Attwood and the middle-class Birmingham leaders—Attwood's
Currency Schemes—Revival of the Political Union—Parliamentary
Reform to be combined with Currency Reform—The middle-class
leaders and the working-men followers—Futile attempts to interest
the Government in currency reform—Alliance effected with the
Working Men's Association and the Anti-Poor Law agitators—
Douglas draws up the National Petition—Great meeting at Glasgow
adopts the policy—General propaganda work—Birmingham meet-
ing at Newhall Hill, August 6, 1838—Election of delegates to the
National Convention—Friction between the London Association
and the Birmingham Union—Difficulties caused by the Currency
Scheme—Rupture between the Union and the Northern extremists
—Violence of Stephens and O'Connor—O'Connor patches up some
sort of peace—Note on Attwood's Currency Theories.

CHAPTER VII

THE PEOPLE'S PARLIAMENT (1838–1839) . . 116–135

Combination of the northern, midland, and southern movements
for the attainment of the Charter—The National Petition—The
National Convention—Election of delegates at public meetings—
Position of Manchester in the movement—Violence in the North—
First meeting of the National Convention, February 4, 1839—Its
membership and characteristics—Debates as to the scope of the
Convention—J. P. Cobbett's resolution limiting its work to super-
intending the Petition—Its defeat, followed by his withdrawal—
House of Commons invited to meet Convention—War declared
against the Anti-Corn Law League—Discussions on procedure—
Rules and Regulations of the Convention drawn up—Clamour for
violent measures outside the Convention—Harney and the London
Democratic Association attack the mild policy of the Convention—
Long delays and hesitations—Decreasing confidence within the
Convention—It is increased by the unfavourable reports from the
" missionaries " sent into the country—Reports from Birmingham
and the south-west—Riots at Devizes—John Richards' reports
from the Potteries—Numerous resignations in the Convention,
including those of the Birmingham delegates—Debate on the right
to possess arms—Debate on ulterior measures—Divided counsels
and indecision—The problem referred to mass meetings—The
Petition handed to Attwood—Removal of the Convention to
Birmingham—Its lack of leadership the chief cause of its failure.

CHAPTER VIII

THE GOVERNMENT PREPARES FOR ACTION (1839) . 136-142

General prevalence of poverty and discontent, especially in the
manufacturing and mining districts—Local effects of the " mission-
aries' " work—Illustrations from Newport (Mon.), Halifax, and
Manchester—Government preparations to resist threatened rising—
Prudence of Lord John Russell—Lack of police and consequent
inevitableness of military action—The appointment of Sir Charles
Napier to command the northern district—His wise policy—The
disposition of his troops—Colonel Wemyss at Manchester—Govern-
ment proclamation against unlawful assemblies—Authorisation of
the formation of a civic force.

CHAPTER IX

THE CONVENTION AT BIRMINGHAM (1839) . . 143-159

Ministerial crisis of May 1839—Its effects on Chartist calculations
—Inevitable postponement of the Petition—Isolation of the Con-
vention in London—Its complaints of lack of support—Comparative
attractions of Birmingham—Changed position there—Collapse of
the Attwoodites and transference of the Chartist leadership to
working men—Collins and Fussell—Fussell's account of the meetings
in the Bull Ring—Their prohibition—Last debates of Convention
in London—O'Connor's motion for transference to Birmingham
carried—" Address to the People " moved—O'Brien's violent
address carried in preference to Lowery's moderate one—May 13
the Convention reaches Birmingham—Its first work to issue " The
Manifesto of the General Convention "—Its terms—Ulterior meas-
ures to be adopted on failure of the Petition—Their weakness as
compared with language of Manifesto—Timid action and adjourn-
ment until July 1—Action of civil and military authorities through-
out the country—Threatened Whitsuntide disturbances—Wemyss's
vigorous action against Ashton-under-Lyne—Riots at Llanidloes,
Monmouth, and Stone—Incendiary hand-bill circulated in Man-
chester—Napier's view as to the prospects—Precautions at Man-
chester—Kersal Moor demonstration—More resignations from the
Convention—Its resumed sessions after July 1—July 4, Bull Ring
riot—Provoked by lack of judgment of magistrates—Convention
condemns them in resolutions signed by Lovett—Arrest of Lovett

and Collins—Threatened troubles at Ashton and Manchester—
Removal of Convention to London—It issues denunciation of
Birmingham magistrates and of paper money.

CHAPTER X

THE PETITION IN THE COMMONS : END OF THE
 CONVENTION (1839) 160-173

July 12, 1839, Debate on Attwood's motion that the Commons
go into Committee to consider the National Petition—Speeches of
Attwood and Fielden—Lord John Russell's speech against the
motion—Disraeli's speech disapproving of Charter, but sympathising
with Chartists—The division—Motion defeated by 235 to 46—
July 15-17, Debates in Convention—A "National Holiday" to
begin on August 12—July 15, Renewed Riots in Bull Ring,
Birmingham—Cold reception of strike proposal—July 22, It is
rescinded by Convention on O'Brien's motion—Committee appointed
to take sense of people on the strike—Most places unfavourable—
Views of Northern Political Union and of Robert Knox—The
Trades Unions outside the Chartist ranks—Convention adjourns
Bill, August—Dying out of strike movement—Arrests and trials—
Trials of Stephens at Chester and of Lovett and Collins at Warwick—
Attitude of Lovett—Reassembly and dissolution of the Convention
—Its final weakness.

CHAPTER XI

SEDITION, PRIVY CONSPIRACY, AND REBELLION
 (1839-1840) 174-190

Attitude of physical force Chartists outside Convention—The
Newport Rising of November 4—Difficulty in ascertaining the
truth as to its origin and course—The story of David Urquhart—
Beniowski and Russian intrigues—Other versions of the story—
General rising projected for which an outbreak in South Wales was
to be the signal—Committees at various centres—Activity of Vincent
and, after his arrest, of Frost in Newport and the Monmouthshire
valleys—The rendezvous at Risca—The night march to Newport—
The fighting round the Westgate Hotel—The suppression of the
Rising and the arrest of the leaders—Preparations for their defence—
Ambiguous attitude of O'Connor—Preparations for a second rising
throughout the country—Reports by magistrates and police—

B

Bradford — Manchester — Birmingham — The hosiery districts — London—Halifax—Nothing serious to happen—Depression of Manchester and Birmingham Chartists—Trial and condemnation of Frost, Jones, and Williams—Some small outbreaks, mainly in Yorkshire, easily suppressed—1840, Further trials and imprisonments—End of the first phase of Chartism—Its want of homogeneity its chief weakness—Diversity of aim made co-operation in revolutionary action impossible.

CHAPTER XII

THE CHARTIST REVIVAL (1840–1841) • • 191-212

Weakness of Chartism during spring of 1840—Proposals to organise the movement more thoroughly—The beginnings in Scotland—August 15, 1839, Delegates meeting at the Universalist Church, Glasgow—Its resolutions—The *Chartist Circular*—Harney's proposals—Schemes of " Republican "—O'Connor's plans for a Chartist newspaper syndicate—Revival of local bodies—Hetherington and the Metropolitan Charter Union—The Newcastle Northern Political Union—July 20, 1840, Meeting at the Griffin, Great Ancoats Street, Manchester—Plans for the National Charter Association drawn up and adopted—Its objects and methods—Its revision to make it legal—Difficulties imposed by the law on political associations—The provisional and the elected executives—Plans of the moral force sections—Christian Chartism—The Chartist Churches—Arthur O'Neill at Birmingham—Report of his sermons—Henry Vincent at Bath—David Brewster at Paisley—Lovett's proposals—His correspondence with Place—His *Chartism*—His plans for a National Association for Promoting the Improvement of the People—Its educational and individualist policy—Place's criticisms—July 25, Lovett's release and establishment in London—Thomas Cooper's plans—His early career and character—How he became a Chartist at Leicester—His Shaksperean Association of Leicester Chartists—The revival resulting from all these efforts.

CHAPTER XIII

CHARTISM *VERSUS* FREE TRADE (1842–1844) • 213-219

Parallel growth of Chartism and the Anti-Corn Law League—Grounds for the antagonism between Chartists and Free Traders—A phase of the class war—Policy of meeting-smashing—Divergencies

of aim of the Chartists—Illustrated from Williams at Sunderland
and Leach at Manchester—Attitude of the *Northern Star*—Futility
of Chartist attitude.

CHAPTER XIV

O'CONNORISM (1841–1842) 220-229

August 30, 1841, release of O'Connor from York Gaol—His
influence on the agitation during his imprisonment—His direction
of the National Charter Association—Petitions for the release of
the Newport leaders—Ways in which the *Northern Star* promoted
O'Connor's ends—Its journalistic success—Its commercial influence
—Chartist leaders become O'Connor's servants and dependents—
Continued faith of the mass of Chartists in him—Illustration of
this from Thomas Cooper—Demonstrations on O'Connor's release—
Demonstration and procession at Huddersfield and elsewhere—
Activity of O'Connor—Plans for the Association—A Convention
and a new Petition.

CHAPTER XV

FALSE DOCTRINE, HERESY, AND SCHISM (1841–1842) 230-250

(1) O'CONNOR'S BREACH WITH LOVETT (1841) 230-236

O'Connor's campaign against his rivals—The essential incom-
patibility between him and Lovett—The National Association and
the National Charter Association—Lovett's bad tactics give colour
to the charge that the former was set up in rivalry to the latter—
Unmeasured attacks on Lovett—March 1841, Lovett's Address of
the National Association excites a new outcry—His democratic
idealism—Violent opposition of the *Star*—Its journalistic methods—
Members of the Chartist Association forced to dissociate themselves
from Lovett's Association—Lovett fails to get general Chartist
support, and is virtually ejected from the Chartist ranks.

(2) THE ELIMINATION OF O'BRIEN (1841–1842) 236-240

O'Brien as the Chartist Schoolmaster—His services to Chartist
doctrine and propaganda—His financial dependence on O'Connor—
His resentment of O'Connor's attitude—Beginnings of the breach—
The General Election of 1841—O'Brien denounced O'Connor's policy
of voting with the Conservatives—The result was that the Chartists

voted on no single principle—O'Brien's candidature at Newcastle-on-Tyne—His address minimises the Chartist standpoint—Legal problems arising from his refusal to go to the poll—October 1841, his release—The *British Statesman* started as his organ.

(3) THE COMPLETE SUFFRAGE MOVEMENT (1842) 240-250

The reshifting of Chartist interest to Birmingham—Contrast of Birmingham Chartism in 1839 and 1842—Partly a reflection of the general change of the Chartist attitude, but largely due to the continued middle-class element in Birmingham Chartism—The Complete Suffrage Movement and Joseph Sturge—Sturge's "Reconciliation between the Middle and Working Classes"—The "Sturge Declaration" drawn up at an Anti-Corn Law Convention in Manchester—Its principles illustrated—They are embodied in the Birmingham Complete Suffrage Union—Its leaders—Edward Miall and the *Nonconformist*—Herbert Spencer and his uncle—Friendly attitude of Free Traders—The Union an attempt to organise a single Radical party—Its Chartist supporters—Fierce opposition of O'Connor—Attitude of the *Northern Star*—Complete Suffrage is "Complete Humbug"—April 5, 1842, Complete Suffrage Conference meets at Birmingham—Its indecisive discussions—Its hesitation to adopt the Charter and its points—The conflict put off till a future date—Stress laid upon the Chartist name—The Complete Suffrage Petition drawn up—State of affairs in Chartist world in spring of 1842—The triangular duel of O'Connor, Lovett, and Sturge.

CHAPTER XVI

THE NATIONAL PETITION OF 1842 . . . 251-258

Progress of the Charter Association in organising the National Petition—Bad trade adds to the Chartist difficulties—The Petition ready—April 12, 1842, the Chartist Convention meets in London—Arrangements for the presentation of the Petition—Address of the Convention—Analysis of the Petition—May 2, The Petition presented to Parliament by Duncombe—May 3, Duncombe's motion that the petitioners be heard—Macaulay's declaration that universal suffrage was fatal to property—Roebuck's ambiguous speech denouncing O'Connor but supporting the motion—Lord John Russell's and Peel's speeches—Defeat of the resolution.

CHAPTER XVII

THE DECLINE OF CHARTISM (1842–1853) . . 259-312

(1) THE PLUG PLOT AND ITS CONSEQUENCES
 (1842–1843) 259-267

Meetings denouncing the rejection of the Petition—The general
strike—The Plug Plot—Chartist Conference in Manchester—
MacDouall's inflammatory manifesto—O'Connor's attack on
MacDouall—Failure of the strike—The Government re-establishes
order—Prosecutions and punishments—MacDouall driven into
exile—Revival of the Complete Suffrage Movement—Second
Birmingham Conference of December 1842—Harney's defence of
the Chartist name—Lovett's resolution carried and break - up of
the Conference—O'Connor's fresh triumph—Sentences on the
rioters.

(2) O'CONNOR'S LAND SCHEME AND THE
 CHARTIST REVIVAL (1843–1847) . . 267-284

Sluggishness of Chartism in 1843—The Birmingham Convention
(1843)—New organisation of the National Charter Association—
The Executive to meet in London—Transference of the *Northern
Star* from Leeds to London (1844)—O'Connor's Land Scheme
proposed—Its origin—O'Connor's *Letters to Irish Landlords*—
Reception of the Scheme at Birmingham (1843) and Manchester
(1844)—Further progress at the London Convention (1845)—
Details of the Scheme—Revival of prosperity weakens Chartism—
Opposition to the Land Scheme within the Chartist fold—Opposition
of O'Brien and Cooper—The National Land Company—Difficulties
of the undertaking—O'Connor's qualities and defects—O'Connor-
ville opened—Ernest Jones becomes O'Connor's chief lieutenant—
Chartists and the General Election of 1847—O'Connor returned for
Nottingham—His work in Parliament.

(3) CHARTISM AND THE REVOLUTION OF 1848 . 284-294

The Revolution of 1848 in Western Europe—The Chartist affinities
with the Continental rebels—Arthur O'Connor and his nephew
Feargus—O'Connor in Belgium—His relations with the German
democrats exiled in Brussels—Friedrich Engels and Karl Marx—
London as a revolutionary centre—The Chartist revival stimulated
by the fall of Louis Philippe—Chartist disturbances—March 6,

The Trafalgar Square meeting—April 3, The Convention in London —Preparations for the presentation of the National Petition— O'Connor's Constitution - making — Counter - preparations of the Government—April 10, The meeting on Kennington Common— Its peaceful and unenthusiastic character—Threatened disturbances in Manchester—The analysis of the Petition by a Commons Committee—Collapse of the Land Scheme after a Commons Committee's Report—Trials and imprisonments—Failure of the movement.

(4) THE LAST STAGES OF CHARTISM (1849–1858) 294–300

Slow stages of the final collapse of Chartism—Illness and death of O'Connor—Ernest Jones as leader—His qualities and their defects—His journalistic efforts—His proposals for the reform of the organisation—His failures and retirement—Other abortive schemes for the reorganisation of Chartism—Lovett's People's League—O'Brien's National Reform League—Clark's National Charter League—Extinction of the Movement—Later history of the Chartist leaders—Ernest Jones's life in Manchester—The Chartist patriarchs.

(5) THE PLACE OF CHARTISM IN HISTORY . 300–312

How far was Chartism a failure ?—The gradual realisation of its political programme, but not through the Chartists—Had Chartism a social and economic programme ?—Negative character of the politics of the period—The concentration of effort on the removal of disabilities—Divergencies in the Chartist ranks as to the social ideal—The schools of Chartism—The agrarian and the industrial schools—Inability of the Chartists to unite except in negations— Chartism as an effort towards democracy and social equality—Its contrast with Young Englandism—Chartism and the Churches— Difficult position of the Chartist leaders—Their necessary want of experience—Their indirect influence in the next generation— Their protest against Cobdenism and Utilitarianism bore fruit in the next generation—Value of its pioneer work—Its preparation of the workers to take a real share in political and social movements —Its influence on Continential socialism — The beginnings of popular democracy.

BIBLIOGRAPHY 313–317

INDEX 319–327

INTRODUCTION

MARK HOVELL (1888–1916)

THE author of this book belonged to the great class of young scholars of promise, who, at the time of their country's need, forsook their studies, obeyed the call to arms, and gave up their lives in her defence. It is well that the older men, who cannot follow their example, should do what in them lies to save for the world the work of these young heroes, and to pay such tribute as they can to their memory.

Mark Hovell, the son of William and Hannah Hovell, was born in Manchester on March 21, 1888. In his tenth year he won an entrance scholarship at the Manchester Grammar School from the old Miles Platting Institute, now replaced by Nelson Street Municipal School. It was the earliest possible age at which a Grammar School Scholarship could be won. From September 1898 to Christmas 1900 he was a pupil at the Grammar School, mounting in that time from IIc to Vb on the modern side. Circumstances forced him to leave school when only twelve years of age, and to embark in the blind-alley occupations which were the only ones open to extreme youth. Fortunately he was enabled to resume his education in August 1901 as a pupil teacher in Moston Lane Municipal School, whose head master, Mr. Mercer, speaks of him in the warmest terms. Hovell also attended the classes of the Pupil Teachers' College. From November 1902 to February 1904 a serious illness again interrupted his work, but he then got back to his classes, and at once went

ahead. Mr. W. Elliott, who first gave him his taste for history at the Pupil Teachers' College, fully discerned his rare promise. " He was," writes Mr. Elliot, " undoubtedly the brightest, keenest, and most versatile pupil I have ever taught, and his fine critical mind seemed to delight in overcoming difficulties. He was a most serious student, but he possessed a quiet vein of humour we much appreciated. We all looked with confidence to his attaining a position of eminence." This opinion was confirmed by the remarkable papers with which in June 1906 he won the Hulme Scholarship at our University, which he joined in the following October. This scholarship gives full liberty to the holder to take up any course he likes in the University, and Hovell chose to proceed to his degree in the Honours School of History. During the three years of his undergraduate course he did exceedingly good work. After winning in 1908 the Bradford Scholarship, the highest undergraduate distinction in history, he graduated in 1909 with an extremely good first class and a graduate scholarship. In 1910 he took the Teachers' Diploma as a step towards redeeming his pledge to the Government, which had contributed towards the cost of his education.

The serious work of life was now to begin. It was the time when the Workers' Education Association was first operating on a large scale in Lancashire, and he was at once swept up into the movement, being appointed in 1910 assistant lecturer in history at the University with special charge of W.E.A. classes at Colne, Ashton, and Leigh, to which others were subsequently added. He threw himself into this work with the greatest energy. He took the greatest pains in presenting his material in an acceptable form. His youthful appearance excited the suspicions of some among his elderly auditors. They used, Mr. Paton tells me, " to lay traps for him. He seemed to know so much, and they wanted to see if it was all ' got up for the occasion.' But he was a ' live wire.' He used to heckle me fine after education lectures at College." This early acquired skill in debate soon rode triumphant over the critics. He did not content himself simply with giving

lectures and taking classes. In order to get to know his pupils personally, he stayed over week-ends at the towns where he taught. He had long Sunday tramps with his disciples over the moors, and though he never flattered them, and was perhaps sometimes rather austere in his dealings with them, he soon completely won their confidence and affection. I remember the embarrassment felt by the administrators of the movement, when a class, which had had experience of his gifts, almost revolted against the severely academic methods of a continuator of his course, and was only appeased when it was fortunately found possible to bring him back to his flock without compromising the situation. He continued in this work as long as he was in England, and when the winter of 1913-14 took him to London, he had the same success with the south-country workmen as with the men he had known from youth up in the north. Mr. E. H. Jones, the secretary of his Wimbledon class, thus describes the impression he made there with a course on the " Making of Modern England " :

Many of the students had misgivings as to the success of what appeared to them as a dull, drab, and dreary subject. These doubts were further increased when, at the first preliminary meeting, a slim, quiet, unassuming, and nervous young man got up, and in a hesitating manner outlined the chief features of the course. The first lecture, however, was sufficient to ensure the success of the venture. His thorough knowledge of the subject, his clear and incisive style, together with a charming personality, held the attention of the class. His realistic description of the condition of the people, especially of the working classes, during the early part of the nineteenth century—the homes they lived in and the lives they lived—showed us at once a man with a large heart, one who sympathised with the sorrows and the sufferings of the people. His great desire was to serve his fellows by educating, and so exalting the manhood of the nation. We, who knew him, understand the motives which prompted him to offer his life for the sake of our common humanity. He hated tyranny ; the beat of the drums of war had no charms for him, unless the call was in the cause of Justice and Liberty." [1]

This appreciation is not overdrawn. There was nothing in Hovell of the clap-trap lecturer for effect. His rather conserva-

[1] *The Highway,* December 1916, pp. 56-57.

tive point of view knew little of short cuts, either to social amelioration or to the solution of historic problems. He offered sound knowledge coupled with sympathy and intelligence, and it is as much to the credit of the auditors as of the lecturer that they gladly took what he had to give.

Hovell's lecturing, important as it was, could only be subsidiary to the attainment of his main purpose in life. As soon as he graduated, he made up his mind to equip himself by further study and by original work for the career of a university teacher of history. His degree course had given him a practical example of the character of two widely divergent periods of history, studied to some extent in the original authorities. One of these was the reign of Richard II., which he had studied under the direction of Professor Tait. He had sent up a degree thesis on Ireland under Richard II., written with a maturity and thoughtfulness which are rarely found in undergraduate essays. This essay he afterwards worked into a study which we hope to print, when conditions again make academic treatises on mediaeval problems practical politics. It was evidence that he might, if he had chosen, become a good mediaevalist. But his temper always inclined him towards something nearer our own age, and his other special subject, the Age of Napoleon I., seemed to him to lead to wide fields of half-explored ground in the first half of the nineteenth century. He attended for this course lectures of my own on the general history of the period, and made a special study of some of the Napoleonic campaigns, which he studied under the direction of Mr. Spenser Wilkinson, then lecturer in Military History at Manchester, and now Chichele Professor of that subject at Oxford. It was Mr. Wilkinson's lectures that first kindled his enthusiasm for military history.

Hovell's main bent was towards the suggestive and little-worked field of social history, and his interest in the labour and social problems in the years succeeding the fall of Napoleon was vivified by the practical calls of his W.E.A. classes upon him. I feel pretty sure that it was the stimulus of these classes that finally made him settle on the social and economic history

of the early Victorian age as his main subject. It was upon this that he gave nearly all his lectures to workmen. Indeed, much of the vividness and directness of his appeal was due to the fact that he was speaking on subjects which he himself was investigating at first hand. A deep interest in the condition of the people, a strong sympathy with all who were distressfully working out their own salvation, a rare power of combining interest and sympathy with the power of seeing things as they were, made his progress rapid, and increasing mastery only confirmed him in his choice of subject. Finally he narrowed his investigations to the neglected or half-studied history of the Chartist Movement, and examined with great care the economic, social, and political conditions which made that movement intelligible.

Hovell's teachers were not unmindful of his promise, and in 1911 his election to the Langton fellowship, perhaps the highest academic distinction at the disposal of the Arts faculty of the Manchester University, provided him with a modest income for three years during which he could carry on his investigations, untroubled by bread problems. He now cut down his teaching work to a minimum, and threw himself whole-heartedly into his studies. Circumstances, however, were not very propitious to him. He was a poor man, and was the poorer since his abandonment of school teaching involved the obligation of repaying the sums advanced by the State towards the cost of his education. The work he now desired to do was perhaps as honourable and useful as that for which he had been destined. It was, however, different. He had received State subsidies on the condition that he taught in schools, and he chose instead to teach working men and University students. So far as his bond went, he had, therefore, nothing to complain of. The Board of Education, though meeting him to some extent, was not prepared, even in an exceptional case, to relax its rules altogether. While recognising the inevitableness of its action, it may perhaps be permitted to hope that the time may come, even in this country, when it will be allowed that the best career for the

individual may also be the one which will prove the most profitable to the community. Otherwise, the compulsion imposed on boys and girls, hardly beyond school age, to pledge themselves to adopt a specific career may have unpleasant suggestions of something not very different from the forced labour of the indentured coolie or Chinaman.

Other difficulties stood in Hovell's way. He had to continue his W.E.A. classes until he had completed his obligations to them, and it required moral courage to avoid accepting new ones. The University also had its claims on him, and untoward circumstances made his lectureship much more onerous than it had been intended to be. In the spring of 1911 a serious illness kept me away from work, and between January and June 1912 the University was good enough to allow me two terms' leave of absence. On both occasions Hovell was asked to deliver certain courses of my lectures, and I shall ever be grateful for the readiness with which he undertook this new and onerous obligation. But he gained thereby experience in teaching large classes of students, and it all came as part of the day's work. Despite this his study of the Chartists made steady progress.

A further diversion soon followed. Up to now Hovell's work had lain altogether in the Manchester district, and *Wanderjahre* are as necessary as *Lehrjahre* to equip the scholar for his task. The opportunity for foreign experience came with the offer of an assistantship in Professor Karl Lamprecht's Institut für Kultur- und Universalgeschichte at Leipzig for the academic session of 1912–1913. This offer, which came to him through the kind offices of Sir A. W. Ward, Master of Peterhouse, was the more flattering since the Leipzig Institute was a place specially devised to enable Dr. Lamprecht to disseminate his teaching as to the nature and importance of *Kulturgeschichte*. Reduced to its simplest terms Lamprecht's doctrine is that the social and economic development of society is infinitely more important than the merely political history to which most historians have limited themselves. Not the State alone but society as a whole is the real object

of the study of the historian. Various doubtful amplifications and presuppositions involved in Lamprecht's teaching in no wise impair the essential truth of the broad propositions on which it is based.

Hovell's own studies of social history showed him to be predisposed to sympathy with the master. But he had never been in Germany, and his German was almost rudimentary. However, he worked up his knowledge of the tongue by acquiring from Lamprecht's own works the point of view of the great apostle of *Kulturgeschichte*. Accordingly by the time Hovell reached Leipzig, he had acquired the keys both of the German language and of Lamprecht's general position. He found that Lamprecht's Institute, though loosely connected with the University, was a self-contained and self-sufficing seminary for the propagation of the new historic gospel, and looked upon with some coldness and suspicion by the more conservative historical teachers. It was a wise part of the system of the Institute that certain foreign " assistants " should present the social history of their own country from the national point of view. Towards this task Hovell's contribution was to be an exposition of the social development of England in the nineteenth century, so that his Chartist studies now stood him in good stead. He was, however, profoundly convinced of the high standard required from a German University teacher, and made elaborate preparations to give a course of adequate novelty and thoroughness. Unfortunately he found that the students who gradually presented themselves were far from being specialists. They were not even anxious to become specialists, and were nearly all somewhat indifferent to his matter, looking upon the lectures and discussions as an easy means of increasing their familiarity with spoken English.

The beginning was rather an anxious time, especially when presiding over and criticising the reading of the *referate*, or students' exercises, which alternated with his set lectures. He was impressed with the power of his pupils to write and discuss their themes in English, though glad when increasing

familiarity with German enabled him also to deal with their difficulties in their own tongue. The only other academic work that he essayed was taking part in Professor Max Förster's English *seminar*. The lightness of the daily task gave him leisure for looking round, and seeing all that he could see of Germany and German social and academic life. He attended many lectures, delighting especially in Förster's clear and stimulating course on Shakespeare, broken on one occasion by a passionate exhortation to the students to forsake their beer-drinkings and duels, and to cultivate manly sports after the English fashion, so as to be able the better to defend their beloved Fatherland. He was much impressed by Wundt, the psychologist, " a little plain and unassuming-looking man dressed in undistinguished black, lecturing with astounding clearness and strength, at the age of 81, to a closely packed and attentive audience of fully 350 students, who look on him as the wonder of his age, and are eager to catch the last words that might come from the lips of the master." He heard all that he could from Lamprecht himself, with whom his relations soon became exceedingly cordial. He found him genial, friendly, and good-natured, and he was impressed by his dominating personality and missionary fervour, his broad sweep over all times and periods, the width of his interests, and the extent of his influence. He sincerely strove to understand the mysteries of the new science. The very abstractness and theoretical character of the Lamprechtian method was a stimulus and a revelation to a man of clear-cut positive temperament, schooled in historical teaching of a much more concrete character. It was easy to hold his own in the English seminar where the discussions were in his own tongue. But he gradually found himself able to take his share in Lamprecht's seminar, where all the talk was in German. " My reputation among the students," he writes, " was founded on my knowledge that the predecessor of the *Reichsgericht* sat at Wetzlar." It was a proud moment when he had to explain that the master's confusion of the modern English chief justice and the justiciar of the twelfth century was the natural error of the

foreigner. He was still more gratified when called upon by Lamprecht to read an elaborate treatise in German on the *der englische Untertanenbegriff*, the English conception of political subjection. His only embarrassment now was that he could never quite convince himself that there was any specifically English conception of the subject at all, and that he rather wondered whether Lamprecht knew whether there was one either. But however much he criticised, he never lost his loyalty to the man. His doubts of the Lamprechtian system became intensified when he found underlying it errors of fact, uniform vagueness of detail, and cut-and-dried theoretical presuppositions against which the broad facts of history were powerless to prevail. One of his last judgments, made in a letter to me in June 1913, is perhaps worth quoting :

Professor Lamprecht is lecturing this term on the history of the United States. His course is exceedingly interesting, but I am bound to say that his history strikes me as highly imaginative. He never speaks of the English colonies. They are always " teutonisch," except when (as to-day) he says in mistake " deutsch." Thus Virginia in 1650 was " teutonisch." He persistently depreciates the English element on the strength of the existence of a few Swedish, Dutch, and German settlements. By some magic English colonists cease to be English as soon as they cross the ocean, so that their desire for freedom and political equality owes little or nothing to the fact of their being English. He carefully distinguishes even Scots from English. He views the history of America down to 1763 as an episode in the eternal struggle of the " romanisch " and " teutonisch " peoples, and the beginning of the decided triumph of the latter, whose greatest victory of course was in 1870-71. I am firmly convinced that he neither understands England, nor the English, nor English history. Still, although I don't agree with half he is saying, I find his method of handling things interesting ; he stimulates thought, if only in the effort to follow his.

The whole period at Leipzig was one of intense activity. Hovell enjoyed himself thoroughly. He was always eager to widen his experiences, and found much kindness from seniors and juniors, Germans and compatriots. He made a special ally of his French colleague, who did not take *Kulturgeschichte* quite so seriously as he did. The two exiles spent the short Christmas recess in a tour that extended as far as Strassburg,

where they moralised on the contrasts between the new Strassburg, that had arisen after 1871, and the old city, that still sighed for the days when it was a part of France. At Leipzig Hovell revelled in the theatres, in the *Gewandhaus* concerts, the singing of the choir of the *Thomas Kirche*, and the old Saxon and Thuringian cities, churches, and castles. He was specially impressed with the orderly development from a small ancient nucleus of the modern industrial Leipzig, with its well-planned streets and spacious gardens, with which the Lancashire towns which he knew contrasted sadly. He attended all manner of students' festivities, drank beer at their *Kneipen*, and witnessed, not without severe qualms, the bloodthirsty frivolities of a students' duel. He was present when the King of Saxony, whose personality did not impress him, came to Leipzig to spend a morning in attending University lectures and an afternoon in reviewing his troops. He saw Gerhard Hauptmann receive an honorary degree, and delighted in the poet's recitation of a piece from one of his unpublished plays. He was so quick to praise the better sides of German life that he was condemned by his French colleague for his excessive accessibility to the Teutonic point of view. His appreciation of German method extended even to the police, whom he eulogised as efficient, and not too obtrusive in their activities. He recognised the thoroughness, economy, and thriftiness with which the Germans organised their natural resources. He spoke with enthusiasm of the ways in which the Germans studied and practised the art of living, their adaptation of means to ends, their avoidance of social waste. He was struck with the absence of visible slums and apparent squalor. The spectacle of the material prosperity obtained under Protection led him to wonder whether the gospel of Cobden in which, like all good Manchester men, he had been brought up, was necessarily true in all places and under all conditions. But he had enough clarity of vision to see that there was another side to the apparent comfort and opulence of Leipzig. He was appalled at the lack of method and organisation when individual enterprise was left to work out

details for itself, as was notably instanced by the slipshod, happy-go-lucky ways in which the affairs of the Institute and University were conducted. He watched with keen interest elections for the Saxon Diet or *Landtag*, when Leipzig's discontent with the constitution of society rose triumphant over an electoral system as destructive to the expression of democratic control as that of the Prussian Diet itself. Things could hardly be well when Leipzig returned, by overwhelming majorities, both to the local and to the imperial Parliaments, Social Democrats pledged to the extirpation of the existing order. A constitution, cunningly devised to suppress popular suffrage, and manhood voting yielded the same result.

Another aspect of German opinion was strange and painful to him. He had been taught that in Germany the enthusiasts for war were as negligible an element as the " militarists " of his own land. But he soon found that the truth was almost the reverse of what he had expected. From the beginning he was appalled, too, by the widespread evidence of deep-rooted hostility to England, even in the academic circles which received him with the utmost cordiality. The violence of the local press, the denunciations of England by stray acquaintances in trains and cafés, seemed to him symptomatic of a deep-set feeling of hatred and rivalry. He saw that Lamprecht studied English history in the hope of appropriating for his own land the secret of British prosperity, and that Förster exhorted the students to play football that they might be better able to fight England when the time arrived, and that both were confident that the time would soon come. He was disgusted at the crass materialism he saw practised everywhere. He was particularly moved by a quaint exhortation to the local public to contribute handsomely to celebrate the Emperor's jubilee by subscribing to a national fund for missions to the heathen. No one saw anything scandalous or humorous in a spiritual appeal based on the most earthly of motives, and centring round the arguments that a large collection would please the Kaiser, and that, as England and America had used missionaries as pioneers of trade and might,

Germany must also " prepare the way for world-power by the faithful and unselfish labours of her missionaries in opening up the economic and political resources of her protectorates." He saw that *Deutschland über alles* meant to many Germans a curious dislocation of values. An agreeable young *privat-docent*, who visited him later in England, showed something of the same spirit when, coming with a Manchester party on an historical excursion to Lincoln, he saw nothing to admire in the majestic city on a hill nor in the wonderful cathedral. Far finer sites and much better Gothic art were, he solemnly assured us, to be seen in Saxony and the Mark of Branden-burg. Very few of his many German friends had Hovell's keen sense of humour.

Hovell's stay in Germany was broken by a visit to England at Easter 1913, when he attended the International Historical Congress in London, where he introduced me to Lamprecht. I was much impressed with the fluency and accuracy which Hovell's German speech had now attained, as well as with the cordiality of his relations to his large German acquaintance. He returned to Leipzig for the summer semester, and was back in England for good by August.

The novel Leipzig experiences had thrown the Chartists into the shade, the more so as Hovell found the University Library capriciously supplied with English books, and catalogued in somewhat haphazard fashion. But he profited by the oppor-tunity of a careful study of the important works which notable German scholars had recently devoted to the neglected history of modern British social development. He found some of these monographs were "too much after the German style, rather *compendia* than analytical treatises, but useful for facts, references, and bibliographies." Others of the " more philosophic sort " gave him " good ideas," and he regarded Adolf Held's *Zwei Bücher über die sociale Geschichte Englands* " specially good." Steffen's *Geschichte der englischen Lohn-arbeiter*, the translation of a Swedish book by a professor at Göteborg, and M. Beer's *Geschichte des Socialismus in England* were also extremely useful. But he was soon on his guard

against the widespread tendency to wrest the facts to suit various theoretical presuppositions, and to realise the fundamental blindness to English conditions and habits of thought that went along with laborious study of the external facts of our history. Though he by no means worked up all his impressions of German authors into his history, the draft, which he left behind him, bears constant evidence alike of their influence and of his reaction from it. It was at this time he first saw his work in print in the shape of a review of Professor Liebermann's *National Assembly in the Anglo-Saxon Period*, contributed to a French review.

On returning to England Hovell established himself in London, where he worked hard at the Place manuscripts (unhappily divided between Bloomsbury and Hendon), the Home Office Records, and other unpublished Chartist material. During the winter he took a W.E.A. class at Wimbledon. By the summer of 1914 he was ready to settle at home again and to put together his work on the Chartists. His fellowship now coming to an end, he undertook more W.E.A. courses in the Manchester district for the winter of 1914–1915, and a small post was found for him at the University, where he received charge of the subject of military history. This study the University prepared to develop in connection with a scheme for preparation of its students for commissions in the army and territorial forces.

No sooner were these plans settled than the great war broke out. The classes in military history were reduced to microscopic dimensions, since all students keen on such study promptly deserted the theory for the practice of warfare. Though anxious to follow their example, Hovell remained at his work until the late spring of 1915, finding some outlet for his ambition to equip himself for military service in the University Officers' Training Corps, in which he was a corporal. In May, as soon as his lectures to workmen were over, he applied for a commission. He had nothing of the bellicose or martial spirit ; but he had a stern sense of obligation and a keen eye to realities. Like other contemporaries who had

sought experience in Germany, he fully realised the inevitableness of the struggle, and he knew that every man was bound to take his place in the grave and prolonged effort by which alone England could escape overwhelming disaster. " I don't think," he wrote to me, " I shall dislocate the economy of the University by joining. What troubles me is of course my book. I have written nearly a chapter a week since Easter. At this rate I shall have the first draft nearly completed by the end of another three months, and I am therefore very keen to finish it. If there were no newspapers I could keep on with it; but the Chartists are dead and gone, while the Germans are very much alive."

In June Hovell was sent to a school of instruction for officers at Hornsea, where they gave him, he said, the hardest " gruelling " in his life, and from which he emerged, at the end of July, at the head of the list with the mark " distinguished " on his certificate. He was gazetted in August to a " Kitchener " battalion of the Sherwood Foresters, the Nottingham and Derby Regiment. But officers' training had not yet become the deftly organised system into which it has now developed. When Hovell joined his battalion at Whittington Barracks, near Lichfield, he found himself one of a swarm of supernumerary subalterns, who had no place in the scheme of a battalion fully equipped with officers. As there were no platoons available for the newcomers to command, they were put into instruction classes, hastily and not always effectively devised for their benefit. He rather chafed at the delay but enjoyed the hard life and the new experience. It was soon diversified by a course of barrack-square drill with the Guards at Chelsea, by an informal assistantship to a colonel who ran an instructional school for officers, by a very profitable month at the Staff College at Camberley, where he soon " felt quite at home, seeing that the place is so like a University with its lecture-rooms and libraries and quiet places," and by a period of musketry instruction in Yorkshire, where an evening visit to York gave him his first practical experience of a Zeppelin raid. Altogether a year was consumed in these preliminaries.

In June 1916 Hovell was back with his battalion, now camped in Cannock Chase. On June 3 he married Miss Fanny Gatley of Sale, the Cheshire suburb in which his own family had lived in recent years. A little later he wrote : " We managed a whole week in the Lake District, where it rained all the time. Then I went back to my regiment and my wife came to stay two miles away." Then the attack on the Somme began, and " we heard rumours that officers were being exported by the hundred." On July 4 he received orders to embark, and crossed to France a week later. There were some vexatious delays on the other side, but at last he joined one of the regular battalions of his regiment in a small mining village. The battalion had been cruelly cut up in the recent fighting on the Somme, and the officers, old and new, were strangers to him. But by a curious accident he found an old friend in the chaplain, the Rev. T. Eaton McCormick, the vicar of his parish at home. He was now plunged into the real business of war, and did his modest bit in the reconstitution of the shattered battalion. " I blossomed out," he wrote, " as an expert in physical training, bayonet fighting, and map-reading to our company. All the available N.C.O.'s were handed over to my care, and they became enthusiastic topographers."

Before the end of the month the battalion was reorganised and moved back into the trenches. On August 1 he wrote to me in good spirits :

Behold me at last an officer of a line regiment, and in command of a small fortress, somewhere in France, with a platoon, a gun, stores, and two brother officers temporarily in my charge. I thus become owner of the best dug-out in the line, with a bed (four poles and a piece of stretched canvas), a table, and a ceiling ten feet thick. We are in the third line at present, so life is very quiet. Our worst enemies are rats, mice, beetles, and mosquitoes.

This first experience of trench life was uneventful, and the battalion went back for a short rest. The remainder of the story may best be told in the words of Mr. McCormick, writing to Hovell's mother to tell her the news of her son's death.

Mark and two other officers of the Sherwood Foresters dined with me on Wednesday last, August 9. We were a jolly party and

talked a lot about home. After dinner he asked me if it would be possible for him to receive the Holy Communion before going into the trenches, and next morning I took him in my cart two miles away, where we were having a special celebration for chaplains. That was the last I saw of him alive. He went into the trenches for the second time in his experience (he had been in a different part of the line the week before) on last Friday. On Saturday night at 9.10 P.M., August 12, it was decided that the Sherwood Foresters should explode a mine under the German trenches. Mark was told off to stand by with his platoon. When the mine blew up, one of Mark's men was caught by the fumes driving up the shaft, and Mark rushed to his rescue, like the brave lad that he was, and in the words of the Adjutant of his battalion, "we think he in turn must have been overcome by the fumes. He fell down the shaft and was killed. The Captain of the company went down after him at once and brought up his body.". . . They knew that he was a friend of mine, as I had been telling the Colonel what a brilliantly clever man he was, and what distinctions he had won, so they sent for me, and the men of his battalion carried his body reverently down the trenches. We laid him to rest in a separate grave, and I took the service myself. It was truly a soldier's funeral, for, just as I said "earth to earth," all the surrounding batteries of our artillery burst forth into a tremendous roar in a fresh attack upon the German line. . . . He has, as the soldiers say, "gone West" in a blaze of glory. He has fought and died in the noblest of all causes, and though now perhaps we feel that such a brilliant career has been brought to an untimely end, by and by we shall realise that his sacrifice has not been in vain.

Over a year has passed away since Hovell made the supreme sacrifice, and the cannon still roar round the British burial-ground amidst the ruins of the big mining village of Vermelles where he lies at rest. While north and south his victorious comrades have pushed the tide of battle farther east, the enemy's guns still rain shell round his unquiet tomb from the hitherto impregnable lines that defend the approach to Lille.

Nothing more remains save to record the birth on March 26, 1917, of a daughter, named Marjorie, to Hovell and his wife, and to give to the world the unfinished book to which he had devoted himself with such extreme energy. This work, though very different from what it would have been had he lived to complete it, may do something to keep his memory green, and to suggest, better than any words of mine can, the promise of his career. But no printed pages are needed to preserve among his comrades

in the University and army, his teachers, his friends, and his pupils, the vivid memory of his strenuous, short life of triumphant struggle against difficulties, of clear thinking, high living, noble effort, and of the beginnings of real achievement. For myself I can truly say that I never had a pupil for whom I had a more lively friendship, or one for whom I had a more certain assurance of a distinguished and honourable career. He was an excellent scholar in many fields; he could teach, he could study, and he could inspire; he had in no small measure sympathy, aspiration, and humour. He possessed the rare combination of practical wisdom in affairs with a strong zeal for the pursuit of truth; he was a magnificent worker; he kept his mind open to many interests; he had a wonderfully clear brain; a strong judgment and sound common-sense. I had confidently looked forward to his doing great things in his special field of investigation. How far he has already accomplished anything noteworthy in this book, I must leave it for less biassed minds to determine. But though I am perhaps over-conscious of how different this book is from what it might have been, I would never have agreed to set it before the public as a mere memorial of a promising career cut short, if I did not think that, even as it is, it will fill a little place in the literature of his subject. When he finally set out for the front he entrusted to me the completion of what he had written. I have done my best to fulfil the pledge which I then gave him, that should anything untoward befall him, I would see his book through the press.

CHAPTER I

THE CHARTER AND ITS ORIGIN

THE Chartist Movement, which occupied so large a space in English public affairs during the ten years 1838 to 1848, was a movement whose immediate object was political reform and whose ultimate purpose was social regeneration. Its programme of political reform was laid down in the document known as the "People's Charter," issued in the spring of 1838. Its social aims were never defined, but they were sufficiently, though variously, described by leading men in the movement. It was a purely working-class movement, originating exclusively and drawing its whole following from the industrialised and unpropertied working class which had but recently come into existence. For the most part it was a revolt of this body against intolerable conditions of existence. That is why its programme of social amelioration was vague and negative. It was an attempt on the part of the less educated portion of the community to legislate for a new and astounding condition of society whose evils the more enlightened portion had been either helpless or unwilling to remedy. The decisive character of the political aims of the Chartists bespeaks the strength of political tradition in England.

The "People's Charter" is a draft of an Act of Parliament, a Bill to be presented to the House of Commons.[1] It is drawn up in a clear and formal but not too technical style, with preamble, clauses, and penalties, all duly set forth. It is a

[1] The Charter is divided into thirteen sections:

I. Preamble.
II. Franchise.
III. Equal Electoral Districts.
IV. Registration Officer.
V. Returning Officer.
VI. Deputy Returning Officer.
VII. Registration Clerk.
VIII. Arrangement for Registration.
IX. Arrangement for Nominations.
X. Arrangement for Elections.
XI. Annual Parliaments.
XII. Payment of Members.
XIII. Penalties.

lengthy document, occupying some nineteen octavo pages, but
brevity itself in comparison with a fully-drawn Bill for the
same purpose from the hands of a Parliamentary draughts-
man. The preamble is as follows :

> Whereas to insure, in as far as it is possible by human fore-
> thought and wisdom, the just government of the people, it is
> necessary to subject those who have the power of making the laws
> to a wholesome and strict responsibility to those whose duty it is
> to obey them when made,
> And whereas this responsibility is best enforced through the
> instrumentality of a body which emanates directly from, and is
> immediately subject to, the whole people, and which completely
> represents their feelings and interests,
> And whereas the Commons' House of Parliament now exercises
> in the name and on the supposed behalf of the people the power of
> making the laws, it ought, in order to fulfil with wisdom and with
> honesty the great duties imposed on it, to be made the faithful and
> accurate representation of the people's wishes, feelings, and interests.

The definite provisions fall under six heads—the famous
" Six Points " of the Charter. First, every male adult is
entitled to the franchise in his district after a residence of three
months.[1] Second, voting is by ballot. Third, there will be
three hundred constituencies divided as equally as possible on
the basis of the last census, and rearranged after each census.
Fourth, Parliament is to be summoned and elected annually.
Fifth, there is to be no other qualification for election to Parlia-
ment beyond the approval of the electors—that is, no property
qualification. Sixth, members of Parliament are to be paid
for their services.

Besides these fundamentals of a democratic Parliamentary
system, there are minor but highly important provisions. The
Returning Officers are to be elected simultaneously with the
members of Parliament, and they are to be paid officials. All
elections are to be held on one and the same day, and plural
voting is prohibited under severe penalties. There is no
pauper disqualification.[2] All the expenses of elections are to
be defrayed out of an equitable district-rate. Canvassing is
illegal, and there are to be no public meetings on the day of
election. A register of attendance of the members of Parlia-
ment is to be kept—a logical outcome of payment. For the
infringement of the purity of elections, for plural voting,

[1] Residence of three months is only mentioned casually, in connection
with registration. [2] Added in 1842.

canvassing, and corrupt practices, imprisonment is the only penalty; for neglect, fines.[1]

As an arrangement for securing the purity of elections and the adequate representation of public opinion in the House of Commons, the " People's Charter " is as nearly perfect as could be desired, and if a sound democratic government could be achieved by the perfection of political machinery, the Chartist programme would accomplish this desirable end. The Chartists, like the men of 1789 in France, placed far too great a faith in the beneficent effects of logically devised democratic machinery. This is the inevitable symptom of political inexperience. We shall nevertheless see that there were Chartists, and those the best minds in the movement, who realised that there were other forces working against democracy which could not be removed by mechanical improvements, but must be combated by a patient education of the mind and a building up of the material welfare of the common people—the forces of ignorance, vice, feudal and aristocratic tradition.

The political Chartist programme is now largely incorporated into the British Constitution, though we have wisely rejected that multiplication of elections which would either exhaust public interest or put an end to the stability and continuity of administration and policy. In itself the Chartist Movement on its political side represents a phase of an agitation for Parliamentary Reform which dates in a manner from the reign of Elizabeth.[2] The agitation began therefore when Parliament itself began to play a decisive part in public affairs, and increased in vehemence and scope according as the importance of Parliament waxed.

The abuses of the representative system were already recognised and turned to advantage by politicians, royal and popular, during the latter half of the sixteenth and the first half of the seventeenth century; but beyond a single timid attempt at reform by James I. nothing was attempted until the great politico-religious struggle between 1640 and 1660. It is here that we must look for the origins of modern radical and democratic ideas. The fundamentals of the representative system came up for discussion, and in the Instrument of Government, the written constitution which established the Protectorate in 1653, a drastic scheme of reform, including the normalisation of the franchise and a sweeping redistribution

[1] For full text see Lovett, *Life and Struggles*, pp. 449 *et seq*. This is the revised edition of 1842, but is substantially the same as that of 1838.
[2] Porritt, *Unreformed House of Commons*, Cambridge, 1903, i. 1.

of seats, was made. In the preliminaries to this the question whether true representation was of persons or of property, which goes to the root of the matter, was debated long and earnestly by the Army in 1647. In the debate on the Agreement of the People, the Radical and Whig standpoints are clearly exhibited.[1]

Mr. Pettus— Wee judge that all inhabitants that have nott lost their birthright should have an equall voice in Elections.

Rainborough—I think its cleare that every man that is to live under a Government, ought first by his owne consent to putt himself under that Government.

Ireton—. . . You must fly for refuge to an absolute naturall right. . . . For my parte I think itt is noe Right att all. I think that noe person hath a right to an interest or share in the disposing or determining of the affaires of the kingdome and in chusing those that shall determine what lawes wee shall bee ruled by heere, noe person hath a right to this, that hath nott a permanent fixed interest in this kingdome.

Here obviously the question of manhood or property suffrage is the issue. Colonel Rich declared that manhood suffrage would be the end of property.

Those that have noe interest in the kingdome will make itt their interest to choose those that have noe interest. Itt may happen that the majority may by law, nott in a confusion, destroy propertie: there may bee a law enacted that there shall bee an equality of goods and estate.[2]

There was at the same time a demand for short and regular Parliaments, and that elections should be made " according to some rule of equality or proportion " based upon " the respective rates they (the counties and boroughs) bear in the common charges and burdens of the kingdome . . . to render the House of Commons as neere as may bee an equall representative of the whole body of the People that are to elect." Parliament was to be elected biennially and to sit not more than eight months or less than four.[3]

Here, therefore, is the nucleus of a Radical Programme : Manhood Suffrage, Short Parliaments, and Equal Representation. We have even a hint at the doctrine of " absolute naturall right," which lies at the base of modern democratic theory since the French Revolution, and which found an echo in the minds of all Chartists two hundred years after the famous

[1] *Clarke Papers,* ed. Firth, i. 299-307.
[2] *Ibid.* p. 315.
[3] *Ibid.* pp. 363 *et seq.,* "Agreement of the People." Gardiner, *Select Documents of the Puritan Revolution,* "Heads of the Proposals."

debates at Putney. With the downfall of the Commonwealth such conceptions of abstract political justice were snowed under by the Whig-Tory reaction. Henceforth both parties stoutly upheld the " stake in the kingdom " idea of representation. The height of this reaction came in the High Tory days of Queen Anne, when the legal foundations of the aristocratic régime were laid. The imposition of a property qualification upon would-be members of Parliament dates from 1710, when it was enacted that the candidate for a county must possess £600 a year and for a borough £300 a year, in both cases derived from landed property.[1] This act was passed in the face of some Whig opposition, as the Whigs would have made exceptions in favour of the wealthy merchants of their party. Two years later followed the first of the enactments throwing election expenses upon the candidate.[2] A further diminution of popular control resulted from the Septennial Act, though this was a Whig measure.

The Radical tradition, however, was not dead but sleeping. It lived on amongst the dissenting and nonconformist sections, whose ancestors had fought and debated in the days of Cromwell and had been evicted in 1662. The revival of Nonconformity under the stimulus of Methodism, the growth of political and historical criticism during the eighteenth century, and the growing estrangement between the House of Commons and the people at large, brought about a resurrection of Radicalism. In the second half of the century the Radical Programme appeared in full vigour.

The first plank of the Radical platform to be brought into public view was the shortening of the duration of Parliaments. In 1744 leave to bring in a Bill establishing Annual Parliaments was refused only by a small majority. In 1758 another Bill was refused leave by a much more decisive vote. In 1771 Alderman Sawbridge failed to obtain leave to introduce a similar measure, although he had the moral support of no less important persons than Chatham and Junius.[3] In the same year a Wilkite society recommended that Parliamentary candidates should pledge themselves to support a Bill to " shorten the duration of Parliaments and to reduce the number of Placemen and Pensioners in the House of Commons, and also to obtain a more fair and equal representation of the people."[4]

[1] Porritt, i. 166. [2] Ibid. i. 185-195.
[3] Veitch, The Genesis of Parliamentary Reform, p. 34.
[4] Ibid. p. 32.

By this time the flood of controversy aroused by the Wilkes cases was in full flow, and the tide of Radical opinion was swelled by the revolt of the American Colonies. In 1774 Lord Stanhope, and in 1776 the famous Major John Cartwright, published more sweeping plans of Parliamentary Reform. Cartwright's scheme is set forth in the pamphlet, *Take your Choice.* Annual Parliaments and the payment of members are defended and advocated on the ground that they were " the antient practice of the Constitution," an argument which was a mainstay of the Chartist leaders. Payment of members was in force down to the seventeenth century, the oft-cited Andrew Marvell receiving wages from his Hull constituents as late as 1678. In claiming Annual Parliaments as a return to ancient ways Cartwright had the authority, such as it was, of Swift.[1] Universal suffrage, vote by ballot, and the abolition of plural voting also found a place in Cartwright's scheme, but he maintained the property qualification for members of Parliament.[2] Thus four of the six " points " of the Charter were already admitted into the Radical programme. It only required a few years to add equal electoral districts and the abolition of the property qualification.

These were added by a committee of reformers under the guidance of Fox in 1780. The whole programme figured in the interrupted speech of the Duke of Richmond in the House of Lords in the same year and in the programme of the Society of the Friends of the People (1792–95). The Chartists were not unaware of the long ancestry of their principles.[3] There was a prophetic succession of Radicals between 1791, when the first working men's Radical society—the London Corresponding Society—was founded, and 1838, when the Charter was published. Down to the outbreak of the French Revolution the Radical faith in England, as in France, was mainly confessed in middle-class and some aristocratic circles. Wilkes, Fox, Sawbridge, and the Duke of Richmond are types of these early Radicals. With the opening of the States-General and the rapid increase of terrorism in France the respectable English Radicals began to shelve their beliefs. On the other hand, the lower classes rallied strongly to the cause of Radical reform, and the Radical programme fell into their keeping, remaining their

[1] *Life of Major John Cartwright*, by his niece F. D. Cartwright, London, 1826, i. 82.

[2] Veitch, p. 48.

[3] Lovett, *Life and Struggles*, p. 168. The preface to the first (1838) edition of the " People's Charter" contains a brief history of the "Six Points" from 1776 onwards.

exclusive property for the next forty years. When the middle class in the days after Waterloo returned to the pursuit of Parliamentary Reform, it was reform of a much less ambitious character. The working classes still held to the six points. During these forty years Radicalism became a living faith amongst the working class. It had had its heroes and its prophets and its martyrs, and when the salvation promised by the Whig reform of 1832 had proved illusory, it was perfectly natural to raise once more, in the shape of the "People's Charter," the ancient standard of popular reform.

By this time, however, the six points had acquired a wholly different significance. In the minds of the early Radicals they had represented the practical realisation of the vague notions of natural right. The programme was a purely political one, and was scarcely connected either with any specific projects of social or other reforms, or with any particular social theory. It represented an end in itself, the realisation of democratic theory. By 1838 the Radical programme was recognised no longer as an end in itself, but as the means to an end, and the end was the social and economic regeneration of society.

CHAPTER II

The years 1815–1840 represent the critical years of the Industrial Revolution. The inventions and discoveries of the previous century had provided the framework of a new industrial society, but the real social development, with the ideas, political and economic, and the new social relationships which grew out of it, appeared in full force only in the generation which followed the battle of Waterloo. It was then that the victory of machine production became an acknowledged fact, and with it the supremacy of large-scale production and large-scale organisation over domestic production and organisation. The rapid growth of production for the foreign market gave to industry a more speculative and competitive character, whilst the lack of real knowledge and experience gave rise to rash and ill-considered ventures which helped to give so alarming a character to the crises of 1816, 1826, and 1836. Though fluctuation in trade was not the creation of the Industrial Revolution, it seems clear that the increase of large-scale production for distant markets, with a demand which was seldom gauged with any exactitude, caused these fluctuations to be enormously emphasised, so that the crises above mentioned (with the last of which the Chartist Movement is closely connected) were proportionately far more destructive than depressions in trade now are. The rapid accumulation of capital and the development of credit facilities aided in the rise of a class of employers who were not the owners of the capital which they controlled. Thus the social distance which separated employers and employed was widened as capital seemed to become more and more impersonal. Under the old domestic system the employer resided as a rule in the neighbourhood of his work-people, but the new

8

captains of industry, whose fathers had perhaps been content to follow the example of the domestic master by living next to their workshops and factories, built themselves country houses farther away from the town, whilst their employees festered amidst the appallingly insanitary streets and alleys which had grown up around the factories. This separation was emphasised when, with the rise of joint-stock companies, the employer became practically the agent for a number of persons who had no other connection with or interest in industry than those arising out of the due payment of dividends. Such conditions arouse no particular feelings of discontent at the present day, but at a time when organisations for mutual protection against oppression were very infrequent and seldom very effective, it was felt that the personal and social contact of the employer and his workmen was the only guarantee of sympathetic treatment.[1] This divorce of classes in industrial society was making headway everywhere, even in those industries which were still under domestic arrangements, as the industry fell more and more into the hands of large wholesale houses. Crude ideas of class war were making their presence felt amongst the working people, whilst employers, who were influenced by the equally one-sided political economy of the period, tended to regard the interests of their class as paramount and essential to the development of national prosperity. The bane of the industrial system was the encouragement it gave to the rise of a brood of small capitalists but little removed in culture and education from the working people themselves, slender of resources, precarious in position, and therefore unable to abate one jot of the advantage which their position gave them over their workmen, often unscrupulous and fraudulent, and generally hated by those who came under their sway. There was as yet no healthy public opinion such as at present reacts with some effect upon industrial relationships, though such an opinion was growing up by the year 1840. Ignorance allowed many abuses to flourish, such as the hideous exploitation of women and children in mines and collieries as well as in other non-regulated industries. Working men might with reason feel that they were isolated, neglected, and exposed to the oppression of a social system which was not of their own making or choosing, but which, as they thought, was not beyond the control of their united power.

[1] See the very interesting remarks in the report on the silk industry of Coventry. *Parliamentary Papers*, 1840, xxiv. pp. 188 *et seq.*

D

The transformation of industrial organisation from the domestic to the large-scale system of production was by no means completed in the year 1840. It is even doubtful whether the large-scale system was as yet the predominant one. The weaving trade, the hosiery trade, and the hardware industry as a whole were carried on under systems which were either domestic or at least occupied a transitional position between the old and the new systems. Even in the mining industry the influence of large capitalists was by no means universal, as an examination of the Reports of the inquiries into the Truck System and into the employment of children in 1842 and 1843 will show.[1] It was in these as yet unrevolutionised or only partially revolutionised industries that the worst abuses and the most oppressive conditions prevailed—abuses which are erroneously supposed to be the outcome of the developed " capitalistic " system.

By the eighteenth century domestic industry was in general under capitalistic control. Whilst maintaining outwardly the organisation as it flourished in the heyday of the gilds, the system had really undergone a radical change. The small, independent, but associated producers of the Middle Ages had been able to maintain themselves because they had only to satisfy the demands of a fairly well known and only slowly developing market. Custom was strong and regulated largely the relations between producer and consumer, and between master, journeymen, and apprentices. Rates of pay, prices, hours of labour, qualities, and kinds of output were all fixed by custom and tradition which often received the sanction of the law of the land. Gradually the market grew and demand became less easy to gauge. This caused a new factor to enter the organisation—the merchant manufacturer, whose function it was to attend to the marketing of goods produced in each one particular industry. The wider the distance in point of time and place between producers and consumers, the more important did the functions of the merchant manufacturer become, until he, in fact, controlled the industry by virtue of his possession of capital. Without capital the gap between producer and consumer could not be bridged. Goods might now be produced many months before they were consumed, and sold long before the purchase money was handed over. Furthermore, the exhaustion of local supplies of raw material in some industries and the introduction of industries dependent

[1] *Parliamentary Papers*, 1842, ix., xv. ; 1843, xiii.

upon foreign supplies—such as silk and cotton—rendered the co-operation of accumulated capital essential. Thus the master manufacturers lost their independence and became mere links between the merchant capitalist and a hierarchy of employees. The journeymen and apprentices sank one step lower in consequence. So far the influence of the capitalist merchant left the organisation of labour untouched. Gradually, however, the desire to extend operations, the growth of capital, and the natural development of the markets for goods induced a desire to cheapen production. Forthwith came a greater specialisation and division of labour. Apprenticeship ceased to be essential to good workmanship, because an all-round knowledge of the processes of production was no longer requisite, but only special skill in one branch. The Act of Apprentices of 1562 fell into oblivion in many trades, and there grew up a generation of mere journeymen who would remain journeymen to the end of the chapter. The master workman became a mere agent, often for a distant, seldom seen, employer. Where apprenticeship still lingered, it was often a means of exploiting the labour of children. The customary relationships which had governed wages and regulated disputes lost all meaning, and competitive notions were substituted for them.

In some industries this development went on faster and farther than in others. In the spinning trade specialisation had early on caused a series of mechanical inventions which by 1790 culminated in the application of steam-power and brought into being the factory system of production. In this the lot of the worker, though bad, was better than that of the domestic industrialist of the succeeding generation. In the weaving trade technical difficulties delayed the introduction of efficient machinery till after the battle of Waterloo, whilst in some cases where machinery was available prejudice and conservatism delayed its introduction. Whilst therefore in the spinning trade the transformation was quick and merciful, in the weaving trades it was slow and terribly destructive. The Government Reports of the time give a very vivid picture of the forces of disintegration and reorganisation at work, and show how efficient an engine of oppression the domestic system could be when the domestic spirit and atmosphere had gone out of it, and an eager, competitive, and commercial spirit had come into it.

In the Coventry silk trade, of which we have an admirable

account,[1] control of the industry was at the beginning of the nineteenth century in the hands of merchant manufacturers of the type above described. Labour was organised under the master weaver who owned looms at which he employed journeymen and apprentices, although apprenticeship was already going out of fashion. When, however, the boom in trade, which was caused by the temporary disappearance of foreign competition during the war, came to an end in 1815, it brought about great changes in the trade. Control had passed to the large wholesale houses of London and Manchester.[2] The large profits had caused many master weavers to become independent traders, backed by the credit of the London houses. When the crash came they were unable to hold out and became either agents for the London houses to which they supplied goods on contract, or they fell back into the ranks of journeymen. In any case the London houses came to be the direct employers of labour and the master weavers were mere middlemen. Regular apprenticeship ceased altogether in many branches during the trade boom, and a new system of apprenticeship was introduced which was in fact a means of obtaining cheap child labour. Prices and wages fell, owing to the competition of machine-made goods from Manchester and Macclesfield, owing to the substitution of cotton for silk goods, and owing to the easier access to the trade. Competitive rates of wages were substituted for the customary rates which had obtained under the old system. Collective bargaining and attempts to get Parliamentary sanction for fixed wage-rates were from time to time resorted to. The latter course was uniformly unsuccessful, but the success of the attempts at collective bargaining depended upon the facilities which the weavers had for combined action. In the town of Coventry, where the labour was concentrated and the old traditions still survived,[3] the recognition of the weavers' standard of life was still effective, but in the country villages the weavers were dispersed, ignorant, and wholly at the mercy of unscrupulous employers.[4] In these districts where the worst-paid work was done, and wages were incredibly low—four or five shillings a week—there seems to have been a total absence of any civilising medium. Education was almost unknown, and the parishes were served by clergy who were non-resident and scarcely

[1] *Parliamentary Papers*, 1840, xxiv. [2] *Ibid.* pp. 33-34.
[3] There was a complicated industrial hierarchy at Coventry which hindered the growth of a true class feeling.
[4] P. 35.

ever visited them. In Coventry itself wages stood in 1838 much where they had been in the latter years of the eighteenth century, but the extraordinary complexity of the organisation in 1838 [1] makes it impossible to say more than the Government Commissioner—that the Coventry weavers were relatively worse off, compared with other classes,[2] than they had formerly been. Others had prospered; they had stood still. Besides, a weaver, who was middle-aged in 1838, could easily remember the time when he earned twice as much for the same work.[3] Such memories, in the absence of real knowledge as to the causes of such changes, were likely to be anything but soothing, and to cause men to give a ready belief to the easy explanations of the socialistic orators and pamphleteers of the time.[4] In fact the only persons who thought at all upon political questions were frankly socialist.

The Coventry trade suffered, as did all others to a greater or less degree, from enormous fluctuations. In December 1831 two-thirds of all the looms in the town were idle,[5] whilst in November 1838 scarcely any were unemployed. It was calculated that on the whole there were four persons doing work which could be accomplished by three working full time. This state of affairs was encouraged previous to 1834 by the abuses of poor relief, which, as the Commissioner remarks, merely subsidised labour for the distant London houses and helped to keep down wages by creating a swollen reserve of labour.[6] In 1830 the poor rates were used to bribe electors (as all weavers who had served a regular apprenticeship were enfranchised), and were more than trebled in consequence.

In spite of these drawbacks the Coventry weavers were perhaps the most fortunate survivors of the old state of affairs. Their neighbours of the immediate vicinity were far worse off. They pursued, as the Commissioner thought, almost an animal existence. There were perhaps twenty thousand individuals in a state of extreme destitution, filth, and degradation, in the town of Nuneaton and its neighbourhood. It is pleasing to read that things had once been worse.[7]

The silk-weavers were, of all those engaged in the trade of handloom-weaving, much the best situated. The worst off were the cotton-weavers. It is not easy to say exactly how

[1] There were five different systems of production and organisation at work (ibid. p. 36).
[2] P. 327.
[3] Pp. 288-9; cf. also pp. 4, 77-78.
[4] P. 187.
[5] P. 12.
[6] Pp. 304-7.
[7] Pp. 302, 322.

many handloom cotton-weavers there were in 1835 or 1838
It was estimated that there were in the Glasgow area in 1838
36,000 handlooms devoted mainly to cotton,[1] but in a small
percentage of cases to a mixed silk and cotton fabric. In
Carlisle there were nearly 2000 ; in the Manchester district from
8000 to 10,000. In Bolton there were 3000. Looms were very
numerous also in the Blackburn-Colne area, and in the
Accrington-Todmorden districts.[2] Perhaps there were more
than 25,000 handlooms in Lancashire, which number, added to
the figures above given, will give over 60,000 handlooms in all
devoted to cotton-weaving, inclusive of the number in which
mixed fabrics were woven. An estimate made at Carlisle gave
an average of two persons to each loom ; in Manchester of two
and one-third,[3] which suggests that between 120,000 and
150,000 individuals were in 1838 still dependent upon the pre-
carious trade of handloom cotton-weaving. As the Committee
of 1834–35 estimated the total number of handloom weavers
in all four branches (cotton, linen, wool, silk) as 840,000, this
estimate is perhaps not exaggerated. The cotton-weavers did
not form any very considerable proportion of the population
of Lancashire — perhaps 60,000 or 70,000 out of a million
and a quarter in 1838 ; but as they were concentrated in a
comparatively small area, and as there were amongst them
old men, who in the halcyon days of handloom-weaving had
acquired knowledge and culture and could make their influence
felt by other people, they attracted considerable attention.

The comparative slowness with which machinery was
applied to weaving was due to several causes. There was the
technical difficulty ; there was the very heavy cost of the
machines, and there was the period of abnormally high prices
at the beginning of the nineteenth century which encouraged
manufacturers to produce on the old lines so as to reap the
immediate profits with as little capital outlay as possible.
A great boom in handloom-weaving marked the years 1795–
1805. Wages were high owing to the abnormal demand for
weavers as compared with spinners. The industry was
swamped by an influx of unskilled hands who quickly learned
sufficient to enable them to earn vastly more than they had
earned elsewhere. Irish labourers poured into Lancashire
and Glasgow. A flood of small masters appeared and for a
while prospered. The end of the war brought on a terrible

<hr>

[1] *Parliamentary Papers*, 1840, xxiv. p. 6.
[2] *Parliamentary Papers*, 1839, xlii. pp. 584, 578, 602.
[3] Pp. 584, 578.

collapse, as the figures given will show. A cambric weaver, who earned from twenty to twenty-four shillings a week in the years 1798–1803, was earning from twelve to sixteen shillings during the years 1804–1816, after which he could earn no more than six or seven shillings. Prices for weaving in some cases fell as much as 80 per cent during the same period.[1] This collapse was rendered more destructive by the more rapid introduction of power-looms after the period of abnormal trade was over. Thus in 1803 there were but 2400 such looms ; in 1820, 12,150 ; in 1829 there were 45,000 ; in 1835 nearly 100,000, of which 90,000 were used in the cotton trade alone.[2] The lot of the weavers was not improved by the subterfuges of the small employers, who cut and abated wages without mercy in their efforts to avoid bankruptcy. Though the number of handloom-weavers constantly decreased, the process was delayed by the influx of still poorer labourers from Ireland, and by the practice of the weavers, in many cases compelled by poverty, of bringing up their children to the loom, a practice which was encouraged by the evil state of the conditions of labour in the factories, which were often the only alternative.

By 1835 the handloom cotton-weavers were mostly employed by large manufacturers, who in many cases had power-loom factories as well. Thus the handloom-weavers fell into two classes—those who competed with power and those who did not. The former were the worse off. They formed a kind of fringe around the factory, a reserve of labour to be utilised when the factory was overworked. Thus they were employed only casually, but helped, with the aid of doles out of the poor rates, to keep down the general level of wages for weaving in and out of the factory. Terrible are the descriptions of the privations of these men. The weavers of Manchester made a return in 1838 of 856 families of 4563 individuals whose average earnings amounted to two shillings and a penny per head per *week*. Of this amount one-half was devoted to food and clothing. Exactly half of these poor souls lived on only one-half of these amounts—or one penny per day for food and clothing.[3] Such reports are confirmed from other towns such as Carlisle, where the average earnings were somewhat, but little, larger.[4] A much smaller average was reported by the weavers of Ashton-under-Lyne.[4] Without relying wholly on these *ex parte* state-

[1] Steffen, *Gesch. der englischen Lohnarbeit* (Stuttgart, 1900–5), ii. pp. 19-20.

[2] *Parliamentary Papers*, 1839, xlii. p. 591.

[3] Pp. 578 *et seq*.

[4] P. 584.

ments, it is clear from the general consensus of reports that wages of one penny an hour for a seventy hours' week were frequent, and even general. The Commissioner said that it was unwise to tell the whole truth on this point, as it was either discredited or gave the impression that such evils were beyond remedy.[1]

It is not to be supposed that the case of the handloom-weavers was a case of exploitation of industrious and honest men by unscrupulous employers. The reports make it abundantly clear that the trade had become the refuge for cast-offs from other trades. There were, however, cases of real hardship, especially where old weavers were concerned. Their lot was exceedingly hard, as they could remember days of prosperity, and often possessed knowledge and education which only served to embitter those memories. The case of some of the Irish immigrants was also hard, because they had been enticed into England by manufacturers for the purpose of reducing wages and breaking strikes.[2]

Against bad masters these poor men had little protection. Combined action was impossible ; there were no funds to support a strike ; and the least threat of such proceedings brought into use more power-looms. In the distressful days of 1836–42 labour was a drug in the market, and to transfer to another industry was therefore possible to very few. The reformed Parliament was not unsympathetic ;[3] it inquired twice, in 1834 and 1838–40, but could not devise a remedy, though it could and did understand the nature of the evil. To relieve such a body of men out of poor rates in such a way as to raise them in the scale of citizenship was impossible in a generation which applauded the deterrent poor law of 1834. To men who had for years besought Parliament to remedy their ills, the Poor Law Amendment Act must have come as a piece of cruel and calculated tyranny, and have completed the alienation of the weavers and similarly situated classes from the established order of things.

The system under which wages were paid in the weaving trade was a source of immense irritation and oppression. Wages were always subject to deductions. Some of these abatements were payments for the preparation of the beam ready for weaving, which was an operation which no weaver

[1] *Parliamentary Papers*, 1840, xxiv. p. 7.
[2] *Parliamentary Papers*, 1836, xxxiv. p. xxxvii.
[3] See, *e.g.*, the instructions issued to Assistant Commissioners who inquired in 1838–40. *Parliamentary Papers*, 1837–38, xlv.

could perform for himself. These were sanctioned by custom, but others were not. Wholesale deductions were made for faults in weaving. The weaver had legal aid against unjust abatements of this sort, but as he received no pay till the question had been submitted to arbitration, poverty usually compelled him to submit at once to the extortion.[1] By this means nominal wages could be largely reduced by tyrannical masters. In one case arbitration was precluded by withdrawing a percentage of the market price beforehand, and in another no wages were stated at all when work was given to weavers.[2] No wonder the experience of the weavers seemed to give point to the teachings of writers like Hall and Thompson, to whom wealth represented a power given to the rich to oppress the poor, and capital a means whereby the employer might extract from the labour of his men so much surplus value as would leave them no more than enough to support a precarious and miserable existence.

The situation of those weavers who were employed in the wool trade was much better than that of the unfortunate cotton-weavers. Some of the old conservatism of the trade still remained, and machinery had not yet made any great headway in it.[3] It was still, both in the West Riding and in Gloucestershire, a domestic industry largely in the hands of small masters, but these were themselves in the control of large wholesale houses.[4] The trade of master weaver was in the southern district annihilated by a strike in 1825 which induced the large employers to set up handloom factories and employ the journeymen direct.[5] The master weavers were compelled to accept work in the factories on the same terms as their own journeymen—a situation which was hardly likely to produce amiable feelings amongst them.[6] The manufacturers, being in the power of the London houses, for which they really worked on contract, seem to have sweated their employees. They were men of little capital and eager to acquire profits. They were unable to do this otherwise than by cutting wages. Strikes were frequent, but it was quite impossible for the weavers to compel the masters to stick to the agreed lists. They practised truck on occasion also.[7] The introduction of the hated factory system,[8] combined with the other grievances,

[1] *Parliamentary Papers*, 1839, xlii. pp. 592-4. [2] P. 598.
[3] Power-looms introduced 1836, pp. 377 *et seq.*
[4] *Parliamentary Papers*, 1840, xxiv. pp. 358, 529, 401.
[5] Regular apprenticeship had of course died out.
[6] Pp. 436-9. [7] Pp. 457-8. [8] Pp. 437-8.

gave rise to a feeling of intense bitterness between masters and men. Wages were low, but not so low as in the cotton trade. Factory weavers earned in 1838 nearly twelve shillings a week ; outdoor master weavers eight, and outdoor journeymen six.[1] These wages were much lower than those of 1825[2] and of 1808, and the Assistant Commissioner estimated that seven weavers out of ten had to seek occasional relief from the poor rates.[3]

The hosiery trade affords another example of the abuses to which the domestic organisation of production may lead when the domestic, semi-paternal motive has gone out of it and given place to a purely commercial and competitive spirit. This change seems to have begun in the hosiery trade about the middle of the eighteenth century when the old Chartered Company lost its privileges. The trade then fell largely into the hands of large hosiers of Derby, Nottingham, and Leicester. The two former localities produced both silk and cotton hosiery, but Leicester specialised in worsted goods. The raw material, that is spun yarn, was of course purchased from Lancashire, Yorkshire, and Derbyshire. At the time of the Government inquiry in 1844–45[4] these large houses were both merchants, purchasing goods from outside makers, and manufacturers on their own account, employing knitters in their own factories. But the bulk of the labour was still performed in domestic workshops, scattered all over the three counties. The knitting was done by a frame which was a complicated piece of machinery, costly to purchase when new, and costly also to maintain in repair. Thus it was rarer than in the hand-loom-weaving trade for the knitter to own a frame, and the custom had obtained throughout a century for frames to be hired by the worker at a fixed rent which was deducted from wages.[5]

In 1844, therefore, employment in the hosiery trade could be obtained from two sources. The first was the hosier himself, either in his factory or as direct employer at home. The hosier supplied frame and yarn, and the price of labour was usually stated on a " ticket." In the second case, which was the more common, the work was obtained from a middleman or " bagman " who received yarn from the wholesale dealer, distributed it to knitters, and deducted from the market price of labour certain expenses which represented the wages of his

own labour and responsibility. Obviously the wages of the knitter were less when employed by a bagman than when employed directly by the hosier.[1] It was upon the bagman system that attention was concentrated in the inquiry of 1844–45.

The bagman was, as a rule, a man of small capital who had induced hosiers to entrust their yarn to his keeping. He was the sole intermediary between the hosier and many scattered knitters. He alone knew the price of goods and the margin between prices and wages. He could not make profit on raw material, nor increase the margin by extending his sphere of operations as a large capitalist employer might. He depended entirely upon his deductions from wages and upon the rent he obtained from frames. The Report of 1845 is a chorus of denunciation of his doings in these two respects.

The rent of frames was a fixed one and bore no relation to the amount or value of work done, nor to the capital value of the frame itself. It was an old customary payment sanctioned by a century of usage. It was open to any one to make frames and hire them to the various workers in the industry.[2] A class of people was thus called into existence whose sole connection with the industry was the income from rents,[3] which were paid week by week without abatement for slack time, so that the rent became a first charge upon the produce of the industry. Frames could be hired to hosiers, bagmen, or knitters themselves. In practice the last never happened, because the knitters were too poor to guarantee the rent. The bagmen paid higher rents than the hosiers, as there too there was an element of risk. Consequently the bagman had to recoup himself from the wages of the knitters, as he had no margin for economies on the side of the hosier.

Thus force of circumstances drove the bagman to exploit the knitters. Framework-knitting had largely ceased to be a skilled trade since the introduction of an inferior make of stockings about 1819.[4] Access to the trade was therefore easy, apprenticeship being a thing of naught. Trade was always fluctuating owing to the changes of fashion. New goods were continually being introduced. Thereupon a new influx of hands, attracted by the good pay in the special branch, took place. Very soon the fashion changed, and the new hands

[1] Report, pp. 59-67. [2] P. 46 of Report.
[3] Some frame-owners, however, had been knitters who had saved their money and invested in frames against old age (p. 52 of Report).
[4] Report, p. 12.

went to swell the ranks of those employed upon the staple products.[1] All this was bad for the poor " stockinger," but the Report of 1844–45 makes it clear that his weakness was ruthlessly exploited by unscrupulous and grasping " bagmen." Not content with deducting the 30 or 40 per cent from wages, allowed by custom for his normal labour and trouble of fetching and carrying yarn and goods, the bagman resorted to underhand tricks. He understated the warehouse prices and pocketed the margin ; he exacted rent for frames when the price of the goods was scarcely sufficient to pay it. In slack times he would give one week's work for one knitter to two or even three and draw full rents for two or three frames instead of one.[2] Finally he resorted to truck.

The Report of 1845 is full of bitter and violent denunciations of the bagmen. None of them is so eloquent as that quoted by Mr. Podmore,[3] but a few are worth quotation : Samuel Jennings was employed by T. P. of Hinckley, who paid all his wages in truck and even charged him rent upon his (Jennings') own frame.[4] One knitter sued his employer in court. " On Saturday the 23rd of December I settled with C. (defendant), and then had one pound of candles on credit, and he also lent me sixpence in money. On the 6th of January I reckoned with him for five dozen stocking feet which I had made during the week. I was in his warehouse and his son was present. My work came to 3s. 6½d. *He deducted for frame rent* 2s. 0½d., candles 5½d., money borrowed 6d., leaving 6½d. to be paid to me."[5] Thomas Revil declares " our middlemen walk the streets like gentlemen, and we are slaves to them." This latter was literally true, as the knitter was always in debt to truck masters, and was consequently unable to quit his employment for fear of imprisonment. The fortunes made by hosiers and bagmen were another source of indignation. Bagmen were often ignorant people of obscure origin, and the rapid rise to fortune of exceptional bagmen, who were more able or more unscrupulous than their fellows, was a source of extreme bitterness. One case was quoted where a shop-boy had in a few years acquired sixty or seventy frames and never paid a penny in coin as wages.

It is to be expected that wages were low. Indeed with hosiers, bagmen, and frame-owners to satisfy out of the produce

[1] Report, p. 97. [2] Report, p. 67.
[3] *Life of R. Owen*, ii. p. 448.
[4] *Parliamentary Papers*, 1845, xv. p. 76 of Evidence.
[5] P. 73 of Evidence.

of the industry, and considering the bad situation of the knitters as regards collective action, the wonder is that wages were not lower. Wages had been artificially reduced by the action of the old poor-law administration in paying out-relief as subsidies to wages. That had of course ceased when the inquiry was made, but a prolonged depression during 1839–42 had reduced thousands of stockingers to destitution.[1] The whole industry was stagnating, so that there seemed little prospect of improvement in the condition of the poor knitters. At the time of the inquiry thousands of them were earning for sixty or seventy hours' labour five or six shillings a week. At the same time it must be remarked that extreme lowness of wages was apparently chronic in the trade, and it is probable that the distress of the 'forties was not exceptional. It was, however, unaccompanied by the extended out-relief of former days since the introduction of the New Poor Law, and the operatives who had formerly borne privation with some resignation were now, through the agency of Chartist and Syndicalist orators, furnished with explanations of their evil situation. The district had been a hotbed of Owenism in 1833–34 and of Chartism ever since 1839, facts which show that the spirit of resignation had given way to a spirit of revolution.

It is necessary to dwell at some length upon the situation of the handloom-weavers and the " stockingers." These two classes of workers were the most ardent of Chartist recruits. They graduated for the most part through the school of Anti-Poor Law Agitation, and furnished many " physical force " men. Furthermore it is clear from the Chartist speeches that the weavers and stockingers were regarded as the martyrs of the economic system and as an indication of the inevitable tendency of the system—an awful example to the workers as a whole.

A modern reader may ask why these workers persisted in an occupation so ill requited. Apart from the natural inertia which makes man of all baggage the least easy to move, there were special causes operating at the time under survey. One was that occupation in other trades was not easy to get owing to trade depression. This was especially the case with the one occupation for which stockingers and weavers were suitable —factory labour. There were sufficient and good reasons too, as every one knows, for avoiding factories in those days.

[1] See *Life of Thomas Cooper*, 1872, pp. 123-43; also Report, pp. 95 *et seq.*

Further, men brought up to the frame and loom were as a rule totally unfitted for other occupations when they reached middle age. Poverty prevented them from apprenticing their children in better-paid trades, and compelled them to employ their families at the earliest possible age, long before they reached their teens. To be sure, the coal and iron mines and the railways took more and more of the young men and, sad to say, young women and children. Thus these industries were recruited largely from the families of those actually employed in them, but a natural elimination, especially in the weaving trade, caused those who were young, hardy, and enterprising to leave it, whilst the old, worn-out, the shiftless, and the young children remained. These, either from discontent engendered by memories of more prosperous days, or by reason of their ignorance, or through hopelessness of improvement, were a ready prey for the revolutionary literature which was freely circulated amongst them.

The case of these industries is not the only one which gave support to those *Klassenkampf* theories which form so conspicuous a part of the Chartist philosophy. Amongst all classes of society the evils of the factory system were held in abhorrence. That those evils were great is sufficiently clear from any impartial account of the early factories. That they attracted universal attention is testified by the immense literature upon the subject. The popularity of the agitation which was led by Sadler and Oastler during the 'thirties is a sign of a developing public conscience. Amongst the working people, however, the agitation was also a part of the general campaign against Capitalism. In other industries, indeed, the exploitation of child-labour was the work not of the capitalist employer, but of the workers themselves. It was done even where there was no excuse on the score of poverty.[1] There employment by the master was a welcome reform. One of the leaders of the Lancashire operatives in the ten hours' campaign was John Doherty, a Trade Union leader of renown and a prominent Chartist. In fact, factory agitation was the one form of Trade Union action which was both safe from legal attack and popular amongst other classes than the operatives themselves. The factory masters were denounced not merely because they did on a large scale what many small employers were doing on a small scale, but also because they represented

[1] *E.g.* Staffordshire potteries, Birmingham metal trades. *Parliamentary Papers*, 1843, xiii. *passim.*

that developed Capitalism which the working classes were being taught by many writers—of whom in this respect James O'Brien was not the least virulent—to hate with their whole souls.

Turning now to other industries, the same transitional state of organisation is to be found in such industries as mining and quarrying, which are at the present day almost exclusively under the control of large capitalists. The Reports of 1842–44 [1] dealing with these industries reveal a variety of industrial structure. In the Portland stone quarries, gangs of quarry-men prospected on their own account. In colliery districts custom varied considerably. In Staffordshire the men were employed by sub-contractors called by the euphonious name of " butties." In Northumberland and Durham the work was controlled by large owners, as is generally the case nowa-days. The gang system seems to have prevailed in Leicester-shire, parts of the West Riding, the Lothians district and North Wales ; the " butty " system in Stafford, Shropshire, Warwick, and Derby ; the proprietor system in the two great northern fields, Lancashire, South Wales and Monmouth, and in Lanarkshire. [2] Where the gang system prevailed the miners contracted, through the agency of their own elected or selected heads, with the owners of the minerals, to procure the coal or iron at specified prices. The owner furnished machinery and sank the shaft ; the miners did the rest. The butty system was the same except that the contract or charter was procured by one or two small capitalists who owned the tools and hired the miners. [3] Under the third system the whole personnel, machinery, and tools were controlled by the proprietors. [4]

Where the workmen were largely independent contractors under the gang system, they could hardly complain of the con-ditions of their labour, but under the other systems complaint was loud and continuous. The butties occupied much the same position in the mining industry as the bagmen in the framework-knitting. They were bound to supply coal or iron ore at a fixed price. They hoped to recoup themselves out of the profits of labour. Being men of small capital, they were

[1] *Parliamentary Papers*, 1842, ix. (Truck) ; 1843, xiii. (Special Report on Staffordshire), p. 1 ; 1843, xiii. p. 307 (Employment of Children in Manufactures); 1842, xv. (Employment of Children in Mines and Collieries); 1844, xvi. (Inspector of Mines).
[2] *Parliamentary Papers*, 1842, xv. p. 39.
[3] *Parliamentary Papers*, 1843, xiii. (Staffs), pp. xxxiii-xxxiv, lxii.
[4] P. ciii.

always in a precarious situation, as each coal-getting venture
entailed a large element of risk. If the price fixed by the
"charter" proved unremunerative, they were compelled to
grind profits or avoid losses out of wages. They resorted to all
sorts of practices : compelled miners to work at certain jobs
without pay ; [1] increased their daily tasks surreptitiously ;
abused the labour of children, especially pauper apprentices,
in a perfectly inhuman fashion ; [2] and finally and inevitably,
paid in " truck." [3] When butties existed, accidents were
frightfully frequent. Lack of capital induced slipshod and
wasteful systems of propping.[4] Naked lights were used.
Dangerous places were worked as a common thing. One
thing, however, butties did not do : they did not employ girls
and women down the shafts. That appalling iniquity was
perpetrated by the miners themselves, but never where butties
had control.[5] Wages were not low, as wages went in 1840.
In Staffordshire daily wages were 4s. previous to the strike
of 1842, when a reduction to 3s. 6d. was attempted. In the iron
mines wages were rather lower—2s. 6d. to 3s. a day. These
wages were of course far from princely, and they were materially
reduced by the system of paying in truck or " tommy." [6] In
some, perhaps many cases, the system of paying wages in
goods was at first productive of much advantage, especially
where the collieries were remotely situated, and the purchase
of goods from the nearest market-town was inconvenient. But
it was so easy to abuse the practice that few who adopted it
avoided the temptation. The practice was all but universal
in the mining industry, whatever the organisation. It was
widespread in other trades too ; and this in spite of the act of
1831 against it.[7] As that act, however, required the workman's
evidence, actual or anticipated intimidation was sufficient to
make it a dead letter.

These abuses were not the only ones connected with the
mining industry. The revelations made in 1842–43 by Govern-
ment inquiries show that the industry was being carried on
everywhere with as complete a disregard for humanity and
decency as could be found in the society of heathen savages.

[1] Vol. xiii. (Staffs), pp. xxxv–xxxvii.
[2] *Parliamentary Papers*, 1842, xv. p. 40.
[3] *Parliamentary Papers*, 1843, xiii. (Staffs), pp. lxxxix *et seq.*
[4] P. xxvii.
[5] *Parliamentary Papers*, 1842, xv. p. 35.
[6] A vivid description of the truck system of the Midlands, derived
largely from official sources, is to be found in Disraeli's *Sybil*, published
in 1845. See also *Parliamentary Papers*, 1843, xiii. (Staffs), pp. lxxxix
et seq. [7] 1 and 2 Will. IV. c. 37.

Children were being employed at an incredibly early age.[1]
Five, six, and seven years was a frequent age for commencing
work in the mines ; exceptional cases of four, and even three
years were found. Monotonous beyond measure was the
labour of these mites who sat in the dark for a dozen hours a
day to open and shut doors. A boy of seven smoked his pipe
to keep him awake.[2] The children employed were of both
sexes, and girls of tender age were condemned to labour like
beasts of burden, harnessed to trucks of coal.[3] Pauper appren-
tices were practically sold into slavery, and treated occasionally
with the utmost ferocity.[4] The employment of adolescent
girls and women was not unknown, especially in Lancashire
and Yorkshire, where, one may suspect, they were driven from
the handloom-weaving, the decay of which was no doubt
responsible also for the exceptionally early employment of
children in those districts.[5] At the same time it must be
noted that the employment of girls and women, where it
prevailed, was not a recent introduction. Lancashire witnesses
declared that it had existed since 1811.[6]

The consequences of this employment of workers of both
sexes underground, considering the extreme ignorance and
semi-barbarism of the colliery population, is better imagined
than described.[7] In fact the reports reveal a state of filth,
barbarism, and demoralisation which both beggars description
and defies belief. Clearly Lancashire, Yorkshire, South Wales
and Monmouthshire, and the Lothians of Scotland were the
worst districts, but all were bad enough. The prevalence of so
appalling a state of affairs is to be explained only by consider-
ing the general isolation of the mining districts. Some, as in
Monmouth, Durham, the Pennine districts, were situated
amongst remote moorlands. In every case the opening of
mines had gathered together a promiscuous population into
districts hitherto unpopulated. Houses were built for the
accommodation of the employees by the colliery masters
themselves. Beyond that little care seems to have been
exercised over the population so concentrated. Churches were
seldom built. The want of religious ministrations was occa-
sionally supplied by Chartist preachers.[8] The only source of
social life was the demoralising atmosphere of the pit or the

[1] *Parliamentary Papers*, 1842, xv. pp. 9-18.
[2] P. 18. [3] Pp. 24-36. [4] Pp. 40-43.
[5] Oldham is pointed out as a curious and mysterious exception.
[6] P. 27.
[7] See especially Lancashire case on p. 132.
[8] *Parliamentary Papers*, 1843, xiii. (Staffs), p. cxxxvii.

E

equally insidious delights of the public-house, usually the
property of the butty or the colliery masters. The Newport
rising of November 1839 was engineered wholly in such public-
houses in the remote hill districts.[1]

Respectable people in the neighbourhood seem to have
considered the collier population as utterly hopeless and irre-
deemable and took little steps to ameliorate or improve their
lot. The masters, we are assured, never entered the pits to see
what was going on, and abuses went unchecked.[2] Parents were
allowed to bring their children into the pit almost at any age.
Women were even allowed to become hewers of coal.[3] The
dress of both sexes was so alike as to be practically indistinguish-
able, even in the light of day.[4] Thus the blame for the horrific
condition of the mining population seems to be distributed
amongst all the classes concerned—masters, butties, parents,
and the public generally. There was a fearful awakening of
the public conscience when the Report of 1842 was published,
and the exclusion of women and children from the mines was
voted in Parliament without a murmur.

The task of those who had previously sought to make an
impression upon this population was hard but not hopeless.
They met with no great sympathy from those who had the
means to help. The Rural Dean of Birmingham [5] was quite
unable to persuade a landowner to give a quarter of an acre of
land to build a church, although his land was annually increas-
ing enormously in value. Another wealthy owner, who drew
£7000 a year without ever seeing one of his employees,
openly boasted of the fact.[6] The vicar of Wolverhampton
applied to a man who was supposed to have £50,000 a year from
mines for funds to build a church, but the man of wealth said
his mines would be worked out in seventy years and the church
would then be of no use.[7] But though the task of reformers
was hard, it was occasionally successful, as at Oldham where,
owing apparently to the development of education, mainly
in Sunday schools, a public opinion had grown up which made
the mining population there an honourable exception to the
general state of semi-savagery.[8] On the whole it is the isola-
tion, geographical and social, of the mining population which

1 Additional MSS. 34,245.
2 *Parliamentary Papers*, 1842, **xv.** pp. 12, 126.
3 In West Riding (p. 24).
4 Vol. xv. *passim.*
5 *Parliamentary Papers*, 1843, xiii. (Staffs), p. 2.
6 P. 4. 7 P. 73.
8 *Parliamentary Papers*, 1842, xvii. App. p. 833.

forces itself most upon one's attention in reading the dismal reports. The colliers had occasionally a dialect which was totally unintelligible to educated ears. They were almost a foreign people. In fact, the inhabitants of Monmouthshire spoke of the colliery districts, where the outbreak of 1839 was brewing, in the language of people who lived on the frontiers of a hostile territory.

The total mining population in 1840 was about three-quarters of a million, the actual number of persons employed being about one-third that number. The census return of 1831 enumerates trades and handicrafts, but omits this large industry entirely.

It will not be necessary to enter into detailed descriptions of other branches of industry. It will be sufficient to say that other industries, such as the pottery and metal trades of the Midlands, were being carried on under conditions which, if not so flagrantly bad as those above described, were yet sufficiently demoralising.[1] Wolverhampton, Bilston, and Willenhall seem to have been the home of the most appalling degradation—a perfect inferno where children were brutalised by severe labour and savage treatment, and grew up into stunted, stupid, and brutal men and women.[2] Hard by was the nail-making district of Dudley where the population is said to have been more degraded even than the miners.[3]

It is necessary to keep clearly in mind this social and economic background of the Chartist Movement. A politico-social movement which was engineered amongst such men (and it is clear that the more prosperous and intelligent organised workers kept aloof from it) could scarcely be compared with the working-class movements of the present day, organised as the latter are by men of clear and shrewd, though perhaps limited outlook, of uncommon ability, backed by three generations of experience and a solid organisation.

[1] *Parliamentary Papers*, 1843, xiii.
[2] Pp. 27, 33. [3] (Staffs), pp. v, vi.

CHAPTER III

THE RISE OF ANTI-CAPITALISTIC ECONOMICS AND SOCIAL REVOLUTIONARY THEORY

DURING the first three decades of the nineteenth century English political and social ideas underwent a profound change. This mental revolution may be attributed to two main causes, the French Revolution and the Industrial Revolution. Both of these produced different effects upon the different classes of the community. The French Revolution commenced by arousing the traditional political radicalism of the English middle class, but the violence of the Revolution itself, together with the teachings of the Economists, who apparently demonstrated the incompatibility of the interests of the employing and employed classes, drove the middle class to resist even moderate measures of political change. At the same time the theories and presuppositions of the Revolution, based as they were on the doctrine of the *Rights of Man*, took a great hold upon the imagination of the working classes and produced levelling theories whose justice seemed all the stronger, as the actual course of events seemed to demonstrate the evils which flowed from social and economic inequality.

The Industrial Revolution, especially during the years 1800–1840, was largely on the social side an instrument of social dislocation. Down to the middle of the eighteenth century English agricultural society was still largely feudal in spirit. The internationalism of feudalism, which had given Western Europe a superficially homogeneous society, was gone, but otherwise feudal conceptions still held sway. The landowner was still the head of a local social system—Mr. Wells's " Bladesover "—which comprised household, farm tenants, labourers, officials. Social relationships consisted largely, on the part of

the lower orders, of feelings of more or less contented depend-
ence upon the great man at the top—feelings which were
religiously inculcated on the basis of " the station of life in
which it has pleased God to place you." On the other hand
the landowner repaid such sentiments with some real degree
of personal interest in the welfare of his subjects, and main-
tained a certain amount of security and stability, which enabled
them to live with some expectation that their lot would never
be worse, though it might not be better. Stability, security,
and dependence were the essentials of this social system. In
industry relations were otherwise but not essentially different.
The merchant manufacturer played the part of the landowner.
He was often in personal touch with those he employed, living
usually in the neighbourhood. The family system of manu-
facture kept alive feelings of associated enterprise and mutual
dependence. The market was known; prices were fixed by
custom and not merely by competition. Steady trade rather
than speculative enterprise was the rule and the ideal.

Under the influence of that commercial and speculative
spirit which prepared the way for the great changes both in
agriculture and industry, these social relationships broke down.
They were unsuited to a period when movement and enterprise
replaced solid security as the basis of economic life. The
unlimited unknown of commerce was preferred to the limited
known, and Captain Cook's voyages into the distant Pacific
were paralleled by many a commercial speculator in the
realms of economic enterprise. Acquisition of wealth, which
opened up to many the prospects of social advancement,
destroyed the old feeling of contented acceptance of that
station of life in which they were born. Hence came the
increasing specialisation in agriculture and industry, the en
closures which alone made possible the improvement of agri-
cultural methods, and the machinery which superseded men.
Employers employed no longer men but hands, no longer
human beings but labour, and the relation between the two
gradually developed into the payment of cash which was held
to cover all the obligations of the one to the other. Payment
for labour, conditions of housing, help in bad times, education,
all these were now commuted in the payment of a weekly
wage. In industry this process was encouraged by the rapid
rise to fortune of poor men who had never been influenced by
the ancient semi-feudal traditions or by the surviving gild
spirit.

The consequence was the formation of a large class of wage-earners who were thrown back upon the earnings of their own hands, and had little claim, besides their labour, to the consideration of society. The natural tendency to association, which under not dissimilar circumstances had appeared so strongly in the early days of the French Revolution, *i.e.* the *Fédérés*, and was the most significant manifestation of national as distinguished from feudal ideas, was in England checked, if not suppressed, by the ferocious Combination Laws. It was not until 1833, with the passing of the first important Factory Act, that public opinion admitted the industrial employees to a claim upon society and public attention. The Factory Acts and cognate legislation substituted a public guarantee, based on the authority of the State, for that private and traditional guarantee of the conditions of life which semi-feudal society had maintained. But between the disappearance of the one and the establishment of the other lies a full generation, during which the working classes, often ignorant, unled, ill-advised, sought refuge in their isolation and helplessness against economic and governmental oppression.

In a world of injustice and inequality, the working men found hope and a call to action in those theories of natural rights and justice which the French Revolution had popularised. The rights of man were contrasted with the wrongs inflicted by the new state of society, and out of the conflict were developed political and social theories of a social-democratic character. It is not maintained that English Socialism developed out of the ideas of the Revolution. It was, on the other hand, largely a native growth, deriving its strength from its criticism of the developing English industrial society, and its economics from the writings of Ricardo. At the same time its constructive side, which of course was its weakest, was based upon theories of abstract justice, and these notions had received a great impetus from the French Revolution. Through Paine and Godwin they had been introduced in a complete form to the English public. Yet, as has been pointed out previously, such ideas were prevalent within a limited circle during the Puritan Revolution, and may even be traced in the famous *Utopia* of More and the equally famous couplet of John Ball. The pre-revolutionary ferment in France did produce its socialistic writers—Morelly, Mably, and to a degree Rousseau himself. Though the teaching of Morelly as to the beneficent influence of suitable environment

upon human character is in many cases akin to that of Robert Owen, there is little doubt that the latter founded his theory largely upon his own experience at New Lanark. In any case the socialistic theory of the Revolution was of little practical importance in the events of that stormy period. The futile conspiracy of Babeuf was the only serious attempt to give the Revolution a socialist character. It was, however, recalled to the minds of the English Chartists by James O'Brien, who translated Buonarotti's account of it.

Early English Socialist teaching falls into three classes. The first and least thoroughgoing, and the one which appeared first in order, was mainly a revolt against the enclosures. It was predominantly agrarian in character. It is represented by William Ogilvie, Thomas Spence, and Thomas Paine. These are mainly advocates of land reform of some sort or other, but similar ideas form part of the schemes of the more thoroughgoing writers. The second class is mainly a criticism of the classical economists, and is rather anti-capitalist than constructively socialist. It is represented by Charles Hall, Thomas Hodgskin, Charles Gray, Piercy Ravenstone, and William Godwin. Finally there is a large and important body of communist doctrine associated with the great names of Robert Owen, Thompson, and J. F. Bray. These writers were mainly concerned with the problem of distribution, but Bray and Thompson preface their constructive schemes by a masterly criticism of the dominant " bourgeois " economics, which, taken with the ideas of Hall and his fellows, in all essentials anticipates that of Marx.

There is one quality which is common to nearly all this body of socialistic and kindred doctrines. That is the reaction towards agriculture and the land, the tendency to regard the growth of large-scale industry as abnormal, unnatural, and dangerous. This is not to be wondered at. The process of enclosure was far from complete even as late as 1800, and it did not seem too late to put a stop to it. In any case agriculture was still considered the natural avocation of the majority of the nation. The growing abuses of the early factory system recalled to many, by way of contrast, the fresh air and green fields of their youth. It is significant that Hall, one of the most conspicuous opponents of manufactures, was a medical man. Apart from these considerations it was held, with some degree of justice, that only by applying his labour to land could a man attain the ideal of socialist theory—the full

produce of his labour. It was supposed that a nation working exclusively upon the land might thus solve the problem of distribution.

This is not the place for a detailed analysis of this mass of socialistic literature, which is to be found in the excellent works of Beer, Menger, and Podmore.[1] But as these socialistic notions formed a large part of the mental equipment of Chartists, a general sketch of their tendency is essential to a proper understanding of the Chartist Movement. The relation of the Chartist Movement to the evolution of socialist ideas is somewhat complex. The Chartist Movement was not a homogeneous thing. It was a general protest against industrial and political oppression, and as the protest swelled the movement swallowed up a variety of agitations of a special and local character, some of which bore little relation to socialist propagandism. It is true that some of the leaders of Chartism were downright Socialists—as we should call them to-day. James O'Brien (commonly known as Bronterre O'Brien) was the unremitting advocate of land nationalisation and collective control of the means of exchange.[2] William Lovett, the noblest of them all, was persuaded that individual ownership of industrial capital was the prime evil of society. Hetherington was a disciple of Owen and Thompson. In spite of this, however, the Chartist Movement was carefully distinguished by its more prominent adherents from the Socialist Movement of the period, which was a communist movement guided by Robert Owen, Lloyd Jones, and William Pare. Feargus O'Connor's Land Scheme was the very antithesis of Socialism, but it was also not a real Chartist scheme.

The Land Reformers, Spence, Ogilvie, and Paine (the ex-member of the Revolutionary Convention and the author of the *Rights of Man*), are one and all under the influence of Natural Rights. They belong to the period which preceded the birth of economic analysis, and therefore detailed criticism of the existing social and industrial system plays little part in their discussions. They proceed by the deductive method, commencing with a statement of the natural and inherent rights of mankind. Clearly the right to subsist upon the land of his birth is the most obvious of these rights. Hence the

[1] Max Beer, *Geschichte des Sozialismus in England* (1913); A. Menger, *Das Recht auf den vollen Arbeitsertrag* (1891), translated as *The Right to the whole Produce of Labour*, by M. E. Tanner and H. S. Foxwell (1899); F. Podmore, *Life of Robert Owen* (1906).
[2] For O'Brien's plans for the nationalisation of the land see Niehuus, *Englische Bodenreformtheorien*, Leipzig (1910), pp. 99-108.

deduction that the land is the common possession of mankind, a proposition to which Locke gave the seal of his authority, but which is probably as old as mankind itself. Spence declares indignantly that " Men may not live in any part of this world, not even where they were born, but as strangers and by the permission of the pretender to the property thereof." Paine suggests that God had not set up an Estate Office in Heaven where title-deeds to perpetual rights over land could be acquired. Ogilvie, a much soberer and more scientific writer, contents himself with the statement that land in its uncultivated state was the common property of mankind.

Naturally the particular conclusions to be drawn from these very wide premises vary immensely. Spence arrives at the absolute prohibition of private property in land ; Ogilvie allows a system of private property with taxation of unearned increment and the parcelling of large estates—a remarkable foreshadowing of the modern policy, and based, like it, upon a more scientific consideration of the question ; Paine aims at paying, out of heavy succession duties upon landed property, an old-age pension to every person as compensation for the loss of his rights in land. Thomas Spence (1750–1814) was the most outspoken and extreme of the three writers. He probably did as much as any other reforming zealot to popularise that fanatical and unreasoning hatred of the landed aristocracy which characterised English radical and revolutionary opinion during the early part of the nineteenth century, and which formed so large a part of the oratorical stock-in-trade of Vincent, O'Connor, O'Brien, and the like, in the Chartist Movement. A sturdy, stiff-necked, fluent Radical, with much of the rebel in his nature, Spence made many zealous disciples and a powerful enemy—the " panic-stricken Toryism " of the Government. He passed a stormy forty years of political agitation, between 1775 and 1814, and died in poverty, as many other good men did at that time. A sample of Spence ought to be given. One of his pamphlets, the *Rights of Infants* (1797), is in the form of a dialogue between a mother and a member of the aristocracy. The mother asks who receives the rents :

Aristocrat—We, to be sure.

Woman—You, to be sure ! Who the Devil are you ? Who gave you a right to receive the rent of our common ?

Aristocrat—Woman, our ancestors either fought for or purchased our estates.

Woman—Well confessed, villains ! Now out of your own mouths will I condemn you, you wicked Molochs. And so you have the impudence to own yourselves the cursed brood of ruffians who by slaughter and oppression usurped the lordship and dominion of the earth to the exclusion and starvation of weeping infants and their poor mothers ? Or at the best the purchasers of those ill-got domains ? O worse than Molochs, now let the blood of millions of innocent babes who have perished by your vile usurpations be upon your murderous heads. . . . Yes, villains ! you have treasured up the tears and groans of dumb, helpless, perishing, dying infants. O you bloody landed interest ! you band of robbers ! Why do you call yourselves ladies and gentlemen ? Why do you assume soft names, you beasts of prey ? Too well do your emblazoned arms and escutcheons witness the ferocity of your bloody and barbarous origin ! But soon shall those audacious Gothic emblems of rapine cease to offend the eyes of an enlightened people, and no more make an odious distinction between the spoilers and the spoiled. But, ladies and gentlemen, is it necessary, in order that we eat bread and mutton, that the rents should be received by you ? Might not the farmers as well pay their rents to us, who are the natural and rightful proprietors ? . . .

Hear me, ye oppressors, ye who live sumptuously every day, ye for whom the sun seems to shine and the seasons change, ye for whom alone all human and brute creatures toil, sighing, but in vain, for the crumbs which fall from your overcharged tables. . . . Your horrid tyranny, your infanticide is at an end !

And did you really think, my good gentlefolk, that you were the pillars that upheld the universe ? Did you think that we should never have the wit to do without you ? . . .

Then comes Spence's panacea :

We women (as our men are not to be depended on) will appoint in every parish a committee of our own sex (which we presume our gallant lockjawed spouses will at least for their own interests not oppose) to receive the rents of the houses and lands already tenanted, and also let to the best bidders, on seven years' leases, such farms and tenements as may from time to time become vacant.

Out of the funds so obtained the expenses of the parish and the taxes will be paid, an allowance be given for each child born and each person buried, and the surplus divided equally amongst the inhabitants of the parish. The famous Newcastle Lecture of 1775, Spence's first utterance upon the question of the land, contains substantially similar proposals, but also suggests certain political reforms—the abolition of the standing army and the formation of a militia, universal manhood suffrage and vote by ballot. Spence left many disciples who were not without influence during the succeeding decades.

William Ogilvie (1736–1819) comes chronologically next after Spence. His work, *An Essay on the Right of Property in Land*, was published in 1782. He stands, however, far above Spence both in depth of thought and in his influence upon later generations. He was a Professor of Humanity at Aberdeen, an excellent scholar and a man of intellectual eminence. He was also a Scottish laird and well versed in agriculture and estate management. Ogilvie conceived agriculture to be the most suitable and profitable occupation for mankind. The higher virtues would inevitably fail amongst a people who lived wholly by manufacture and industry. Ogilvie was thus the earliest foe of the modern industrial society.

Starting, like Spence, with a declaration of the common right of mankind to the land, Ogilvie plunges into an analysis of the greatest importance. Land, he declares, has three values, the original value, the improved value, and the improvable value, corresponding to the value of the land in its natural uncultivated state, the value of the improvement due to cultivation, and the value of the possible improvement of which it is capable. This statement at once puts the discussion upon a higher plane than Spence's dogmatic assertion of natural rights to land, and the analysis is worthy of a countryman of Adam Smith and David Hume. Probably Ogilvie was stimulated by the reading of Smith's great work. In an estate worth £1500 a year Ogilvie suggests £200, £800, and £500 as the original, improved, and improvable value. The first and third cannot belong to the landowner, but the second is undoubtedly private property, as it arises from the labour already applied to it. Ogilvie would recover the original value by a tax upon land, and the improvable or accessory value by a tax upon unearned increment or " the augmentation of rents." Apart from this he is the enemy of large estates, which he desires to break up. He calculates that there is sufficient land in Great Britain to give 10 acres to every citizen. Every landowner who has more than that quantity of land must surrender the surplus. Of the 10 acres remaining the landowner will have a right to all the three values. From the surplus fund of land a parcel of 40 acres will be granted to every adult male who applies. He will cultivate it for his lifetime and be subject to quasi-feudal obligations. Failing such measures Ogilvie advocates a Board of Land Purchase to multiply small holdings. Measures ought to be taken to discourage the growth of manu-

factures until agriculture is developed to the highest possible degree.

Ogilvie's scheme is not so much a scheme for the recovery of the lost rights to land as the purely utilitarian one of maintaining the ascendancy of agriculture. The agricultural society of the later Middle Ages is his ideal, a society of small landholders held in the bonds of mutual dependence and mutual obligations.

The veteran Thomas Paine (1737–1809) has an equally utilitarian purpose. The title of his work, published in 1797, is a *résumé* of its contents: " Agrarian Justice, opposed to Agrarian Law and Agrarian Monopoly, being a plan for Meliorating the Condition of Man by creating in every Nation a National Fund, to pay to every Person, when arrived at the Age of 21 Years, the Sum of £15 Sterling, to enable him or her to begin the World ; and also £10 Sterling per annum during life to every Person now living of the Age of 50 years and to all others when they shall attain that Age."

The gist of Paine's argument was that the majority of mankind had lost its rights in the land. It was impolitic to try to recover the land itself, but the owners of land could be compelled to compensate the dispossessed out of their revenues. This compensation fund would be raised out of a succession duty of 10 per cent upon inheritances passing in the direct line, and of twice as much upon those passing to collateral heirs. A fund of $5\frac{3}{4}$ millions would thus be raised annually, which would be sufficient for the purposes indicated. Similar proposals had already found a place in Paine's *Rights of Man*. Paine's underlying idea—that the landowners ought to compensate the common folk for the loss of their rights in the land—was seized upon by Cobbett as the basis of his opposition to the Poor Law of 1834. Cobbett regarded the Poor Rate as the compensation fund, and taught that the receipt of relief was a right and not charity.

Closely allied with these three agrarian reformers, and standing, too, under the influence of Rousseau and the *Rights of Man*, is Charles Hall. Hall's book, however, by its greater economic insight, as well as the incisive attack upon the developing industrial system, forms a transition between the criticism of the agrarian system and the anti-capitalistic teachings which followed the publication of Ricardo's work in 1819. It was published in 1805 under the title *Effects of*

Civilisation on the People in European States.[1] Hall was a doctor of medicine of considerable attainments who, soon after he gave to the world his famous book, was consigned to the Fleet Prison for debt, and died there about 1820 at the age of eighty. It was natural that a man so circumstanced should take the pessimistic view of civilisation made current by Rousseau's famous Discourse. Hall's work is a terrific denunciation of the oppression of the poor which seems to be the inevitable consequence of the existing state of society. As a doctor of medicine Hall was acquainted to the full with the terrible effects of extreme poverty and overwork undertaken in pestilential factories. These evils are the result of two great faults in the organism of society—Private Property and Manufactures. The latter is even worse in its consequences than the former. By their means Civilisation divides mankind into Rich and Poor, and gives the former power to oppress the latter. Riches is a power directed to oppression. No despotism is worse than that of Capital. Capital is the means whereby the Rich rob the Poor of the larger part of their produce. It is not Nature, as Malthus declares, who condemns the Poor to poverty, starvation, and death, but Capital. Capital is given in the form of wages and material to the labourer that he may produce more goods, but even the goods given as capital were originally taken from the labourer. The latter is powerless to keep more than a very small share of his produce because he is at the mercy of the Rich, and the law will not allow him to combine with his fellows for better protection. The development of manufactures has not, as Adam Smith declared, freed the workers from dependence, but has plunged them into a worse slavery than ever. It is a slavery which propagates disease, vice, ignorance, and revolution. Manufactures are withdrawing labour from agriculture and so increasing the cost of food. Hunger is added to other evils. The more manufactures develop, the greater the gulf between rich and poor. Such a tendency will end in social anarchy and revolt, out of which, as in France, a military despotism will assuredly arise. But the rich may prevent this by declaring a war. The war against France is a case in point.

Hall's furious analysis ought logically to lead to sweeping proposals of remedy, but these are of the most modest description, amounting to no more than the abolition of primogeniture and the restriction of manufacture of articles of luxury.

[1] Niehuus, as above, pp. 67-75, analyses Hall's work.

This logical anti-climax is a feature of nearly all the earlier writings of this school. It results partly from a want of sound economic teaching—a want which the yet indeterminate state of the science could not supply. It is due partly no doubt to a typically English unwillingness to push the arguments based upon natural rights to a logical conclusion. Later Socialist writers worked with better materials than Hall. They used the theoretical groundwork furnished by David Ricardo (1772–1823) and the practical experiments of Robert Owen (1771–1858).

The second decade of the nineteenth century saw an important advance in socialistic theory. The violent fluctuations in trade, the advance of factory production, the dismal conditions which followed the end of the great war, the panic-stricken measures of the Government to repress popular movement, and the increasing unrest of the manufacturing population, all seemed to attest the truth of Hall's most pessimistic prophecies. On the other hand, socialist thought received important reinforcements. In 1813 appeared Robert Owen's *New View of Society*, which came as a gospel of hope and happiness to many who desired the welfare of their fellows. It held out a promise of infallible success in the improvement of the lot of the poor and the oppressed. In 1817 appeared Ricardo's *Principles of Political Economy and Taxation*, the indirect source of nearly all socialist economics.

Owen, it is true, remained almost untouched by the development of economic theory. He was an empiric from first to last. His first work, the *New View*, contained the essence of all his teaching—that any character, from the best to the worst, may be given to any community by the application of the proper means, which means are generally under the control of those who have influence in human affairs. In itself this doctrine, that human character was the creation of environment, was by no means new. It had been almost a commonplace in pre-revolutionary France. But backed as it was by the evidence of the marvellous work accomplished at New Lanark by Owen himself, " by the application of suitable means," Owen's teaching at once acquired commanding authority. It at once became the theoretical and practical stand-by of the Factory Reformers. It taught others to see in a properly constituted government the means of social regeneration. It was therefore a chief source of Chartist theory. Many leading Chartists, Lovett, O'Brien, Hetherington, Watson, Dr. Wade,

and others, began their public career under Owen's auspices. Owen himself was hostile to extensive political action and distrustful of popular control, so that he and his special followers, who took the name Socialists, kept steadfastly apart from all political movements and propagated their teachings in the form of Communism. Owen was neither a politician nor a demagogue. He appeared only once as a popular leader. That was during 1829 to 1834, when he inspired the Co-operative Labour Exchange and Syndicalist movements, which will be dealt with later.

It was Ricardo's fate, whilst writing what was intended to be at once an explanation and a defence of the capitalistic system of production, to furnish the enemies of capitalism with their most deadly weapons. Modern economists have felt it incumbent upon them to modify or reject the Ricardian premises which led to such astounding and subversive conclusions.[1] The discussion as to what Ricardo actually did mean, or what he took for granted, may safely be left to experts. It is sufficient to indicate those points upon which anti-capitalistic theory seized. These relate of course to the claims of Labour. Ricardo says, for instance, that " the comparative quantity of labour " is " the foundation of the exchangeable value of all things," and that this doctrine is " of the utmost importance in political economy." [2] Further, he speaks of the " relative quantity of labour as almost exclusively determining the relative values of commodities." [3] Though he introduces reservations allowing that labour applied to making of tools, implements, and buildings, that the elements of time, risk, rate of profits, and quality of labour also influence value, he keeps these reservations in water-tight compartments and permits the superficial reader to assume that they are of no importance in comparison with the great fact of Labour. The rough-and-ready conclusion was drawn—Labour is the source and measure of Value.[4] In the hands of an ingenious writer like Hodgskin the reservations are indeed noted, but only to be swept away. As tools, implements, and buildings are created by labour, their value too depends upon the labour expended

[1] *E.g.* Marshall, *Principles*, p. 561.
[2] *Principles of Political Economy and Taxation*, 3rd ed. 1821, ch. i. sect. 1.
[3] *Ibid.* sect. 2.
[4] William Thompson, *On the Distribution of Wealth* (edition of 1850), sect. 1: " Wealth is produced by Labour: no other ingredient but Labour makes any object of desire an object of wealth. Labour is the sole universal measure as well as the characteristic distinction of wealth." " Wealth is any object of desire produced by labour." " Labour is the sole parent of wealth."

upon them, and the claim of the capitalist to a reward for their use is without foundation. The quality of labour is of no account, as all labour is equally necessary.

The " natural price of labour is that price which is necessary to enable the labourers one with another to subsist and to perpetuate their race without either increase or diminution." " The market price for labour is the price which is really paid for it. . . . However much the market price may deviate from its natural price it has, like commodities, a tendency to conform to it." It is pretty clear that Ricardo did not mean the absolute and indispensable minimum of necessaries of life when he referred to " subsisting," but spoke of the " comforts which custom renders absolute necessaries." That is, not mere subsistence level, but the customary standard of life was the basis on which the natural price of labour was to be calculated. But such qualifications could hardly hold their own against such language as, " It is only after their privations have reduced their number, or the demand for labour has increased, that the market price of labour will rise to its natural price." [1]

The question naturally suggested itself, What proportion did the reward of labour bear to the value created by labour ? This question was solved to the great satisfaction of Socialists by a reference to the statistics of Patrick Colquhoun. Colquhoun demonstrated, apparently on insufficient evidence, that the national income in 1812–13 was 430 millions. Of this the working classes, including the army, navy, and paupers, received somewhere about one quarter.[2] Clearly, therefore, the labourer, so far from receiving the value his labour created, received only one quarter, the remainder being distributed amongst capitalists, landlords, and Government in the shape of profits, rents, and taxes. This statement of the case was improved upon by later writers who assumed that the proportion received by the labourer was decreasing. Hodgskin speaks of the labourer's having to make six loaves before he can eat one.

Here, then, was capitalistic economy convicted out of the mouth of its greatest champion, and a host of writers seized upon the damning evidence and hammered it at white heat into a terrific indictment of the greed and rapacity of capitalists, landlords, and " tax-eaters." Socialists, like James O'Brien,

[1] Ricardo, *Principles of Political Economy and Taxation*, chap. v.
[2] Beer, p. 162. Colquhoun's book, published in 1814, was a *Treatise on the Population, Wealth, Power, and Resources of the British Empire in every Quarter of the World*.

and Radicals, like Cobbett, argued themselves into tempestuous incoherence, whilst lesser men, like certain of the Chartist leaders, decorated their speeches with phrases culled from the writings of their betters, and perorated in pæans of praise upon the virtues of the producers of all wealth, and in torrents of vituperation upon the robbers who stole it from them.

Thomas Hodgskin was the first of the popular writers to take advantage of Ricardo's work. Ricardian economics had been the stand-by of the employers in the Trade Union controversy of 1824–25. Their argument, put briefly, was: high wages, low profits; low profits, slow accumulation of capital; slower accumulation, less capital; less capital, diminished demand for labour; diminished demand for labour, collapse of wages; hence poverty, distress, privation at work to redress the balance upset by high wages and large families. Therefore all depended upon keeping up rate of profits. This constituted the claim of capital to a share of the produce of industry. It was this claim which Hodgskin proceeded to refute in his famous little pamphlet, called *Labour Defended against the Claims of Capital, or the Unproductiveness of Capital Proved* (1825).

The argument commences with a statement of Ricardo's definitions. Commodities are produced by the united application of Labour, Capital, and Land, and are divided between the owners of these. The share of the landlord is rent, but as rent is merely a surplus of the fertile over the less fertile land, it cannot keep the labourer poor. The share of the labourer is that quantity necessary to enable the labourers one with another to subsist and perpetuate their race without either increase or diminution. The share of capital is all that remains after the landlord's surplus and this bare subsistence of the labourer have been deducted. On what grounds does Capital claim this large share? M'Culloch replies that Capital enables us to execute work that could not otherwise be performed: it saves labour and it enables us to produce things better and more expeditiously. Mill says that Capital supplies the labourer with tools and raw materials. For this the owner expects a reward. Capital is also an agent combining with labour to produce commodities. Further, the capitalist saves and accumulates more capital upon which Labour depends. For all this Capital deserves reward. Hodgskin proceeds to examine these ideas.

The goods which are given to the labourer to maintain him until his wares are brought to market are not the result of

F

accumulation or saving but of concurrent production by other labourers. The labourer has indeed no stock of food and clothing, but neither has the capitalist. The capitalists do not possess one week's stock of food and clothing for the labourers they employ. These goods are being concurrently produced by other groups of labourers. Food at least cannot be stored up. In fact, the only thing which can safely be said to be stored up is the skill of the labourer. If this were not so, the various commodities could never be produced at all. Each set of labourers relies upon the due performance by the other sets of their stipulated social tasks. This is clearly true where industrial operations are not completed within the year and there can be no exchange of products. It is not capital which stores up this skilled labour, but wages and parental care. In fact, the reason why capital is able to support and employ labour is that capital implies already the command of some labour and not the accumulation of goods.

It is true that Fixed Capital does increase the productivity of labour to an immense degree. But obviously these instruments of production are themselves the produce of labour. The economists say that they are stored-up labour and as such entitled to payment. But they are not stored up but used. They derive their utility from present labour and not because they are the result of past labour. Everything depends upon the use made of these machines, and peculiar skill is required of the labourer in using them. In the creation of fixed capital three things are required : knowledge and inventive genius ; manual dexterity to make the machines ; skill to use them. The great services of fixed capital are due to these qualities and not to the dead machines. And when did an inventor receive the due reward of his genius ?

Circulating capital does not, like fixed capital, add to the productivity of labour, but the capitalist claims the same rate of profit on both. In either case the profit is derived from the power capital gives over labour. *This power is of old standing, and is derived in the first instance from the monopoly of land and the state of slavery which consequently ensued.*

The position of the capitalist is as follows. One set of labourers is making food ; another is making clothing. Between them steps in the capitalist and appropriates in the process of exchange the larger part of the produce of both. He separates the two groups so that both believe that they depend upon him for their subsistence. The result is that the

labourer must give at least six times as much labour to acquire a particular commodity as that commodity would require to make. For one loaf the labourer must give the labour of six. The capitalist therefore imposes an infinitely worse tax upon labour than the Corn Laws, but he is sufficiently influential to make it appear that the latter alone are the cause of all the evils under which the labourer suffers.

Under the present system Mr. Ricardo is perfectly correct in stating that the labourer will only obtain from the capitalist as much as will enable him to maintain his kind without increase or decrease. The exactions of capital are the cause of poverty.

In the concluding part of his argument Hodgskin displays the characteristic moderation of the earlier writers. Capital being unproductive, it follows that the labourer ought to receive the whole produce of his labour. But how is this to be determined, seeing that no labourer produces any commodity independently ? It can only be determined by the judgment of the labourers themselves as to the value of their labour. Hence the labourers ought to be free to bargain and, if necessary, to combine for the purpose.

Hodgskin allows that the capitalist who directs labour deserves a reward as a working man ; but the idle capitalist has no claim at all upon the produce of labour. Trade union action will be good so far as it deprives the idle capitalist of his profits, and bad if it puts the industrious employer out of action.

Thus the whole of the elaborate argument ends in a justification of Trade Unionism. It has an atmosphere of artificiality and sophistry which would rob it of all value for a modern reader. It depends too much for its effect upon the exploitation of the false and verbal distinctions which marred contemporary economic theory. It is clever rather than convincing. It is weak at the one point where it ought to have been strong, namely, the explanation of capital as power over labour. He takes refuge in remote historical theory. Whilst he acknowledges the services which management of industry confers, he justifies a refusal to pay higher wages to the master than to the labourer on the ground that all labour is equally necessary in society—a manifestly false conception.

From the " wrong twist," which Ricardo unconsciously and Hodgskin consciously had given to economic theory, developed several divergent lines of radical and socialist doctrine.

On the one hand there was the revolutionary pessimistic school, represented by James O'Brien, who pushed the apparent admissions of Ricardo (with whose views Malthus was associated) to a terrifying conclusion, and prophesied a revolutionary termination to the oppression of capital. The present system condemned the poor to eternal and undiminishing poverty, whilst the rich throve on the surplus value extracted from the labour of the poor. The right of the labourer to the whole produce of his labour became an axiom. But the gulf between the practical wrongs of labour and its theoretical rights would grow until it was filled with the debris of the shattered capitalistic system. Then would militant labour march across and take possession of its true and undiminished heritage.

The other school, represented by William Thompson and J. F. Bray,[1] was more scientific in its methods, more positive in its conclusions, and less militant in its language. Thompson and Bray devoted themselves to further analysis of the conception of surplus value—the five loaves which Hodgskin's labourer produces but does not receive; they also examined the mechanism of exchange, through which, as Hodgskin suggests, the extraction of surplus value is accomplished. In both respects they left very little for later thinkers to add to the results of their inquiry. Both writers were much under the influence of Robert Owen, and saw in Owen's co-operative communities the solution of the problem. The labourer could only obtain the full produce of his labour in communities in which co-operative production, voluntary exchange, and co-operative distribution were the basis of industrial organisation. They were therefore enthusiastic advocates of the Owenite schemes. They were not popular writers in the sense that Hodgskin was. Their works were excellently written, but they were without popular appeal. They wrote with the serene tranquillity of men who awaited with sure and certain hope the accomplishment of their highest desires. They wrote for a small circle, and their task was to give a scientific foundation to the purely empiric notions of Owen. But the mass of working people whom the teachings of Owen reached interpreted them in the light of bitter experience, and had little patience with the ideal schemes of Thompson and his friends.

Manifold was the influence of this body of doctrine upon

[1] *Labour's Wrongs and Labour's Remedy, or the Age of Might and the Age of Right*, Leeds, 1839.

the mind of the working class. Various truths had been established. The industrial system was flagrantly unjust. The power of capital was founded upon robbery perpetrated generations ago. It was exercised to rob the labourer of three-quarters, nay, five-sixths, of the wealth he created, and to keep him, his fellows, and his posterity, down to the uttermost minimum of subsistence, leaving him a prey to the competing demons of high wages with over-population, and low wages with privations. The monopoly of capital was the great social evil; the destruction of it was the basis of future happiness. The source of all the ills under which the labouring class suffered was revealed. Low wages, fluctuations, insecurity, bad houses, disease, poverty, pauperism, ignorance, and vice—all this was the work of the twin monopolies of land and capital.

The decade 1825–1835 was a very critical period in the history of the working classes of this country. A multitude of hopes and fears, of excitements both internal and external in origin, played upon the minds of the industrious masses. The Industrial Revolution was extending its sway; the improved power-loom of 1825 and the locomotives of 1830 represented its latest triumphs. The commercial crisis of 1826 was a threatening omen, whilst the emancipation acts of 1828 and 1829 inspired hopes of political freedom which rose sky-high with the death of George IV., the return of a reform ministry, and the news of the July Revolution in France. The agitation of 1830–32 for the Reform Bill was mainly political in character, and suspended temporarily agitations of a very different nature. Among these was the Trade Union movement which had taken a new lease of life since 1825, when it had been relieved from the worst of its legal restrictions.

The new Unionism derived its economics from Hodgskin, and its inspiration from Robert Owen. Owen's chief merit was that he filled the working classes with renewed hope at a time when the pessimism, both of orthodox economists and of their unorthodox opponents, had condemned labour to be an appendage of machinery, a mere commodity whose value, like that of all commodities, was determined by the bare cost of keeping up the necessary supply. Owen laid stress upon the human side of economics. The object of industry was to produce happier and more contented men and women. It had not done so hitherto because of the bad system of distribution and exchange. To cure this, Owen made two proposals. The first was a co-operative system of production and distri-

bution which took form in the co-operative communities set up under his auspices. The other was the restoration of the natural standard of exchange, namely, the labour standard, which had been superseded by the introduction of money. Owen had that incomparable and serene self-confidence which made his Utopian proposals ring like a revelation in the minds of those who listened. They were led to believe that there was an infallible short-cut out of the Slough of Despond to the Celestial City. There was consequently a tremendous outburst of Owenite literature and a rapid growth of Owenite societies between 1825 and 1830. It was during this period that Hodgskin, Gray, and Thompson added their quota to the mass of criticism directed against existing society and its economic theory. Co-operative trading societies, societies for the spread of co-operative (that is, Owenite) education, exchange bazaars based upon labour value, and attempts to set up co-operative or communistic colonies, all flowed from the inspiration of Owen. But the greatest Owenite triumph of these years was the capture of the Trade Union movement in 1832–34.

Since the revival of 1825 Trade Unionism had developed in the direction of action upon a large scale. The constant defeat of local unions produced the belief that successful action was only possible when the whole of the workers in an industry were brought into line. This belief was applied first in Lancashire, which county, by reason of the greater concentration of workers and factories, offered the most favourable theatre for industrial warfare. A great general union or federation, in which all parts of the United Kingdom were represented, was attempted in the cotton industry in 1830. It was followed by a still larger union including other trades and calling itself "National." In 1832 this was followed by the Builders' Union, which in its turn was superseded by the largest scheme of all in 1834 — the Grand National Consolidated Trades Union. This last was a purely Owenite scheme. It included a vast variety of trades—agricultural workers, both skilled and unskilled, bonnet-makers, tailors, hosiers and framework knitters, gas-workers, builders, textile workers of all sorts, engineers, and cabinet-makers.

Owen's idea was that of a glorified Exchange Bazaar, with which he had been experimenting in London in 1832. The producers in each branch of industry were to be organised into National Companies. Production would be regulated by a

central organisation, and exchange would be carried out on the basis, presumably, of labour value, or perhaps exchange would be dispensed with and the distribution of goods be performed by the central body on some equitable plan. To organise such a scheme would have taxed the resources of a modern state to the uttermost, and to control hundreds of thousands of harassed and oppressed workers, brimming with renewed hopes, burning with zeal and fired with indignation against their old enemy, Capital, was a task from which the boldest modern Labour leader would shrink. But the serene optimism of Owen saw only the promised land, the perils of the way being ignored. The members of the Union pressed recklessly on. The first step was to acquire the means of production, and to achieve this a series of strikes on a hitherto unheard-of scale was instituted. Weapons of terrorism were not eschewed. But the assault failed : the organisation was too weak, Government came to the aid of capital, the law was invoked, and the movement smashed.

There were clearly many aspects of the activity of Owen, and each was represented by a different group of disciples. There was first the little group which drank the pure water of Communism — Gray, Thompson, Bray, Pare, Lloyd Jones, and their followers, who took the name of Socialists. This was a select body and came comparatively little into the light of publicity. There were also groups of factory reformers, such as those who formed the Society for Social Regeneration —a typically Owenite designation. This was led by Fielden of Todmorden, and was connected with local societies throughout the North of England. Educationalists in plenty derived inspiration from Owen. They, however, concern us little. There were also the half-converted Trade Unionists whose movement collapsed in 1834. Not the least important of the Owenite converts, however, was the little group of London artisans whose story is related by William Lovett the Chartist, and to whose activities the Chartist Movement owes its origin.

Socially and politically London differed considerably from the manufacturing towns of the North and Midlands in 1830, and this difference was then greater than it is now, when the more general diffusion of wealth and learning has considerably lessened the supremacy of London in these respects. London was then probably the only English city in which there was a considerable body of highly skilled artisans, for there alone was there a large wealthy and leisured class

whose wants could find employment for skilled handicraft. The manufacturers of the north, even when wealthy, did not always adopt a style of living commensurate with their earnings, for they often lacked the tastes which accompany hereditary riches. But London was alike the centre of society, fashion, politics, affairs, law, medicine and letters. It was the home, for part of the year at least, of an enormous proportion of the wealthy and leisured class. To meet their needs arose vast numbers of superior craftsmen, employed upon the better-class wares which found their best market in West-minster and the City. The political and commercial life of the metropolis furnished the most important of these artisans, from the political point of view. These were the compositors, employed upon the various newspapers and in the printing and publishing houses. These were necessarily men of fair education, keen intelligence, and of some acquaintance with the affairs of the world.

Apart from their superior rates of pay, these artisans of the capital had various other advantages over the mass of working people elsewhere. They had strong trade societies in which they were able to maintain apprenticeship regulations and high rates of wages, and as experts in trade union methods they were well acquainted with the problems of agitation and organisation.[1] Living as they did in the centre of affairs, these men enjoyed opportunities of education and of inter-course which were far beyond what the " provincial " centres could provide. The districts of London were not then so specialised nor the different social classes so segregated as they have since become, under the influence of improved com-munications. The central districts, Charing Cross, Soho, Seven Dials, Holborn, Fleet Street and the City, contained a very mixed population in which Francis Place the tailor kept shop a few doors away from the Duke of Northumberland's town house. Seven Dials and Spitalfields, and parts of Holborn contained festering rookeries in which pauperised silk-weavers, labourers, and criminals found a refuge. The excellent little group of men who founded the London Working Men's Association lived in the district between Tottenham Court Road, Gray's Inn Lane, Charing Cross, and Fleet Street. Here during the late 'twenties and the early 'thirties flourished political and social discussion of every description. Dr. Birk-beck had started the London Mechanics' Institution, which still

[1] *E.g.* Lovett's difficulty with the Cabinetmakers' Union.

exists as the Birkbeck College, where in 1827 Thomas Hodgskin was appointed lecturer in political economy. Place's shop at Charing Cross was the focus of middle-class radicalism. Richard Carlile's shop in Fleet Street, his sometime shopman James Watson's shop in Bunhill Fields, disseminated radical and anti-Christian literature and kept alive the radical traditions of 1816–1822, associated with the names of Wade, Wooler, Carlile himself, Henry Hunt, and William Benbow. Carlile ran the Rotunda, a building not far from the southern end of Blackfriars Bridge, in which working men radicals met frequently in eager and heated debate. John Gale Jones, a hero of the London Corresponding Society, was a favourite speaker there. Various coffee-houses, such as Lovett's, were equally well known centres of radical intercourse. The debates in the House of Commons, the latest scandal which threw light upon the degenerate character of the aristocracy, the astounding events in France, the latest Owenite idea, Cobbett's speeches, the vices of the Established Church, and the evil consequences of priestcraft, Hodgskin's economics, the reputation of Malthus and Ricardo, all these in their infinite variety were subjects of general discussion in these rendezvous of the London artisans. Ever since the days of Pitt and Fox, Westminster had been the scene of exciting political life. It was one of the largest constituencies, with ten thousand electors, and its franchise was wide. Westminster was, needless to say, therefore a radical constituency, and its radical vote had been organised on a system which anticipated Chamberlain's Birmingham caucus, by Francis Place, amongst whose followers many of the better-class artisans must be reckoned.

Amongst these London artisans the radical tradition had always been strong. The London Corresponding Society had risen from amongst London artisans, and two of its greatest members, Gale Jones and Francis Place, were still active in political affairs down to 1838, by which time the radical tide had mingled with the socialist torrent. The struggles of Carlile, Wade, and Wooler for freedom of press and conscience had preserved the radical idea in those days after 1819, when organised agitation was an offence punishable by transportation. After 1825, however, the younger generation of working men in London began to drift over to the new doctrines of social rights promulgated by Hall, Thompson, Hodgskin, Gray, and above all Robert Owen. Hodgskin lectured at the

London Mechanics' Institution on political economy from 1827. Whilst Hodgskin provided the weapons for the attack upon the existing system, it was Owen who provided the ideal of the new.

Owen, however, never commanded the entire allegiance of the mass of London working men, owing to his dislike of political methods, and his condemnation of the radical reformers. They therefore took up his ideas in a form which, though acceptable to themselves, cut them away from the thoroughgoing disciples who believed in the communistic idea. Thus they formed in the spring of 1829, whilst Owen was away in America, the First London Co-operative Trading Association and a sister society, the British Association for Promoting Co-operative Knowledge. The first was an experiment in retail trading, which, it was hoped, would lead to the accumulation of capital in the hands of associations of working men, and ultimately to the capture of all national trade and industry by such associations. This was perhaps the first working-class experiment in Owenism, and illustrates the sanguine optimism which the Owenite teachings produced. The second was a propagandist body and was instrumental in setting up a number of other societies throughout London, which led to the conversion of very many working men to socialistic ideas. Although Owen, on his return, laughed in a benevolent fashion at these puny efforts, he did not hesitate to use the material thus provided to set up his Labour Exchange scheme in 1832. Its failure no doubt confirmed the leaders of the working men in their view that the regeneration of society could not be accomplished without the aid of political power, and that democracy was the necessary preliminary to social justice.

These views were specially represented by the National Union of the Working Classes and Others which grew out of the British Association for the Promotion of Co-operative Knowledge on the latter's decease early in 1831.[1] The hopes of political radicals ran high in these days, and the National Union took a great part in fomenting the general excitement. The members were bitterly opposed to the Reform Bill of 1832,

[1] There is apparently some confusion in the narrative given by Place and followed by Beer, p. 239 (Wallas, pp. 269, etc.) as to the origin of the National Union of the Working Classes. There are, in fact, two stories, which are probably duplicates. There is an account in Lovett's handwriting in Additional MSS. 27,822, pp. 17 *et seq.*, in which the National Union, etc., is derived from the British Association for Promoting Co-operative Knowledge. On the close anticipation of the Chartist programme by this society see E. Dolléans, *Le Chartisme*, i. 26-29. Lovett, Watson, Hetherington and Cleave were its leading spirits.

which was in truth but a very small instalment of democracy, and their conduct and language increased in violence as the prospects of a middle-class victory in the reform campaign became brighter. With the passing of the Bill the combination of political disappointment with anti-capitalist notions caused vague ideas of class war to take clearer shape and become as unquestioned truths in the minds of the working men. These views are already prevalent in the debates of the National Union as reported in the *Poor Man's Guardian.*

CHAPTER IV

THE London Working Men's Association was the last of a series of similar organisations, extending as far back as 1829, and including the First London Co-operative Trading Association, the British Association for Promoting Co-operative Knowledge, and the National Union of the Working Classes and Others, which covered the period from 1829 to 1833. The character of these bodies has already been described. They present a gradual evolution from " voluntary communism to social democracy," [1] that is, from non-political Owenism to a belief that democracy is the necessary preliminary to social equity and justice. This evolution was modified by two events which had a very disturbing influence upon the minds of thinking working men. The Reform Bill of 1832 was a profound disappointment to them, and the sudden attack by the new middle-class Parliament upon the Trade Unions, ending in the barbarous sentence on the Dorchester Labourers in 1834, was a still greater blow. The ideas of the working classes took on a sharper edge. The Reform Bill and the Dorchester Labourers' case were regarded as cause and effect ; the middle class were using their newly acquired political supremacy to further their economic interests. Hence the idea of class war, which made the possession of political power more essential than ever to the working classes. Without the franchise the working men would be absolutely at the mercy of the middle class.

The National Union faded away during 1833–34 on the rise of militant Owenism in the shape of the Grand National Con-

[1] Wallas, *Life of Francis Place*, p. 269.

solidated Trades Union. The little group of men, from whose exertions the whole series of unions and associations took its rise, had already for some time been devoting themselves to another agitation, the object this time being the abolition of the stamp duty on newspapers. This agitation had achieved a partial victory in 1836, when the stamp duty was reduced from fourpence to one penny. This was a solid gain to working men, to whom the newspaper became for the first time accessible. Within a year or two of the reduction there was a rapid growth of popular, radical newspapers which played a very important part in the Chartist movement itself. This agitation had been carried through largely by the exertions of five men—Francis Place, William Lovett, Henry Hetherington, John Cleave, and James Watson, who had been the leading spirits ever since 1829.

William Lovett was thirty-six years of age in 1836. He was born at Penzance in Cornwall of humble parentage. His father, whom he lost when he was still an infant, was the captain of a small trading vessel. His mother reared him upon stern Methodist lines. He was sent to two or three schools at which he acquired some acquaintance with the three R's. He served an apprenticeship to rope-making, but his tastes lay more in the direction of cabinet-making which he contrived to learn in his spare time.[1] In 1821 he migrated to London, and after some difficulty he succeeded in obtaining entrance to the trade and society of the Cabinetmakers, of which society he eventually became President.[2] He thus took a place in the van of the trade union movement, to which he was able to render able service. He was methodical, careful, and business-like, qualities which were highly prized in those early days, when there were few to whom correspondence, the keeping of books, accounts, and minutes could be safely entrusted. Lovett was the universal secretary.

Lovett's political education began in a small literary society called the " Liberals," of which he gives us no details.[3] He joined the London Mechanics' Institute, where he heard Birkbeck, and probably Hodgskin, lecture. He also heard Richard Carlile and Gale Jones speak in the various coffee-houses where radicals congregated. From Carlile he derived a hatred of dogmatic and intolerant Christianity and was persuaded " that Christianity was not a thing of form and

[1] *Life and Struggles*, pp. 1-10. [2] *Ibid.* pp. 24-32.
[3] *Ibid.* pp. 34 *et seq.*

profession for mercenary idlers to profit by," [1] a belief which led him into disputation with his wife who was a devout Churchwoman. Hetherington certainly and Watson probably shared these views too.

Lovett's radical views were quickly reinforced by the teachings of Hodgskin, Owen, and others. He became an enthusiastic believer in Owenism. He was storekeeper for the First London Co-operative Trading Association in 1829.

I was induced to believe that the gradual accumulation of capital by these means would enable the working classes to form themselves into joint stock associations of labour, by which (with industry, skill, and knowledge) they might ultimately have the trade, manufacture, and commerce of the country in their own hands. [2]

He continued to take an active part in the Owenite propaganda down to the failure of the famous Labour Exchange Bazaar which was founded in 1832, but with the militant Owenism of 1834 he had nothing to do, devoting himself to his own affairs and the Newspaper Tax campaign. He was also a prominent member of the National Union of the Working Classes, and took a great part in its activities.

Lovett's expressions of his political and social opinions are comparatively rare, but one or two may be cited. In 1836 we find him arguing in the columns of Hetherington's *Twopenny Dispatch*.[3] Individualism is the great cause of the evil lot of the working classes. The right of individual property in land, machinery, and productive power ; the right of individual accumulation of wealth, " which enables one man to engross for luxury what would suffice to make thousands happy " ; and the right to buy and sell human labour by which the multitude are made subservient to the few—these are fountains of social injustice. Through these rights guaranteed by existing laws, industry is improperly directed to enriching the few instead of benefiting the many. Individual property means individual interests and a tendency *under any form of government* to influence legislation in favour of individual interests. The Corn Laws are a case in point. Individual interest and not surplus population is the root of social evil. Lovett is thus a social revolutionary. Permanent social happiness is to be expected only from the substitution of some higher principle than self-

[1] *Life and Struggles*, p. 37. [2] *Ibid.* p. 41.
[3] September 10, 1836.

interest as the basis of human society. Without this, changes in the form of government are futile.

At the same time the enfranchisement of the people under a truly democratic system would be a step towards bringing about this substitution. Thus Lovett in a conversation with Place in 1837 : " People would contend for a better state if they had political power." Place : " No, if they had intelligence." [1] Lovett undoubtedly agreed with Place. All his life Lovett believed that education was the indispensable preliminary to social regeneration. It was not so much intellectual conviction as a passionate sense of the injustice of things as they were that drove him into political agitation.[2]

On a later occasion Lovett expressed himself at greater length upon the evils of individual accumulation of capital. The primary evil is the trafficking in human labour.

This he conceived to be a pernicious principle in society. We admitted an individual to avail himself of the small savings of his own industry, or it may be of the assistance of his friends, and with these means thus to traffick in human labour, to buy it cheap and sell it dear, and as his means increased, to purchase machinery or other productive powers, and thus to supersede human labour. The fruits thus accumulated we allow him to transmit to his children : they, becoming rich, intermarry and mix with the aristocracy, and thus by this principle we are building up exclusion and corruption on the one hand faster than we can reform evils on the other.[3]

Lovett was a tall, thin man with a delicate frame and an ardent spirit. A description by an admirer runs thus :

Mr. Lovett is a tall, gentlemanly-looking man with a high and ample forehead, a pale, contemplative cast of countenance, dark-brown hair, and possessing altogether a very prepossessing exterior, in manner quiet, modest and unassuming, speaking seldom, but when he does so, always with the best effect. His voice is good though not powerful, his figure commanding, and the slow, clear and distinct enunciation of his thoughts at once arrests the attention and sympathy of his audience.[4]

Place's description is more critical :

Lovett was a journeyman cabinet-maker, a man of melancholy temperament, soured with the perplexities of the world. He was

[1] Additional MSS. 27,819, p. 263.
[2] W. J. Linton, *Memories*, p. 40: " Lovett was the gentlest of agitators, a mild, peace-loving man, whom nothing but a deep sense of sympathy with and duty towards the wronged could have dragged into public life."
[3] *The Charter*, February 17, 1839, p. 51.
[4] *Brief Sketches of the Birmingham Conference*, 1842.

however, an honest-hearted man, possessed of great courage and persevering in his conduct. In his usual demeanour he was mild and kind, and entertained kindly feelings towards every one whom he did not sincerely believe was the intentioned enemy of the working people ; but when either by circumstances or his own morbid associations he felt the sense, he was apt to indulge in, of the evils and wrongs of mankind he was vehement in the extreme. He was half an Owenite, half a Hodgskinite, a thorough believer that accumulation of property in the hands of individuals was the cause of all the evils that existed.[1]

And again :

He is a tall, thin, rather melancholy man, in ill-health, to which he has long been subject, at times he is somewhat hypochondriacal; his is a spirit misplaced.[2]

Lovett was therefore a man of a not unfamiliar revolutionary type. His was an impulsive and sensitive spirit which felt the wrongs and sufferings of others as keenly as those inflicted upon himself, liable to the extremes of melancholy and of enthusiasm ; an intellectual revolutionary differing from his more reckless colleagues in possessing an austere morality, unswerving honesty and courage, and a better insight into the difficulties and dangers which beset the path of the reformer. Lovett was no orator : sensitive and diffident, and endowed with but a weak voice, he did not shine in assemblies of any size. As adviser and administrator he was invaluable. He was a more competent guide than leader. He lacked the will to impose himself upon followers, and disdained to gain a precarious authority by exercising the arts of a demagogue, for which *rôle*, indeed, he lacked nearly all the qualifications. In fact Lovett carried his democratic ideas to the extreme of repudiating leadership altogether[3]—an idea which he perhaps owed to Hodgskin who, we are told by Place, was an anarchist. This, unfortunately, was neither good theory nor good practice. Good leadership was exactly what the working people wanted in those days. Leaders they had and Lovett was the best of them.

Henry Hetherington was eight years older than Lovett. He was a compositor by trade and had spent a little time abroad in Belgium. He, like Lovett, was educated in the radical and Owenite traditions, and was a thoroughgoing free-thinker. He is described by Place as an honest-hearted fellow who was

[1] Additional MSS. 27,791, p. 67. [2] *Ibid.* p. 241.
[3] Linton (*James Watson*, p. 41) says Lovett was " impracticable."

liable to be imposed upon by rogues. He was the leader of the working-class agitation for the abolition of the newspaper duties. He was the publisher of a series of radical unstamped newspapers of which the most important were the *Poor Man's Guardian*, started in 1831 as a weekly penny paper for the people, and the *Twopenny Dispatch*, started in 1835 on the decease of the *Guardian*. He was also partially responsible for the *Republican*, the *Radical*, and the *Destructive or People's Conservative* in the years 1831–34. He was an active member of the various unions of which mention has been made. He was a better speaker than Lovett, having more confidence and not being handicapped by physical difficulties. He acted as missionary for the National Union in 1831.[1] He was a downright, clear-headed, and trustworthy man. His fight against the newspaper stamp showed him to be a stubborn and ingenious campaigner, and he no doubt supplied some of the qualities in which Lovett was lacking. He was prosperous in his business after 1835 and was apparently a generous giver.

Hetherington left behind a remarkable statement of his views in 1849 :

I calmly and deliberately declare that I do not believe in the popular notion of the existence of an Almighty, All-Wise and Benevolent God, possessing intelligence and conscious of his own operations. . . . I believe death to be an eternal sleep. . . . I consider Priestcraft and Superstition the greatest obstacle to human improvement and happiness. I die with a firm conviction that Truth, Justice, and Liberty will never be permanently established on earth till every vestige of Priestcraft and Superstition shall be utterly destroyed. . . . I have ever considered that the only religion useful to man consists exclusively of the practice of morality and in the mutual exchange of kind actions. In such a religion there is no room for priests. . . . These are my views and feelings in quitting an existence that has been chequered by the plagues and pleasures of a competitive, scrambling, selfish system : a system in which the moral and social aspirations of the noblest human being are nullified by incessant toil and physical deprivations : by which indeed all men are trained to be either slaves, hypocrites, or criminals. Hence my ardent attachment to the principles of that great and good man Robert Owen. I quit this world with the firm conviction that his system is the only true road to human emancipation : that it is indeed the only just system for regulating the affairs of honest, intelligent human beings—the only one yet made known to the world that is based on truth, justice, and equality.

[1] *Republican*, July 30, 1831.

While the land, machines, tools, implements of production and the produce of man's toil are exclusively in possession of the do-nothings, and labour is the sole possession of the wealth producers—a marketable commodity, bought up and directed by wealthy idlers, neverending misery must be their (*sic*) inevitable lot. Robert Owen's system, if rightly understood and faithfully carried out, rectifies all these anomalies. It makes man the proprietor of his own labour and of the elements of production : it places him in a condition to enjoy the entire fruits of his labour, and surrounds him with circumstances which will make him intelligent, rational, and happy.[1]

A powerful testimony indeed to the inspiration and influence of Robert Owen. Hetherington shared the prevalent view of his circle that Owen's system could not be carried into practice until the working classes were enfranchised.[2]

James Watson was a year older than Lovett, having been born in Malton in 1799. When eighteen years old he went to Leeds as a drysalter's apprentice. There he came into contact with the struggling radicals of the Carlile - Bamford period, when radicalism was almost equivalent to high treason. As a result he volunteered to keep open Richard Carlile's shop whilst the radical champion was in Dorchester Gaol, and so reached London in 1822. In the following year he was visited with the usual penalties and found himself in gaol also, where he improved his mind with Gibbon, Hume, and other anticlerical historians. In 1825 he came into contact with the generous Julian Hibbert, a scholar and a gentleman of republican ideas, who dragged Watson through a serious illness and bequeathed to him a sum sufficient to set him up as a printer and publisher. He took a prominent part, with Lovett, Hetherington, and others, in the various Owenite ventures from 1828 onwards, and also in the campaign against the newspaper taxes. In 1834 he was imprisoned for publishing blasphemous writings. A letter he wrote from Clerkenwell Gaol to his wife, to whom he was but newly married, shows the same melancholy outlook which we have already observed in Lovett.

Do not let my staidness disconcert you or make you think I am unhappy. Remember, my dear Ellen, what a school of adversity I have been trained in, the obstacles I have had to encounter, the struggles I have had to make ; to which add that my studies, by choice I admit, have been of a painful kind. The study of the cause and remedy of human woe has engrossed all my thoughts.

[1] G. J. Holyoake (edited by), *Life and Character of H. Hetherington*, etc., 1849. [2] Additional MSS. 27,819, p. 263.

His favourite poem, significantly enough, was William Cullen Bryant's *Thanatopsis*. Watson was a kindly, lovable man, an honest Yorkshireman with the broad and generous qualities bred on the Yorkshire moors, a man, we are told, after the fashion of Cromwell's Ironsides.

Watson and Lovett, perhaps Hetherington too, represent an interesting revolutionary type. They are intellectual men whom modern education might have lifted into quite other spheres of life, where their abilities would have found that expression which political agitation alone seemed to offer in their own day. They were men driven into revolutionary thought by the appalling misery which they saw around them and which tinged their whole mental outlook with a melancholy which sought refuge in political agitation. A feeling of baffled helplessness in the face of the massed array of vested interests, ignorance, prejudice, and conservatism added bitterness to their thoughts. But a horror of violence, of bloodshed, and of hate deprived them of that callous, calculating recklessness which is essential to a physical force revolutionary, and they were helpless in face of such men when the movement which they started took on the nature of a physical force demonstration.[1]

John Cleave was about the same age as Hetherington. He was the latter's right-hand man in the agitation for the unstamped press. He kept a bookseller's shop in Shoe Lane at the Holborn end, and was the publisher of the *Weekly Police Gazette*, which attained a very large circulation. He was less refined and perhaps less able than his three colleagues, but he was a capable and fluent speaker of courage and conviction. Like Hetherington he was very useful as delegate or missionary.

These were the leading spirits in the London Working Men's Association which came into existence in the summer of 1836. We have two accounts of its foundation, from Place and from Lovett. Place relates how John Black, editor of the *Morning Chronicle*, who had assisted very enthusiastically in the campaign for a free press, and had therefore come into contact with the Lovett and Hetherington group, tried, during the summer of 1834 when that campaign was at its height, to form the artisans into a study circle. On applying to Lovett with this suggestion, he found him " cold and especially guarded." He received no more encouragement from the other members of the group. Place attributed this to the growing jealousy conceived by the

[1] W. J. Linton, *James Watson, a Memoir*, 1879, pp. 1-73.

artisans against the middle class, as a result of their great disappointment over the Reform Bill.[1] Lovett's account confirms this important particular. On the conclusion of the campaign against the newspaper taxes, he relates, it was seen that the agitation had brought together a number of influential working men—

. . . and the question arose among us whether we could form and maintain a union formed *exclusively of this class* and of such men. We were the more induced to try the experiment as the working classes had not hitherto evinced that discrimination and independent spirit in the management of their political affairs which we were desirous to see. . . . They were always looking up to *leadership* of one description or other. . . . In fact the masses in their political organisations were taught to look up to great men (or to men professing greatness) rather than to great principles.[2]

The main difference between Place and Lovett is that Place suggests that Black did, after all, have something to do with the foundation of this famous body, whilst Lovett does not allude to him. The minute-book of the Association [3] gives the following particulars :

At a meeting of a few friends assembled at 14 Tavistock St., Covent Garden, June 9, 1836, William Lovett brought forward a rough sketch of a prospectus for *the* Working Men's Association (*i.e.* the question had already been discussed). It was ordered to be printed for further discussion.

On July 17 it was proposed to invite some thirty-three persons to form the nucleus of the Association. Amongst these original members were of course Lovett, Hetherington, Watson, and Cleave. Of lesser importance were Richard Moore, a carver in wood, an honest, unobtrusive man ; John Gast, the famous shipwright of Rotherhithe ; Richard Hartwell, a compositor ; and Richard Cray, a Spitalfields silk-weaver who wrote a very curious report upon the handloom silk-weavers of London. Lovett acted as Secretary and Hetherington as Treasurer.[4]

The objects of the Association are thus stated by Lovett :

To draw into one bond of unity the intelligent and influential portion of the working classes in town and country. To seek by every legal means to place all classes of society in possession of the equal political *and social* rights.

Then follow two specific demands, " a cheap and honest

[1] Additional MSS. 27,819, p. 23. [2] *Life and Struggles*, pp. 91-2.
[3] Additional MSS. 37,773. [4] Additional MSS. 37,773, p. 6.

press" and "the education of the rising generation," the latter of which, and especially the determination with which it was pressed upon the attention of the public by the Association, awards to this little group of artisans a not unworthy place amongst the pioneers of English education. The methods adopted are as follows :

To collect every kind of information appertaining to the interests of the working classes in particular and to society in general, especially statistics regarding the wages of labour, the habits and condition of the labourer, and all those causes that mainly contribute to the present state of things : to meet and communicate with each other for the purpose of digesting the information acquired.

The views and opinions based upon this were to be published in the hope of creating "a reflecting public opinion" which would lead to a *gradual* improvement of the working classes "without commotion or violence." The formation of a library and the provision of a proper place of meeting close a programme of agitation as laudable in its objects as it is sound in its methods.

Conceiving its purposes in this serious spirit, the Association was naturally correspondingly careful in its choice of members. It rigidly excluded all but genuine working men, though it admitted to honorary membership members of the middle class, "being convinced from experience that the division of interests in the various classes in the present state of things is too often destructive of that union of sentiment which is essential to the prosecution of any great object." [1] Thus several radical members of Parliament were elected honorary members. Francis Place, James O'Brien, John Black of the *Morning Chronicle*, Feargus O'Connor, Robert Owen, W. J. Fox, later member for Oldham, and Dr. Wade, Vicar of Warwick, a jovial, eccentric doctor of divinity weighing some twenty stones, and an enthusiastic Owenite, all were similarly honoured by admission to the Association. [2]

Even genuine members of the labouring classes were not admitted without careful inquiry. Proposals for admission were frequently rejected or put back for further investigation. It was preferred to keep the Association small rather than depreciate the quality of its membership, or to run the risk of faction and disunion. These precautions were very necessary in view of the difficulties previously experienced in keeping

[1] Lovett, *Life and Struggles*, pp. 92-3.
[2] Additional MSS. 37,773, pp. 8-11, 24-5.

together similar bodies. Stringent as they were, they did not prevent reckless and revolutionary persons from entering and disturbing the unity of the Association. The total number of members admitted between June 1836 and 1839 was 279, exclusive of 35 or more honorary members. It is unlikely that the total strength was ever greater than 200. The subscription was one shilling per month, sufficiently considerable to exclude many would-be members. The receipts rose to £20 in the quarter ending June 28, 1837, and there was a surplus of 4s. 8d. After this the Association quitted the peaceful waters of quiet educational activity and launched out on the stormy ocean of public agitation.[1]

The earliest proceedings of the Association were concerned with the appointment of committees and sub-committees to investigate and report upon various subjects of working-class interest. One committee inquired into the composition of the House of Commons and published a famous report, called *The Rotten House of Commons*, towards the end of 1836. Another committee inquired into the condition of the silk-weavers of Spitalfields, and a manuscript report, drawn up by Richard Cray, found its way into the archives of the Chartist Convention of 1839.[2] It has no claim whatever to scientific accuracy, but is noteworthy as a pathetic description of the decay of a once reputable class of artisans, and as a specimen of popular anti-capitalistic thought. A third committee about this time drew up an address of sympathy with the Belgians, then endeavouring to establish their autonomous constitution. Another committee, in which, as we may justifiably surmise, Lovett was the chief, published the *Address and Rules of the London Working Men's Association for benefiting Politically, Socially, and Morally the Useful Classes*. It was principally an exhortation to their fellows in the country to found similar societies. They must use caution in selecting members, excluding the drunken and immoral. For real political education a selected few is better than a carelessly gathered multitude; a mere exhibition of numbers must be avoided—how different this from the mass demonstrations of 1831–32 ! Failure and disappointment may be the immediate reward, but knowledge and enlightenment will conquer in the end. Before an educated people Government *must* bow. These admirable

[1] Additional MSS. 37,773, pp. 28, 42, 57. The publications of the L.W.M.A. are in a volume collected by Lovett and presented to the British Museum (8138 a 55).
[2] Additional MSS. 34,245 B, pp. 3-20.

sentiments received unstinted praise from no less a person than Francis Place himself, who otherwise was quite out of sympathy with the social democratic tendency of the Association.[1]

The Rotten House of Commons was a scathing attack upon the unrepresentative character of that House and a stirring denunciation of the Reform Bill of 1832. It was strongly reminiscent of similar pamphlets published by the aristocratic radicals of the Wilkes epoch. The gist of the pamphlet is that the House of Commons is now the scene of a struggle between landed and moneyed interest, both equally dangerous to the interests and well-being of the useful classes. The bias of the argument is distinctly against the industrial and commercial faction.

Will it, think you, fellow-countrymen, promote our happiness, will it give us more comforts, more leisure, less toil, and less of the wretchedness to which we are subjected, if the power and empire of the wealthy be established on the wreck of title and privilege ? . . . If the past struggles and contentions we have had with the monied and commercial classes to keep up our wages—our paltry means of subsistence—if the infamous Acts they have passed since they obtained a portion of political power form any criterion of their disposition to do *us* justice, little have we to expect from any accession to that power, any more than from the former tyrants we have had to contend against.

Some of these men had put on the cloak of reform, but intended not to lose their exclusive privileges ; others were for gradual reform " lest we should make any advance towards depriving them of their exclusive prerogative of leading us from year to year through the political quagmire where we are daily beset by plunderers, befooled by knaves, and misled by hypocritical impostors "—a master-hand here truly.

Then follows a recital of the various interests represented in Parliament—Fundholders, Landholders, Money-makers, nobles of all ranks, Army, Law, Church, Manufacturers, and Employers —showing how incompatible such representation is with the true interests of the useful classes. The remedy is obvious— universal suffrage, ballot, annual parliaments, equal representation, abolition of the property qualification for members of Parliament, but above all a free press. Out of 6,023,752 males of full age only 839,519 had the vote. One-fifth of the latter elect a majority of members of the House of Commons,

[1] Additional MSS. 27,819, pp. 221-4.

for 331 were elected by only 151,492 votes, that is, one-fortieth of the male adult population had the power to make laws binding upon millions.

This pamphlet was published and scattered broadcast. It became the stand-by of radical orators throughout the country and spread the repute of the Association amongst working people everywhere. The Association published many other pamphlets during 1837, but none attained the celebrity of this one.

In January 1837 the Association accepted an offer of Francis Place to hold a study and discussion circle on Sunday mornings. Place left short notes of these conversations, which apparently consisted of duels between equally convinced exponents of orthodox and Hodgskinite economics. Place confessed his failure to convert the workmen, in a note which he later appended :

In a few, and only a few, instances have I been able to convince some of the trades delegates, who have consulted me, of the absurdity of the notion that everything produced or manufactured belongs solely to the people who made it, and this too without reference to the many hands it has gone through, the manufacturing hands being alone contemplated by them.[1]

This association with so thoroughgoing a supporter of orthodox, " Malthusian " economics as Place was destined very soon to bring the Association into bad odour when the agitation against the new Poor Law became violent, that law being universally regarded as a product of " Malthusian " subtlety.

The Association was growing both in numbers and in influence during the first year of its existence. It received notable recruits, including the redoubtable orator, Henry Vincent, who joined in November 1836,[2] and was quickly elected on the committee. Vincent was a young man of twenty-three or thereabouts, short, slight, extremely prepossessing, and with an unusual gift of speech. Like Hartwell and Hetherington, Vincent was a compositor. By midsummer 1837 the Association was exactly a hundred strong. It had gathered a library of radical and socialistic literature. We read, for example, that Messrs. Williams and Binns of the Sunderland Mechanics' Institution (of whom more hereafter) presented the Association with a copy of Hampden in the Nineteenth Century and were

[1] Additional MSS. 27,819, pp. 229-63. [2] Ibid. 37,773, pp. 24-8.

rewarded with duplicate copies of Thompson's *Distribution of Wealth*, and two Owenite works by Edmonds. Also " on the departure of Citizen Wm. Hoare the Association presented him with a splendid copy of Thomas Paine's works." [1]

Early in the existence of the Association danger raised its head in the shape of a deputation from the Cambridgeshire Farmers' Association, whose leader, a certain J. B. Bernard, was a currency maniac of the Attwood type. The report of a committee appointed to deal with the question, which was one of co-operation between the two bodies, is worth noting as an early indication of the Chartist habit of desiring to suppress all special agitations in favour of a general political movement.

The points urged on the part of the farmers were an adjustment of the currency so as to raise prices to enable them to meet their engagements or a reduction of burthens proportionate to their means. . . . It was replied on the part of the Association that the working classes were opposed to the raising of prices, as their increasing numbers, together with the new powers of production, were obstacles which would prevent their wages from being raised in proportion to high prices : also that, if by this plan they could relieve the farmer, they would then lose his co-operation in seeking a better state of things.

The report goes on to say that the Association urged upon the farmers the desirability of combining to acquire political power.[2]

Bernard, however, had other ideas than that of co-operating with the Association. He wanted to play a part of his own. Early in 1837 he established himself in London, having acquired some interest in the *London Mercury*, a popular radical organ run by one John Bell, and edited by James O'Brien. He attached himself in a parasitic sort of way to O'Brien and to Feargus O'Connor, who had been a political free-lance since he had lost his seat in Parliament in 1835. All these, except Bernard, were honorary members of the Working Men's Association, and we may presume had been somewhat piqued by the cool and independent way in which the working man had received them. They commenced a rival radical agitation both in London and all over the country, and from their efforts sprang various associations, with programmes including such items as Universal Suffrage, the " Protection of Labour," and the abolition of the New Poor Law. These societies received a patronising blessing from the older association.

[1] Additional MSS. 37,773, pp. 61, 50. [2] *Ibid.* 37,773, p. 11.

The leaders of this new movement were conspicuous members of a violently revolutionary clique, headed by Neesom, a man of sixty or so; George Julian Harney (born in 1817), who had been Hetherington's shop-boy, had passed several sentences for selling unstamped papers, and had filled his head with the doings of Marat and other Jacobins of '93; Allan Davenport, an old cranky radical, who died not long afterwards, and a few others. Most of these individuals played a part in the Chartist Movement, though not a very reputable one.

The setting up of this agitation was the signal for war between the Bernardites and the Working Men's Association. It arose apparently out of a trade squabble between Hetherington and the *Mercury* proprietors, as owners of rival papers. Hetherington was accused of smashing up a meeting called by Bernard at Barnsley in May 1837. O'Brien denounced Hetherington and his fellows as " scheming impostors," " bought tools of the Malthusian Party " in the pages of the *Mercury*. Hetherington retorted in kind by calling his rival newspaper proprietors Tories in disguise.[1] There was a stormy meeting of the Working Men's Association in June, when Bell and O'Brien appeared to answer charges against them.[2] The dispute between these rivals was not improved by the intervention of Augustus Harding Beaumont,[3] a young and fiery politician of exceedingly ill balanced mind.

The Working Men's Association, however, enjoyed an almost complete victory over its rivals. Its worst enemies seem to have collapsed about the summer of 1837. Bernard and Bell quarrelled, the *Mercury* was sold,[4] and O'Brien left stranded, until he began to write for O'Connor in the *Northern Star*. O'Connor and Beaumont found a more congenial field for their demagogic activities amongst the half-starved weavers, the factory operatives, and the semi-barbarous colliers of the North of England. Harney, Neesom, and the rest applied for admission to the Working Men's Association, which they obtained only with difficulty.[5] Harney at once began to cause trouble by entering into a controversy with O'Connell on the subject of the Glasgow Cotton Spinners. This was regarded by the Association as a breach of etiquette. Harney was censured. He replied by publishing the correspondence with O'Connell

[1] *London Mercury*, May 28, June 4, 1837.
[2] Additional MSS. 37,773, pp. 52, 56.
[3] *London Mercury*, June 18, 1837. [4] August 13, 1837.
[5] Additional MSS. 37,773, pp. 62, 74, 75.

in the *Times*, together with some disrespectful remarks upon the leading men in the Association. A stormy scene resulted in the resignation of Harney and his friends. They at once retaliated by setting up a rival society called the London Democratic Association. This thoroughgoing O'Connorite body carried on a propaganda of extreme violence, to the great disgust of the older and soberer Association in Gray's Inn Lane.[1]

Thus began the historic quarrel of Lovett and his followers and O'Connor. It was primarily the result of sheer incompatibility of temper between the sincere, self-sacrificing, but somewhat sensitive and resentful London artisan, who knew working men and shared their best aspirations, and the blustering, egotistical, blarneying, managing, but intellectually and morally very unreliable Irishman, who probably had never done an honest day's work in his life. It was secondarily a division between Lovett and a man whose methods of agitation included everything anathematised in the *Address and Rules* — hero-worship, clap-trap speeches, mass demonstrations leading to physical force ideas, and even more reckless oratory. The quarrel thus begun was never healed, and exercised throughout a baneful effect upon the Chartist agitation.

Whilst this strife was proceeding, the Association had been extending its influence by encouraging the formation of similar associations in the country. Occasional applications for copies of the Rules were received in the early months of the Association's career and a special sub-committee was appointed in February 1837 to deal with these.[2] This was followed up by the despatch of " missionaries " into the country to help in the foundation of daughter associations. Cleave made the first such tour to Brighton in March.[3] Hetherington was in Yorkshire in May and again in September. These two combined agitation with the prosecution of their newspaper business. The two flourished well together, as other agitators, like O'Connor and Beaumont, discovered. In August 1837 Vincent and Cleave were at work in Yorkshire, Vincent visiting amongst other places his old home at Hull. The efforts of these able speakers were crowned with success, and within a few months over a hundred working-men's associations sprang into being.[4]

[1] Additional MSS. 37,773, pp. 85-98. [2] *Ibid.* 37,773, pp. 26, 37.
[3] *Ibid.* 37,773, p. 40.
[4] *Ibid.* 37,773, pp. 62, 63, 65, 67 ; 27,819, p. 58 ; 27,822, p. 82.

This missionary zeal was backed up by a stream of publications. An *Address to Reformers on the Forthcoming Elections* (the general election on death of William IV.) urged that only candidates who pledged themselves to Universal Suffrage " and all the other great essentials of self-government " should be supported. Next came an *Address to the Queen on Political and Religious Monopoly*, which the working men wanted to present in person to the Queen. They were told by the Lord Chamberlain that they must attend the next *levée* in court dress. This of course was out of the question, so they contented themselves with a spirited and indignant protest. An address on the subject of National Education, published late in 1837, is probably from the hand of Lovett as it contains the germ of the proposals afterwards developed in the book *Chartism*. It sketches a plan of state-aided, but not state-controlled, secular national education, based largely upon an older scheme of which Place has preserved the details.[1] Ignorance, says Lovett, is the prolific source of evil, as knowledge of happiness. Poverty, inequality, and political injustice follow inevitably from the fact that one part of society is enlightened whilst the other is in darkest ignorance. The fearful prevalence of crime and the callous severity of punishment are equally the fruits of lack of education.

Is it consistent with justice that the knowledge requisite to make a man acquainted with his rights and duties should be purposely withheld from him, and then that he should be upbraided and deprived of his rights on the plea of ignorance ?

A true Lovett touch this !

The school buildings should be provided by Government, but the power of appointing teachers, selecting books, and the general management of the schools should be in the hands of a local school committee. This body should be elected by universal adult suffrage (women being enfranchised too), should sit one year and report every half-year. The expenses of maintenance, salaries, books, and the like should be met by a local rate, whilst a Parliamentary Committee, appointed *ad hoc*, should supervise the Government's disbursements. Five types of schools are recommended : infants' schools for pupils from three to six years old ; preparatory, for children from six to nine ; high schools for children from nine to twelve ;

[1] Additional MSS. 27,819, pp. 13-14 and 236.

colleges for students of twelve years upwards; and normal schools for teachers. Illuminating are the remarks upon educational method, as representing a reaction against the memory-cram of Lancaster and Bell. Illuminating, too, is the remark that cleanliness and punctuality are to be enforced " as the best means of amalgamating class distinctions."

Shortly afterwards, in December 1837, the Association issued an *Address to the Reformers of Great Britain and Ireland.* This was in reply to an address by the Birmingham Union, which had recently declared for the democratic reform of Parliament. With this Address the London Working Men's Association made its second great step towards the foundation of the Chartist agitation.

The first step had been taken early in the same year. On the last day of February a public meeting was called under the Association's auspices in the famous Crown and Anchor Tavern in the Strand. This was the first public appearance of the Association and created a great stir. All the principal members spoke. Feargus O'Connor and John Bell were present, not, we are assured, with the goodwill of the promoters of the meeting. A petition to the House of Commons was the result. This petition was the basis of the People's Charter. The preamble lays down

... that obedience to laws can only be justly enforced on the certainty that those who are called on to obey them have had, either personally or by their representatives, a power to enact, amend or repeal them. That all those who are excluded from this share of political power are not justly included within the operation of the laws : to them the laws are only despotic enactments and the legislative assembly from whom they emanate can only be considered parties to an unholy compact devising plans and schemes for taxing and subjecting the many. . . . That the universal political right of every human being is superior and stands apart from all customs, forms, or ancient usage : a fundamental right not in the power of man to confer or justly to deprive him of [*sic*]. That to take away this sacred right from the person and to vest it in property is a wilful perversion of justice and common sense, as the creation and security of property are the consequences of society, the great object of which is human happiness. That any constitution or code of laws formed in violation of man's political and social rights are [*sic*] not rendered sacred by time nor sanctified by custom.

Conversely, a constitution of this kind could only be maintained by force and fraud.

The prayer of the petition contained the " six points of the

Charter." The United Kingdom should be divided into two hundred equal electoral districts returning one member each. Every person (women included) above twenty-one years old should be entitled to be registered as a voter after six months' residence. Parliament should be re-elected annually on June 24, Midsummer Day. The only qualification for candidates should be nomination by at least two hundred electors. Voting should be by ballot. Parliament should sit from the first Monday in October until its business for the year was accomplished. It was to rise in any case not later than the first of September following. The hours of business were to be from 10 A.M. to 4 P.M. The salary of each member was fixed at £400 a year.[1]

The petition is interesting as a sample of popular radical theory, which preserved a strong flavour of abstract doctrine long after the middle-class radicals had become disciples of Bentham in theory and opportunists in practice. It is noteworthy that this original conception of universal suffrage included women's suffrage, a demand which the Charter afterwards abandoned. The belief that Government, as it then existed, was maintained by force or fraud was not allowed to remain a mere statement of a theory. It explains the faith of many later Chartists in the power and influence of mass demonstrations which were expected to prove to the Government that its physical force foundation was no longer sound.

The meeting at the Crown and Anchor aroused the interest of the small group of radical members of Parliament which included Sir William Molesworth, Daniel O'Connell, Hindley, Sharman Crawford, Joseph Hume, John Arthur Roebuck, and others. These encouraged the Association to continue its public exertions. The leaders of the Association began to sound their parliamentary friends as to the possibility of getting the question of universal suffrage introduced into the House of Commons. A conference was arranged between the two groups, and took place on May 31 and June 7, 1837. The basis of discussion was the petition of February drawn as a bill. Most of the members of Parliament were disinclined to present a bill of so sweeping a character, and suggested a policy of opportunism and reform by instalments. O'Connell was specially zealous in his advocacy of the " fourpence in the shilling policy," but his suggestions met with little approval. The working men were not prepared

[1] Lovett's pamphlets, 8138 a 55.

either to surrender the leadership of the popular reform movement, as O'Connell had suggested, or to abate one jot of their
demands. However, Roebuck agreed to present the Association's petition for universal suffrage, and the others promised
to support him.[1] For various reasons, however, nothing more
was done until the spring of 1838. The Association published
an account of these proceedings in its *Address to Reformers
on the Forthcoming Elections*.[2]

From this time onwards the London Working Men's Association gradually abandoned its quieter methods of agitation, and
made with its radical programme a public bid for the leadership
of working-class opinion. Its missionary tours were immensely
successful, and its petition and the various manifestos it had
published found a wide and enthusiastic response. During
the latter months of 1837 the working classes in the manufacturing districts began to be infected with a vague but widespread excitement. The trade boom was over and unemployment was on the increase. Agitators like Hetherington,
Cleave, and Vincent found audiences ready made at every
street corner. As the year wore on the failure of the harvest
began to tell its tale ; prices rose as wages fell. Discontent
was growing apace. Resentment against the New Poor Law
added to the excitement. The handloom weavers of the
northern counties were especially touched by the new regulations, whose rigour had passed almost unnoticed in the years
of good trade and cheap corn, which followed the passing of the
Poor Law Amendment in 1834. Agitations sprang up like
magic. Under the stimulus of Stephens, O'Connor, Oastler, and
other orators of a fiery and sentimental character, the working
people of the North broke out into a furious campaign against
the restriction of poor relief. Radical papers like the *Northern
Star*[3] and the *Northern Liberator* carried the flaming words of
the various orators to the ears of thousands who had not heard
them spoken. Nor did these speeches lose much in being
reduced to print, as they were read out loud by orators of equal
passion and less eloquence, in public-house and street-corner
meetings. Birmingham was rousing the Midlands to a campaign of a different character, in which it was endeavouring to
enlist working-class support.

It was at this moment, too, that the Government aroused
the antagonism of all Trade Unionists by the prosecution of the

[1] Additional MSS. 27,819, p. 210 *et seq.*
[2] Lovett, *Life and Struggles*, pp. 164-72. [3] See later pp. 93-6.

Glasgow spinners who were accused of assassinating a blackleg of grossly immoral character.[1] The memory of the Dorchester Labourers was still fresh, and Archibald Alison, who was writing the history of modern Europe to "prove that Providence was on the side of the Tories," had, as Sheriff of Lanarkshire, the case in hand. Already Alison was breathing out threatenings of slaughter against the Trade Unionists within his jurisdiction.[2]

Into the last-named affair the Association threw itself with energy. A Parliamentary inquiry into the conduct of the Trade Unions as a whole was set on foot, largely on the initiative of Daniel O'Connell, who was regarded as displaying unusual animosity against them. A Committee of Trades Delegates was set up in London to watch over the inquiry on behalf of the Unions ! The London Working Men's Association appointed three of its members on this Committee, Lovett, of course, being Secretary, and gave twenty-five shillings out of its scanty funds towards expenses.[3] The Parliamentary Inquiry fizzled out in spite of the voluminous charges of Alison, and the Committee found it necessary to do no more than issue a manifesto or two and to give help to the witnesses for the Trade Unions during their visit to London.

This action gained the Association further support. Three of the accused spinners were admitted as honorary members, and thus communications were opened up with the working people of the North. The London Working Men's Association was rapidly becoming a propagator of working-class solidarity. With its hundred and fifty allied associations in all parts of the country,[4] the Association could safely lay claim to the leadership of working-class opinion. Its agitation was not local : it was national and general. It aimed at no partial measures but at a radical reform of the institutions of the country, which would pave the way to social legislation in any desired sense.

In fact the Association was carried away by the excitement of the times and its own success in winning support for its radical programme. It had already achieved a considerable triumph, for the Birmingham Political Union in its desire to gain popular support for its Currency scheme had declared in favour of the radical programme. The Association was spurred on by this success and by the desire to seize and maintain

[1] *Parliamentary Papers*, 1837–38, viii. 211-12. [2] Pp. 92-187.
[3] Additional MSS. 37,773, p. 99.
[4] See *Address of Radical Reformers of England, Scotland, and Wales to the Irish People* (1838) for list.

control over the whole movement, of which it fondly imagined it was the author.

It was this feeling, no doubt, which induced the Association to take up again in the spring of 1838 the project of a Parliamentary Bill embodying the specific radical demands, which had been mooted in the previous year. The idea underlying this proceeding was that, as the Bill was about to be presented to the Commons by Roebuck or some other radical member, a great and general agitation should be set on foot throughout the country with a view to bringing to bear upon the House of Commons that pressure which, it was believed, had compelled the Government to pass the Bill of 1832.

At the meeting of June 7, 1837, a committee of twelve had been appointed to draw a Bill. The committee consisted of O'Connell, Roebuck, Hindley, Leader, Col. Perronet Thompson, and Sharman Crawford, all members of Parliament; and Lovett, Watson, Hetherington, Cleave, Vincent, and Moore of the Working Men's Association. This appointment had been announced to the working men of the country in the address on the forthcoming elections, and had raised great expectations. But the Parliament men did not keep their side of the bargain. O'Connell went on a trade union hunt which robbed him of all support amongst the English working people. Roebuck, as agent of the Assembly of Lower Canada, was busy with the case of the Canadian rebels, and the others were probably already involved in the Free Trade agitation, in which they foresaw much greater prospects of success than in a Bill compelling the House of Commons to sit daily from 10 till 4 for £400 a year. Lovett was therefore advised by Roebuck and urged by the Association to draw up the Bill himself. This he did in the intervals when he was not engaged in earning his living. "When I had finished my work I took it to Mr. Roebuck, who, when he had read it, suggested that I should show it to Mr. Francis Place of Brompton [1] for his opinion, he having taken a great interest in our association from its commencement." Place suggested improvements in the text, and the amended measure was discussed by the committee of twelve. Roebuck wrote the preamble, an address was prefixed to it by Lovett, and the whole was printed and published on May 8, 1838, as the "People's Charter." [2]

[1] Place had in 1833 left the shop at 16 Charing Cross, and taken a house at 21 Brompton Square. G. Wallas, *Life of Francis Place*, p. 330.
[2] P. 164 *et seq.* Additional MSS. 27,819, 210 *et seq.*

H

These proceedings throw some light upon the relations of the Association and the Parliament men. That the latter should be content to allow a bill of this importance to be drawn by an enlightened cabinetmaker and a radical tailor suggests that they had no particularly sanguine views as to its prospects in the House of Commons. Nor were they enthusiastically in love with its provisions. Scarcely any of them were as radical as the " People's Charter." Place says they were all lukewarm, which is very likely. But the Association was also very luke-warm in its co-operation with the Parliamentary Radicals. Its members were very suspicious and very jealous. They were intensely desirous of keeping the leadership of the move-ment out of the hands of middle-class men who had " betrayed " them in 1832 and prosecuted them in 1834. The Parliament men were kept scrupulously at a distance and the Association negotiated with them in a spirit of cold and exaggerated independence. The class-war ideas, revealed by such pam-phlets as *The Rotten House of Commons*, prevented any hearty co-operation, and ultimately put a stop to any common action at all between the working men and the other classes of society. In any case the Parliamentary Radicals played no further part in the whole movement.

The publication of the " People's Charter " was a triumph for the Association. The name itself recalled much, for there had been a string of pamphlets with similar titles since 1831. The document and the petition which accompanied it received the assent of radical working men in all parts of the country.[1] The programme which they put forward rapidly swept away all local and specific demands. Factory Reform, Currency Reform, abolition of the New Poor Law, of Truck, of the Corn Laws, all these demands were buried in the great demand for democratic institutions through which all the just desires of the people might become law. Within six months of the publication of the Charter the larger part of the working classes was united under its standard. Few of the local leaders were able to resist the popularity of the Charter. Oastler and Stephens were steadfast in their refusal to call themselves Chartists, and they were swept aside. O'Connor shouted as usual with the largest crowd and became a Chartist stalwart when he was sure that the Charter was the best thing to shout for.

The Working Men's Association laboured with increasing

[1] Additional MSS. 37,773, p. 111 *et seq.*

energy in the popularisation of the Charter. It was presented with some ostentation to the great demonstrations at Glasgow and Birmingham in May and August 1838. Vincent went on missionary tours which took him to Northampton, Manchester, Bristol, Bath, Trowbridge, and Birmingham.[1] From these journeys, in fact, he never returned, for he took up his residence at Bath, where he attained immense popularity as an orator and as editor of the *Western Vindicator*, a paper as inflammatory as his own speeches. Through this organ Vincent became a furious and reckless preacher of social revolution, a circumstance which made him the first victim of Government action in 1839. Hartwell,[2] another missionary, was similarly affected by the immense audiences which gathered to hear him on his wanderings. He, too, deserted the quiet ways of the Association for the turbulent methods of the North and Midlands.

The behaviour of these two members was a chief symptom of the break-up of the Association, which, as it were, died in giving birth to the Chartist agitation. Some of the members, led by Vincent and Hartwell, were desirous of turning the Association into a large agitating body, like the unions of 1831–32, or like the enormous bodies then rapidly mobilising in the North and Midlands. They wanted it to desert the placid methods of the past two years. They considered that their two years' agitation had sufficiently educated the opinion of the people, and that the time was now ripe for more energetic measures, for a public display of strength, and it might be for an actual revolution. Motions began to be introduced at the meetings of the Association with a view to increasing its numbers, a step which shows that the Association had travelled far from its sober declaration against the fascination of mere multitudes.[3] These tendencies were stimulated by the great meetings at Glasgow and Birmingham, at the latter of which the Association was represented by Vincent, Hetherington, and the Rev. Dr. Wade. The proposal for a Convention was taken up with enthusiasm and the elections were carried out at a public meeting in Palace Yard, Westminster, on September 17, 1838. The notion of a Convention carried with it suggestions of revolutionary activity, and by the end

[1] Additional MSS. 37,773, pp. 116, 117, 133.
[2] Place calls Hartwell " a reckless, evilly-disposed fellow." Hartwell had been treasurer to the Dorchester Labourers' Fund, which position he lost under grave suspicion of dishonesty.
[3] *Ibid.* 37,773, pp. 106-108.

of the year there was a distinctly revolutionary party in the Association. Hartwell contrasted with pain the apathy of London as compared with the rest of the country. O'Connor was beginning to gain a following amongst the London Democratic Association as at Birmingham, and at a meeting on December 20, 1838, Lovett found himself overborne by the party of physical force.[1] Both at Birmingham and in London the influence of excitement and of O'Connor sufficed to reduce, if not to annihilate, the party of moderation.

The meeting at Palace Yard was practically the last spectacular proceeding of the London Working Men's Association. It was a great meeting. The Association packed it carefully with supporters and sympathisers. It was a public meeting only in a formal sense. The High Bailiff of Westminster was the convener, and so the law was observed. The resolutions were all cut and dried. Eight delegates were proposed for election — Place, Roebuck, O'Brien, Lovett, Hetherington, Cleave, Vincent, and Hartwell. Place and Roebuck declined, and Moore and Rogers were elected in their place. There were present at the meeting delegates from all parts of the kingdom, Ebenezer Elliott of Sheffield, quickly lost to Chartism, Douglas and P. H. Muntz of Birmingham, Feargus O'Connor, and several of his northern fire-eaters, and delegates from Edinburgh, Colchester, Carmarthen, Brighton, Ipswich, and Worcester.

So the great movement got under weigh. Henceforward the London Working Men's Association was swallowed up in Chartism. Its leading members were transferred to a higher sphere of activity in the People's Parliament, but when the revolutionary intoxication had passed they returned without regret to the quiet educational activity which some had relinquished with much misgiving, whose results were surer and better, though visible only to the eye of faith.

Sanguine to the end, however, though its finances were depleted, the Association lent its aid to the project of founding a newspaper to serve as a Chartist organ in London. London alone was without a Chartist newspaper. Glasgow, Newcastle, Leeds, and Birmingham were well supplied, but not so London. A Committee of thirty was appointed by a meeting of London Trade Societies in September 1838, and a prospectus of a weekly paper to be called *The Charter* was issued. Lovett was Secretary to this Committee, and Hartwell was apparently manager of the printing department. William Carpenter, the

[1] Additional MSS. 27,820, pp. 354-58.

writer of the once famous *Political Letters,* a Radical of some repute, was appointed editor. Hetherington was publisher. The capital was to be raised by subscriptions amongst the trade societies and similar associations. The paper was issued for the first time on Sunday, January 27, 1839. It was very badly managed, and as an experiment in voluntary associated enterprise it was a failure. It cost sixpence, which was more than working people could afford to pay, and it was too sober to appeal to the mass of Chartists to whom the language of the *Northern Star* was more intelligible. Carpenter was a poor editor, and the management was careless. The paper never paid its way and was sold early in 1840.[1]

The immediate purpose of the London Working Men's Association was the formation of an organised body of working-class opinion. It was first necessary to build good foundations which could hold out through long agitations. Hence the foundation of Working Men's Associations and the precautions suggested in the choice of members. The next step was to furnish a programme and the materials for propaganda. Hence the pamphlets all urging the foundation of a distinct working-class party which should rival and ultimately overthrow the two historic " capitalistic " parties. So far so good. Unfortunately, however, the materials for building up the party were but poor. The Associations throughout the country were not up to the standard of the London Association ; their members were men of less understanding and were easily carried away by the excitement around them. The organised trade societies, which form so strong an element, with their funds and organisation, in the modern Labour Party, came but little into the movement. Finally, when the Birmingham and the northern agitations threatened to break up the scheme altogether, the London Working Men's Association admitted them, violent, unorganised, and undisciplined as they were, and so created a party which was certainly big, but was not the sound, organised, and orderly party which they had planned. After 1839 the London Working Men's Association virtually ceases to influence the Chartist movement. It had done its work, and though it was still in existence in 1847, it was never in its later years any more than a backstairs organisation.

[1] Additional MSS. 27,821, p. 22 ; 34,245 A, p. 398. Letters in Place Collection, vol. 66, at Hendon.

CHAPTER V

THE AGITATION AGAINST THE NEW POOR LAW

(1834–1838)

THE Poor Law Amendment Act of 1834 was passed with little or no opposition in Parliament in accordance with the report issued by the commission of inquiry appointed in 1832. The provisions of the Act may be divided into two parts, those concerning the new organisation of the system of relief, and those dealing with the principles on which relief was to be administered. The unit of local administration under the new Act was the union of parishes. For each union an elective board of Guardians of the Poor was set up. As the poor rates were exclusively levied upon buildings and land, the franchise was a property franchise admitting of both plural and proxy votes, a system which placed chief control in the hands of the wealthier owners of property. The central administration, created for the first time, was a Parliamentary Commission of three members, whose powers, though wide, were defined by the Act, and whose competence was limited to a period of five years from the passing of the Act. The principles on which relief was to be granted were frankly deterrent. They may be summarised thus : That relief should not be offered to able-bodied persons and their families, otherwise than in a well-regulated workhouse. That the lot of the able-bodied pauper should be made less eligible than that of the worst situated independent labourer outside.

For two years the Commissioners, or rather their secretary, Edwin Chadwick, laboured successfully to introduce the new system into the rural districts. When, however, they commenced operations in the manufacturing areas in 1836, they met with an opposition whose violence and fury grew with the passing of the period of good trade into a period of unparalleled

depression and distress which lasted with scarcely a break till 1842.

The campaign which now commenced with a view to repealing the Act had a double character. It was a conservative opposition to a radical measure, and it was a popular outburst against what was conceived as a wanton act of oppression.

The Act of 1834 was the first piece of genuine radical legislation which this country has enjoyed; it was the first fruits of Benthamism. For the first time a legislative problem was thoroughly and scientifically tackled. It bore on its surface all the marks of genuine Radicalism, desire for centralised efficiency and a total disregard of conservative and vested interests. Under the old system each parish had been an almost independent corporation, administering relief and levying rates with scarcely a shadow of control from the central Government. Under these circumstances abuses and vested interests had grown up to an appalling extent. Parishes often fell into the hands of tradesmen, property owners, manufacturers, public-house keepers, and the like, who exploited both paupers and public in the interests of their own pockets. These, of course, offered a strenuous resistance to the new measure. Then there was a genuine regret on the part of antiquarians and conservatives to see the parish, a very ancient unit of local government, superseded by an artificial unit, designed largely with a view to diminishing the influence of local feeling. The diminution of local independence was of course carried still farther by the strong control exercised by the Commissioners, who therefore came in for an incredible amount of abuse. No abusive epithet was bad enough for the " three kings of Somerset House." Their power was alleged to be despotic, to be unconstitutional, to be derogatory to the sovereignty of Parliament, and so on.

The popular opposition was of a totally different character. It was directed against the deterrent character of the new system, though the popular leaders did not of course disdain to use the political arguments of their learned and Parliamentary allies, and *vice versa*. The basis of popular hatred of the law is thus stated by a competent authority :

People now are prone to look upon the stormy and infuriate opposition to the Poor Law as based upon mere ignorance. Those who think so are too ignorant to understand the terrors of those times. It was not ignorance, it was justifiable indignation with

which the Poor Law scheme was regarded. Now, the mass of the people do not expect to go to the workhouse and do not intend to go there. But through the first forty years of this century almost every workman and every labourer expected to go there sooner or later. Thus the hatred of the Poor Law was well founded. Its dreary punishment would fall, it was believed, not upon the idle merely, but upon the working people who by no thrift could save, nor by any industry provide for the future.[1]

Without going quite so far as to include the whole of the industrious classes as actual or potential paupers, one may safely assert that to hundreds of thousands of working people outdoor relief was a standing source of subsistence supplementary to their scanty wages, and to probably an equal number outdoor relief was an occasional and even frequent resort. The substitution of workhouse relief made that public institution the prospective home of a vastly larger proportion of the poorer classes than would be the case at the present time, so that the deterrent system of relief came as a terrible shock to those who had been wont to rely upon poor relief without experiencing any loss of self-respect or of personal liberty.

The purpose of the Act of 1834 was to attack the abuses of outdoor relief to able-bodied persons. These abuses were serious enough, but it was acknowledged that they were far more prevalent in the agricultural districts than in the manufacturing areas, where wages were higher on the whole and a greater spirit of independence was prevalent. During the years of 1823–49 the average expenditure on poor relief per head of population was three times greater in the agricultural counties of Cambridgeshire, Suffolk, Essex, and Lincolnshire than in the counties of Lancashire and Cheshire. In these agricultural counties practically the whole of the working class was pauperised. In the manufacturing districts only certain grades of labour were in that situation. The handloom weavers, the stockingers of Leicester, Nottingham, and Derby, whose situation was being reduced to that of second-rate, unskilled labour, and the multitude of Irish labourers who were swarming into the English manufacturing areas—these provided the mass of pauperism in those parts.

The situation created by the New Poor Law was particularly galling to the handloom weavers, so recently respected and influential members of industrial society. Hence it was

[1] Holyoake, *Life of J. R. Stephens*, p. 59.

amongst them that the opposition was strongest. Under the old system their wages, as they were reduced by economic pressure, were reinforced by outdoor relief. Many had come to look upon this as legal compensation for their loss in wages and resented its withdrawal as a piece of downright robbery. Of course the system was on the whole a bad one. It did help to perpetuate a class of labour which might otherwise have been absorbed into other occupations. It often provided reserves of cheap labour for factory masters. It occasionally allowed other persons than factory owners to fill their pockets at the expense of the public. Owners of tumble-down cottages, for example, being also guardians, paid their own rents to themselves by way of out-relief to their miserable tenants.[1] At the same time none but an official, to whom human beings were as documents in pigeon-holes, would expect a middle-aged, worn-out handloom weaver to be usable in any other industry, and most of the handloom weavers, who were not Irish immigrants, were oldish men, quite unfit for anything else. It was sheer cruelty to refuse them relief altogether, except in a detestable workhouse, where they were separated from wife and children, with little prospect of ever getting out again. No wonder they preferred to starve. The stockingers were in similar case, except that they had not the same memory of days of prosperity, and their indignation was perhaps less tinged with bitterness. Even factory workers were not immune from the terrors of the workhouse during the years which followed the great trade collapse in 1836–37, whilst the unskilled general labourers, who were often Irish immigrants, added an element of a turbulent character to the opposition to the new enactment. It was therefore in the factory and handloom areas of Lancashire, Cheshire, and Yorkshire that the campaign against the workhouse was most violent. Carlisle was also the scene of furious outbursts. There the mass of the population was engaged in handloom weaving, mostly in the employ of one firm—that of Peter Dixon. The hosiery districts were equally excited by the new system of relief and played considerable part in the campaign which began in Lancashire as soon as the effect of the Act was realised.

The theoretical basis of the popular movement was supplied by William Cobbett (1762–1835), pamphleteer, journalist, radical, tory, agriculturist, moral adviser, popular historian,

[1] See Reports on Bolton and Macclesfield Unions, *Parliamentary Papers*, 1846, vol. xxxvi.

and, since 1832, member of Parliament for Oldham. Cobbett
had been almost alone in his opposition to the Poor Law
Amendment Bill in Parliament, and soon after it became
law he published his views upon it in his *Legacy to Labourers*.
This little book is an excellent example of Cobbett's contro-
versial gifts. Its arguments are as clear and telling as its
style. Its bold assumptions and sweeping assertions, as well
as its grotesque errors of fact (Cobbett alleges that the popu-
lation of England had not increased during the previous
half-century), are all characteristic of this unparalleled contro-
versialist, and furnished ammunition of which his even more
uncritical followers made unsparing use.

The *Legacy* must be read in connection with Cobbett's
admirable but rather perverse *History of the Reformation*.
The two together form a strong plea for regarding poor relief
as a legally recognised commutation of the rights of the poor
in the land. The seizure of the lands of the Church which, he
maintained with some truth, were granted for charitable pur-
poses (an argument applied over and over again by his followers
to justify the disendowment of the Anglican Church) was fol-
lowed by the provisions regarding relief of the poor on which
the famous Act of 1601 was based. This Act, Cobbett argued,
recognised the legal right of the poor to assistance from the
receivers of rent. The Act of 1834, a " Bourbon invention,"
repealed this right and destroyed it without compensation.
This was the main contention, and it formed the theme of
most of the speeches delivered by Anti-Poor Law orators.
Thus O'Connor at Dewsbury in December 1837 : " Had you
any voice in the passing of this law ? . . . Did you send repre-
sentatives to Parliament, thus to betray you and rob you of
your inheritance ? " [1]

Cobbett's argument goes further than this. On what
ground, he asks, was this legal right abrogated ? On the
ground that poor rates were swallowing up the estates of the
landlords. This was in fact absurd. Are the landlords
ruined by the poor, to whom they pay £6,700,000, when they
pay thirty millions to usurers [2] and seven to " sinecurists " ?
Was the country being ruined for a paltry seven millions when
the taxation paid was fifty-two millions ? And, further, even
suppose the landlords were paying more, was it not a fact that
they were receiving ten or twenty times as much rent as they

[1] G. R. W. Baxter, *The Book of the Bastiles*, **p. 392.**
[2] *I.e.* National Debt interest.

had formerly received ? Not the poor, but the army, the debt, the clergy, the sinecurists, the pensioners, the privy councillors, were swallowing up the estates of the landlords.

The object of the Act was to compel the people of England to live on a coarser diet. He, Cobbett, had seen the official instructions to this effect. As no one but the weakest would accept relief under the new system, labourers would be prepared to work for any wages they could get. Thus the English labourer would be screwed down to Irish wages and Irish diet. Oastler paraphrased this into a corrupt bargain between landlords and factory masters to provide cheap labour for the factories.[1] Further, the Act abrogated that " neighbourly " system of relief which had flourished so long, in favour of a tyranny exercised by three distant commissioners and their secretary, who were perfectly unmoved by pity or compassion, and whose minions were to steel themselves to equal callousness.[2]

This publication found an echo everywhere in the manufacturing districts. The new Act was denounced as the " Coarser Food Bill," and " Irish wages " became a very useful and effective bogey. The evil effects of the old system Cobbett and his readers absolutely ignored. It is true that the wholesale demoralisation which accompanied the old system was not so prevalent amongst the manufacturing people, but even there it had the effect of prolonging the agony of the handloom weavers and similarly situated workers, by subsidising them in their hopeless conflict with the machine weavers. The relief paid in aid of wages benefited no one but the employer of handloom weavers, who was able to extract the current rate of profits without having to set up expensive power-looms. The competition of subsidised labour only tended to reduce wages all round, even in the factories. Thus the old system tended to make the situation of the half-pauperised labourer the normal standard of life, whilst the new aimed at setting up that of the independent labourer. There is little evidence to show that the new system actually did tend towards reducing wages, so that the " coarser food " and " Irish wages " cries were sheer absurdities, although they acquired a certain show of reality during the very distressful years of industrial depression which followed the collapse of 1836.

The centralisation which characterised the Act of 1834 was its strongest point, and it was this which earned the new system the deepest hatred of the classes affected by it. Under

[1] Baxter, pp. 356, 366, 412. [2] *Legacy to Labourers*, pp. 7-27.

the old system it was quite easy to bring pressure to bear upon the relieving authorities, independent, isolated, and unsupported as they were by the authority of the State, and composed very often of persons who had no interest in keeping down expenditure. This was the "neighbourly system" of Cobbett; the system under which the local publican maintained his family and relatives out of poor rates ; under which the sweater of framework knitters undersold Saxon hosiers by "making up" wages out of poor funds, and under which workmen on strike demanded relief as a substitute for trade union funds.[1] Occasionally, however, the old system was capable of better use. Thus in 1826 the manufacturers of Lancashire tried to establish a minimum wage for weavers, and called upon the various Poor Law authorities to relieve those who could not obtain work at the minimum fixed, until trade improved and they were all employed. But under the new system local pressure was powerless, except, as we shall see, through an organised and widespread movement. The units of administration were larger, the local authorities were much stronger, as they were elected and supported by the wealthier and more influential classes. Moreover, behind the local unions stood the Poor Law Commission with its wide and all-pervading powers.

For the first time English local opinion came into contact with the official mind. The haphazard, rule-of-thumb method of administration, which admitted of infinite variation of practice, and totally excluded the scientific and consistent treatment of any social problem, was replaced by a rigid uniform system, administered by officials whose authority was derived only in part from local opinion, and whose practice was dictated by precise and rigid rules, against which local opinion was powerless. The new administrator of poor relief, who could not be moved by persuasion or threats, who referred applicants of all descriptions to the "Act of the 4 Will. IV.," who treated all questions in a clear but totally objective and unemotional fashion—such a personage was a new and terrific apparition. The English working man, whether in town or country, to whom the local magistrates were the source of all public authority, and the local magistrates themselves with lingering feudal notions of local autonomy, and a considerable idea of their own importance, were equally enraged at the calm assumption of authority by distant com-

[1] *Third Report of Poor Law Commissioners.*

missioners and local Boards of Guardians who could not be coerced. Against such a system parochial agitation was powerless. The only remedy was the repeal of the Act. That required a more than local movement.

The agitation against the New Poor Law began in 1836. It was divided into two parts : an organised attempt to prevent the introduction of the law, and a popular movement of protest against the law itself. This latter movement, which was later absorbed into the Chartist Movement, was of a totally different character from the agitations which were then commencing in London and Birmingham under the auspices of the Working Men's Association and the Political Union. This difference was of decisive influence upon the fate of Chartism.

The Anti-Poor Law Movement, on its popular side, was, in fact, a rebellion in embryo which never came to full development. Its historical ancestry may be traced back through the Pilgrimage of Grace, Jack Cade, and the Peasants' Revolt. It was a protest against social oppression, against a tyranny which hurt the poor by making them poorer. It was a mass demonstration of misery. It had no programme but redress of grievances. It had no social theory but the restoration of rights which had been taken away, and no political theory except a belief that the sovereign's duty was to protect the poor against the oppressor. It has been well said that the reasons which men give for an opinion they hold are often totally different from the reasons which led them to take up such an opinion. Thus whilst the theoretical opposition to the New Poor Law was based on Cobbett's book, the real grounds of protest were far older in origin than that. The leaders of the movement drew their inspiration from the Bible, from a belief that the Act was a violation of Christian principles. Now this tendency to hark back to the Bible and to Christianity as a basis of political and social practice is the most interesting phase of the whole Chartist Movement. Religious sanction for radical opinions is the only refuge for persons unacquainted with abstract political, or social, or economic theory. And naturally so, for nowhere do we get the standards of eternal justice so clearly set up for us as in the pages of the New Testament. Thus we find that the authority of the Bible or of Christian teaching in some form or other is claimed in all the movements we have mentioned. John Ball's famous couplet may well furnish the text on which all the later popular movements may furnish the sermon. Thus the Anti-Poor Law agitation,

led by a Wesleyan minister, a religious, sentimental opponent of child-labour, and a philanthropic employer, falls into line with all these earlier movements. It is racy of the soil, and a most remarkably interesting revival of a popular religious sentiment, dead since the Tudors, and brought to life again by the disciples of John Wesley.

Relying thus on a higher sanction than that of the State, the popular leaders urged their followers to resist the Act even to the extreme of armed rebellion. The movement was thus of extraordinary vehemence and violence. The rank and file were men already rendered desperate by continuous and increasing poverty, ignorant and unlettered men deprived, or fearing to be deprived, of a resource on which they had long counted, men coarsened by evil surroundings and brutalised by hard and unremitting toil, relieved only by periods of unemployment in which their dulled minds brooded over their misfortunes and recalled their lost prosperity. The popular agitation was entirely without organisation. It centred exclusively in the personality of a few leaders. Its methods were thus far removed from those of the Anti-Corn Law League or the London Working Men's Association. It was not educative; it appealed not to reason but to passion and sentiment. Its leaders were not expert agitators, aiming at the conversion of public and Parliament, but mob orators, stirring up passions and spreading terror, hoping to frighten the Government into a suspension or a repeal of the hated Act. Hence there was always an element of futility in the movement. The Reformed Parliament could not be terrorised; it was too strongly supported by the mass of educated and propertied people. Perhaps a glimmering notion that this was the case explains the ease with which the leaders of the agitation were persuaded to range their followers under the Chartist standard.

Cobbett having died in 1835, the leadership of the agitation in the North devolved largely upon his colleague in the representation of Oldham, John Fielden of Todmorden, a " Methodist Unitarian." He came of a family which had risen to fortune during the Industrial Revolution. He and his brother were owners of extensive spinning and weaving factories at Todmorden, where the family reigned in semi-feudal state over an obedient population. In some of his sympathies Fielden was a Tory, though, being a Free Trader, he was classed as a Radical in Parliament. He was distinguished by an attitude of Owenite benevolence towards his workpeople. In earlier days

he was a great advocate of the minimum wage idea for hand-loom weavers, and his projected " Boards of Trade," to fix the wages of these unfortunate operatives, received the approval of the Select Committee of 1834–35. He was an early convert to the Owenite schemes for factory reform, and in 1832 founded the " Society for National Regeneration " in which Owen was interested. This Society started an agitation for factory reform, in which several leaders of the Anti-Poor Law agitation were active. Fielden's own part in the latter agitation was small but important. He represented it in Parliament, where he was indefatigable in the presentation of petitions. By his own exertions he prevented the introduction of the Act of 1834, or of the Registration of Births, Marriages, and Deaths Act of 1837, which was closely connected with it, into the Todmorden area at all. It was a good generation later before pressure from Whitehall compelled the Todmorden Union to build a workhouse.[1] Fielden also encouraged similar resistance in neighbouring towns, like Huddersfield and Bury. This re-sistance was so effective that Lancashire and the West Riding were administered under the old system for several years after the Act was otherwise in full working order.

Two of Cobbett's sons, J. P. and R. B. B. Cobbett, both lawyers, played some part in the movement. They helped to run a periodical called the *Champion*, in which Fielden was also interested. As demagogues the two Cobbetts were failures, and when the agitation assumed a ferocious law-breaking character, they almost fell out of the movement.

The real leaders of the Anti-Poor Law agitation were Richard Oastler and Joseph Rayner Stephens. Oastler (1789–1861), " the factory king," was steward to the family of Thornhill, whose estates lay about Huddersfield, and he himself lived at Fixby Hall, the home of the absentee Thornhills, upon the moors on the Lancashire side of Huddersfield. He had come into prominence in 1830, when he opened a campaign against the exploitation of child-labour in the Yorkshire factories, an agitation which brought him into touch with Fielden, Robert Owen, and Michael Thomas Sadler. Stephens (1805–1879) was the son of a Wesleyan minister, and was educated at the Manchester Grammar School. In 1825 he entered the Wesleyan ministry and went off to a mission

[1] See for the resistance to the new Poor Law in Todmorden, J. Holden, *A Short History of Todmorden*, pp. 188–93, and H. M'Lachlan, *The Methodist Unitarian Movement*, ch. vii.

station at Stockholm, Sweden, where he seems to have done good work and got himself well liked.[1] In 1830 he returned and took up a call at Ashton-under-Lyne. Four years later, owing to his taking an active part in a disestablishment campaign, he was compelled to sever his connection with the Methodist body. Like Gladstone shaking off the dust of Oxford, Stephens now felt himself unmuzzled, and plunged at once into a vehement Factory agitation, emulating in Lancashire the repute of Oastler in Yorkshire. He continued, also, to preach as a free-lance, and a chapel was erected for him at Ashton, which remained his headquarters.

It would be a far from unprofitable occupation to speculate on the influence of Methodism, both within and without the Church of England, upon the politics of the early nineteenth century. Oastler himself was a member of the Established Church, but his father was a Methodist of the first generation and a personal friend of John Wesley. In those days the gulf between Church and Methodist chapel was not wide, and professional convenience may have determined Oastler's choice of worship. In all his modes of thought he was a very replica of Stephens.

The strength of the Methodist movement was its appeal to those religious emotions in the masses of the people, which in a carefully organised form were the strength of the mediaeval Church, and which even in these days are not so overlaid with rational considerations as to be insensible to the appeal of a General Booth or a Spurgeon. The appeal of Wesley, as a protest against the soulless, high-and-dry formalism of the Church of England, was essentially popular. He re-established the notion that even the agricultural labourer had a soul, a fact which tended to be obscured by the social arrangements then coming into force. He taught, and his followers taught, vigorously, effectively, the existence of a God who cared for all the dwellers upon earth, who would not let even a sparrow fall, and who went to the extreme sacrifice to purchase from the evil adversary the souls of all His children. These teachings, which showed an effective contempt of dogma, were pressed home by a mixture of general and personal appeal, and general and personal denunciation, culled largely from the language of

[1] He learnt how to preach in Swedish, and acquired a strong taste for Scandinavian literature, which he communicated to his younger brother, George Stephens (1813–1895), professor at Copenhagen between 1855 and 1893. There was a touch of the undisciplined imagination of the Chartist preacher in some of the constructive work of the author of the *Runic Monuments.*

the Old Testament applied with ingenuity and freedom, as though the preachers were not tied by a strict belief in the verbal inspiration of Holy Writ.

The methods rather than the theology of Methodism were turned directly to the purposes of political agitation by Stephens and Oastler. In fact it may be safely said that Stephens went a long way towards making the factory and poor law movement into a kind of religious revival. He issued forth from the chapel, and sermons were his chief weapon in the war upon Mammon. With Stephens and Oastler alike the Bible was the source of all political and religious teaching. Says Oastler : " I have resolved to go right on. I take the Bible, the simple Bible with me, without either note or comment, and in spite of all that men or devils may devise against me, I will have the Bill." [1] Oastler had an extraordinary faculty for playing upon the feelings of his audience, tears and shudders being equally at his command. Some of his speeches even now cannot be read without tremors, especially those in which he produced, as evidence of factory horrors, the scalp of a girl who had been caught in a driving belt.

Stephens's special gift was denunciation. He conceived himself as a successor of Bishop Latimer or of those Old Testament prophets, summoned by the Almighty to chastise the Jeroboams and Ahabs of their time, prophets " who told kings what they were to do and the people likewise, who told senates and legislatures what kind of laws they were to make and what laws they should not make." He imagined himself at war with Satan, whose reality and vitality, already an established dogma of the Wesleyan community, was vouched for by the existence of such persons as Malthus and the Poor Law Commissioners. These he compared to Pharaoh who ordered a massacre of innocents, but unfavourably, as Pharaoh was frank about the matter whilst the Commissioners were hypocritical.[2]

Both Oastler and Stephens were thoroughgoing Tories.[3] In fact Stephens's political ideal was a theocracy of the Old Testament type in which the preacher announces the will of God, the king enforces it, and the people submit to it. Altar, Throne, and Cottage are the true homes of mankind. In a society of this description neither class distinctions, factories,

[1] December 20, 1832. Election speeches in Manchester Reference Library.
[2] Sermon at Charlestown (Ashton), January 6, 1839 (Man. Lib., T 498, 10).
[3] See Oastler's amazing election address in the 1832 election.

I

parliaments, nor poor laws have any place. The Bible is the charter and the Decalogue the law of the land. It is easily conceivable how Stephens and, to a lesser extent, Oastler could become leaders of an armed insurrection against the Poor Law Amendment Act. That Act was conceived as a " law of devils," the work of a Parliament which stood between Throne and Cottage, and which carried on its evil work through commissioners who were as murderous as Pharaoh of old. It was lawful to resist such a law.

If Lord John Russell wanted to know what he (Stephens) thought of the New Poor Law, he would tell him plainly, he thought it was the law of devils . . . if vengeance was to come, let it come : it should be an eye for an eye, a tooth for a tooth, limb for limb, wife for wife, child for child, and blood for blood.[1]

In Lancashire and Yorkshire the eloquence, activity, and fearlessness of Stephens and Oastler raised them to a pitch of popularity and authority such as few men have attained. Their personal influence was immense, and they were rewarded with passionate adulation for their exertions in the popular cause. Lovett was probably thinking of these two eminent demagogues when he penned his bitter lines about the tendency of working people to look up to leaders. Another hostile critic relates of Stephens :

He was utterly careless of other men's opinions and paid little or no regard to the feelings of any but those he wished to command : and these were the working people. Over these he domineered, carrying everything he wished with a high hand : he was obeyed, almost adored, by multitudes, . . . Of personal consequences he was wholly reckless.[2]

Thus did Stephens exemplify in his own person the political supremacy of the preacher. In Ashton and in many of the other small manufacturing towns his word was law. And Oastler's reputation in Yorkshire was no whit less. It was a Wesley-Whitefield crusade again. The appeal was to the same class of people, the methods were the same, only the object was different.

In the hands of these two men Toryism assumed a terrifying aspect. They lashed their followers into a continuous state of fury which finally culminated in threats of insurrection and of incendiarism. They seized without inquiry upon every

[1] Holyoake, *Life of J. R. Stephens*, p. 122.
[2] Place, in Holyoake's *Life*, p. 76.

argument which would help to discredit the New Poor Law and the Commission which supervised its enforcement. Did the Act authorise the segregation of the sexes in the workhouse ? Then it was a beastly Malthusian device, and Stephens could pour out sentimental references to the destruction of peaceful family life, and dilate upon the villainies of " Marcus," to the horror of his hearers. " Marcus " was the pseudonymous author of a ghastly parody of " Malthus on Population," in which various devices for painless infanticide were described. Stephens affected to believe that this absurd pamphlet was the work of the Commissioners or of their myrmidons, and the hoax, if it was such at first, quickly became a serious belief. No abuse, in fact, was bad enough for the " Malthusians," which term itself became the supremely abusive epithet for all enemies of the popular cause.[1]

The agitation spread rapidly. In every town on both sides the Pennine border, committees sprang into existence to carry on the good work. Most of these committees had already seen service in the Factory Act agitation. In fact it may be said that nearly the whole of the Anti-Poor Law campaigners had transferred their energies temporarily from the Factory Movement. In Manchester, R. J. Richardson of Salford, a wordy, pedantic logic-chopper of the worst description, and William Benbow, an old Radical who had been through the desperate days of Hampden Clubs, Spencean propaganda and Peterloo massacre ;[2] in Bury, Matthew Fletcher, a medical man of sorts ; in Ramsbottom, Peter Murray MacDouall, a very young medico destined to be important in the Chartist Movement, became the best-known local leaders. Yorkshire had William Rider and Peter Bussey, the former a journalist with the Northern Star, the latter a beer-house keeper at Bradford. Wherever the opposition was strong, as at Todmorden, it was found impossible to elect the Boards of Guardians or to find officials willing to serve. Riotous proceedings followed the attempts to enforce the law by the introduction of the Registration Act of 1837, for which the

[1] Mackay, History of English Poor Law, 1834–1898, pp. 239–41.
[2] Herr Beer, in his careful research upon Benbow's (Sozialismus, pp. 249–51) career, has apparently overlooked a passage in Hunt's Memoirs (London, 1820–22), vol. iii. pp. 409 et seq., where Benbow of Manchester is mentioned along with Samuel Bamford of Middleton as delegate to a meeting at the " Crown and Anchor," 1817. Bamford, in his Life of a Radical (c. i. p. 8), calls him " William Benbow of Manchester." Hunt, in the Green Bag Plot, 1819, says, " Benbow of the Manchester Hampden Club " was reported by a Government spy to have been manufacturing pikes in 1816. I feel sure that this is William Benbow, the Chartist. See later, p. 138.

unit of administration was the same as that of the Poor Law, the Guardians being also the registration authority. The Bury folk denounced the attempt to introduce the Poor Law *via* the Registration Act as " low cunning and deceit," " illegality and moral turpitude." [1]

Within a few months after the campaign opened the excitement throughout the two shires was already high. It was sufficient at least to attract the attention of radicals and revolutionaries of all kinds. The London Working Men's Association was already feeling its way to establish similar associations amongst the factory population. Much more important, however, was the coming into the North of two men who had hitherto confined their political attention to the capital. These were Augustus Harding Beaumont and Feargus O'Connor.

Beaumont was a youngish man of somewhat superior birth and in well-to-do circumstances. He was a kind of Byron, an aristocrat who threw himself recklessly and probably uselessly into popular revolutionary movements. He was of a wild disposition, uncontrolled temper, and unbalanced intellect. He had seen some stormy doings in France, and had become a figure in London radical circles, where he was on the Dorchester Labourers' Committee. In speech he was brutally candid and vehement to the verge of madness. In fact it was an outburst of this description at a public meeting in January 1838 which carried him off and prevented him from adding to the difficulties of the other Chartist leaders. In 1837 he founded at Newcastle-on-Tyne a paper called the *Northern Liberator*, which was one of the best of the popular newspapers. It took a vehement part in the campaign led by Oastler and Stephens, and in other respects it was noted for its intelligent interest in foreign affairs.

Feargus O'Connor deserves some special reference. He was born in 1794 of an Irish landed family in County Cork. His family had in the preceding generation been closely associated with nationalist and revolutionary movements, and consequently enjoyed no little popularity in the county and elsewhere. Both his father, Roger, and his uncle, Arthur O'Connor had been United Irishmen. Roger had claimed for his family a highly dubious descent from the Kings of Connaught ; Arthur, a more serious and prominent rebel, had been the chief agent in bringing about a French invasion of

Ireland, and was still living in exile in France. The family remained fairly well-to-do, and Feargus lived the rollicking life of a young squireen. He was educated at Trinity College, Dublin, and was called to the Irish bar, but never practised to any extent. Of his life in Ireland O'Connor afterwards gave many fantastic accounts,[1] but there is reason to believe that it was of a somewhat lurid description.[2] In 1832 the joint influence of Daniel O'Connell and his own family procured the election of Feargus for the county of Cork. He entered Parliament as one of O'Connell's " tail." He was perhaps one of the best of a rather second-rate lot.[3] He had courage and readiness in debate and an independence of character which brought him under O'Connell's ban. At the election of 1835 he was again returned, but unseated on the ground that he was not qualified to sit—an objection which was probably as sound in 1832 as in 1835, had O'Connell seen fit to allow it to be brought forward in the earlier year. That interrupted his parliamentary career for twelve years. He settled, somewhat precariously circumstanced, no doubt, in Hammersmith, and became acquainted with English radical movements in which for a year or so he played but an ineffective *rôle*. The growing agitation in the manufacturing districts offered him a better chance of distinguishing himself. He toured the North in August 1836, and made the acquaintance of Stephens and Oastler, and finally followed the example of Beaumont, quitting London and fixing himself in Leeds as the proprietor of the famous *Northern Star*, a weekly radical paper, which first beamed on the popular political world in November 1837.

O'Connor was a big, rather handsome-looking man endowed with great physical strength and animal feelings. He was capable, especially when his mind became disordered, of incredible feats of exertion and endurance, so that as a travelling agitator he was perfectly ubiquitous. No journey was too long to undertake. As an Irishman he dearly loved a " row," and was supremely in his element in such Donnybrook affairs as the Nottingham election riot of 1842. He was well versed in all the arts of popularity, and could be all things to all men. With rough working men he was hail-fellow-well-met, but he could be dignified when it was necessary to make a more serious impression. He was almost irresistible in conversation, with his fine voice, his inexhaustible stock of anecdote, in short,

[1] *National Instructor*, 1850. [2] O'Connell's *Correspondence*, i. 370.
[3] *Ibid*. i. 391, 412, 430.

with his true Irish blarney. These talents were equally displayed from the platform. He had a great bell-like voice, such as was Henry Hunt's chief oratorical asset. In fact he resembled Hunt sufficiently to be regarded by his Manchester admirers as the true wearer of that prophet's mantle. O'Connor could tune his song to suit any ear. In Parliament he was a good House of Commons man and spoke more sensibly than many. To the London artisans he spoke as an experienced politician. In the North, amongst the fustian-jackets and unshorn chins he was the typical demagogue, unloading upon his unsophisticated hearers rigmaroles of absurdity and sedition, flavoured by irresistibly comic similes and anecdotes. He worked on his popular audiences by flattery of the most flagrant character, or by constant references to the sacrifices he had made in the cause of the people. He had a pretty faculty for denunciation. The following is a delightful specimen. He was once hissed by wealthy folk in his audience at Sunderland.

Yes—you—I was just coming to you, when I was describing the materials of which our spurious aristocracy is composed. You gentlemen belong to the big-bellied, little-brained, numskull aristocracy. How dare you hiss me, you contemptible set of platter-faced, amphibious politicians ? . . . Now was it not indecent in you ? Was it not foolish of you ? Was it not ignorant of you to hiss me ? If you interrupt me again, I'll bundle you out of the room.[1]

As a political thinker O'Connor was quite negligible. He was totally without originality in this respect and borrowed all his ideas. James O'Brien, who wrote for the *Star*, was perhaps his chief source of inspiration. He took up the prevalent ideas as he found them and proceeded regularly from the less to the more popular. At first he was advocating the " three points " of Radicalism, then it was Factory Legislation, then the Poor Law, then the Charter. He never originated any movement, probably not even the Land Scheme which was later associated with him. He came into the various agitations and turned them into channels which ran in anything but the direction desired by their originators. His serious speeches were sometimes miracles of incoherence and absurdity, even when he had revised them for the *Northern Star*. One short specimen must suffice here :

I am one of those who from experience has [*sic*] learned that

consideration of foreign interests has been forced upon us by neglect of our domestic resources : and I believe that overgrown taxation for the support of idlers and the unrestricted gambling speculations upon labour, applied to an undefined and unstable system of production without regard to demand, is the great evil under which manual labourers are suffering.[1]

O'Connor's reply to Cobden in the famous debate at Northampton in 1844 [2] may well be studied from this point of view. His inability to follow out an argument became greater with the advance of mental disorder.

In the North of England O'Connor's rise to popular leadership was rapid in the extreme. Within fifteen months from the foundation of the *Northern Star*, he was the universally acknowledged leader in those parts. The apparition of an apparently wealthy newspaper proprietor, of superior education, an ex-member of Parliament, and undoubtedly sincere in his championship of the people's cause, was a welcome one to the leaderless multitudes. Stephens and Oastler were prevented by other duties from assuming complete control, whilst the older trade union leaders, like Doherty, were not sympathetic with so disorganised a movement. O'Connor was further welcomed for the sake of his rebellious ancestry, which lost neither in numbers nor in rebelliousness in his frequent references. In 1838, when O'Connell made his attack upon Trade Unionism, it was remembered in O'Connor's favour that he had been O'Connell's enemy. At the end of the same year the arrest of Stephens removed his most serious rival, who, however, had already been losing ground through the drifting of the Anti-Poor Law agitation into Chartism—a process much encouraged by O'Connor—and through his condemnation of Radicalism, for it was his habit to pose as a Tory and a Royalist.

O'Connor had, in fact, all the instincts and certain of the qualities requisite for domination. Hence his quarrel with O'Connell. He wanted himself to be the O'Connell of the English Radicals, and actually succeeded in reducing the later Chartist leaders to the position of a " tail." He was a man of energy and will, and had some commercial instincts which saved him from the disasters into which cleverer men, like O'Brien, fell. His foundation of the *Northern Star* was a great stroke of business. He took over the funds, to which he himself contributed little or nothing, from a committee, of which

[1] *Northern Star*, April 17, 1839. [2] *Ibid*. August 10, 1844.

the Swedenborgian ex-minister William Hill was chief, and floated the concern very successfully. Hill became editor, and a good editor too, and Joshua Hobson ably assisted as publisher, but the power which " boomed " the paper was O'Connor. He encouraged working men to subscribe by publishing any and every report of any meeting, however insignificant, and simple weavers were delighted to discover that they had " given it to the capitalists in fine style." They saw their names in print and their speeches were praised editorially. The *Star* quickly became an institution, and no public-house was complete without it. It made no pretence at being an " elevating " paper. Like many cheap papers to-day, it gave the public exactly what the public wanted. In fact O'Connor and his men may be regarded as pioneers of cheap journalism. They gave away things for nothing, and sometimes rose to illustrations, especially portraits of Radical heroes. Through the *Star* O'Connor rose to power. He made money by it. He exercised " graft " through it. Chartist leaders became his paid reporters, and his reporters became Chartist leaders. It was Tammany Hall in embryo. The paper could make or unmake reputations, and local leaders went in terror of its censure. Place declared that the *Northern Star* had degraded the whole Radical Press.[1] It was truly the worst and most successful of the Radical papers, a melancholy tribute to the low level of intelligence of its readers. The same explanation will perhaps do for O'Connor's success as well, for the paper was an expanded O'Connor. For a while after its foundation the paper did furnish some ammunition for Radical orators in the articles written by O'Brien. It was the educative effect of O'Brien's leaders that caused O'Connor to style him the " schoolmaster of Chartism." When these ceased the paper sank to a lower level.

For such a man, conceited even to megalomania, ambitious, energetic, to a certain degree disinterested and sincere, an agitator and demagogue to his finger-tips, the North of England presented an ideal field of operations. A great vague mass of desperate, excited, and uneducated labourers was crying out for leaders in the campaign against the new oppression of the Poor Law. Their lack of programme was paralleled by O'Connor's disregard of programmes. He came forth to lead them he knew not whither, and they followed blindly.

At first O'Connor was compelled to play a comparatively

[1] Additional MSS. 27,820, p. 154.

modest part. He was one amongst several leaders almost
equally endowed with powers of denunciatory oratory, and
in the latter months of 1837 and throughout 1838 their fol-
lowers' desire for passionate expression was almost satiated
with the torrents of rhetoric, poured forth from a multitude of
platforms and repeated afresh in the pages of the *Star*. Beau-
mont, O'Brien, O'Connor, Oastler, Stephens, and a host of
lesser men vied with each other in the luridness of their oratory.
The climax in this stage of the movement came in January
1838. On the 1st there was a meeting at Newcastle-on-Tyne
to demand the repeal of the Poor Law Amendment Act.
O'Connor, Stephens, Beaumont, and others were present.
Stephens's peroration was conspicuous even amongst much
sulphurous oratory :

And if this damnable law, which violated all the laws of God,
was continued, and all means of peaceably putting an end to it
had been made in vain, then, in the words of their banner, "For
children and wife we'll war to the knife." If the people who pro-
duce all wealth could not be allowed, according to God's Word, to
have the kindly fruits of the earth which they had, in obedience to
God's Word, raised by the sweat of their brow, then war to the
knife with their enemies, who were the enemies of God. If the
musket and the pistol, the sword, and the pike were of no avail,
let the women take the scissors, the child the pin or needle. If
all failed, then the firebrand—aye, the firebrand—the firebrand, I
repeat. The palace shall be in flames. I pause, my friends. If
the cottage is not permitted to be the abode of man and wife, and
if the smiling infant is to be dragged from a father's arms and a
mother's bosom, it is because these hell-hounds of commissioners
have set up the command of their master the devil, against our
God.[1]

A week later a great meeting was held at Leeds, where
Beaumont, O'Connor, John Taylor, and Sharman Crawford,
M.P., were the speakers. Crawford protested against the un-
bridled language of the three demagogues, whereupon Beau-
mont rose and denounced his critic with such passion that he
fell into some mental derangement, which, coupled with his
foolishness in flinging out of the overheated room on to the
top of the London stage-coach, brought about his death on
January 26, 1838. He was not yet thirty-seven years old.[2]

So month after month the North of England was lashed into
frenzy by these leaders. It is hard to say what would have

[1] *Northern Star*, January 6, 1838.
[2] Additional MSS. 27,821, pp. 14-24.

become of this movement, had it not been swallowed up in Chartism. Probably it would have died away, burned itself out. It was not a revolutionary movement, nor were its leaders revolutionaries. It is true that there were real revolutionaries, like O'Brien, John Taylor, and William Benbow, among them, but their time was not yet come. The true revolutionary does not give way to rhetoric like the example of Stephens above quoted. Mere words will not satisfy him, and we have no evidence that either Stephens, Oastler, or O'Connor was prepared to go beyond mere words. Their business was to protest, which they did thoroughly, and to prevent their own suppression under the six Acts, which they did partially and temporarily. When they found that, as a result of their exertions, the New Poor Act was not enforced, and that they could still harangue their followers unmolested, they were virtually in the position of an army which accomplishes by mobilisation all that a successful campaign would bring, and which, being unwilling to disband without attacking somebody, allows itself to be led anywhere. So the agitation passed into Chartism. It gave up its negative character and acquired a positive programme. It became more organised under the influence of Birmingham and London Radicals. But these Northern Chartists retaining their violent methods and their incendiary leaders, gave that tumultuous aspect to the movement by which it is best known. Fully developed Chartism derives its programme from London, its organisation from Birmingham, its personnel and vehemence from Lancashire and Yorkshire.

CHAPTER VI

THE Birmingham Political Union, which had played so great a part in the Reform movement of 1830–32, declined and dissolved in 1834 after four years' activity. Like other politically minded people, the leaders of this Union awaited quietly the fruits of their labours in the form of measures of social reform. Meanwhile they took full advantage of the trade boom of 1832–36. Even politicians must earn their living, and the leaders of the Political Union were flourishing bankers and manufacturers to whom prosperous trade was not without attractions. During these years the Reformed Parliament was energetically at work and gave forth the result of its labours in the Poor Law Amendment Act and the Municipal Reform Act of 1834–35. Good trade, enormous business with the United States, and super-luxuriant harvests diverted public attention from politics, and no doubt the reaction was wholesome after the excitement of the Reform Bill campaign. The militant Owenism, which had largely contributed to the downfall of the Birmingham Union in 1833–34, passed away, to all appearances, as quickly as it had arisen. In 1836, however, came the first indications of an economic collapse, heralded by astounding events in the United States. As the year wore on the magnitude of the collapse grew, and Birmingham trade began to suffer severely. Distress and unemployment increased to an unparalleled extent. The austerity of the New Poor Law now became apparent, and all the ugly symptoms of social unrest made their appearance.

The leaders of the old Union, many of whom were now members of the new Corporation of the town, felt it incumbent upon them to take measures to ameliorate the sad state of

many of their fellow-townsmen and former faithful followers, A Reform Association was set up in 1836 with this object. It quickly developed into something more. Instead of seeking merely to relieve the local distress, the leaders determined to devise a remedy for the general evil. It was not far to seek. Thomas Attwood (1783–1856), the Birmingham banker, had long possessed an infallible plan, and his colleagues easily became true believers. Here is his diagnosis and his remedy. The cause of distress is the dearness of food and the dearness of money. The landlords pass laws to make food dear and the money lords pass laws to make money dear. The result is great distress which drives people to the workhouse. But the relentless cruelty of the dominant classes pursues them here also and converts their place of refuge into a horrible dungeon. To crown all, the tyrants have established a Police Force to repress all protests and to nip sedition in the bud.[1] What was the remedy ? Obviously the repeal of the Corn Laws and the Money Laws, but especially the latter. Peel's Act of 1819, which authorised the return to gold payments and the " restriction " of the currency, must be repealed, and proper measures must be taken to regulate the currency according to the state of trade. The great panacea was the " expansion " of the currency by the issue of more paper money. As blood to the body so currency to trade : more blood better health. Paper money would increase business, destroy unemployment, increase wages, decrease debts, in fact make everybody happy.

Being a banker Attwood could pose as an authority, and he had long gathered round him a body of fervent disciples who had fought the glorious campaign of 1830–32 under his leadership. Among these were R. K. Douglas, who urged his views in the *Birmingham Journal* ; T. C. Salt, a lamp manufacturer [2] employing one hundred men, and a man of considerable influence amongst working people ; Benjamin Hadley, an alderman, and a churchwarden of the Parish Church ; George Edmonds, a solicitor, a guardian of the poor, and a convinced Radical ; George Frederick Muntz, who made a fortune by the manufacture of a metallic compound known as "Muntz metal"; P. H. Muntz, also a man of finance ; and Joshua Scholefield, who with Attwood himself represented the borough of Birmingham in Parliament. The working-class wing of the party was led by John Collins, a shoemaker

[1] Additional MSS. 27,819, p. 75. [2] *Charter*, March 3, 1839, p. 81.

and a Sunday School teacher, an honest character, held in very high respect, and an orator of some talent.

Early in 1837[1] this group began to agitate the currency theory in and out of Parliament. As the distress in the town grew, so did the activity of the old Unionists, in their capacity of the Birmingham Reform Association. In April 1837 they decided to enlist working-class support for their movement and to call upon the ancient glories of 1830-32. On the 18th they passed a resolution, restoring the name Birmingham Political Union.[2] The formal revival took place on May 23, and a few days later the Union, which already numbered over 5000 members, published its first address to the public, asking for support in its endeavours to find a remedy for the existing distress.[3]

This, as it later appeared, was a fatal step. The revival of the Union was more than the revival of a name : it was the resurrection of a programme whose realisation was compatible with the Currency Scheme only in the sanguine minds of the followers of Attwood, and even they were not unanimous in their optimism. On June 19 a great meeting of the Union decided upon a programme of Parliamentary Reform which included Household Suffrage, Vote by Ballot, Triennial Parliaments, Payment of Members of Parliament, and the abolition of the Property Qualification.[4] The Attwoodites had thus added to their dubious measure of Currency Reform, which was scarcely calculated to awaken the enthusiasm of the working classes or of any other class except that of debtors who would like to avoid payment, a political reform in which they were only secondarily interested. To carry one measure of doubtful value, they proposed to agitate for five others which, though much more desirable in themselves, were calculated to arouse the very strongest resistance. Supposing that their influence in Birmingham was due to the manifest advantages of Currency Reform, they continued to keep that measure as the first plank of their platform. It is doubtful whether the working classes of Birmingham were really concerned about currency at all, but they were concerned about the vote.[5] The position of the

[1] Additional MSS. 27,819, p. 75.
[2] Ibid. 27,819. pp. 79-84.
[3] Ibid. 27,819. p. 94. [4] Ibid. 27,819, p. 99.
[5] This is demonstrated in my opinion by the ease with which O'Connor was able to undermine the influence of the Attwood group in December 1838. Place was hostile to the Currency Scheme, and ridiculed the Attwoodites mercilessly. He charges them with intending to smuggle the Currency Scheme into the Chartist programme without obtaining the assent of the Chartists or even of the working men of Birmingham (ibid. pp. 134-8).

Attwoodites was thus false, and its weakness was quickly exposed when they turned their programme over to the working classes as a whole. The Currency plan was quietly shelved and with it the Birmingham Political Union.

The split between the working-class members of the Union and their wealthy leaders, which developed gradually during 1838, was at first hidden under the show of general harmony. The great meeting of June 19, 1837, at which fifty thousand persons are said to have been present, decided to send petitions to the Premier asking for immediate measures of relief.[1] The deputation urged its Currency Scheme, suggested action by Order in Council as being more expeditious than by bill, and came away satisfied that Melbourne was a convert. Attwood was re-elected to Parliament, on the monetary question, as he thought. The activities of the Union were extended into the neighbourhood of Birmingham and societies were formed to spread the Attwood gospel.[2] In this connection Place made the famous sally, noted by Mr. Graham Wallas. " Adhesion meant submission to Mr. Attwood and his absurd currency proposal, which few understood and all who did condemned." The London Working Men's Association, which was acting demurely in alliance with the Radical group in the Commons, made offer of alliance with the Birmingham Union in the cause of Universal Suffrage. The offer was not publicly accepted, as the communication came under the Corresponding Societies' Acts, and was therefore unlawful.[3]

In the autumn when Parliament reassembled the currency campaign began afresh but culminated, it is to be feared, in a total defeat on November 2, 1837. A deputation led by Attwood harangued Melbourne and Spring Rice, the Chancellor of the Exchequer, for two hours, but unfortunately for their success the speakers had the most diverse opinions upon the remedy to be adopted, and as all the members of the deputation spoke, it is not surprising to know that Melbourne was not prepared to act upon such discordant advice.[4] The deputation went back to Birmingham to report progress. The difference of opinion widened. Some were for continuing the currency campaign ; others under P. H. Muntz, Hadley, and Salt were

[1] Additional MSS. 27,819, p. 111.
[2] *Ibid.* 27,819, pp. 114-16. Place suggests that the Currency notion was thrust on them.
[3] Perhaps the Birmingham people were not sorry, as they did not want equal alliance but preponderant influence.
[4] Additional MSS. 27,819, pp. 127 *et seq.* ; on the authority of the *Birmingham Journal.*

for shelving it in favour of Universal Suffrage. On November 7 P. H. Muntz brought forward a resolution to that effect, and carried it in spite of opposition and some uproar.[1] This decision saved the situation and the Union for the time being by securing a wider working-class support for it, but it piled up difficulties for the future. A movement in favour of Universal Suffrage could not long remain tied to the apron-strings of the Birmingham Union, as was fondly hoped, and the currency question still remained to be solved. Douglas compromised by inserting an Attwoodite clause into the National Petition of 1838, which clause was contumeliously rejected by the Convention in 1839.

Meanwhile the resolution of November 7 had unexpectedly large results. Lord John Russell had roused the ire of Radicals by his " finality " declaration. On the 28th Douglas carried a resolution of protest in the Council of the Union, and on December 7 the Union called upon all Radicals to unite in an attempt to procure the reform which Lord John had declared impossible. This was an appeal to Cæsar with a vengeance. The Radicals of Great Britain were mainly amongst the working classes, and in rousing them to political action the Birmingham Union had stirred up a giant which was destined to turn and rend it. The first response to the appeal was made by the London Working Men's Association, and these two organisations began to agitate on a much larger scale. Political excitement was growing. The accession of Queen Victoria was expected to have great and good things in store for the working people. Meanwhile distress and unemployment increased. The population of the North of England began to become restive. Stephens and Oastler were active and had recently acquired an accession of agitating violence in O'Connor and the *Northern Star*, and in A. H. Beaumont and the *Northern Liberator*. It was a bad time to appeal to working-class feelings. The better sort of working people were angry over their 1832 disappointment, dismayed by their Trade Union failure of 1834, and saw in the prosecution of the Glasgow Cotton Spinners a declaration of the Government's hostility to their legitimate aspirations ; whilst the poorer operatives in the domestic industries were horrified at the deterrent Poor Law Administration. Fiery sentimentalists, like Oastler and Stephens, found it easy to rouse such a population to fury. Even in normal times it was an unruly people. From 1830 onwards order was

[1] Additional MSS. 27,819, pp. 145-8.

only maintained in Manchester by military force.[1] It was to this stormy ocean that Attwood and his friends proposed to entrust their frail currency bark. An early shipwreck awaited it.

The Birmingham Union now entered upon a dazzling phase of activity. Its leaders fancied themselves as victorious generals, once more leading the legions of industrious patriots into the legislative citadel, as they fondly supposed had been the case in 1831–32. They would set up their standard in the Midlands and call all working men into it. They anticipated that their massed battalions would overawe Melbourne as easily as Wellington or Lyndhurst. They were moral force men, but they fancied that moral force meant only a display of the potentialities of physical force. Edmonds spoke darkly about the substantial thing behind moral force which produced the impression upon rulers.[2] Attwood, carried away by excitement and disappointment, on December 19, 1837, denounced the Radicals in the House for their unspeakable dulness in remaining unconvinced by his Currency eloquence, and voted them a dogged, stupid, obstinate set of fellows from whom the people had really nothing good to expect. He was for extreme measures and substituted Universal Suffrage for Household Suffrage in his political creed. He would get two million followers—a force to which Government must bow.[3]

This speech and its programme provided the raw material for the National Petition, as it came to be called. The meeting of June 19 had decided upon a petition in favour of Radical reform, and the document itself was drawn up by R. K. Douglas. The Petition in its final shape demanded Repeal of Peel's Act of 1819 and of the Corn Laws; and the amended political reforms mentioned by Attwood in December.

Agitation began in the immediate neighbourhood of Birmingham and was pursued for some three months. In March 1838, a great step forward was taken, and it was decided to send a missionary to Glasgow.[4] That town, in common with most of the other industrial centres, was labouring under severe depression. In the immediate neighbourhood there were thousands of handloom weavers whose distress was chronic during normal times and acute during the depression.

[1] J. P. Kay, *Working Classes in Manchester*, 1832.
[2] Additional MSS. 27,819, p. 149.
[3] *Ibid.* 27,819, p. 162. [4] *Ibid.* 27,820, p. 68.

The operatives in the factories had been terrified by the prosecution of their leaders. In general there was plenty of combustible material for an agitator. The Birmingham Union sent Collins as their emissary. His business was to bring over the discontented of Glasgow to the Attwoodite standard, and to persuade them to organise an agitation on the same lines as at Birmingham. Collins did his work effectively, and his enthusiastic reports gladdened the hearts of the Birmingham leaders, who, we are assured by an unfriendly witness, badly needed the stimulus.[1] From this time onward the monster petition idea gathered support and substance. At Birmingham there was jubilation to excess. Men began to think in millions, but while Douglas moderately hoped for two million supporters, Salt was admonished by P. H. Muntz to expect six millions. So confident were the leaders of ultimate success that they already began to talk of coercing Government by " ulterior measures," [2] assuming already that the millions who were to sign the Petition would be effective political warriors instead of what they for the most part were — non-combatants who hoped the Birmingham people would win. This assumption that all sympathisers are as zealous and determined as their leaders, is common to all enthusiasts, and explains much that seems the height of folly in the subsequent developments of the movement. But the confusion of signatories and supporters was common to all Chartists for a long time.

Collins acted the part of an Attwoodite John the Baptist with great efficiency, and in May the time was ripe for the Messiah himself to appear in Glasgow. On April 24 Collins's mission culminated in a conference of trades at Glasgow which resolved to call a monster meeting on May 21, and to invite a deputation from Birmingham.[3] This was duly reported by Collins to headquarters, and the Birmingham leaders made an enthusiastic response. At a monster meeting on May 14 a deputation was appointed, consisting of Attwood, Joshua Scholefield, P. H. Muntz, Hadley, Edmonds, Salt, and Douglas. To this meeting was presented a draft petition which was to be sent to Glasgow for adoption there. This was the first public appearance of the National Petition.[4]

The Glasgow Demonstration was an immense success. It was believed that one hundred and fifty thousand Radicals,

[1] Additional MSS. 27,820, p. 76. [2] Ibid. 27,820, p. 73.
[3] Ibid. 27,820, p. 78. [4] Ibid. 27,820, pp. 82, 89.

K

marshalled under thirty-eight banners, took part. Besides Attwood and his friends, there were other speakers, including James M'Nish, the hero of the Cotton Spinners' trial, and two delegates, Murphy and Dr. Wade, from the London Working Men's Association. These last named presented to the meeting the " People's Charter." [1]

This meeting, therefore, brought the beginning of an organised " national " movement a step nearer. It still remained to cultivate the other fields of discontent in the North of England and in Wales. Glasgow, Birmingham, and London were now apparently brought into line. The Birmingham Petition and the London Charter were both made public. What was equally important, plans for future agitation and organisation were suggested. Attwood made two remarkable propositions— the summoning of a National Convention to concentrate the Radical strength, and a General Strike of all the industries— masters and men together, in order to humble the common enemy, the Government. It was to be a modern secession to the Sacred Mount, peaceful, complete, and effective. Unfortunately for Attwood, he had been long since forestalled in the idea of a General Strike, and by men of less peaceable natures.

From Glasgow the deputation went on a tour in Scotland as far north as Perth, visiting Edinburgh, Kilmarnock, Stirling, Dundee, Cupar, Dunfermline, Elderslie (Renfrew), accompanied occasionally by Dr. Wade.[2] It returned in great triumph to Birmingham, leaving Collins to work his way slowly through the North of England where he made acquaintance with J. R. Stephens, whose methods and language horrified him.[3] He popularised the National Petition in the industrial districts of Lancashire and Yorkshire some time before the People's Charter obtained a footing there. Meetings began to be held in June and July[4] in support of the Petition, whilst the first mention in the *Northern Star* of the Charter is on July 16 in connection with a meeting at Dewsbury. The idea of a Convention took hold of popular imagination. On July 17 the Birmingham Union held a meeting at which the plan of a Convention took practical form, and the results of its deliberations were made public. It was to be called the General Convention of the Industrious Classes, and was to consist of

[1] Additional MSS. 27,820, pp. 109-119.
[2] *Northern Star*, June 2, 1838. [3] Additional MSS. 27,820, p. 141.
[4] *E.g.* Leeds, June 5 ; Oldham, July 1.

not more than forty-nine members. No delegate was to be elected as the representative of any organised body, or by any organisation, but elections must be made in meetings called with every legal formality and open to the public at large. These precautions were necessary in view of the laws against Corresponding Societies. The Birmingham people would lead the way at a meeting on August 6, at which their delegates would be elected,[1] and the People's Charter and National Petition adopted.

The meeting on August 6, 1838, at Newhall Hill is the official beginning of the Chartist Movement, that is, of the union of all working-class Radicals in one movement. Besides the Birmingham leaders, there were present Feargus O'Connor and R. J. Richardson, representing Yorkshire and Lancashire respectively; Wade, Henry Vincent, and Henry Hetherington, representing the London Working Men's Association; Purdie and Moir, representing Scotland. A crowd of 200,000 people lined the side of the hill at the foot of which the hustings were placed. To those on the platform the crowd presented a wonderful sight, and the enthusiasm generated by the presence of so vast an assembly was immense. Attwood was the principal figure. It was perhaps the climax of his Radical career, and he improved the occasion with a speech which lasted, on a moderate computation, two and a quarter hours, in which he reviewed the whole case against the Government and looked forward to a sure and speedy victory. The ultimate goal was the abolition of the Corn Laws, the Money Laws, and the Poor Law of 1834, and a reform of the Factory System. P. H. Muntz appealed for an abandonment of all sectional movements in favour of Petition and Charter. These were enthusiastically adopted, and the meeting proceeded to an election of delegates to the Convention. No less than eight were appointed, all the Union leaders being elected except Attwood, who, as Member of Parliament, would help the cause there. These delegates were authorised to take charge of the arrangements for the summoning of the Convention and the circulation of the Petition.

Thus a great general working-class movement began its career. For the next three years the forces of working-class discontent, of popular aspirations and enthusiasms were concentrated as they had never been concentrated before under the standards of the National Petition and the People's Charter.

[1] *Northern Star*, August 4, 1838.

The Attwoodites were intoxicated with the unexpectedly large success of their schemes and contemplated with satisfaction their future progress towards a sure and certain victory. But the Birmingham Union died in giving birth to the Chartist Movement.

For a time all went well. The election of delegates was carried out in all parts of the country during September and the following months.[1] Nevertheless from this time forward the Birmingham Union lost hold upon the Movement, and when the Convention met leadership was already gone from their delegates. The Union itself began to collapse and it was the Convention which dealt the final blow.

This downfall was due to a combination of forces working both within and without the Union. In the first place the Birmingham Political Union was an anachronism, a resurrection from the days before militant Owenism had inculcated the idea of a class war. It was a body whose rank and file were working people and whose leaders were middle-class men. As such it was opposed to the prevailing tendency amongst working people. The London Working Men's Association was founded with the idea of excluding any but *bona fide* artisans, and though it in practice was prepared to co-operate with middle-class people, it made no concealment of the fact that it held such co-operation to imply no subordination. The London working men would accept no terms but equal alliance. They had drunk deep of the liquor of O'Brienism and, in the somewhat limited social philosophy at their disposal, identified the middle class with the capitalist employing class, whose elimination was one of the principal articles of their creed. The working men of the North, who had suffered more personally from the evils they denounced, held the same views, but in a cruder and more violent form than did the skilled artisans of London. Neither section, however, believed that the interests of middle class and working class could possibly be identical, or that a middle-class leader was to be trusted. The mere fact that a middle-class leader was zealous for a particular object was a guarantee that that object was not one for which working men should strive.

There are early hints that the London Working Men's Association was not inclined to allow the Birmingham leaders or their programme to take first place in the national move-

[1] Place, Additional MSS. 27,820, gives notices of thirty-eight meetings between August 6 and December 18, of which fourteen elected delegates.

ment. The presence of Dr. Wade at Glasgow, Edinburgh, and
Birmingham was very significant. Wade had been a member
of the old Birmingham Union in 1832, and had created a storm
by advocating the formation of a Working Men's Union on
the ground that middle-class leadership could not possibly
be satisfactory to working men. Middle-class people would
invariably be attracted by speculative bubble schemes which
would depreciate labour.[1] He used the language of militant
Owenism of which he, Vicar of Warwick as he was, was a prop
and pillar. He was in fact a Christian Socialist of an early
generation and a pronounced type. He was active in various
purely Owenite societies in London and a member of the semi-
Owenite National Union of the Working-Classes. For his
temerity the Birmingham Union proposed to exclude him,
and it is probable that the old leaders of the new Union were
not pleased to be haunted by his presence and his continual
thrusting forward of the Charter.[2] The London W.M.A. had
other reasons for suspecting the Attwoodites besides class
prejudice. They did not like the Currency Scheme. O'Brien,
who borrowed some currency lore from Attwood, thought his
plans unsound and said so.

The Currency Scheme was in truth a great source of weak-
ness. The Attwoodites had obtained popular support by
promising immediate benefit for both master and man from
the adoption of their scheme. When the political programme
was added, a body of supporters was obtained who were far more
concerned for the vote than for paper money. Place indeed
did not hesitate to ascribe the collapse, not only of the Bir-
mingham Union, but also of the whole movement, to the Cur-
rency Scheme. Attwood and his lieutenants, he declared,
were not at all eager for the Petition and Charter, and started
the movement for Universal Suffrage as a means of intimidat-
ing Government to accept the Currency notion. Hence they
were always ready to let it drop. This conduct played into the
hands of the violent leaders.[3] Place further maintained that
the Attwoodites themselves considered with some misgiving the
possibility that a Parliament, elected by Universal Suffrage,
might not care to legislate about the Currency, either because
the question was not understood or because a remedy could not
be devised to suit all opinions.[4] This is certainly a damaging

[1] Additional MSS. 27,796, pp. 333-4.
[2] Attwood said later that he never saw the Charter till the meeting of
August 6, and had no time to examine it or he would not have supported it.
[3] Additional MSS. 27,820, p. 2. [4] Ibid. 27,820, p. 41.

statement, for if Attwood and Douglas felt that the nation as a whole would reject their panacea, it is easily conceivable that their enthusiasm for Radical reform would evaporate. But Place adds to his indictment. He declares that, having come to the conclusion that the Currency Scheme would not meet with universal approval or be universally comprehended, they smuggled it into the National Petition, hoping that their "tacking" would be unnoticed in the popular enthusiasm.[1] With all respect to Place as a shrewd politician and a contemporary observer, it must be confessed that he proves too much. He later on praises Douglas for his caution and moderation,[2] and it is permissible to hope, therefore, that Douglas was not such a reckless trickster as this sort of conduct implies. Furthermore, there was a sufficient fund of currency ideas in popular circles to make a project of currency reform seem less criminally absurd than Place thought it was.[3] The currency question was not *res judicata* by any means, and even Peel's currency theories could be called into question by reputable authority in the next generation.

Apart from class hatred and currency schemes, the Birmingham Union incurred the hostility of many of its new disciples by its moderation. It was this more than anything else that ruined the Union and eliminated it from the movement. When Attwood and his colleagues transformed a more or less local and harmless currency agitation into a national political movement, they found that they were not the only agitators in the field, and that their reputation was as nothing amongst those whom they aspired to lead, compared with that of mob-orators like Stephens, Vincent, or O'Connor. Hence from the very beginning they figured as generals of brigade rather than as commanders-in-chief. Throughout the whole Chartist array there was no commander-in-chief—no one with the authority of a Cobden or the capacity for organisation of a George Wilson.

The immediate cause of rupture between the northern extremists and the Birmingham Union, which occurred in November-December 1838, was the fiery campaign of J. R. Stephens, to whom the People's Charter seemed to give renewed fire and eloquence. From the beginning of September Chartist

1 Additional MSS. 27,820, pp. 132-8.
2 *Ibid.* 27,820, p. 274.
3 Cobbett had agitated the question: see also 1834, *Comm. on Hand-loom Weavers*, qq. 973 *et seq.* 5560-66. This committee made some vague statements on the question in the report, p. xv.

meetings, often by torchlight,[1] began to be held in Lancashire and Yorkshire, at which Stephens was a regular speaker. On October 29 there were violent speeches at a torchlight meeting at Bolton, where delegates were elected to the Convention. On the following day Douglas made a grave speech on the subject to the Union. Salt specifically denounced O'Connor, who had talked moral force to Salt and violence in Lancashire.[2] This was, in fact, O'Connor's practice. He varied his tone according to his audience, like a true demagogue. Salt thought O'Connor was playing them false.

In any case O'Connor aided considerably. On September 8 the *Northern Star* published an article headed : " The National Guards of Paris have petitioned for an Extension of the Suffrage, and they have done it with Arms in their hands." On October 18 he was present at the great meeting at Peep Green, Bradford, and made vaguely suggestive remarks upon tyrannicides whilst his lieutenant, Bussey, advised the audience to get rifles.[3]

O'Connor attended the meeting at Preston on November 5 at which Marsden was elected delegate. He made a speech in which he declared that the power of kings was only maintained by " physical force." The Government would not dare to use physical force against them as at Peterloo because they (the Government) knew that the wadding of the first discharge would set fire to Preston. That was not threatening language but soothing language, intended to prevent the Whigs from firing the first shot. At the same meeting James Whittle referred to the authors of the New Poor Law in terms of Psalm 109. Technically O'Connor's speech was not an appeal to violence, but it was calculated to familiarise his audience with suggestions of an unpeaceable character. On the following day at Manchester he said he was for peace, " but if peace giveth not law, then I am for war to the knife." O'Connor seldom made direct and unqualified declarations.[4] The next day at Manchester O'Connor pooh-poohed Douglas's idea that three years' agitation would be required to secure the Charter. Why wait three years ? if the Charter was good it was good in 1839 as in 1842. *Would delay serve their cause ? Would not the agitation evaporate ?* [5]

Meanwhile the agitation waxed fast and furious. Stephens made a speech at Norwich so violent that the *Northern Star*

1 *E.g.* at Bolton, Bradford, Rochdale, Oldham, Bury.
2 Additional MSS. 27,820, pp. 272-4. *Northern Star*, November 17, 1838. 3 Additional MSS. 27,820, p. 260.
4 *Ibid.* 27,820, p. 287. 5 *Ibid.* 27,820, p. 292.

expurgated it.[1] Douglas obtained an account and declared to the Birmingham Union that something must be done as Stephens was elected a delegate to the Convention. The Birmingham people were beginning to regret their precipitancy in admitting such roaring lions into peaceful currency pastures.

At the weekly meeting of the Union on November 13 there was an unexpected visitor. It was O'Connor, who, following his usual custom, entered when proceedings were in full swing in order to concentrate all attention upon himself.[2] He had come to defend himself against the calumnies of Salt and Douglas. He had been charged with traitorously preaching physical force, and had gone so far as to declare that on September 29, 1839, all moral agitation must come to an end and other measures be taken, if the Charter were not by that time obtained. O'Connor, who made a very ingenious defence, had had some legal training. He pointed out, amongst other things, that it was quite necessary to fix a limit to peaceful agitation because the people would become impatient and the agitation would gradually die away.[3] This was probably a true statement of the attitude of the Lancashire and Yorkshire Chartists at least, but it augured badly for the soundness of the Chartist cause and the discipline of its zealots. O'Connor scored, too, by pointing out that the Birmingham leaders had sinned also in the matter of violent language. That was true. The real difference between Birmingham and the northern Chartists was that the Birmingham leaders regarded a display of numbers—of " physical force "—as a useful background to lend reality to their views, but the northern people looked upon physical force as the whole picture.

A week later O'Connor appeared again before the Union, evoking cheers and sympathy by pretending to be on his trial before the honest working men of Birmingham. Meanwhile Stephens was breathing fire and slaughter with undiminished vigour. On November 12 he attended a meeting at Wigan and denounced the London and Birmingham leaders as old women.[4] He probably felt, what many of his followers later on openly said, that the Charter-Petition agitation would smother the Anti-Poor Law Movement in which he was so

[1] Additional MSS. 27,820, p. 295.
[2] O'Connor was uninvited. His habit of intruding where he was not required was a cause of immense friction, as he was seldom content to be passive, and sometimes diverted meetings to purposes for which they were never intended.
[3] Additional MSS. 27,820, p. 304. *Northern Star*, November 17.
[4] *Northern Star*, November 17.

absorbed. In view of this language, the meeting of November 20 at Birmingham was exciting and stormy. The Union was divided between Salt and O'Connor. Muntz was hissed. The meeting was adjourned.[1] The attack on O'Connor was renewed in the *Birmingham Journal* of November 24, in which Douglas roundly declared that, whatever O'Connor's party said and professed, their real programme was ILLEGALITY, DISORDER, and CIVIL WAR.[2]

There was a final conference on November 28, O'Connor again attending. The meeting was awaited with much misgiving. Apparently the Birmingham leaders were not unanimous as to the course to be pursued with respect to their unruly ally. Some were for repudiating him, which was perhaps the most honourable course. Others were for conciliation, thinking that a repudiation of O'Connor would remove the northern counties, and perhaps Scotland too, from the agitation. At the same time O'Connor, seeing the wide possibilities before a great national agitation, and knowing how popular the Petition-Charter programme was becoming, was prepared to make concessions to the nominal leaders of the movement. The result was that the meeting passed off with a restoration of harmony, both sides giving the soft answers that turn away wrath. Douglas and Salt spoke with absurd adulation of the Irish demagogue. Salt apologised. O'Connor was gracious. George Edmonds, who wanted to get rid of O'Connor at any price, tried to pin him down to an explicit repudiation of force, but O'Connor shuffled and the meeting was in his favour. Collins suggested a middle course which did not bind O'Connor to a repudiation of Stephens and all his ways. This was accepted and the meeting broke up, the Birmingham leaders fancying that they had at last muzzled their inconvenient rival. But the impression left by a study of these proceedings is rather that O'Connor had undermined the authority of the leaders in their own Union, especially amongst the working people over whom no one could so easily acquire influence as he. He no doubt relied upon his blarneying capacity when he invited himself into the Union meeting on November 6. If he did, his confidence was justified by the outcome.[3]

Nevertheless O'Connor's conduct was for a time distinctly moderated after this event. At Bury he addressed a torchlight meeting on December 8. This was " the most remark-

able " of the torchlight meetings. It was held in defiance
of Fielden's warning that the Government was prepared to
prosecute the conveners of and participators in such gatherings.
The speeches, O'Connor's included, were apparently milder
than usual. A week later he repudiated physical force in the
Northern Star. He did not prevent the insertion in the same
paper of a letter from O'Connell denouncing himself, Oastler,
and Stephens by name. It seemed as if harmony were
completely restored, but it was a very delusive peace which
reigned, and equally short-lived.

NOTE ON ATTWOOD'S CURRENCY THEORIES

That these were really deserving of the ridicule heaped upon
them by Place will be evident to the attentive reader of the reprint
of Attwood's article of 1822 in the *Birmingham Journal* of May 5,
1832. The source of all social evils was the resumption of cash
payments in 1819, which made debts, contracted previous to 1819
in an inflated currency, payable in a restricted currency, and thus
enhanced the burdens of debtors. The argument runs thus:

In 1791 Currency and Prices were in a normal state. From
thence till 1797 the Currency became depreciated and prices rose
owing to the creation of £5 Bank of England notes, the extension
of other note issues, and the growing burden of taxes and loans
By 1797 currency was depreciated 50 per cent. Not only paper
but gold too was depreciated, the latter, as Cobbett showed, by
sympathy. From 1797 onwards, by reason of the Bank Restriction,
there was a further rise in the prices of property and labour of from
50 to 70 per cent, making 100 per cent or 120 per cent in all. Thus
the loans and obligations contracted between 1797 and 1819 were
contracted in a currency which possessed only one half the value
it had before the war. This applied both to public and private
contracts, to industrial debts as well as to the rents of farms.
Furthermore the high taxation during the war was only possible
through the inflation of the currency, since the high prices reduced
the actual value absorbed by the taxation (*e.g.* a tax of 40s. was
discharged by goods worth only 20s.).

Public obligations contracted during the war amounted to 1247
millions, private obligations to 1245 millions, making roughly
2500 millions. Government by removing the Bank Restriction
practically doubled these obligations, making them 5000 millions.
This measure was the measure of a body of creditors; hence their
eagerness to double the burden of their debtors. Had Parliament
been a body of debtors it would have halved the burden of debtors.
A body composed of both would do what reason and justice required
—*coin ten old mint shillings into one pound sterling*. Even this
measure would leave prices double those of 1791.

In this treatise confusion and error are so confounded as to make it difficult to know which fallacy to handle first. One or two errors of mathematics may be tackled first. He says before 1797 the *currency was depreciated* 50 per cent. Later on he says this 50 per cent *rise of prices* was increased another 50 or 70 per cent. A 50 per cent depreciation of currency is not the same as a 50 per cent rise of prices which he assumes is the case, but a 100 per cent rise. This error curiously enough is avoided a few lines further on, where he makes a rise of 100 per cent or 120 per cent in prices equivalent to a depreciation of currency by one half (unless, of course, this statement is a lucky shot which was really aimed at the wrong target but hit the right one).

Finally the highest percentage of depreciation of paper as expressed in gold between 1797 and 1819 was not more than 25 per cent, equivalent to a rise in prices of goods as expressed in paper money of $33\frac{1}{3}$ per cent. One may feel sure that for the most part contracts would be made with the requisite reservations on this point, and hardship would be more nominal than real on the return to cash payments.

The soundness of Attwood's economics may be deduced from the fact that he assumed that it was a matter of no consequence whether prices rose through development of trade—*i.e.* of demand—or through depreciation of the currency. It was a distinction without a difference, he thought.

CHAPTER VII

(1838–1839)

THERE is something mysterious about the facility with which the Anti-Poor Law Agitation passed over into Chartism, with whose objects it had apparently nothing in common. During the summer of 1838, meetings, called to protest against the Poor Law Amendment Act, found themselves listening to speeches in favour of the Charter and assenting to resolutions in support of the National Petition. Some explanations may be hazarded. In the first place, the Anti-Poor Law Agitation had come to a crisis. It had prevented the Act from being enforced, with the result that, during the greater part of the period of trade depression (1836–42), out-relief was paid as usual. Thus the leaders had to face the question—whether to be content with this achievement or to go on agitating until the Act was repealed. The latter alternative, in view of Stephens's exhortations, might involve armed insurrection, unless—here was the crux of the matter—a *national* agitation, on the lines suggested by Birmingham and London, succeeded in putting political power into the hands of the people. Then the peaceful repeal of the Act would be easy. This reasoning will explain the eagerness of the northern leaders to justify to the Chartist Convention the possession of arms, and their immediate resort to arms and drilling as soon as the National Petition was rejected. The Northerners probably looked upon the Birmingham and London men as potential reinforcements in the event of extreme action. The Birmingham proposals for joint action would be welcome, both from this point of view and from the existing lack of organisation in the North—a defect which would be remedied by the creation of a central body like the proposed Convention. One last point may be

116

hinted at. In November 1838 O'Connor at a meeting at Manchester said it was necessary to put a period to agitation, lest the enthusiasm should evaporate.[1] Perhaps we shall not be wrong in assuming that enthusiasm for Poor Law repeal had already begun to evaporate, and to be replaced by discontent of another description.

However that may be, the growth of distress and privation during the year 1838 tended inevitably to weld the agitations together. Scotland was agitated by the prosecution of the Glasgow cotton-spinners, whose fate recalled the immortal Dorchester Labourers of '34. In South Wales, where the mining districts presented an unequalled field for agitation, the eloquence of Henry Vincent, backed by John Frost, a tradesman of Newport and a J.P. to boot, had an enormous effect. Vincent explained to the ignorant and half-barbarous miners how that they were despoiled of a large proportion of the wages, which they earned at such risk to themselves, for the purpose of supporting in idleness and luxury a degraded and despotic aristocracy. This explanation of the long familiar evils of truck and mining royalties naturally raised the Welshmen to an incredible pitch of indignation. It was the sole burden of Vincent's oratory, but, as a well-known authority has said,[2] repetition of an assertion without attempt at proof or demonstration is the one essential of mob-oratory, and Vincent possessed a faculty of infinite variation upon one theme. South Wales was also to have, in 1843, its own peculiar form of rebelliousness in the curious " Rebecca riots," directed mainly against the payment of road tolls. Men, dressed as women, obeying the orders of a mysterious " mother Rebecca," smashed toll-bars and defied discovery. It was alleged that a lawyer, Hugh Williams of Carmarthen, was the instigator. He passed, like all other local agitators, into the Chartist ranks.

The Charter was put forward in May, and the Petition in August 1838. The former was distributed throughout the Working Men's Associations, and the latter was formally published at the great Birmingham meeting of August 6.[3] From this moment the excitement began to rise to fever heat. At scores of meetings the Petition and Charter were adopted with immense enthusiasm. This was especially the case in the North. Everybody was carried away by the fire and fervour

[1] Additional MSS. 27,820, p. 292. [2] Le Bon.
[3] Its terms had already been made public two months before.

of the movement. The speeches became more and more inflammable and exulting. It is from this period that the gems of Stephens and O'Connor are derived. Attwood was in the seventh heaven, and even the less enthusiastic leaders of the London Working Men's Association began to imagine that the day of redemption was at last about to dawn. All the leaders were, in fact, overjoyed at the amazing response to their propaganda and allowed themselves the wildest prophecies as to future successes. Douglas's assurance that they would achieve success in three years was regarded as insane caution. Enthusiasm centred mainly in the election of the Convention from which the most extravagant results were expected.

The spirit in which the Northerners approached the crisis may be inferred from the speeches and events connected with the series of mass meetings which began to be held during the summer and autumn of 1838. The earlier meetings were called to adopt some sort of organisation. Thus a Manchester Political Union and a Great Northern Union at Leeds, comprising between them the country on both sides the Pennines, came into existence. The Poor Law Amendment Act has already sunk into the background. The Manchester Union proclaimed its abhorrence of violent language and physical force, but its first great demonstration on Kersal Moor, on September 24, was graced by the presence of Stephens, O'Connor, and others who were advocates of violent courses. This demonstration was one of the most remarkable of all Chartist meetings. The *Leeds Times* thought there were a quarter of a million people present, which is scarcely credible. There was an immense array of speakers, representing all parts of the Chartist world. The dominant note was struck by Stephens, who declared that the Charter was not a political question but a knife and fork question : not a matter of ballot-boxes but of bread and butter. This tone sounded throughout all the subsequent babble about arming or not arming, about natural rights and legal rights, which filled up the debates of the Convention. For Chartism was in these manufacturing areas a cry of distress, the shout of men, women, and children drowning in deep waters, rather than the reasoned logical creed of Lovett, or the fanatical money-mongering theories of Attwood. Impatience, engendered by fireless grates and breakfastless tables, was the driving force of much northern Chartism.

The Manchester demonstration was one of a series arranged

to elect the delegates to the Convention. These delegates had to be elected by public meeting and not by definite organisations. Otherwise the Convention would become in the eyes of the law a political society with branches, which was illegal under the infamous Acts of 1819. The day following the Kersal Moor meeting, a similar demonstration took place at Sheffield, Ebenezer Elliott being in the chair. Sheffield definitely and Manchester largely [1] were not strongly moved by the oratorical fireworks of Stephens and O'Connor. The speeches at Sheffield were conspicuously mild. Elliott declared that the objects the people had in view were, " Free Trade, Universal Peace, Freedom in Religion, and Education for all." Another speaker placed the Repeal of the Corn Laws in the forefront of his programme, followed by " a thoroughly efficient system of Education for all," " good diet for the people and plenty of it," and " facilities for the formation of Co-operative Communities." A huge demonstration at Bradford took place on October 18. Hartshead Moor was like a fair, a hundred huts being erected for the sale of food and drink. The Chartists declared that half a million people were present : a soberer estimate divides that number by ten. It was a fiery meeting. Everybody talked about arms, O'Connor upon the virtues of tyrannicide.

Similar meetings took place in practically every important manufacturing town between Glasgow, London, and Bristol, and the election of delegates proceeded rapidly. In October meetings were held for the purpose of collecting the funds destined for the support of the Convention. But the joy experienced at this rapid progress was clouded by apprehensions, for which a terrifying change in the character of the northern meetings was responsible. In October meetings began to be held at night in the murky glare of hundreds of torches, in various parts of Lancashire and Yorkshire, on the pretext that the factory-owners objected to meetings during working hours, whereby much time was lost. The psychological effects of large crowds and excited speakers were emphasised by the eerie surroundings ; it was but a short step from torchlight meetings to factory burning. The authorities were pardonably anxious and tried to put a stop to these meetings. But their action only increased the temperature of the speeches, which became

[1] Manchester itself was not unlike London, possessing a strong middle class, *e.g.* Cobden, and a class of superior artisans who shared middle-class Radical views. But Manchester itself was sometimes swamped by the influx from the smaller towns, which were unanimously Chartist.

inflammatory beyond words. Such meetings were held at Bolton, Bradford, Oldham, Rochdale, and Bury during October, November, and December. The arrest of Stephens at the end of December seems to have put a stop to them.

The increasing violence of the propaganda in Lancashire and Yorkshire began to instil misgiving and terror into the more moderate Chartists in London, Birmingham, and Scotland. Suggestive and inciting articles began to appear in the *Northern Star*. On September 8 a notice in capitals appeared : " The National Guards of Paris have petitioned for an extension of the Suffrage, and they have done it with arms in their hands." [1] O'Brien was contributing inflammatory articles also. At Preston, on November 5, O'Connor talked about physical force without cease. He assured his hearers that the Government would not use force against their force because " they know that the wadding of the first discharge would set fire to Preston." [2]

Very soon the breach between the preachers of violence and the preachers of peaceful agitation was already complete, and a campaign of denunciation had begun. O'Connor scoffed at the " moral philosophers," [3] Stephens denounced the Birmingham leaders as " old women," whilst younger and more reckless leaders, like Harney, who was to represent Newcastle-on-Tyne, loudly proclaimed their lack of confidence in such things as Conventions. [4] The crisis came early in December. The Edinburgh Chartists had passed a series of resolutions condemning violent language and repudiating physical force. These " moral force " resolutions called forth a torrent of denunciation from O'Connor, Harney, Dr. John Taylor, and others. A furious controversy followed. Various Chartist bodies threatened to go to pieces on the question. There were fiery meetings in London and Newcastle to deal with the matter, and controversy of a highly personal description followed. [5] On January 8 O'Connor went to Edinburgh to undo the effect of the resolutions, and on the 9th he persuaded a Glasgow meeting to rescind the resolutions, whereupon Edinburgh denounced Glasgow as " impertinent." A furious meeting at Renfrew, where John Taylor and a minister named Brewster were opposed, lasted till three in the morning. [6]

[1] The Padiham Chartists had a banner with the motto, " Sell thy garment and buy a sword " (*Northern Star*, October 27, 1838). [Much on this page is a repetition of p. 111.]
[2] Additional MSS. 27,820, p. 287. [3] *Ibid*. 27,820, p. 292.
[4] *Ibid*. 27, 821,p. 5. [5] *Northern Liberator*, January 19, 1839.
[6] Additional MSS. 27,821, pp. 13-16.

What Birmingham thought of all these proceedings on the part of O'Connor had better be left to the imagination. The excitement was raised still higher by the news that Stephens had been arrested at Manchester on a charge of seditious speaking and lodged in New Bailey gaol. The Ashton followers of Stephens had long ago threatened with dire punishment the men who should dare to lay hands on their hero,[1] but they for the present contented themselves with threats and efforts to procure arms. Stephens was released on bail after a few days' confinement and was at liberty for some months. He was compelled to moderate his language for fear of damaging his case. Meanwhile a subscription was opened to conduct his defence.[2] It raised over £1000. The conduct of the northern agitation fell more completely into O'Connor's hands.

In spite of the dissension, the excitement, and the confusion, the organisation of the movement proceeded. The signing of the Petition and the collection of the " Rent " (an idea borrowed from O'Connell) went on merrily, and informal meetings of delegates took place at Manchester, Birmingham, and Bury with a view to clearing the way for the Convention. The month of January passed in comparative harmony, whether the result of Stephen's arrest following upon other evidences of the Government's watchfulness, or the consequence of suppressed excitement, is difficult to say. All attention was concentrated upon the 4th of February, when the Convention was to meet. Doubt and desperation, disquiet and uncertainty, struggled with hope and confidence for the souls of thousands of working men during the first five breathless weeks of the New Year. Was the New Year to bring the hoped-for reform or the half-dreaded insurrection ?

The Convention met on February 4, 1839, at the British Hotel, Cockspur Street, Charing Cross.[3] It consisted, nominally, of some fifty-three members, but as several did not attend, its effective strength was less than the forty-nine required to avoid the consequences of the Act of 1819, which placed certain restrictions upon the holding of adjourned meetings. It turned

[1] *Northern Star,* October 27, 1838.
[2] *Northern Liberator,* January 19, 1839.
[3] After two days its meetings were transferred to Bolt Court, Fleet Street, " in the Hall of the Ancient and Honourable Lumber Troop " (*Life and Struggles*, p. 201 ; Gammage, p. 105). See the contemporary description of it by the French *féministe*, Flora Tristan, quoted in Dolléans, i. 286-7. Where not otherwise noted the authority for the debates in the first Convention is the *Charter* newspaper.

out, however, that the Convention was a legal assembly and was
never in danger of prosecution under the Act mentioned.
London was represented by seven members of the Working
Men's Association, including Lovett, Cleave, Hetherington,
and O'Brien, and by one William Cardo, a shoemaker of
Marylebone. In addition the Association had " lent " Vincent
to Hull and Cheltenham, and William Carpenter to Bolton.
Similarly the London Democratic Association found places for
Harney and Neesom, its chiefs, at Newcastle and Bristol.
Thus London furnished a quarter of the whole assembly.[1]
Birmingham sent five representatives out of the original
eight, including Collins, Douglas, Salt, and Hadley. From the
North of England came a score, including O'Connor, MacDouall,
who sat for Ashton-under-Lyne in place of Stephens, R. J.
Richardson, who represented Manchester, Ryder, Bussey,
Pitkeithly, who were the beginning of an O'Connorite " tail,"
and Richard Marsden, a handloom weaver from Preston.
Scotland had eight representatives. Wales had two, Jones
of Newtown in Montgomery and John Frost of Newport.
Three from the hosiery districts, including Dr. A. S. Wade,
Vicar of Warwick, and half a dozen from scattered towns like
Hull and Bristol made up the tale. Only one agricultural
area was represented, and that by courtesy only, and not by
virtue of Chartist zeal. It was Dorset, which sent George
Loveless, one of the famous labourers of '34. He never took
his seat.

Nearly one-half the assembly belonged to the non-artisan
classes. Some, like O'Connor and John Taylor, were sheer
demagogues ; others, such as O'Brien and Carpenter, were
doctrinaire social revolutionaries. The Birmingham delegates,
except Collins, were prosperous fellows who had drifted into
political agitation. Hadley was an Alderman of Birming-
ham and a warden of St. Martin's Church in the Bull Ring.
Douglas was the editor of the *Birmingham Journal*, and Salt
was a lamp manufacturer on a considerable scale. Wade
was a kind of Christian Socialist, a predecessor of Charles
Kingsley. James Taylor was a Methodist Unitarian preacher
who lived at Rochdale, and preached on a Methodist Unitarian
circuit in East Lancashire. There were several medical men,
inspired, no doubt, by similar motives, several booksellers, a
lawyer,[2] and a publican or two.

[1] It was a matter of £ s. d. Delegates who *lived* in London cost less
than those *sent* to London.

[2] James P. Cobbett, son of the great William.

Many Chartists, seeking after the event to explain the misfortune which attended the career of this assembly, attributed its failure to this large sprinkling of middle-class folk, but it must be said that the divisions and dissensions which ruined the Convention cannot be traced to the class divisions which prevailed. On the main points at issue the working men were divided as well as the " middle-class men." Place remarks that the class-war teaching was sufficient to frighten off the middle class as a body from the movement, but not sufficient to induce working men to elect leaders of their own kind to conduct their affairs.[1] It was a sober, black-coated, middle-aged body which met on February 4, 1839.[2] Harney, MacDouall, Vincent, and John Taylor were the youngest, as they were the most fiery, of the delegates. Neesom and Richards[3] were already in their sixties, and quite a number were beyond fifty. Many of the delegates were married men with families already grown up. Truly not a very revolutionary-looking assembly.

On the same day there also met the first great Anti-Corn Law League Conference and the Imperial Parliament—three vastly different political assemblies almost within a stone's throw of each other. It was the portentous beginning of a triangular struggle which all but transformed the political and social character of the United Kingdom. The gage of battle was thrown by the successive rejection in Parliament of motions for Parliamentary Reform and for the Repeal of the Corn Laws. A ten years' war followed.

The first meetings of the Convention were purely formal. R. K. Douglas of Birmingham, who had had in hand the arrangements for the Convention, the Petition, and the " National Rent," acted for the time as chairman. It was decided to appoint a chairman daily in rotation. Lovett was of course appointed secretary, though O'Brien objected on the ground that he was " not in agreement with the men of the North as to the methods by which the Charter was to be obtained." The question as to the payment of delegates was left to the " constituencies " and their representatives for settlement. Douglas presented a report upon the Petition and the amount of rent subscribed and then vacated the chair in favour of Craig of Ayrshire, the first regular chairman.

Many signs testify to the enormous enthusiasm and extra-

[1] Additional MSS. 27,822, p. 83.
[2] *Northern Star*, November 2, 1839.　　　[3] Of the Potteries.

vagant hopes which the Convention called into being. From all parts of the country addresses flowed in.[1] Some were read to the delegates amid scenes of the greatest joy. Newspaper articles dilated upon the great event.[2] Petitions were addressed to the Convention in legal form, as if to be presented to the House of Commons,[3] whereby the delegates were immensely flattered. Most significant of all was the large amount of National Rent which was subscribed. By March 7, £1350 had been received — more than enough to cover all expenses. Small and poverty-stricken districts subscribed incredibly large sums, deeming no sacrifice too great for the purchase of their own and their children's freedom. The hosiery village of Sutton-in-Ashfield, Nottinghamshire, subscribed £20, whilst Leeds, the home of the *Northern Star,* subscribed but five.[4] This tremendous enthusiasm gave the delegates a very exaggerated conception of their powers and abilities and influenced their deliberations very unfavourably at times, whilst their failure to rise to the heights demanded of them transformed excessive optimism into the most dismal disillusionment.

The effects of this exaggerated self-esteem were visible when the vital question was raised—what was the purpose and competence of the Convention ? It was brought forward on Tuesday, February 5, by J. P. Cobbett, but was shelved for the time being. The question was raised again on the 14th and this time it came to a discussion. The question at issue was, Is the Convention a petitioning and agitating body only, or is it a working-class Parliament, with the same authority over the working class as the Parliament at Westminster over the whole nation ? Is it entitled to defy the law or even to use force to encompass its purposes ? Cobbett upheld the first of these views and brought forward a series of resolutions declaring that the Convention was called merely to superintend the Petition, that it ought to sit no longer than was requisite for that purpose, and that it was not competent to decide upon any subsequent measures, especially anything that involved law-breaking, and so to bind its constituents to defy the law.[5] The majority was clearly opposed to this view. On the previous day O'Connor had declared that the Convention

[1] Letter-Book of Convention, Additional MSS. 34,245, A and B.
[2] *E.g. The Charter,* February 10, 1839.
[3] Additional MSS. 34,245, pp. 27 and 103.
[4] *Ibid.* 34,245, A, p. 84.
[5] *Charter,* February 10 and 17, 1839.

would not be sitting if the people thought they could do no more than petition. This probably represents the view of the majority, at any rate of the working-class delegates, who regarded themselves as bound to make the Charter into law by any means whatsoever. MacDouall declared that if the Convention was not to proceed to ulterior measures, he would go home at once. A few delegates, led away by the revolutionary atmosphere attaching to the name of Convention, even dreamed of permanent sittings and Committees of Public Safety. The resolutions were rejected by thirty-six votes against six. Cobbett thereupon quitted the Convention. This was the first of many defections.[1]

How exaggerated a notion some of the delegates had of their own importance appears from the motion, passed on the 13th on the proposition of O'Brien, that the House of Commons be invited to meet the Convention at the Crown and Anchor Tavern on the 27th of February to disabuse the minds of the members of that House as to the character and intentions of the Convention.[2] Delegates wrote " M.C." after their names after the fashion of " M.P." They imagined that they had sufficient influence to meet the House of Commons on equal if not superior terms. They repeatedly argued that they had been elected by a much greater number of voters than those who sent men to Westminster, consequently they were entitled to at least as great a share of power as Parliament.

There was for the time being considerable hesitation about specifying the exact means to be adopted in the event of the rejection of the Petition by the Commons, but as the Petition was not yet presented there was no immediate need of a decision on that point. Meanwhile a declaration of war upon the Anti-Corn Law League and all its ways was proclaimed. This is one of the few questions upon which complete unanimity was displayed. O'Brien was the chief advocate of this policy, and made a speech in his best and most virulent style.[3]

Following this the Convention busied itself with the discussion of its procedure and rules. A week was thus spent, at the end of which a pamphlet was issued bearing the title " Rules and Regulations of the General Convention of the Industrious Classes, elected by the Radical Reformers of Great Britain and Ireland in Public Meetings assembled, to watch

[1] *Charter*, February 17, 1839.
[2] *Ibid.* October 17, 1839. Additional MSS. 27,821, p. 33.
[3] *Charter*, February 17, 1839.

over the National Petition and obtain by all legal and constitutional means the Act to provide for the just representation of the People, entitled the ' People's Charter.' " The detailed rules bear out the title. In this document the Convention becomes a peaceful agitating body; there is no mention of anything else.

Despite this official avowal of law-abiding intentions, the advocates of violent courses were becoming more and more conspicuous. They were aided by doleful reports about the Petition, which made success by peaceful agitation seem very remote indeed. The Birmingham delegates had not attended the Convention since the opening of the session, excusing themselves on various pretexts. A letter from Salt, dated February 17, relates that he has just heard with great concern that there is no probability that the Petition will have more than 600,000 signatures. " In this case we can no longer call it a ' National Petition.' The assumption on which we have proceeded proved false : our position is entirely changed, and I have not yet any very definite idea of the measures it will become our duty to adopt." [1] The *Birmingham Journal* followed this with the suggestion that the Convention should dissolve until the Petition became more largely signed.[2] This was ill news indeed and came as a great shock to the sanguine spirits of the Convention. More serious still perhaps was the obvious fact that the Birmingham delegates had lost their nerve and were preparing to abandon the whole business. The Convention, which had hoped to present the Petition before the end of February, and so provoke an early decision upon the question of further measures, was compelled to postpone the event for two months. Finally May 5 was fixed as the day for the presentation of the Petition. The Convention was thus required to nurse the excitement and enthusiasm of its followers for nine weeks longer, without committing itself too far. This was no easy task, but more difficult still was the preservation of unanimity within the Convention itself.

Early in March dissension began to grow threatening. On the 2nd the London Democratic Association, a violent and reckless body, held a meeting at which Harney, Ryder, and Marsden were the chief speakers. Inflammatory speeches were the order of the day. The Convention was denounced for its delays and its cowardice, and three resolutions were carried and then communicated to the Convention itself.

[1] Additional MSS. 34,245, A, pp. 41-2.　　[2] *Ibid.* 27,821, p. 40.

That if the Convention did its duty, the Charter would be law in less than a month : that there should be no delay in presenting the Petition : and that all acts of injustice and oppression should be met by resistance.

These resolutions caused an immense hubbub in the Convention, which spent three whole days in discussing the conduct of its three traitorous delegates, who narrowly escaped expulsion. It is significant that the three outspoken advocates of violence found only three other supporters within the whole convention. One of these was Frost, the future rebel of Newport.[1]

Though the majority of the Convention was unwilling to avow a policy of violence, individual members were not so timid in the use of threats. The policy adopted by many of the northern delegates, especially O'Connor and his followers, was to adopt an official caution in the Convention and reserve their violence for public meetings. Thus whilst on the 7th of March Harney and his colleagues were officially condemned, nevertheless on the 16th several members of the majority on that occasion joined Harney in a carnival of denunciation which had as its scene a public meeting at the Crown and Anchor Tavern. This meeting produced some significant speeches. Sankey, a doctor from Edinburgh, moved a resolution declaring that the Convention had a right to adopt any means whatsoever in order to carry the Charter, and that every meeting had a right to censure or approve any act of the Convention. Mere petitioning would not carry the Charter, which would be rejected, however many signatures it had, unless they were " the signatures of millions of fighting men who will not allow any aristocracy, oligarchy, landlords, cotton lords, money lords, or any lords to tyrannise over them longer." Rogers, a mild-mannered tobacconist, spoke of signing the Petition in red, but hoped they would achieve their object without bloodshed. O'Connor spoke in the same sense as Sankey. Millions of petitions would not dislodge a troop of dragoons. He warned the delegates that they would have a duty imposed upon them by the people after the Petition was presented. There would be martyrs. If the Convention should separate without doing something to secure the Charter, the people would know how to deal with the Convention. Harney wound up the evening by declaring that by the end of the year they would have universal suffrage or death.[2]

[1] *Charter*, March 10, 1839.
[2] *Morning Chronicle*, March 19, 1839; *Charter*, March 24, 1839.

If this meeting was intended to scare away from the Convention all the moderates, it was not unsuccessful, as the sequel showed. It was followed by a furious debate in the Convention on the 18th, dealing with the Rural Police Bill then before Parliament.[1] A long series of tirades was brought to a climax by Dr. Fletcher of Bury. " He would not recommend the use of daggers against a Rural Police, but he would recommend every man to have a loaded bludgeon as nearly like that of the policeman's as possible ; and if any of these soldiers of the Government, for soldiers they would really be, should strike him, to strike again, and in a manner that a second blow should not be required. . . . If resistance was necessary to oppose the Rural Police Bill, resistance there would be."

The next day, the 19th of March, the *Morning Chronicle* published accounts both of the meeting of the 16th and of the debate of the 18th. Fletcher was apparently horrified to realise how terrific his speech looked in cold print, and denounced the paper for having garbled it. The same paper printed a letter from Wade, dissociating himself from the sentiments expressed on the previous Saturday. Nevertheless from the Rural Police the discussion drifted on to the question of arming. As a justification, the Convention ordered the collection of certain articles in the *Morning Chronicle*. After the Bristol Riots of 1831, that journal [2] advocated the arming of respectable householders to defend life and property in such crises. Although this measure was not without justification in the pre-constabulary days, the Convention regarded it as on a par with its own proposed resistance to the introduction of police. When, however, the articles were collected, they were, on O'Connor's suggestion, put on one side.[3]

So the weeks passed without any decisive event. The Petition was not presented, and two months had gone. Constituencies were paying their delegates [4] and were looking anxiously for some return for their sacrifices. " Had we not been buoyed up," wrote the poor folk of Sutton-in-Ashfield, thinking of their £20, " by the hope that our sufferings would ere long have been ameliorated by the adoption of the People's

[1] The opposition to this Bill was due largely to the belief that the police were intended to enforce the New Poor Law as well as to provide additional soldiery against a possible insurrection. The speakers mostly had the example of France before their eyes, the police being suspected of being nothing but spies and informers.

[2] November 1831. [3] *Charter*, March 31, 1839.

[4] *E.g.* Craig was paid £6 a week (*Northern Star*, September 7, 1839). The two Manchester delegates were *promised* £5 a week each, but did not get so much.

Charter, the people would ere now have been driven to des-
peration." [1] We can well believe Place when he declares that
the general tone of the Chartists during March showed a certain
loss of confidence, or at least reaction from over-sanguine
expectations.[2] They had expected a much more rapid march
of events, but the Convention, partly through its own better
knowledge, partly through its disunion, and partly through
inexperience and lack of real leaders, had been induced to
postpone the crisis. Events over which the Convention had
no control produced further delays, and the Petition was only
laid before Parliament on June 14, while the discussion on it
did not take place until July 12. It was like postponing a
declaration of war for six months. The army began to lose
heart and the enemy grew stronger. This was just what
O'Connor had prophesied and Harney dreaded.

Nothing perhaps contributed more to damp the original
enthusiasm of the Convention than the revelation that, so far
from being a dominant majority in the nation, Chartists were
only a struggling party. This revelation was made by the
reports of some of the fifteen missionaries, sent out at the end
of February to agitate the districts not yet attacked by Chart-
ism. On March 8 Salt reports from Birmingham. He has
visited Willenhall, Stourbridge, Bilston, and Kenilworth, the
three former in the heart of the Black Country, and has not
even been able to get together a meeting. Wolverhampton,
Darlaston, West Bromwich are little better. But Salt was not
a good missionary. He had an eye to his lamp factory all the
time. He notes that the middle-class folk are standing aloof,
and thinks that without the aid of a few middle-class men, who
have leisure to instruct, nothing can be done for a long period.[3]
This to a body which is full of bitter anti-middle-class feeling !
When Salt and Hadley reported thus to the Birmingham
Union, they were but ill received.[4]

From the south-west came reports from Duncan, Lowery,
and Vincent. The two former were in Cornwall.

We find that to do good we will have to go over each place twice,
for the People have never heard of the agitation and know nothing
of political principles ; it is all uphill work. Were we not going
to it neck or nothing, we should never get a meeting ; the trades-
people are afraid to move and the working men want drilling before
entering the ranks.[5]

[1] Additional MSS. 34,245, A, p. 84, March 1.
[2] Ibid. 27,821, p. 58. [3] Ibid. 34,245, A, p. 107.
[4] Ibid. 27,821, pp. 65-9. [5] Ibid. 34,245, A, p. 120, also p. 148.

Moir and Cardo had similar experiences in Devonshire.[1] Vincent was nearly murdered by a mob at Devizes. This was a specially severe blow, considering Vincent's hitherto unbounded popularity and success as an agitator. At the head of a procession Vincent had entered the ancient borough-town and mounted a waggon in the market-place. According to Vincent's account, Lancers, Yeomanry, and special police were mobilised to do honour to the event. Hardly had he mounted the waggon than a horn was blown and a volley of stones hurled. Vincent was knocked clean out of the waggon by a stone which struck him on the head. A body of bludgeon-men stormed the waggon and in a moment the market-place was a scene of riot. The Chartist banners were captured and recaptured, and Vincent, with Roberts [2] and Carrier, was with difficulty rescued by the special constables. An hour later a mob assembled in front of their lodging and threatened to burn them out. The High Sheriff intervened and had them escorted out of the town by the constabulary and others. The mob rushed the escort and seriously mauled the three unfortu-nates, so that Vincent collapsed and had to be carried off in a gig.[3]

From Sheffield came a request that a delegate be sent to rouse the workers there. Very little success, the communi-cation adds, had followed attempts to further the Chartist cause in Sheffield, but greater things were expected if the Convention sent a delegate. It was emphatically stipu-lated that a moral force man be sent.[4] It was reported that Leeds had only just commenced to take part in the agitation.[5]

One of these missionary reports deserves reproduction here ; it is from old John Richards, agitating in the Potteries, dated March 22, 1839.

I arrived in the Potteries on Wednesday night. The Councill of the Union were assembled and received me with hearty and Deafen-ing Cheers as soon as order was Again restored. Thursday Night was Appointed for me to Address A Meeting, and I Assure A more Enthusiastic meeting never Assembled. I stated the object of the Council of the pottery political Union in sending for me home to be to Compleat the Agitation in the Potteries and to Extend it

1 Additional MSS. 34,245, A, p. 128, B, p. 33.
2 W. P. Roberts, later the "miners' attorney-general." Webb, *History of Trade Unionism*, pp. 164-6.
3 Additional MSS. 34,245, A, p. 228.
4 *Ibid.* 34,245, A, p. 188, April 2. 5 *Ibid.* p. 198, April 3.

to the Neighbouring Towns. Attended the following places. Last
week Tunstal on Monday, Lane End on Tuesday, Burslem on
Wednesday, Stoke on Thursday, Congleton on Saturday, Sandbatch
on Monday.[1] Open-air meeting at one o'clock, Tuesday Night
Fenton; Wednesday night Leek. At Congleton Sandbatch and
Leek have formed political Unions formed Committees and Set
them to work to obtain Signatures and Collect National Rent
and I hope with a good prospect of Success . . . As regards the
Condition of the different towns I have visited, I can only say that
poverty destitution and Its accompanying feature Squalid Misery
form the principal feature. At Leek and Sandbatch I found the
Inhabitants fully Convinced that everything was wrong and yet
Ignorant of the Means to Cure the evils . . . to these people I
pointed out that the root and cause of the privations of the Sons of
Labour lay in the want of the Franchise. This was news to them. . . .
At Leek I found the workmen reduced to the Lowest degree possible
for Human nature to endure. Many were the Men who publickly
Stated that with fifteen hours Labour per Day the Utmost they
could earn was from 7 to 8 Shillings per Week. I do not wonder
that men thus Situate Should make use of Strong language. Rather
do I wonder that they keep in any bounds, but this I do Say that
If something be not Speedily done to give a greater Plenty to the
working Man, Something of A very fearfull Import must follow.
Nor will It be possible for me, let me do my Utmost, to keep that
Peace you know I so much long to be kept by the Operatives of
England. . . . Shall have to Visit those places ere I see you. Shall
Impress on them the Motto Peace Law Order, but I fear all will
be of no avail, this being the Language used in those places—Better
to die by the Sword than perish with Hunger.[2]

More powerfully than by the none too encouraging reports
of the missionaries was the Convention disturbed by a series
of resignations. On March 28 Dr. Wade resigned. He was
opposed to the continual talk about arms. A few days later
the Birmingham delegates all resigned. The meeting at the
Crown and Anchor was the immediate cause of their with-
drawal, as it showed that the Convention was ready to " peril
the success of Radical Reform on an appeal to the last and
worst weapon of the tyrant and oppressor." [3] The Conven-
tion spent some hours in denouncing the conduct of the
Birmingham people. The latter had indeed played an igno-
minious part in the movement. They had gone into it, hoping
to launch their currency scheme upon the rising popular tide.

[1] A report of March 28 states that Richards had to cover all these
distances on foot. Additional MSS. 34,245, A, p. 173.
[2] Additional MSS. 34,245, A, p. 147. The punctuation of the original
has been slightly amended to make the meaning clear.
[3] *Charter*, March 31, 1839 ; April 7, 1839.

They had expected rapid success. Instead, they found that leadership had passed out of their hands and that success was remote. They had talked vaguely about physical force, but shrank from associating with the men who were really determined to use it. They therefore pleaded business reasons for not attending the Convention (which, it is true, was likely to take up far more time than they could spare without deserting their business altogether, as Cobden did) and at a favourable opportunity withdrew altogether from a movement whose course filled them with apprehension. Collins manfully defended them against their enemies in the Convention, some of whom had apparently been stirring up opposition to Douglas, Salt, and Hadley in Birmingham itself. The consequence was that the Chartist cause in that city fell into the hands of a reckless and unscrupulous crew, a fact which later turned out very disastrously.[1]

On April 9 the Convention plunged into a discussion upon the right of the people to possess arms. R. J. Richardson of Manchester, who had a taste for antiquarian research, introduced the question in an interminable oration loaded with citations of every conceivable description. He moved for a committee to inquire into the existing state of the law upon the subject. The debate which followed reached the very climax of futility, and exhibited a hopeless division amongst the delegates. Sankey, who had distinguished himself at the Crown and Anchor by his bold words, now betrayed a strong disposition to eat them. Amid the fog of discussion the practical good sense of the Scotsman, Halley, sounds strangely welcome. What, he wanted to know, was the practical value of the resolution ? Were they going to prepare for a campaign ? Had they a large enough following in the country ? To these questions no answer was vouchsafed, for none could be given. Nobody knew why the discussion was opened, and only half a dozen moderates like Halley, and two or three firebrands like Harney, had courage to commit themselves to any definite views at all. This debate especially deserved the censure passed by the *London Dispatch* that the Convention was more concerned to show how clever it was than to further the cause with good suggestions and sound measures.[2] The discussion ended in a declaration of the Convention's opinion that it was lawful to possess arms. It had the effect of encouraging the collection of arms in various parts of the

[1] *Charter*, April 14, 1839. [2] May 19, 1839.

country, a proceeding which did not escape the notice of the Government.[1]

On April 18 Wood of Bolton resigned, having become a Poor Law Guardian, to the great horror of his constituents. Clearly the Anti-Poor Law excitement was subsiding. He delivered a Parthian shot at the Convention by informing his people that if they wanted a physical force revolution they must elect a different Convention. On the 22nd, Matthew, one of the Scottish delegates, resigned also.

A resolution was introduced by O'Connor on the 22nd, suspending all missionary work and requiring the attendance of all delegates till the Petition was presented. Place says this was dictated by a fear that Government was preparing to pounce upon the missionaries,[2] a view which Vincent's arrest early in May serves to support, but it was also due in part to the diminishing attendances of the remaining delegates. O'Connor's speech was another example of indirect terrorism, intended to scare away the remaining moderates. He denounced those who had resigned as " deserters," and declared that the lukewarmness of certain delegates would only cause a greater impatience on the part of those who, being without breakfasts and dinners, were anxious that the Convention should show them how they were to be had. It was useless for the Convention to sit there philosophising. The delegates would have to act or their constituents would think they were enjoying themselves on their salaries. When the Petition was rejected, as it would be, they would have to declare a permanent sitting [3] and *invite the country to address the Convention* in order that they might consider in what way they could best carry out the objects of their just cause. Unless the Convention brought itself *morally into collision* with other authorities, it would do nothing to show its own importance.

He then proceeded to hint that the middle-class folk in the Convention were the cause of its lukewarmness. He talked vaguely of a general strike as an alternative to physical or moral force. The operatives would " meet the cannon with the shuttle and present the web to the musket." O'Connor knew none but cotton and woollen weavers. He finally denounced moral philosophers as the bane of their cause,

[1] The Aberdeen Chartists wrote to Dr. Taylor, asking whether the constitutional maxims quoted in the debate applied also to Scotland, as they had passed a resolution in favour of arming (Additional MSS. 34,245, A, p. 260). [2] *Ibid.* 27,821, p. 93.
[3] An improvement of an earlier passage in the speech in which O'Connor suggested that they should sit till the funds were exhausted.

and declared that the delegates who had deserted were paltry cowards.

This speech indicates an important change of attitude of the Convention on the vital question of " ulterior measures," *i.e.* measures to be adopted after the Petition was rejected. May 5 was very near, and the Convention would have to have some definite measures with which to face its followers in the country. But some delegates were definitely opposed to any appeal to arms ; others who had been valiant in speech were none too pleased to find that they might have to vindicate their valour in conflict with soldiers and police ; others who might be perfectly willing to sacrifice themselves had scruples against sacrificing others also ; yet others were anxious to make better preparations before provoking an outbreak. Amidst this clash of opinion, one course seemed to recommend itself to the delegates—the least admirable course of all. Already it had been decided to hold a series of mass meetings during Whit-week. It was now decided to leave to the Chartists in mass meeting assembled the decision which the Convention had not will enough to take for itself. As Bussey, a reputed firebrand from the West Riding, remarked, it was dangerous for the Convention to be ahead of the opinion of its constituents. This was the result of the deliberations on the 22nd and 23rd.[1] The following day was spent in excited recrimination between the extremists on both sides, and no business was done.

On May 7 the Convention completed the first stage of its work by handing over to Attwood and Fielden, who were to present it, the great Petition. It contained 1,200,000 signatures. It was rolled upon a huge bobbin-like structure and placed upon a cart. The Convention marched two abreast as escort, and delivered it at Attwood's house. This consummation had not been accomplished without an eleventh-hour hitch. Attwood and Fielden had demanded that the Convention should pass a resolution condemning violent language and physical force. This produced an excited debate in the Convention, and the resolution was not passed. Apparently the matter was compromised, but Attwood had still another scruple. He objected to the Charter on the ground that it would give two hundred representatives to Ireland out of six hundred, which he considered too great a proportion. However, the Petition was deposited at his house and he was left in charge, scruples and all.

[1] *Charter*, April 28, 1839.

The Petition had long since ceased to be the focus of Chartist thoughts and hopes. Very few delegates continued to express the opinion that it might be seriously considered by the Commons, and even they cherished the hope against their better knowledge. The Convention devoted itself to the consideration of "ulterior measures." Soon after the Petition was handed over to Attwood, the Convention quitted London for Birmingham after a session of three months. With the arrival in Birmingham a new phase of the movement began, in which the evils of dissension, recklessness, and lack of proper leadership worked themselves out to a dismal and ignominious end.

It must be confessed that the Convention had not accomplished great things. Considering the exertions made, the Petition had not been very extensively signed. Though 1,200,000 looks a respectable figure enough, yet it compares unfavourably with the later Petition of 1842.[1] Through the missionaries the Convention had accomplished something. In fact, this was the most hopeful and successful side of its work, but it was not developed enough. The truth is that the leadership of the movement was never thoroughly in the hands of the Convention. The latter was being driven by the excitement and impatience of its followers. The longer it delayed, the greater grew the pressure from behind, until the Convention was wrecked by forces which it could no longer control.

[1] Richard Carlile in a pamphlet preserved in Home Office Papers (40-43), p. 8, says that the Petition of 1839 compared very badly with that of 1817.

CHAPTER VIII

THE GOVERNMENT PREPARES FOR ACTION

(1839)

THROUGHOUT the manufacturing and mining districts an atmosphere of excitement and terror was spreading during the early months of 1839. Poverty and scarcity grew. A very bad harvest in the previous year increased the price of bare necessaries of life to thousands who in time of good harvests were scarce able to live, whilst the dislocation of trade reduced wages and increased unemployment. The streets of many a Lancashire town were filled with pale, gloomy, desperate, half-famished weavers. The workhouses were besieged (for the New Poor Law was yet in abeyance), though many a stubborn operative preferred to starve in silence. " There is," wrote a sympathetic observer [1] later in the year, " among the manufacturing poor, a stern look of discontent, of hatred to all who are rich, a total absence of merry faces : a sallow tinge and dirty skins tell of suffering and brooding over change. Yet often have I talked with scowling-visaged fellows till the ruffian went from their faces, making them smile and at ease : this tells me that their looks of sad and deep thought are not natural. Poor fellows." [2] " It looks as if the falling of an Empire were beginning," wrote the same noble soldier in the early days of 1839.

In truth the aspect of Great Britain in these days was sufficiently terrifying. From Bristol to Edinburgh and from Glasgow to Hull rumours of arms, riots, conspiracies, and insurrections grew with the passing of the weeks. Crowded meetings applauded violent orations, threats and terrorism were

[1] General Sir Charles Napier.
[2] W. F. P. Napier, *Life and Opinions of Sir C. J. Napier*, ii. 77 (September 24, 1839).

abroad. Magistrates trembled and peaceful citizens felt that they were living on a social volcano. The frail bonds of social sympathy were snapped, and class stood over against class as if a civil war were impending.

The acquisition of arms by the more desperate of the manufacturing and mining folk must have begun before the meeting of the Convention.[1] A letter from the Loughborough magistrates, dated January 30, relates that the framework knitters, under the influence of Stephens, are making enormous sacrifices out of their terribly small wages for the purchase of arms and for the support of their two representatives in the Convention.[2] Stephens's arrest must have given a considerable impetus to the collection of weapons of war. From this time onwards similar reports were received almost daily by the Government from magistrates, officials, and private persons of all descriptions. " Better to die by the sword than perish with hunger " was the prevalent feeling. The Mayor of Newcastle reports in February that arms are being collected in that district.[3] In March it was stated that the colliers and foundry-men in the Newport and Merthyr districts were forming clubs, which organised the purchase of arms through hawkers. Thomas Phillips, the Mayor of Newport, who played a great part in the suppression of the rising which took place later in the year, relates that meetings are frequently held in the public-houses in the remote colliery districts when neither civil nor military authority is available.

The missionaries attend at public-houses or beershops where a party has been assembled. The missionary expounds to them the grievances under which they labour, tells them that half their earnings is taken from them in taxes : that these taxes are spent in supporting their rulers in idleness and profligacy : that their employers are tyrants who acquire wealth by their labour : that the great men around them possess property to which they are not entitled.[4]

This sounds very much like a *résumé* of Vincent's doctrines,[5] as reported by the Crown witness at his trial. The manager of the Pontypool Ironworks went about in fear of death, and had once escaped a mauling only by putting on female costume.[6] From Halifax in April came a report that much drilling and collection of arms was going on amongst the handloom weavers,

[1] Stephens said on November 4, 1838, at Hyde that the burial clubs were purchasing arms ; at this meeting pistols were discharged.
[2] Home Office, 40 (44), Leicester.
[3] *Ibid.* (46), Newcastle-on-Tyne.
[4] *Ibid.* (43), Monmouth.
[5] *Ibid.* (45), Monmouth.
[6] *Ibid.*

M

who were reduced to such desperation as to resolve to better themselves at the expense of the community.[1] Bradford and Barnsley magistrates reported in similar terms about the same time.[2] At Halifax a book about barricade and street fighting, and the method of facing cavalry with the pike, written by an Italian revolutionary named Macerone, was circulated.[3] Pikes, manufactured out of old files stuck into a handle, or acquired in some similarly inexpensive fashion, were the favourite weapon, though not a few Chartists obtained muskets. These martial preparations were carried on even in the remote districts of Scotland, as far as Aberdeen, though the little weaving towns, like Barrie's " Thrums," [4] were the chief centres of excitement.

Frequent and tumultuous public meetings increased the excitement. Delegates of the Convention, who there expressed themselves cautiously and vaguely on the subject of arms and physical force, were less reticent whilst addressing their friends and followers in the country. Vincent set the whole of South Wales ablaze, and when he was at last arrested early in May, every one held his breath in terror of the inevitable insurrection. No work was done in Newport on the day the news arrived. In Lancashire the various agitators and delegates used the most extreme language. William Benbow was the most outspoken of these advocates of armed revolution. He was a cobbler of Manchester, now about sixty years old. He had lived through the desperate days of Hampden Clubs and the Six Acts. He had been a friend of Sam Bamford of Middleton and William Cobbett.[5] In 1816, if we are to trust Henry Hunt, Benbow had been denounced by a Government spy for manufacturing pikes in view of a projected rising. He was also the author of a pamphlet advocating the general strike as a political weapon. A thoroughgoing, hardened revolutionary, Benbow had in no wise been discouraged by the experiences of his earlier days. We have seen him as a leader in the Anti-Poor Law agitation,[6] and he came forward now with greater enthusiasm than ever. He travelled all over Lancashire preaching his doctrine of strikes and insurrection. At a meeting in Manchester he spoke, we are told, " like a mad thing." [7] MacDouall, O'Brien, Richardson, and a host of

1 Home Office, 40 (43), Manchester.
2 *Ibid.* (51), Yorkshire. 3 Napier, ii. 16.
4 *The Little Minister*. " Thrums " is Kirriemuir in Forfarshire.
5 *Northern Star*, April 2, 1842.
6 Compare above, p. 91.
7 *Manchester Times*, April 27, 1839.

others spoke of nothing but arms. MacDouall urged his hearers at Hyde to prepare themselves for the struggle, whereupon some one in the crowd fired off a pistol.[1] At other meetings, too, pistol shots took the place of applause. What was true of Lancashire and South Wales was true also of every important manufacturing area, for everywhere the magistrates were terror-struck. To what extent arming and drilling were actually carried on it is of course difficult to say. The wildest tales were about. Three hundred thousand Lancashire men would march at the signal of the Convention.[2] The arms in the Tower of London could easily be seized and distributed. Untold thousands of Welsh colliers were ready to move. That these rumours were exaggerated goes without saying. More significant, however, is the fact that the most sanguine advocates of violent courses in the Convention had themselves to confess that they had grossly overestimated their following and their influence in the country.

These proceedings were not in the least hidden from the Government. Perhaps the Chartists did not intend that they should be, for with many it was an article of faith that moral force backed by a *display* of physical force would accomplish the surrender of the House of Commons. It was thus possible for many delegates, in the Convention and elsewhere, to advocate the possession of arms without being in the least desirous of using them. Thus the drilling went on with no great attempt at concealment. The Government was well informed as to the state of affairs. From magistrates, town clerks, mayors, officials, and private persons hundreds of reports were received, relating to all parts of the country. With this information before him, Lord John Russell, the Home Secretary of the Melbourne Administration, was able to act wisely and tactfully.

The wisest and most tactful step was the appointment of Major-General Sir Charles J. Napier to the command of the Northern District in April 1839. Napier, the future conqueror of Sind, was perhaps the most brilliant officer of the school of Wellington, but apart from that he was a true gentleman, and a wise and kindly ruler of men. His journal, which forms an important source of our information for this troublous period, reveals a man of the most admirable character. His soldierly qualities were only exceeded by his sympathy with the un-

[1] *Manchester Guardian*, June 12, 1839. Meeting on April 22.
[2] Napier, ii. 43.

fortunate men whose wild projects it was his duty to frustrate. In politics he sympathised with the Liberals and with the Conservatives of the school of Lord Ashley, who was trying with increasing success to voice the claims of the poorer classes upon the attention of the State and of Society. No better choice could have been made by Lord John Russell, who, though steadfastly opposed to the claims of the Charter and the National Petition, was scarcely less sympathetic and forbearing in his conduct at this crisis than Napier himself, although far more nervous.

The Government in fact handled this difficult situation in an excellent fashion.[1] On the one hand it was not unaware of the nature of the insurrectionary movement, and it was already taking steps to grapple scientifically with the problem of social discontent. The manifold careful inquiries which were made during this and the succeeding years [2] are sufficient witness at least to a desire to do something for these less fortunate members of society. On the other hand the insurrectionary movement was a fact, and Government was bound to protect lives and property against threatening destruction. The difficulty was that there was no police force to speak of outside the London area, and the larger and smaller manufacturing towns were therefore compelled to rely upon military protection in times of riot. Thus Bradford (Yorkshire) with a population of 66,000 had a police force of about half a dozen.[3] Neither Manchester nor Birmingham had a properly organised force until the summer of 1839. Most of the smaller towns had no civil force at all. Under these circumstances the use of military force was inevitable, but neither Napier nor the Home Secretary was prepared to allow it to be used as recklessly as at Peterloo. Much of their energy was in fact devoted to soothing terrified magistrates and manufacturers who wanted to garrison every town and every factory like a fortress, and to let loose the soldiery upon the slightest provocation.

Napier proceeded therefore very cautiously. He found himself in command of between five and six thousand men and eighteen guns. This was a far from sufficient force unless very carefully used. It was scattered all over the northern counties, sometimes in very small units, such as half companies and less. At Halifax, for instance, forty-two soldiers were billeted in

[1] Russell had refused to put down Chartist meetings on the ground that freedom of speech must be preserved (Hansard, 3rd ser., xlix. 455).
[2] See above, especially Chapter II. [3] Home Office, 40 (51), Yorks.

as many houses.[1] Napier at once proceeded to concentrate his forces at what he held to be the decisive points. His head-quarters were for the time being at Nottingham. Newcastle-on-Tyne, Leeds, Hull, and Manchester were the strategic points. In the Newcastle area he had 900 men ; in the Lancashire area, 2800 ; in Yorkshire, 1000.[2] Manchester was regarded by Napier as the centre of the insurrectionary movement, and he kept one of his best officers, Colonel Wemyss, constantly there, with a force which at one time must have amounted to 2000 men with some guns. This concentration, he notes with relief, was completed by May 1. Napier exerted himself to provide barracks of some sort in every town where the soldiers were posted, as he was afraid that they would be cut off or tampered with if they were left in billets. The provision of barracks was a constant stipulation whenever magistrates applied to him.

In one other district where the Chartists were particularly threatening, namely Monmouthshire, Lord John Russell ordered up troops. This was at the end of April. The troops were to be sent from Sussex or Wiltshire.[3]

It was generally supposed that the day on which the petition was presented would be the day of the outbreak. All the preparations, therefore, were made against the 6th of May, the date originally fixed. On May 3 the Government issued a proclamation against persons who " have of late unlawfully assembled together for the purpose of practising military exercise, movements, and evolutions," and against persons who " have lately assembled and met together, many of them armed with bludgeons or other offensive weapons, and have by their exciting to breach of the peace, and by their riotous proceedings, caused great alarm to our subjects." Magistrates are to take all measures to suppress such unlawful assemblies. This proclamation was followed by a letter from the Home Secretary, authorising the formation of a civic force for the protection of life and property where such was held to be in danger. Government would supply arms to such bodies on application through the proper channels.[4]

Whether this proposal to arm one body of inhabitants against the others was wholly wise may well be doubted. In many districts it would amount to the arming of the richer against the poorer classes, and give the struggle the aspect of a

[1] Napier, ii. 16. [2] *Ibid.* ii. 19-22.
[3] Home Office, 40 (45). Pencil note on back of letter dated April 30.
[4] *Northern Liberator*, May 11 and 18, 1839.

social war. That the proposal was not only made but often carried into practice shows already the degree of terror and bitterness which had entered into social relationships. But in the absence of a regular police force it was perhaps the best course of action, unless a very free use were made of the soldiery, which was perhaps still less advisable. The Government was very cautious in supplying these volunteer bodies with arms. Firearms were very seldom issued, cutlasses being supplied instead.

Thus the two parties made their preparations, the Government cautiously and tactfully, the Chartists noisily and perplexedly. Whether there would be an outbreak of civil war depended largely upon the action of Napier and the Convention. To the latter we must therefore turn again.

CHAPTER IX

THE CONVENTION AT BIRMINGHAM

(1839)

A STRANGE event upset the Chartist calculations early in May 1839. The Whig Government of Lord Melbourne had at no time possessed a sound working majority. In a division upon the question of suspending the constitution of Jamaica in consequence of the evil treatment of the negro freedmen by the white oligarchy, the Government majority dwindled to five, and on the following day, May 7, Melbourne decided to resign. This unlucky event put an end for the moment to all ideas of presenting the National Petition, as there was no prospect of a hearing for it. It made a bad impression, too, that the House of Commons should apparently be so concerned with the affairs of Jamaica as to bring about a change of Government at so critical a time. The Convention was compelled to face the prospect of another long wait for the decisive moment at which political agitation might pass into armed insurrection. The delegates were of course far from unanimous either as to the necessity or as to the precise moment for the employment of force. Some were opposed to force altogether, others were for waiting until the Petition was definitely rejected, and yet others, convinced that the Petition was useless, were for an immediate appeal to arms.

The Convention had not been unimpressed by the preparations of the Government to resist any insurrectionary movement. Without going as far as Place, who believed that all the proceedings of the Convention about this time were dictated by a cowardly fear of prison, the biggest braggarts like O'Connor being the most arrant of cowards,[1] we may well agree that none of the delegates wanted to go out of their way

[1] Additional MSS. 27,821, pp. 113-14.

143

to get themselves arrested. They wanted to keep their forces together if there was to be an outbreak, and the seizure of the delegates would either provoke a leaderless insurrection or put a stop to the whole agitation, at least for the time being. Neither of these alternatives was pleasant to contemplate. The delegates, therefore, felt themselves unsafe in London, almost under the eyes of Government and the already efficient Metropolitan Police. The debates in the Convention had not escaped the notice of the Home Secretary, who especially asked for reports of the proceedings there.[1]

In the Metropolis the Chartists had totally failed to get together a real following. An effort to organise agitation in London had been made by the Convention, but it did not accomplish much. Long and loud were the complaints about the apathy of the Londoners " because they had more wages than the men of the North." [2] A meeting addressed by Pitkeithly and Smart at Rotherhithe on March 28 drew only fifty or sixty persons, and Pitkeithly complained that he had only to call a meeting in the North and he would crowd a room six times as large as the present one.[3] The notion that the populace of London would play in a Chartist Revolution the part of the Paris folk in the French Revolution, if it were ever entertained, was hopelessly impossible. In London the Convention, in spite of its exertions, was never more than an interesting phenomenon.

The thought was natural, therefore, to withdraw from London to some place where there was a greater following and a greater immunity from arrest. Birmingham was the town selected. The delegates believed that the Convention could combine preparation with propaganda, and Birmingham, the half-way house to the North and to South Wales, was naturally the first stopping-place for a movable People's Parliament.

Birmingham Chartism had undergone a change since the collapse of the Attwood party. The moderate middle-class element had seceded and left the leadership in the hands of working men. Collins still preserved a tolerable following,[4] but he was overshadowed by a noisier party led by Brown, Powell, Donaldson, and Fussell. Brown, Powell, and Donaldson were elected delegates in the place of Douglas, Hadley, and

<hr />

[1] Home Office, 40 (44), Metropolis. Pencil note on back of letter, date May 3 : " I wish to have account of proceedings of the Convention itself."
[2] Home Office, 40 (44), Metropolis. [3] *Ibid.*
[4] A strong protest was received by the Committee against the election of Brown and his colleagues, *Charter*, April 28, 1839.

Salt, whilst Fussell stayed in Birmingham to agitate. Since the end of March the behaviour of the Chartists had become more and more provocative.[1] The Bull Ring, a triangular space in the centre of the town, and a gateway into the poorer quarters, was crowded day after day with excited meetings, and the tone of the speeches became more and more inflammatory. The shopkeepers in the High Street were half ruined by the stoppage of their business. The Mayor [2] professed to believe that there was no danger of any serious disturbances, but the manager of the Bank of England branch feared for his strongboxes.[3] A letter from Fussell to Brown, dated May 7, describes the excitement in Birmingham. The Bull Ring is daily beset by crowds " waiting to hear the result of the Petition." All the week no work has been done, and Fussell has addressed the crowds during the day-time "to preserve the peace." The soldiers are all under arms and the Riot Act has been read " to exasperate the people." " And Depend upon it no stone shall be left unturned by Mee for the Purpose of keeping up the excitement." " I shall continue my exertions though the Workhouse be My Doom." He urges Brown, who no doubt kept him informed of the course of events in the Convention, to use all his force to get the Convention to transfer its sittings to Birmingham " as this was their battlefield and the men of Birmingham their forces." [4] The next day, however, the magistrates of the town forbade meetings in the Bull Ring and also meetings of any sort where seditious and inflammatory language was used. On the 9th MacDouall and a certain James Duke, of Ashton-under-Lyne, were in Birmingham ordering a score of muskets and bayonets to be sent to the latter's home at Ashton, and promising an order for several hundred more if these were approved.[5]

These indications suggest strongly that the " movement party," both in the Convention and in Birmingham, desired the removal to that town because they thought it a better base of operations for the intended outbreak. The supposed weakness of the newly created municipal body, which included a large sprinkling of the ex-leaders of Birmingham Chartism, the supposed strength of the physical force Chartists, and the existence of large stores of munitions of war, encouraged the

[1] A speech of March 28, probably by Brown : " We know the use of barricades. We know how to make use of the lanes and alleys. We know the use of broken glass bottles. We know the use of *aqua fortis*," etc.
[2] William Scholefield. [3] Home Office, 40 (49), Birmingham.
[4] Additional MSS. 34,245, A, p. 414.
[5] Home Office, 40 (49). Sworn deposition of gunmaker at Birmingham.

hope that a successful beginning might be made there. When, on May 8, O'Connor for the second time moved the transference of the Convention, a majority of three to one was in favour. O'Connor said that the advent of a Tory Government would make it dangerous to stay in London, whereas at Birmingham they would be safe. Lovett voted with the majority, Hetherington, Cleave, Hartwell, Sankey, and Halley with the minority. Cleave, Sankey, and Halley entered a very strong protest against the removal, and had it recorded in the minutes. Cleave and Halley said they would quit the Convention altogether, but changed their minds, whilst Sankey wobbled again and struck out his signature from the protest.[1] George Rogers, another London delegate, withdrew also. He was treasurer to the Convention. He wanted to know what character the Convention would assume, now that the Petition was disposed of, for he would sign no cheques, except for a petitioning body. He wanted to know what the Whit-week meetings were for. Anticipating no satisfactory answer, he resigned.[2] Thus the moderate party was rapidly disappearing.

The sittings in London were terminated by proceedings which showed how far the Government's measures had taken effect upon the delegates. On May 6 Lowery had moved an " Address to the People " of a moderate character. This was rejected and replaced by an Address compiled by O'Brien, who said it was intended to urge the people to take arms without saying so in as many words. The gist of the Address was as follows : The first duty of the people was to obey the law, for a premature violation of it would ruin the cause. Their oppressors were trying to provoke such an outbreak through spies and traitors ; they had already induced incautious persons in Lancashire to practise training and drilling in contravention of the Six Acts ; they were arming the rich against the poor. The only way to avoid these schemes and plots was to be rigidly law-abiding, to avoid spies and traitors, to keep their arms bright at home, but not to attend meetings with them, and to be prepared *with those arms* to resist attempts to suppress their peaceful agitation with physical violence.[3]

It is significant of the wavering attitude of some at least of the delegates towards the use of force that, on Carpenter's motion, the crucial words " with those arms " were deleted. Place says that the debate was very excited. Burns and

[1] Additional MSS. 34,245, A, p. 432.
[2] *Ibid.* 34,245, A, p. 410. [3] *Charter*, May 12, 1839.

Halley, the Scottish delegates, opposed the Address altogether. Burns said that so far from being in a majority, they were only a minority of the nation. (He was met with cries of " We are ten to one.") He answered that he was glad to hear it. They had only to show that they were in such a majority and there would be no need to talk of arms.[1] Many of the delegates spoke very boastfully of the strength of their following. With this ambiguous address, and the completion of the arrangements for the great Whit-week campaign, the Convention quitted London.

It reached Birmingham on May 13. There was apparently no great excitement and no meetings were held in the Bull Ring. So far the Convention's injunctions regarding the strict observation of the law were effective. The delegates evidently heaved a sigh of relief on quitting London, which O'Connor said was " the most damnable of all places for bad air " ; the members had come to Birmingham " to recruit their health." [2] The Convention was welcomed by an address from the Radicals of Duddeston-cum-Nechells, a suburb of Birmingham. Its authors " hail with heartfelt and boundless joy the auspicious hour which has given to the millions of our brethren in political bondage a mighty Congress, solemnly elected by the people, to assert and win our natural and imprescriptable [sic] rights and franchises," and invoke " upon your gigantic labours the blessing of that Providence at whose breath every oppressor shall be swept from off the land." [3]

Once arrived in Birmingham, the Convention took up a vigorous line of action. It treated the preparations of the Government as a signal for hostilities, and issued what may be regarded as a declaration of war. This was the fiery document styled " The Manifesto of the General Convention of Industrious Classes," which ran as follows :—

Countrymen and fellow-bondsmen ! The fiat of our privileged oppressors has gone forth, that the millions must be kept in subjection ! The mask of CONSTITUTIONAL LIBERTY is thrown for ever aside and the form of Despotism stands hideously before us : for let it be no longer disguised, THE GOVERNMENT OF ENGLAND IS A DESPOTISM AND HER INDUSTRIOUS MILLIONS SLAVES.

Fellow-countrymen, our stalwart ancestors boasted of rights which the simplicity of their laws made clear and their bravery protected : but we their degenerate children have patiently yielded

[1] Additional MSS. 27,821. pp. 126-8.
[2] *Ibid.* 27,821, p. 170. [3] *Ibid.* 34,245, A, p. 442.

to one infringement after another till the last vestige of RIGHT has been lost in the MYSTICISM of legislation, and the armed force of the country transferred to soldiers and policemen.

Then follows an appeal to "rouse from your political slumbers." The Convention would lead. The Petition would be rejected and "*we may now be prepared for the worst.*"

Men and women of Britain, will you tamely submit to the insult ? Will you submit to incessant toil from birth till death, to give in tax and plunder, out of every twelve hours' labour, the proceeds of hours to support your idle and insolent oppressors ? Will you much longer submit to see the greatest blessings of mechanical art converted into the greatest curses of social life ? to see children forced to compete with their parents, wives with their husbands, and the whole of society morally and physically degraded to support the aristocracies of wealth and title ? Will you thus allow your wives and daughters to be degraded ; your children to be nursed in misery, stultified by toil, and become the victims of the vice our corrupt institutions have engendered ? Will you permit the stroke of affliction, the misfortunes of poverty, or the infirmities of age to be branded and punished as crimes, and give our selfish oppressors an excuse for rending asunder man and wife, parent and child, and continue passive observers till you and yours become the victims ?

Unless freedom was attained, revolution must follow and ruin and destruction would be the result. The middle class had betrayed the people, Whigs and Tories alike were hostile. Nevertheless the people must not be tempted to *commence* the struggle which the Government was preparing to wage. "We have resolved to obtain our rights peaceably if we may, forcibly if we must."

Then followed a list of " ulterior measures " to be adopted in the event of the rejection of the Petition. This list had been drawn up by a committee from the multitude of suggestions made from time to time by the delegates and others. Most of them were expedients which had been proposed in the height of the Reform Bill struggle eight years before. At every Chartist meeting until July 1, the following questions were to be submitted :

1. Whether Chartists will be prepared, AT THE REQUEST OF THE CONVENTION, to withdraw all sums of money they may INDIVIDUALLY OR COLLECTIVELY have placed in savings banks, etc., and whether at the same time they will be prepared immediately to convert their paper money into gold and silver ?
2. Whether, IF THE CONVENTION SHALL DETERMINE

THAT A SACRED MONTH WILL BE NECESSARY to prepare
the millions to secure the Charter of their political salvation, they
will FIRMLY resolve to abstain from their labours during that
period, as well as from the use of all intoxicating drinks ?

3. Whether, if asked, they would refuse payment of rents, rates,
and taxes ?

4. Whether, according to their old constitutional rights, they
have prepared themselves with the arms of freemen to defend the
laws and constitutional privileges their ancestors bequeathed to
them ?

5. Whether they will support Chartist candidates at the General
Election ?

6. Whether they will deal exclusively with shopkeepers known
to be Chartists ?

7. Whether they will resist all counter and rival agitations ?

8. Whether they will refuse to read hostile newspapers ?

9. Whether they will OBEY ALL THE JUST AND CONSTI-
TUTIONAL REQUESTS OF THE MAJORITY OF THE CON-
VENTION ? [1]

These " suggestions " betray great perplexity on the part
of the Convention. Compared with the incisive character of
the prefatory address, they make an almost ridiculous impres-
sion. They rest largely upon the ill-founded assumption that
the Chartist enthusiasts were everywhere a majority amongst
the working people. They follow the tendency already noted,
to place the responsibility for extreme measures and their
consequences upon the shoulders of the rank and file instead
of the leaders. Behind all, there seems to lie a hope that these
suggestions, by bringing the more reckless and unthinking
Chartists face to face with stern realities, might have a sobering
effect and put an end to the possibility of conflict altogether.
The appeal to arms now takes a secondary place and the
economic weapons, the general strike, a run on the banks, and
boycotting, are put into the first place.

The manifesto and the " ulterior measures " were not adopted
without great division of opinion. Lovett and Harney were
its chief defenders—a curious alliance. Lovett thought it was
the most honest and courageous step to take. The Convention
ought not to go on postponing the decision; it ought to give
a lead to its followers even at the cost of some sacrifice.
Harney was sure it would precipitate the long-wished-for
conflict.[2] There was strong opposition from Halley, Cleave,

[1] *Charter*, May 19, 1839, p. 258.
[2] Place says Harney *opposed* the Address on this very ground (Additional
MSS. 27,821, p. 175), but I prefer my own reading of the matter.

Whittle, and others. Most curious was the attitude of
O'Connor and O'Brien. O'Connor spoke very doubtfully in
favour of the address, whilst O'Brien thought the Convention
ought to make sure of its ground before publishing the mani-
festo. They ought to be certain of the unanimous support of all
Chartists before proceeding with it. Perhaps nothing reflects
more the wavering courage of the Convention than the request
(No. 9) that Chartists should obey the decisions of the majority.
They feared that the personal influence of minority delegates
would suffice to tear away large bodies of Chartists and put an
end to unity. That O'Brien and O'Connor should be forsaking
the paths of violence and precipitancy was more significant
still.

On the 16th it was decided, on the proposition of Marsden
and O'Connor, that any serious step on the part of the Govern-
ment to arrest the delegates should be the signal for the
adoption of the "ulterior measures." Yet Vincent had been
arrested the week before! On the motion of O'Brien and
O'Connor solemn warnings were issued with regard to the
parading of arms in public, and to the avoidance of disorder
at public meetings. Chairmen were to dissolve meetings on
the first sign of tumult.[1] Thus timorously and cautiously did
the Convention enter upon the great Whitsuntide campaign
which was to indicate whether they could safely proceed to
defy Government and society. After three days' sittings in
Birmingham, the Convention adjourned until July 1.

By this time the civil and military authorities had the
situation well in hand, though panic and terror were by no
means diminished. Everywhere special constables were being
sworn in—at Bradford, for instance, to the number of 1835 [2]—
and armed associations sprang up in threatened areas. The
Yeomanry was called up in the rural districts. Magistrates
were beginning to arrest individual Chartists, whenever they
felt safe in so doing. Many were so arrested in Lancashire.[3]
A dozen members of the London Democratic Association were
seized with arms in their hands.[4] There was a riot towards
the end of April at Llanidloes. Hetherington, who had visited
the district shortly before the outbreak, reported that Llanid-
loes and Newtown (Montgomery) were filled with armed
Chartists. As a result of the outbreak a number of Chartists
were arrested. At Derby, Strutt, the famous threadmaker,

[1] *Charter*, May 19, 1839. [2] *Ibid*. May 26, 1839.
[3] *Ibid*. May 12, 1839. [4] *London Dispatch*, May 12, 1839.

fortified his mills with cannon and had a troop of horse in readiness.[1]

It had been generally understood that May 6, the day originally intended for the presentation of the petition, would be the critical day, the commencement of the insurrection. In Lancashire, Monmouthshire, and elsewhere the excitement, terror, and panic rose to a climax during the first week of May. On the 4th, Colonel Wemyss, in command at Manchester, reported: " Two Magistrates from Ashton-under-Lyne came into Manchester this forenoon seemingly in great alarm, and made a requisition for troops. I immediately put a squadron, a gun, and four companies of the 20th Regiment in march on the Ashton Road." It turned out that the magistrates had arrested four Chartists, but the mob had prevented them from sending their prisoners to Manchester.[2] The sending of a force of all three arms in such a case shows how great the tension seems to have been. The Manchester magistrates were not so alarmed as their neighbours in the smaller towns, owing to the presence of Wemyss and his garrison, but they sent in disquieting reports as to the accumulation of arms and the prevalence of drilling. There was a second outbreak at Llanidloes on May 7. One of the delegates for Birmingham, Powell, was arrested.[3] At Monmouth a riot was barely avoided on the arrival of Vincent and Edwards, who had been arrested on the 7th. The Convention sent down Frost to provide legal assistance, and it was probably his personal influence alone which prevented a premature outbreak.[4]

May 6, however, passed without serious events, and attention was concentrated on the Whitsuntide campaign. Napier, in his headquarters at Nottingham, was keeping the situation well in hand, though alarming reports reached him from all quarters. It seems clear from his reports that many of the Chartist rank and file were under the impression that the great Whitsuntide demonstrations were to be of a much more business-like character than the mere discussion of possible " ulterior measures." A fragment of a torn letter was put into his hands, which suggested that ideas of barricades and street warfare were about, and that Whit Monday was the day appointed to begin. At Stone, in Staffordshire, barricades were actually erected.[5] A handbill circulated in Manchester runs thus :

[1] *Charter*, April 28, 1839. [2] Home Office, 40 (43), Manchester.
[3] *Charter*, May 12, 1839. [4] Additional MSS. 27,821, p. 133.
[5] Napier, ii. 12, 27.

Dear brothers! Now are the times to try men's souls! Are your arms ready? Have you plenty of powder and shot? Have you screwed up your courage to the sticking place? Do you intend to be freemen or slaves? Are you inclined to hope for a fair day's wages for a fair day's work? Ask yourselves these questions and remember that your safety depends on your own right arms. How long are you going to allow your mothers, your wives, your sweethearts, and your children to be for ever toiling for other people's benefit? Nothing can convince tyrants of their folly but gunpowder and steel, SO PUT YOUR TRUST IN GOD, MY BOYS, AND KEEP YOUR POWDER DRY . . . Be ready then to nourish the tree of liberty with the BLOOD OF TYRANTS. . . . Now or never is your time: be sure you do not neglect your arms, and when you do strike do not let it be with sticks or stones, but LET THE BLOOD OF ALL YOU SUSPECT moisten the soil of your native land.

> Let England's sons then prime her guns
> And save each good man's daughter,
> In tyrants' blood baptize your sons
> And every villain slaughter.
> By pike and sword your freedom strive to gain
> Or make one bloody Moscow of old England's plain.[1]

As Whitsuntide drew near, Napier became more and more confident that the Chartists would not accomplish much in the way of carrying out their threats. On May 15 he wrote:

The Chartists hardly know what they are at. The people want food and think O'Connor will get it for them: and O'Connor wants to keep the agitation alive because he sells weekly 60,000 copies of the *Northern Whig* [*sic*]. While this lasts he will try to prevent an outbreak. No premeditated outbreak will occur, I think, whilst our imposing force furnishes an excuse for delay: and delay will injure their cause because the deputies are paid and the people are growing weary of the physical-force men.

The second part of this statement shows a better appreciation of the situation than the first. Later on, Napier writes that the orders of the Convention to avoid parading arms at public meetings was due to " funk."

They [the leaders] saw they would be obliged to lead their pikemen in the field, and knowing Demosthenes did not like fighting, they as orators think it not derogatory to follow his example.[2]

The Whitsun demonstrations were carried through peacefully and quietly, but the panic amongst the magistracy and propertied folk was as great as ever. The chief demonstrations were at Huddersfield and Manchester, and meetings of some importance took place at Newcastle-on-Tyne, Mon-

[1] Napier, ii. 29. [2] *Ibid.* ii. 27, 38, 34.

mouth, Bolton, and Sheffield. At Huddersfield O'Connor
was the chief attraction, but the magistrates there said the
affair was poor compared with the previous demonstrations.
At Manchester, on May 25, a crowd, whose number varies from
twenty thousand, according to the *Times*, to half a million,
according to the Chartist papers, marched to Kersal Moor to
hear O'Connor, Dr. Fletcher, Dr. Taylor, and some local
orators. The meeting was wholly peaceable.

Napier was apparently very much afraid of an outbreak in
Manchester and took very peculiar precautions. He heard that
the Chartists had five brass cannon, and purposed desperate
things under the lead of Taylor, who had come down from
Glasgow. He thereupon gave a private artillery exhibition to
a few Chartist leaders with whom he was acquainted.[1] He
also sent a message to the responsible persons to tell them
" how impossible it would be to feed and move 300,000 men ;
that, armed, starving, and interspersed with villains, they must
commit horrid excesses; that I would never allow them to
charge me with their pikes, or even march ten miles, without
mauling them with cannon and musketry and charging them
with cavalry, when they dispersed to seek food ; finally, that
the country would rise on them and they would be destroyed
in three days." [2]

These measures doubtless damped much of the warlike
ardour of the Chartist leaders. Napier and Wemyss went in
person to the Kersal Moor demonstration. His troops had
been strengthened by the 10th Regiment from Liverpool, and
he had promised the magistrates to arrest any one who preached
treason after the meeting had dispersed. Napier's estimate
that the meeting was thirty or thirty-five thousand strong, we
may take to be fairly correct, but he says that not five hundred
of this crowd were seriously bent on mischief.

Wemyss addressed a few of the people in high Tory oratory and
argued with a drunken old pensioner, fiercely radical and devilish
sharp : in ten minutes one-eighth of the whole crowd collected round
Wemyss and cheered him.[3]

The speeches, delivered by the official Chartist orators at this
meeting, consisted largely of eulogies of Henry Hunt and the
Peterloo martyrs. Resolutions condemning the delegates
who resigned from the Convention were passed, as well as
resolutions approving the programme of " ulterior measures."

[1] Napier, ii. 40. [2] *Ibid.* ii. 43. [3] *Ibid.* ii. 39-43.

At Newcastle-on-Tyne, however, where Harney, Dr. Taylor, and other advocates of extreme measures were the speakers, the speeches were censored by the chairman. James Craig spoke of agitating the bricks and mortar, Harney of marching on London, Taylor and Lowery of the advantages of a general strike of colliers.[1] Generally speaking, however, the Whitsuntide campaign gave the authorities little real ground for uneasiness, though the panic, generated by the frequent assemblies of Chartists and the wild rumours which were abroad, was in no way abated.

The campaign was continued throughout June 1839, but there was increasing evidence of disaffection in the Chartist ranks. On May 15 James Craig of Ayr quitted the Convention with leave of absence. He had been regarded as a stalwart and promising leader, but apparently he had lost his nerve. He fell into a sordid squabble with his former constituents about his salary as delegate, and the Chartist body in that neighbourhood was split into fragments.[2] R. J. Richardson resigned towards the end of May because his Manchester supporters were either unable or unwilling to pay him the five pounds weekly which had been promised as his salary. Apparently a rival, Christopher Dean by name, had been preferred to him.[3] Halley, the Scottish delegate, who had always been so powerful an advocate of sober measures, took advantage of the adjournment of the Convention to sever his connection with it, for which, curiously enough, he was denounced in person by Richardson himself.[4] Not only resignations but arrests thinned the ranks of the Convention. About the beginning of June Carrier of Trowbridge was arrested, and on the 8th MacDouall. The latter was committed on the charge of attending a seditious meeting at Hyde towards the end of April, when he had advised his audience to make use of arms if soldiers were called out, sentiments which were greeted with pistol-shots. MacDouall thereupon squabbled with his Ashton constituents, seemingly because he was suspected of desiring that part of the fund raised for Stephens's

[1] *Northern Liberator*, May 25, 1839.
[2] *Northern Star*, September 7, 1839. Additional MSS. 34,245, A, p. 447 ; B, pp. 36, 58.
[3] Dean's credentials : " Stephens Squair (*i.e.* Stevenson Square, Manchester). We the men of Manchester in Public assembled have Duly elected Cristipher Dean, Operative stone Mason, as a fitt and proper person to Represent us in the People's Convention. Sign in be halfe of the meating. William Rushton, Chairman." Additional MSS. 34,245, A, p. 201, April 4. [4] *London Dispatch*, July 7, 1839.

trial should be applied to his own defence.[1] He also quitted the Convention.

The effect of these resignations ought not to be exaggerated. They did not imply entire withdrawal from the movement, for Richardson, Ryder, and MacDouall continued to be very active leaders. In fact the two latter probably resigned because they felt that they could be of much more use in the country than in the Convention. On the other hand, the constant local dissensions, of which more and more is heard from this time onward, could not but have a bad effect upon the unity which was requisite for any effective action. It was frequently reported that the more timid were openly withdrawing from the movement. In the Convention the steady shrinkage had a depressing effect, and the wavering which characterised its earlier proceedings was emphasised in the later. It was finally left to accident and the restlessness of the remaining members to precipitate a crisis.

The Convention met again on July 1 at Birmingham. The next day it was decided to migrate, on July 10, once more to London,[2] a very curious move which is excused, though not at all explained, by the fact that Attwood's motion upon the prayer of the Petition was down for the 12th. On July 3 and 4 the party of violence, led by Dr. Taylor and MacDouall (whose resignation does not seem to have taken effect), began to advocate an early decision upon the adoption of ulterior measures, basing their arguments upon the evidence of readiness supplied by the meetings during the past six weeks. Craig alone seriously questioned the preparedness of their followers, and finally abandoned the Convention. After some very irresolute proceedings, it was decided to put into force the milder of the "ulterior measures," the run on banks, exclusive dealing, the newspaper boycott, and so on, at an early date. The question of a general strike was held over until the fate of the Petition was known. In the minds of the movement party the strike was synonymous with insurrection, for they refused to listen to Lovett's argument[3] that a strike fund should be formed, preferring Benbow's vague but unmistakable reference to the "cattle upon a thousand hills"[4] as the most suitable strike fund.

[1] *Charter,* June 16, 1839; July 7, 1839. See also curious account in *Manchester Guardian,* June 29, 1839.
[2] Moir proposed this: said they ought to be at hand to take every advantage of the embarrassments of the Government and of the Bank of England. [3] Additional MSS. 27,821, p. 283.
[4] See his *Grand National Holiday,* 1831.

The action about which the Convention was debating was precipitated by events which took place in Birmingham on July 4. The return of the Convention had raised the excitement in that town to fever heat. The magistrates had forbidden meetings in the Bull Ring since the beginning of May,[1] and the Chartists had been meeting at Holloway Head, not many minutes' walk away. With the increasing excitement the Bull Ring was again invaded, despite the prohibition. The magistrates therefore sent for a detachment of the Metropolitan Police. The Mayor, William Scholefield, with two other magistrates, proceeded to London and brought back sixty constables.[2] This was on July 4. On arriving at Birmingham about eight o'clock in the evening, they found a meeting in full swing in the Bull Ring. As if to make the earliest use of their new weapon, the magistrates ordered the police to disperse the meeting, which was perhaps a thousand strong. The struggle which ensued was bloody and indecisive until soldiers were brought up. Many of the crowd were armed in various ways, and ten policemen were seriously wounded and taken to hospital. Some dozen armed and unarmed Chartists were arrested on the spot. The magistrates wrote off at once for a further draft of Metropolitan Police, and forty were sent next day. Meanwhile the crowd had reassembled in the Bull Ring, and towards midnight, in spite of the efforts of Dr. Taylor and MacDouall (whose presence was not likely to suggest peaceful behaviour) to dissuade them, the infuriated body began to pull down the wall surrounding St. Martin's Church, which stands at the lower end of the Bull Ring, to use the stones as missiles or for a barricade. The police came up again and arrested the two delegates with seventeen other Chartists. The next morning, Friday, the magistrates mobilised some hundreds of tradesmen as special constables, but nevertheless excited crowds continued to assemble, especially round the Golden Lion Hotel, where the Convention was sitting. The magistrates released MacDouall upon examination, but not Taylor.[3]

[1] Additional MSS. 27,821, p. 112. [2] Hansard, 3rd ser. xlix. 86.
[3] The meeting was undoubtedly illegal. First, because it had been forbidden to hold meetings in the Bull Ring, which was a narrow and confined space, bounded by rows of shops. Meetings there, unless small, were very detrimental to business in the shops. Second, because the meeting was attended by armed men. But there is no doubt that the magistrates acted very hurriedly and recklessly. They did not read the Riot Act or give any warning before attempting to disperse the meeting. Scholefield, the Mayor, said he had always been received with groans on passing the Bull Ring, and he was probably angry and timorous. There were only twenty

These events produced a situation in which Lovett was supreme. Where personal sacrifice was required, Lovett's courage was beyond question. In the excited and half-terrified Convention he brought forward a series of strong resolutions condemning the magistrates of Birmingham.

That this Convention is of opinion that a wanton, flagrant, and unjust outrage has been made upon the people of Birmingham, by a bloodthirsty and unconstitutional force from London, acting under the authority of men who,[1] when out of office, sanctioned and took part in the meetings of the people, and now, when they share in the public plunder, seek to keep the people in social and political degradation. That the people of Birmingham are the best judges of their own right to meet in the Bull Ring or elsewhere, have their own feelings to consult respecting the outrage given, and are the best judges of their own power and resources to obtain justice. That the summary and despotic arrest of Dr. Taylor, our respected colleague, affords another convincing proof of the absence of all justice in England and clearly shows that there is no security for life, liberty or property till the people have some control over the laws they are called upon to obey.

These resolutions were carried without opposition, and it was further decided to have five hundred copies of them placarded throughout the town. Characteristically enough, Lovett insisted that his own signature alone should be attached, so that the Convention should run no risk. Characteristically enough, the Convention was quite willing to sacrifice him. Lovett and Collins, who had acted as chairman at this momentous sitting, took the draft to the printer. The placards appeared on Saturday morning, the 6th. Lovett and Collins were arrested the same day for publishing a seditious libel, hurried before the magistrates, whom Lovett upbraided as traitors to the Chartist cause, and were committed to Warwick Gaol, where they were forthwith lodged.

This was Lovett's hour. He knew perfectly well that the publication of his resolutions was a serious offence, but he wanted to break the law. Against a wholesale insurrection, which might involve the sacrifice of innocent lives, the destruction of property, and the poisoning of social and political feeling, he had always raised his voice in protest. To break a bad law by his own personal act, to vindicate the justice of his cause by his eloquence before the judges and before the world outside, and by suffering with fortitude the punishment

street-keepers, and six or seven constables in Birmingham itself before the new police force was organised. See also *Charter*, July 7, 1839.

[1] The reference is, of course, to the Attwood-Muntz-Scholefield body.

which his action involved, to do all this was Lovett's moral force.
Thus had he resisted the ballot for the Militia in 1831; thus had
the Newspaper Taxes been defied and successfully defied; thus
would Lovett win the Charter. He would be the advocate of
the disfranchised before the bar of public opinion and speak
where his advocacy would be most effective. It was a noble
ideal, but it was the ideal of a martyr, not of a leader of would-
be insurgents. Yet it is not questionable that Lovett accom-
plished more by this sacrifice for the cause of Chartism and the
advance of democracy in England than all those who sneered
at his moral philosophy and brandished their arms when the
enemy was absent. In the history of the first Chartist Con-
vention there is but one cheering episode, and Lovett is its
hero.

The news of the events at Birmingham produced intense
feeling throughout the Chartist world. Lancashire was as
usual the focus of the excitement. On July 2, Wemyss, at
Manchester, reported that one Timothy Higgins of Ashton-
under-Lyne had been found in possession of twenty-seven
rifles and muskets of various descriptions and three pistols.
A placard was posted at Ashton Parish Church :

Men of Ashton, Universal Bread or Universal Blood, prepare your
Dagger Torch and Guns, your Pikes and congreve matches and
all march on for Bread or blood, for life or death. Remember the
cry for bread of 1,280,000 was called a ridiculous piece of machinery.[1]
O ye tyrants, think you that your Mills will stand ? [2]

On July 10 the Manchester Chartists issued a placard calling
a meeting to protest against the introduction into Manchester
of a DAMNABLE FOREIGN POLICE SYSTEM and to
denounce the BLOODY DOINGS of the police at Birming-
ham. The placard is headed in leaded type TYRANNY !
TYRANNY !! WORKING MEN OF MANCHESTER.

The Convention added to the excitement by rushing through
various strong resolutions regarding the immediate resort to
ulterior measures. The National Holiday or General Strike
was still kept in reserve. These resolutions were published in

[1] A reference to the huge bobbin on which the National Petition was
wound.
[2] Napier reports (ii. 62) in the House of Commons that at Wigton the
magistrates were horrified to discover that the persons they had appointed
as special constables had arms and " would soon settle your forty soldiers,
if they are saucy." Of this period he relates thus : " Alarm ! Trumpets !
Magistrates in a fuss ! Troops ! Troops ! Troops ! North, South, East,
West ! I *screech* at these applications like a gate, swinging on rusty
hinges, and swear ! Lord, how they make me swear ! "

the form of placards. On July 10 the Convention, now back again in London, passed a resolution of censure upon the Government for allowing the police to be used for suppressing public meetings.

> This Convention is of opinion that wherever and whenever persons, ASSEMBLED FOR JUST AND LEGAL PURPOSES and conducting themselves without riot or tumult, are so assailed by the police and others, they are justified upon every principle of law and of self-preservation in MEETING FORCE BY FORCE, EVEN TO THE SLAYING of the persons guilty of such atrocious and ferocious assaults upon their rights and persons.[1]

The manifesto of the Convention, embodying the resolution to resort immediately to ulterior measures, appeared in Manchester, on July 12, in the shape of a placard summoning a meeting for the next day " to support the People's Parliament, and to recommend [*sic*] her MAJESTY to dismiss her Present Base, Brutal, and Bloody, Advisers." The placard contains the list of ulterior measures, signed by twenty-seven of the delegates. In heavy print are the recommendations to withdraw money from the savings banks, to run for gold, and to abstain from excisable articles. In smaller and smaller type are the recommendations to boycott and to obtain arms, whilst a reference to the Sacred Month is scarcely legible.

A manifesto against the paper money system was issued by the Convention about the same time.

> The corrupt system of Banking, speculating and defrauding the industrious, had its origin, has been perpetuated, and still form [*sic*] the greatest support of despotism, in the fraudulent bits of paper our state tricksters dignify with the name of money. Through its instrumentality our rulers destroy freedom abroad and at home. Our whole system has been tainted by its pestilential breath. . . . It has created one set of idlers after another to prey upon the vitals of the industrious. . . . It has raised up a host of defenders (who) have induced thousands to assist in upholding their corrupt system, while they are being robbed by that system of three-fourths of their labour.

This was the O'Brien-O'Connor counterblast to Attwood's currency theories. Within a day or two of the publication of this outburst, Attwood was using the National Petition to float his currency notions, and Lord John Russell was refuting him out of the mouths of his own petitioners.

[1] Placard at Bolton, Home Office, 40, 44.

CHAPTER X

(1839)

ON July 12, 1839, Attwood brought forward in Parliament a motion for a committee of the whole House to take into consideration the National Petition. Thus for the first time did the claims of the Chartists receive anything like a reasonable amount of attention from the House of Commons, and the Chartist world waited breathless to hear the result. Attwood's speech was restrained. A good speech it certainly was not. It was the utterance of a crank, who was trying with admirable self-control not to intrude his peculiar ideas into a subject which offered an enormous temptation to do so. He described the origin of the Petition and the rise of the Birmingham Union, the great distress of the operatives and the even greater distress, hidden under a mask of pride, of the manufacturer. He suggested rather than declared outright that this distress was due " to the cruel and murderous operation which had pressed for twenty years together on the industry and honour and security of the country." This was practically his only reference to the currency scheme. He defended the various demands of the Charter as part of the ancient constitution of England, and warned the House against disregarding the prayer of a million operatives. He urged the Commons to grant even part of the Petition—Household, if not Universal Suffrage, Triennial if not Annual Parliaments, to repeal the Poor Law, the Corn Law, and the Money Law. He was convinced that the five points of the Petition must be granted, but, he added in a despondent tone, " he only wished he were equally sure they would produce the fruits that were expected from them," a

160

remark which, if it meant anything at all, meant that from the currency scheme alone was salvation to be expected. It was a speech which the Chartists themselves repudiated. It was a middle-class Birmingham Union speech, not a Chartist speech.

Fielden briefly seconded the motion. Both he and Attwood were guilty of confusing the issues. Both had enlarged rather upon the necessity of relieving misery than upon the question of granting civil and political rights. Each offered his own panacea for the prevalent distress, and so turned the discussion on to side issues. Apart from the manifest absurdity of expecting to cure the many-rooted evils of society by a single remedy, this was a bad error in tactics. The Government spokesman was Lord John Russell, and he seized the advantage thus offered. He attacked not the Petition and not even Attwood's speech, but the views which Attwood was known to hold. It was an unfair attack in a way, for Attwood had scarcely mentioned his favourite theme, and his speech does not contain the word " currency " at all. Russell spoke as one who was enjoying the opportunity of suppressing a bore, which Attwood undoubtedly was. He turned Attwood's theories upside down—a feat which required little skill—and finally produced, to give the unfortunate man his quietus, the recently published manifesto of the Convention on the Banking and Paper Money Systems. Attwood saw in the expansion of the Paper Currency a remedy for all social ills. Not so the Convention, which, led by O'Brien, pronounced that " amongst the number of measures by which you have been enslaved, there is not one more oppressive than the corrupting influence of paper money." Lord John proceeded to demonstrate the impossibility of improving the lot of the labouring classes by legislation, and consequently by universal suffrage. He hinted that the granting of the rights demanded by the Petition would bring about the demolition of the Monarchy, of the House of Lords, and of the institutions of the country in general.

Benjamin Disraeli followed. His speech was the most interesting contribution to the debate. It was an attack upon the reformed constitution, not in the Chartist sense but in the sense of an idealised Toryism. " The origin of this movement in favour of the Charter dated from about the same time that they had passed their Reform Bill. He was not going to entrap the House into any discussion on the merits of the constitution they had destroyed and that which had replaced it. He had always said that he believed its char-

acter was not understood by those who assailed it, and perhaps not fully by those who defended it. All would admit this : the old constitution had an intelligible principle, which the present one had not. The former invested a small portion of the nation with political rights. Those rights were entrusted to that small class on certain conditions—that they should guard the civil rights of the great multitude. It was not even left to them as a matter of honour ; society was so constituted that they were entrusted with duties which they were obliged to fulfil. They had transferred a great part of that political power to a new class whom they had not invested with those great public duties. Great duties could alone confer great station, and the new class, which had been invested with political station, had not been bound up with the great mass of the people by the exercise of social duties." Disraeli's insight was not at fault. There is no doubt that the Chartist Movement does reflect a certain decline or change in social sympathies which the economic revolutions of the two generations previous had brought about. To this extent Disraeli was right in declaring that the Chartist Movement arose neither out of purely economic causes nor out of political causes, but out of something between the two, that is, to a lack of the lively interest taken by each class in the welfare of others, which Disraeli supposed to be the peculiar merit of pre-1832 society. As a matter of fact, that clever orator might have been embarrassed to declare at what exact period his ideal society had existed, for the aristocracy had taken its full share in breaking down the old social bonds. " The real cause," said Disraeli, " of this, as of all real popular movements, not stimulated by the aristocracy . . . was an apprehension on the part of the people that their civil rights were invaded. Civil rights partook in some degree of an economical and in some degree certainly of a political character. They conduced to the comfort, the security, and the happiness of the subject, and at the same time were invested with a degree of sentiment which mere economical considerations did not involve." To Disraeli, therefore, civil rights consisted in the claims of the less fortunate upon the more fortunate classes of society. These claims had been ignored, for instance, by the introduction of the New Poor Law, which, though not the cause of, was yet closely connected with, the Chartist Movement. In the passing of that measure both sides of the House were culpable : they had " outraged the whole social duties of the State, the mainstay,

the living source of the robustness of the commonwealth."
" He believed that the Tory party would yet rue the day
when they did so, for they had acted contrary to principle—
the principle of opposing everything like central government
and favouring in every possible degree the distribution of
power." In short, Disraeli was preaching a feudal ideal, with
patriarchal benevolence as the basis of social relations. But
such an ideal was impossible in those days, when an industrial
working class and an industrial middle class had come into
existence. This middle class, Disraeli maintained, was the
basis of the new constitution. It had received political station
" without making simultaneous advances in the exercises of
the great social duties "—a charge by no means devoid of
truth. Hence it was detested by the working classes. The
trial of Chartist leaders before the Birmingham magistrates
had demonstrated that. " He was not ashamed to say, how-
ever much he disapproved of the Charter, he sympathised
with the Chartists. They formed a great body of his country-
men : nobody could doubt they laboured under great griev-
ances, and it would indeed have been a matter of surprise,
and little to the credit of that House, if Parliament had been
prorogued without any notice being taken of what must
always be considered a very remarkable social movement."
Disraeli concluded with a characteristically scathing denuncia-
tion of the Ministry, and gave place to the honest but prosy
Hume. His speech is well worthy of study. Had he been
possessed of constructive genius equal to his insight, Disraeli
would have been a statesman indeed. But there was in his
speech too great an air of detachment ; it was too objective,
regarding Chartism as an interesting phenomenon of which
he alone had grasped the true meaning, and not as a tremen-
dous human convulsion involving the welfare of a million
struggling and despairing beings ; an affair of flesh and blood,
of bread and butter, not an affair of party politics or Tory
Democracy.

Hume made a brave speech in favour of the Charter, but
O'Connell declared that the Chartists had ruined the Radical
cause by their insane and foolish violence, whereby they had
alienated all the middle class. Several other speakers followed,
but, apart from Russell and Disraeli, scarcely any who voted
against the motion took part in the discussion. Summer
days are scarcely suitable for serious debate, and members
were not interested. The ignominious fall and still more

ignominious restoration of the Government had scotched political interest generally. Hume and Attwood led 46 followers into the lobby, but five times as many—to be exact, 235— mustered against them. The Petition was dead, slain by the violence of its supporters, the tactlessness of its chief advocates, the inertia of conservatism, and its own inner contradictions.[1]

The Petition was dead, but Chartism was yet alive. The rejection of the Petition had long been foreseen, but its actual demise left the way clear for the decision on Ulterior Measures about which the Convention had boggled so long. The delegates had now to make up their minds, and that quickly. The excitement throughout the country was higher than ever. The approaching trials of various leaders—Stephens, Lovett, Vincent—the constantly increasing number of arrests, both of leaders and rank and file, all helped to make the tension greater. On the other hand, the gradual shrinkage in the Convention and the undoubted secession of moderates in the country required that some heroic decision should be taken at once, before the repute and prestige of the Convention were wholly destroyed.

Immediately after the rejection of the motion of the 12th, Fielden and Attwood suggested that the Convention should organise another petition, which suggestion the Convention rejected forthwith, thereby breaking finally away from the Birmingham leaders—and in fact from the Anti-Poor Law leaders too. Instead, the Convention now drew from its armoury its most potent weapon—that of the General Strike, the " National Holiday " or " Sacred Month."

The question was brought forward on July 15, a day already fixed for the discussion. Thirty delegates were present. O'Brien, O'Connor, and Dr. Taylor were absent, a fact upon which Carpenter commented bitterly, for it was these men who had made the largest promises to their followers and the strongest threats to the Government. Marsden opened the debate in favour of the strike. Marsden was a desperately poor weaver, who had horrified his audiences with his description of the sufferings of his fellow-weavers. A strike was nothing to him, to whom both work and play alike were synonymous with starvation. His passionate demand for action was answered by James Taylor, the Methodist Unitarian minister of Rochdale, and Carpenter, who showed with absolute clearness how little their followers were prepared for a strike. Their argu-

[1] Hansard, 3rd ser. xlix. 220-78.

ments were not answered. Most of the delegates supported the strike because they did not know what else to do. Having raised such expectations in the minds of their followers, they felt that they must do something to justify themselves. They could not bear the thought that they had deceived themselves as well as their constituents, and so let themselves drift into a general strike without knowing in the least how it was to be conducted. Of preparations involving funds, food, stores, they would not hear ; they would live on the country like an invading army. To them a strike was one thing, a general strike quite another thing. Yet for a general strike of this insurrectionary description they discussed no preparations, though the complicated arrangements of an ordinary strike were simple in comparison with those requisite for such a desperate venture. In fact, one is driven to the conclusion that the Convention delegates decided to recommend a general strike, partly because they had to decide on something and partly because they knew that it was impossible.

After two days' discussion it was resolved by thirteen against six votes (five abstentions) to recommend the commencement of the National Holiday on August 12. Thus the weightiest decision of the Convention was carried by one quarter of its original strength. The next day a Committee was appointed to promulgate the decree. Trade Unions were to be asked to co-operate. Eight delegates, sitting in London, were given a month in which to organise a national stoppage of industry in a land where industry was stopping of its own accord, in a land where only a strike of agricultural labourers could have had much effect, in a land where men, women, and children were begging to be allowed to work even for a pittance. As if to show how topsy-turvy its ideas had become, the Convention adopted an address urging the middle class to co-operate in this measure.

Whilst the Convention was thus engaged, the Chartist cause received irreparable injury through a riot which took place on the 15th of July, again at Birmingham, where the presence of the London police was a source of extreme exasperation, not merely to the Chartists and the numerous enemies of the newly formed Corporation,[1] but to the majority of the Council itself.

[1] In some newly incorporated towns, like Bolton, Manchester, Birmingham, there was a strong conservative faction which had opposed incorporation, and thwarted the new municipal bodies to the utmost of its power. The Chartists received much countenance from this factious body, especially in the matter of opposing the introduction of a police force. These facts help to explain the weakness of the borough councils at times like this.

In the early evening crowds began to assemble in the vicinity
of the Warwick Road in the hope of greeting Lovett and
Collins on their release on bail from Warwick Gaol. The two
heroes, however, avoided the ovation, and the disappointed
crowd rushed into the Bull Ring, where the police were stationed
in the Public Office. The Public Office was attacked, and the
police, having apparently learned caution, refused to retaliate
without express orders. For more than an hour the rioters
were undisturbed. They smashed the street lamps, and tore
down the iron railings of the Nelson Monument which stands
at the lower end of the Bull Ring. With the weapons so
obtained they began to force their way into the shops. A tea-
warehouse and an upholsterer's shop were sacked and a bonfire
made of their contents ; other shops shared the like fate.
There was no looting ; destruction, not plunder, was the order
of the day. At a quarter to ten the London police began to act.
Their chief, assuming that the Mayor alone could authorise
action, had spent over an hour in bringing him and other
magistrates on to the scene of the riot. The police, reinforced
by infantry and cavalry in considerable numbers, then suc-
ceeded in dispersing the crowd, after which their energies were
employed in extinguishing the fires which the rioters had
started. The two shops first attacked burned till past midnight.
What with their careless haste on July 4 and their stupidity
on the 15th, the newly appointed Birmingham magistrates
had made a very inauspicious start in their official careers.[1]

Such ebullitions as these could hardly be viewed with com-
posure by the Convention. To control such reckless forces
was a task which a Convention of Napoleons would have
attempted with misgivings, and the Chartist Convention was
rapidly losing its nerve. For some time it must have been
aware of a gradual secession of the moderate party amongst
its followers from those who followed counsels of violence, and
this schism was widened by the decision to adopt the general
strike. Hitherto this secession had been viewed in the light
of a beneficial purge, the moderates being regarded (probably
with no good reason) as a minority, but gradually the con-
viction grew that the division which existed was one which
was likely to rend the whole Chartist body in pieces. A curious
example of this loss of nerve is afforded by a letter dated
July 21, addressed by R. J. Richardson to the Convention.[2]
This man, the verbose, pedantic retailer of bad law, the one-

[1] Hansard, 3rd ser. xlix. 447. [2] Additional MSS. 34,245, B, p. 53.

time terror of moderates, and the enthusiastic advocate of arming, now regrets that he is no longer a member of the Convention, as there never was a time when prudence and caution were more requisite in its debates. He will offer advice. He considers the decision to hold the National Holiday undigested and ill-timed. The Convention had not even reviewed their resources, but had relied upon false and exaggerated reports. In the South of England there was no following. Even in Manchester, the faithful stronghold, the Chartists could not make an effective strike; the hands were on half-time; many have petitioned to be allowed to work longer. The employers were praying for the Convention to order a strike so as to be relieved of the necessity of locking their workpeople out altogether. Liverpool is still less hopeful. Neither Yorkshire nor Scotland was much better. The National Holiday is hopeless, and would only "bring irretrievable ruin upon thousands of poor people, while the rich would not suffer in comparison." Thus did Richardson find wisdom.

The Convention found wisdom also. On Monday, July 22, the Convention met to hear O'Brien's views upon the National Holiday. He had been absent the previous week, and now moved that the decision then taken be rescinded. In his speech he made the best of a bad job. He had been one of the stalwarts of the physical force revolutionaries. Now he was compelled to recognise that all the assumptions on which his former views rested were false, and it required no little courage on his part to make his confession that both he and the majority of the Convention had been deceivers and deceived. Whilst still retaining a belief in the general strike as the ideal political weapon, O'Brien declared that the Convention was incompetent to wield it. They were not unanimous or at full strength. Their followers in the country were not unanimous, and therefore the strike would be a ghastly failure. The Convention, therefore, ought not to advise so dangerous a proceeding, but leave the matter to the people, "who were the best judges after all, whether they would be able to meet the exigencies of a strike, and he would prefer that the Convention should leave the holiday to the people themselves, and at the same time tell the people that nothing but a general suspension of labour could convince their oppressors of the necessity of conceding to them their rights." Surely a miserable exhibition of leadership! Phrases like " pregnant with such dreadful consequences for

which the Convention would be morally, if not legally, responsible " do not sound well in the mouth of one who had long been damning the consequences. Nor was the solicitude for the followers, but for the delegates themselves, to whom prison and Botany Bay were becoming dreadful realities.

On this the Convention proceeded to an orgy of recrimination. One fact was clear: the delegates had grossly exaggerated their following and influence. Now they sought to blame each other for it. Neesom and MacDouall especially came in for abuse. O'Connor spoke both for and against the motion in a speech of which Fletcher said he could not make head or tail. Fletcher said that the Convention would now listen to his advice, to win the middle class to their side. Poor Fletcher had had enough of Chartism. He was an Anti-Poor Law man who had got into troubled waters. Duncan said those who voted for the Holiday ought to carry it through. Skevington and MacDouall protested against the motion as cowardly, but the former voted for it and the latter abstained. Half a dozen delegates alone had the courage to vote against the motion, twelve voted for it, and seven were too perplexed to vote at all. The formal result was the appointment of a Committee to take the sense of the people upon the question of a general strike ; the real result was the suicide of the Convention and the temporary collapse of the whole movement.[1]

The Committee which was thus appointed obtained a number of replies, which are preserved in the letter-book. J. B. Smith writes from Leamington in fierce reproach. If the holiday is begun, will the Convention be ready to control the idle workmen ? Will the strikers not assume that they have the Convention's permission to pillage and plunder ? Why had the Convention never talked of saving money for Ulterior Measures instead of talking so much about arms and force ? From Sheffield came a better report, but not encouraging. Coventry was decidedly against the strike. Colne reported that " the principal obstacle in the way of the holiday arises from those operatives and trades who are receiving remunerating wages for their labour, and whose apathy and indifference arise more from ignorance of their real position than an indisposition to benefit their fellow-men." At Preston, a supposed physical force stronghold, the Chartists could do nothing to further the strike as the trade societies refused to help. Neither Rochdale nor Middleton was decidedly favourable

[1] *London Dispatch*, July 28, 1839 : *Charter*, July 28, 1839.

to a strike. The Convention, and especially O'Connor, has forfeited all respect, and the people know not whom to trust, reports James Taylor.[1] Richards from the Potteries sends no encouragement; Knox from Sunderland none. Hyde, a regular Chartist arsenal, requests Deegan to withdraw his vote for the strike. Some places which favoured a strike wanted others to give the lead. Huddersfield and Bath protested against the abandonment, but these were isolated instances.[2]

Two communications from the North exhibit the local divergence of views which perhaps existed in nearly every important Chartist locality towards the end of July. On the 21st the Northern Political Union addressed a threatening manifesto to the middle classes, urging them to join the working people against the boroughmongers and aristocracy. If the middle class allow the aristocracy to put down Chartism, the working people " would disperse in a million of incendiaries," and warehouses and homes would be swallowed up in one black ruin ! This address, which was probably the work of O'Brien, landed most of its signatories in gaol. On the 20th Robert Knox, the delegate for Durham, published an address to the middle classes in exactly opposite terms, comparing Capital and Labour to the two halves of a bank-note, each useless without the other. Knox said that the possession of political power by the middle class has hitherto tended to obscure this fact of mutual dependence. These addresses were both communicated to the Government by local authorities.[3] When leaders were so divided, it is no wonder that followers were perplexed.

The failure of the strike policy throws an interesting light upon the status of the Chartist rank and file. It is clear that the trade societies as a whole stood outside the Chartist movement, though many trade unionists were no doubt Chartists too. The societies could not be induced to imperil their funds and existence at the orders of the Chartist Convention, and without the organised bodies of workmen the general strike was bound to be a fiasco. The workmen who could be relied on to participate in the strike were precisely those whose economic weight was least effective — handloom weavers, stockingers, already unemployed workmen of all sorts. The colliers, it is true, labouring under special grievances, might

[1] O'Connor had written an article in the *Northern Star*, July 27, dissuading Chartists from the strike policy.
[2] Additional MSS. 34,245, B, pp. 38, 110, 119, 123, 125, etc.
[3] Home Office, 40 (51) and (46).

have made a very effective striking body, but they were precisely the people who preferred armed insurrection. In fact, those Chartist leaders who advocated insurrection had at least logic and consistency on their side. Their policy was likely to be at least as successful as a strike, and they did make preparations for it. In fact, it is hard to escape the impression that the apparent indifference, displayed towards the doings of the Convention about this time by certain of the former advocates of insurrection, was due to the fact that they were busy organising a revolt, and that the appeal of the Convention was only to a middle party amongst their followers, which had neither the wisdom to be moderate nor the courage to be rebel.

The same procedure was now adopted as in the previous instance, when the Convention shirked a decision upon Ulterior Measures. It published an address in which it congratulated itself that it had discovered the error of proposing a general strike, announced nevertheless that the project was not abandoned, and then adjourned for a month to give the delegates time and opportunity to direct the movement and complete the preparations. There was no further meeting till the end of August.

In this interval the great movement died away. The local authorities, backed up by Government, made wholesale arrests of Chartists for illegal possession of arms, for attending unlawful meetings, for sedition, and for many other offences, reaching, in the case of three who were arrested at Birmingham for participation in the fight with the Metropolitan Police, to high treason, for which they were condemned to death, the sentence being commuted to transportation. No less than a score of members of the Convention were arrested during the summer months of 1839, and a vast number of the rank and file. Among these were Benbow,[1] the fiery old advocate of the National Holiday; Timothy Higgins of Ashton-under-Lyne, who had a regular arsenal in his cottage; and the whole of the leaders of the Manchester Political Union[2] and the Northern Political Union of Newcastle.[3] There were several abortive attempts, especially in Lancashire, to put into force the National Holiday in spite of the official abandonment of that measure, and they led to more arrests.[4] Wholesale trials followed. At Liverpool some seventy or eighty Chartists were brought up together; at

[1] *Northern Liberator*, August 17, 1839.
[2] *Manchester Guardian*, August 3.
[3] *Northern Liberator*, August 3, 1839.
[4] *Manchester Guardian*, August 14, 1839.

Lancaster, thirty-five;[1] at Devizes, twelve. At Welshpool thirty-one Llanidloes rioters were tried, the sentences ranging from fifteen years' transportation to merely binding over to keep the peace.[2] At Chester Higgins, MacDouall, and Richardson were brought before the Grand Jury, which returned true bills for various charges. Only occasionally did the Chartists make any attempts to put a stop to the course of prosecution. A policeman who was to be a witness against Stephens was half-murdered in Ashton,[3] whilst the Loughborough magistrates were compelled to release two prominent Chartists because their followers terrorised all likely witnesses.[4] Generally speaking, the prosecutions went on unhindered. The Convention busied itself with a Defence Fund, and local subscriptions were set on foot for the purpose of procuring legal aid. This appeal met with no great response. The enthusiasts still preferred to devote their savings to the purchase of arms, whilst the others were unwilling to spend theirs on such worthless rogues as, for example, Brown, the Birmingham delegate, who, before his arrest was conspicuous for his absurd violence, and afterwards begged and prayed the Convention " not to let him be sacrificed." [5]

Two trials at this time provoked more than ordinary interest : those of Stephens at Chester, and Lovett and Collins at Warwick. Stephens defended himself in a speech lasting five hours. It was a very bad defence. In spite of the fact that he had been arrested for attending an exceedingly riotous Chartist meeting, he devoted his speech to a long denunciation of Carlile, Paine, Bentham, and Radicalism generally. He denounced the prosecuting counsel, the Attorney-General, in set terms, and declared that he had been a victim of persecution. Stephens cut a really bad figure, and with his trial and imprisonment he disappeared from the Chartist world, except for one brief reappearance in opposition to his former colleagues, at Nottingham in 1842. He was sentenced to eighteen months' imprisonment in Knutsford Gaol, but was transferred to Chester Castle, where he was handsomely treated.

Very different was Lovett's defence. He was charged with publishing a false, scandalous, and inflammatory libel. Lovett admitted the libel and the publication, but pleaded

[1] *Northern Liberator*, November 16, 1839.
[2] *Charter*, July 21, p. 415. [3] *Manchester Guardian*, July 10, 1839.
[4] Home Office, 40 (44), July 25.
[5] Additional MSS. 34,245, B, pp. 61-2, 68.

justification. He made no real defence, but made use of the
opportunity to vindicate the principles for which he was
willing to suffer imprisonment. He had evidently prepared his
speech with great care. It was a very good speech indeed, and
drew forth unstinted praise from the prosecuting counsel, who
refused to believe that Lovett was a working man. Lovett
appealed to a greater tribunal than that before which he was
brought to trial. " Public opinion," he said, " is the great
tribunal of justice to which the poor and the oppressed appeal
when wealth and power have denied them justice, and, my
lord, it is for directing public attention to a flagrant and unjust
attack upon public liberty that I am brought as a criminal
before you." [1] Collins was defended by Serjeant Goulburn.
Both received the same sentence, twelve months' imprison-
ment. They spent their time partly in agitating against the
harshness of the prison rule, in which they achieved some
success, and partly in writing their famous pamphlet on
Chartism. The spirit in which Lovett endured his imprison-
ment may be divined from the following passage, written to his
wife on October 1, 1839 :

> In your letter before last you intimated that Mr. Place was still
> making some exertions on our behalf. Now, my dear girl, while I
> have no great partiality for being in a prison, I have no inclination
> to get out of it by anything that can in any way be construed into
> a compromise of my principles.[2]

He might have been released on giving a pledge to keep out
of politics.

These prosecutions had a very depressing effect upon the
Chartist cause, and the reputation of the Convention sank
lower and lower. It had scarcely accomplished anything, and
the great expectations with which it had commenced had come
to nothing. The arrest and imprisonment of so many leaders
produced a feeling of helplessness which damped all enthusi-
asm. From all parts of the country came reports of hope-
lessness, disappointment, and dissension, and when the Con-
vention met for its last sittings at the end of August, it met
merely to dissolve in ignominy.[3] Dr. Taylor proposed the
dissolution of the Convention. He had already denounced
many of his colleagues as a pack of cowards, and he now pro-

[1] Trial, published by Hetherington. (Manchester Free Library, H. 154.)
[2] Place Coll., Hendon, vol. lv. p. 72.
[3] Lowery on September 5 reported his mission to Ireland, which was a
total failure, ascribed to O'Connell's influence.

posed to exclude them all from re-election by a self-denying ordinance. The debate resolved itself into a fierce altercation between Dr. Taylor and Harney on the one side and O'Connor and his " tail " on the other. The recriminations show how deep the local dissensions had gone. Finally the motion to dissolve was carried. The Convention then plunged into a sordid and squalid squabble about money matters. It appears that O'Connor had been using his wealth, derived of course from the enormously increased sales of the *Northern Star*,[1] to buy up a following in the Convention, and even to subject the whole body to his influence by offering himself as security for various objects. This policy he pursued until he became the absolute ruler of the Chartist world. The accounts seem to have been kept with gross carelessness, and money voted with great laxity. In this atmosphere of recrimination, squabble,[2] and intrigue the great Chartist Convention disappeared. It left two Committees, one, of which O'Connor and Pitkeithly were the chief, to dispense the sum of £429, available for the Defence Fund, and another to draw up the valedictory address. The latter produced three addresses : one fiery, dictated by Dr. Taylor; one mild, composed by O'Brien; and one compromising. None of them was published; the Convention was to the last incapable of any decision.

[1] 1838 : average sales per week, 10,900 ; February–May 1839 : average, 48,000—a fact which gives colour to belief that O'Connor deliberately prolonged the Convention so as to keep up circulation. O'Connor proposed (*Northern Star*, September 21, 1839) to pay for another Convention out of his own pocket.

[2] A curious feature of these squabbles was that Fletcher, an Anti-Poor Law stalwart, declared that the Charter had been put forward by the supporters of the hated Act to capture the Anti-Poor Law agitation (*Northern Star*, October 19, 1839). He even hinted at Government agency.

CHAPTER XI

IT is hard to resist the notion that the Chartist Convention had already ceased, long before its dissolution, to be the focus of interest, at least on the part of the more thoroughgoing Chartists.[1] Even those who believed in constitutional methods were tired of the succession of resolutions which were not carried out, and of debates which left things much as they were before. Since the Whitsuntide campaign and the Birmingham riots, there seems to have been a notable decline in Chartist oratory and public meetings. The moderates were tending to desert, whilst the extremists were adopting quite different methods. Secret meetings on a considerable scale were now heard of in various places—meetings of small groups in private houses. There had been also notable withdrawals from the Convention of leading advocates of violence. Rider, Harney, and Frost had long ceased to take active part in its deliberations, though it was known that they were busy in various districts. A strong propaganda of violence was being carried on, but less openly. Cardo, Hartwell, and Dr. Taylor were conspicuous in this. Harney was not less active. The nervousness, not to say panic, exhibited in the latter debates of the Convention, suggests that there was some knowledge and no little apprehension of the existence of secret forces working towards violent extremes. Wemyss at Manchester reported in July 1839 that the ostensible leaders were being pushed on from behind by others who might precipitate an outbreak in

[1] The Scottish Chartists had wholly withdrawn from the English movement as early as August, when a Scottish delegate assembly drew up the plan of a separate organisation. *Chartist Circular*, preface.

spite of the obvious unpreparedness of the nominal leaders.[1]
This has special reference to the preparations for the National
Holiday, but it no doubt indicates a state of affairs which
was becoming more and more general. John Frost, the un-
fortunate Newport rebel, is alleged to have declared that he
was compelled against his will to undertake the leadership.

The Newport Rising was the climax of this secret prepara-
tion. On the early morning of November 4 a body of some
three thousand colliers [2] under the leadership of John Frost
marched in a single column upon Newport (Monmouthshire).
In the centre of the town the head of the column was unex-
pectedly brought up by a small body of soldiers in the Westgate
Hotel, covering the line of advance. A few Chartists were killed
and wounded, and the remainder dispersed without coming
into action.

Round this event stories and rumours of every description
gathered. On the Chartist side no reliable account has ever
been published. The matter became a subject of violent re-
crimination amongst the Chartists in later years, and the
truth, known in the first instance to very few, was obscured by
charges and counter-charges until the task of estimating the
true significance of the event becomes well-nigh impossible.

One non-Chartist account may be given first. It comes
from David Urquhart,[3] who had been in the British Diplomatic
Service in Constantinople, and had thereby become a furious
anti-Russia fanatic, and saw in the Chartist insurrection of
1839 one more sample of Russian intrigue. He claimed to
have derived his information from authentic Chartist sources.
In this there is truth, but his information is so coloured by his
peculiar notions that the story appears quite fantastic.

Urquhart begins with an account of the origin of the
Chartist movement. It was set on foot as a result of a com-
pact between Hume and Place, in order to counteract the Anti-
Poor Law agitation. The movement quickly attracted ad-
vocates of violence, amongst whom Dr. Taylor, Harney, and
one unnamed (probably Vincent) were the chief. These, how-
ever, were not the real leaders of the conspiracy, which was
organised by men of genius. It was so marvellously designed
that it betrayed the hand of past-masters in the art of secret
revolution. So excellent was the plot that no Englishman

1 Home Office, 40 (43); *Manchester Guardian*, July 30.
2 Estimates of the number vary extraordinarily. The affair, it must
be remembered, took place in the dark.
3 *Diplomatic Review*, July 1873.

could have excogitated it. It was of foreign origin. It was, in fact, modelled on the Greek Hetairia, and Russian agents were at the back of it. The chief of these agents was Beniowski, an alleged Polish refugee, who, however, was a former member of the Hetairia. A secret insurrectionary committee of five was appointed to direct the organisation. Cardo, Warden, Westrapp, and another, who was a high police official, were also members. Cardo and Warden were men of the highest genius, the one a Socrates and the other a Shakespeare.

A general rising was planned for the end of the year. One hundred and twenty-two thousand armed and partially trained men were ready, and a Russian fleet would provide munitions. Beniowski was to command in Wales, where apparently the main rising was to take place. Urquhart, however, got wind of the plot in time to put a stop to it. He convinced Cardo, Warden, and Dr. Taylor (who was to have some part in the plot) that they were the victims of a Russian *agent provocateur*, and persuaded them to abandon it. Frost, however, he did not reach in time, and so could not save him.

Feargus O'Connor was not involved in the affair at all, as he was regarded as too cowardly and unreliable. He was only concerned with the circulation of the *Northern Star*. This on the information of a member of the Convention of 1839—perhaps Cardo.

So much for Urquhart's story. It forms the source of the very unsatisfactory narrative of Thomas Frost,[1] a Croydon man who came into the Chartist movement in its last stage, eight years or so after the events at Newport. Frost appears to give much credence to Urquhart's story, but adds nothing to it. The narrative of Gammage [2] is more circumstantial even than Urquhart's. Gammage came into the movement about 1842, and later developed into a thoroughgoing opponent to O'Connor. His account is published with a view to blackening O'Connor, and is based upon the revelations of one William Ashton of Barnsley. These latter were made public in 1845 [3] in the midst of fierce attacks upon O'Connor, then Chartist dictator, and purported to be damning evidence of O'Connor's treachery in connection with the affair. There is a further account by Lovett,[4] but it is of no great value. Lovett was in

[1] *Forty Years' Recollections*, London. 1880, pp. 102 *et seq.*
[2] *History of the Chartist Movement*, 1854, pp. 282 *et seq.*
[3] *Northern Star*, May 3, 1845.
[4] *Life and Struggles*, pp. 239-40.

prison at the time of the rising, and his account was not published till 1876.

All these not altogether trustworthy accounts have one thing in common, that a general rising of some kind was projected, and that the outbreak in Wales was to be the signal. There was a committee in Birmingham and another with its headquarters at Dewsbury in Yorkshire. The head committee was no doubt in London. Dr. Taylor, Frost, Bussey, and Beniowski are mentioned as the chiefs of the affair. Taylor was to take the lead in the North, Bussey in Yorkshire, Frost and Beniowski in Wales. It should be noted, however, that if we take into consideration *all* the accounts of this projected rising, practically no prominent and unimprisoned Chartist's name would be omitted from the list of the reputed leaders of the alleged rising.

Of the activities of these men and of the local committees we have little or no information previous to the Newport affair. Beniowski was a Polish refugee, and followed the not unusual career of revolutionary intrigue. He was a fine, tall, aristocratic-looking man of considerable talent and energy. He appears to have been a prominent member of the London Democratic Association, which was saturated with the sentiments of French revolutionaries. He was in receipt of a pension of £3 a month from the British Government as trustee for a fund for the support of Polish refugees. In May Lord John Russell ordered this to be stopped, on information regarding Beniowski's behaviour.[1] Evidently the Government had been keeping him under surveillance. All accounts assign to Beniowski one of the chief places in the plot. Of his doings nothing is known definitely until after the Newport affair, though it is probable that he was actively engaged in the military preparations.

Frost had been sent back into the district early in May, when the news of Vincent's arrest was known. He was a Newport man and the leader of the local Chartists, and had been town councillor, mayor, and justice of the peace. But early in 1839 Lord John Russell had removed him from the Commission of the Peace by reason of his seditious language at meetings. This mild martyrdom had greatly increased his local popularity. After the collapse of the Convention he threw all his energies into organising violent proceedings in Newport and the neighbouring coal-mining valleys of

[1] Home Office, 40 (44), Metropolis.

Monmouthshire. The result was the most formidable manifestation of physical force that Chartism ever set on foot.

The idea of a rising had been mooted early in the year, but the lack of preparation, which had scotched the general strike, had brought about a postponement. When Vincent had been lodged in Monmouth Gaol the notion of rescuing him by force seems to have been entertained, but the evidence given at the trial suggests rather that the immediate purpose of the local rising was to give the signal to the other confederates, the rescue project remaining in the background. One story, that the non-arrival at Birmingham of the mail-coach, which passed through Newport, was to be the signal for action in the Midlands, may well be true, for there was a committee at work in Birmingham, of which Brown, the ex-delegate, one Parkes, Smallwood, and Fussell were apparently the chiefs. They held secret meetings, which, however, were not unknown to the police, whose agents tried in vain to obtain admission. The Birmingham magistrates had already issued an order that all makers of munitions must deposit their stocks in the barracks. Drilling and training were carried on, and communication was kept up in a kind of cipher. Whenever any suspicious persons entered the meetings, a semi-religious character was imparted to the gathering. The Chartists at Birmingham seem to have had a friend at court in one of the magistrates, who gave them warning of police activity, but they suffered greatly from the attentions of spies employed by the new police commissioner in the city. Fussell and Harney himself remain under grave suspicion in this connection,[1] and a serious attempt was made to corrupt Parkes.

Beyond this there is little information as to the preparations for the rising of which Frost's was to be the beginning. The Newport affair was planned and carried out with great secrecy. The conditions were favourable. In the scattered and lonely colliery villages amongst the hills the hand of authority was almost unknown, and it was easy to preserve secrecy. It was known that the available military force was small. There was a tiny detachment at Newport, a larger body, two companies, at Abergavenny, about eighteen miles—a day's march —away, and a still larger force at Newtown in Montgomeryshire, which, by reason of its remoteness, was quite out of

[1] There is in the Home Office papers a letter from the Birmingham police commissioner which throws much suspicion on Harney. When Harney was charged at Birmingham with sedition, no evidence was offered, and he was discharged! (*Northern Liberator*, April 11, 1840).

relation to the South Welsh movement. Armed associations had been formed at Newport under the suggestion of Lord John Russell. All things considered, the military and civil force was not such as could have offered much resistance to a carefully planned attack. The affair was planned with a certain modicum of military technique. Reconnaissance of a sort was made, and outposts were stationed to arrest strangers and prevent news from reaching the town. So good were the preparations that no precise information appears to have filtered through until the Chartists were actually assembling for the march, on the evening of November 3. The chief rendezvous was the mining village of Risca, on the Ebbw, six miles north - west of Newport. It was intended to occupy the town during the night, hold up the mails, thus giving the signal to the other districts, and then to march on Monmouth to release Vincent. The force which is said to have assembled was much larger than the authorities expected. One part was apparently told off to block all exits from the town and to hold off reinforcements and relief, whilst the other smaller body, variously estimated at one to ten thousand strong, marched into the town. Thomas Phillips, the energetic Mayor of Newport, who took a prominent part in the fighting, says the Chartists were organised in sections of ten under a section commander, and the marching column occupied a mile of road—perhaps 3000 men, as untrained troops would straggle in marching. Perhaps the *Morning Chronicle's* estimate of a thousand is the best. Such a force would be ample to overpower what was then a small town with a garrison of twenty-eight soldiers.

Night operations are naturally the most difficult of military undertakings, and even with trained forces the utmost care is required to avoid loss of direction, delays, noise which will betray, and to ensure the exact co-ordination of the various parts of the scheme. This affair was naturally bungled. A brewer named Brough relates his experiences. He was seized by a patrol on the Pontypool road at half-past nine on Sunday evening, November 3, and marched about for eight hours until Frost ordered his release. There was much marching and counter-marching; some detachments had marched all night; and a great deal of time was wasted. Instead of reaching Newport at 2 A.M., it was nine o'clock and broad daylight when the column attained its objective. The authorities had been warned of the assembling of armed bodies in the hills

by the arrival in the town of terrified refugees who escaped the Chartist sentries. It was the same at Abergavenny, where there was no little panic. At Newport the troops had been lodged in the Westgate Hotel, fronting the main street and covering the Chartist advance. As the insurgents debouched opposite the hotel there was a fierce burst of musketry. The colliers made a stand, but were at a disadvantage against troops under cover. Some managed even to enter the hotel by a passage way, but after a short engagement the Chartists fled, leaving fourteen dead and some fifty wounded, of whom ten died shortly after. One hundred and twenty-five persons were arrested, including Frost, Zephaniah Williams, and William Jones, the chief leaders. Twenty-nine of these were committed for trial, all but eight on a charge of high treason. A Special Commission was issued to try them, and the trial commenced on December 10 at Monmouth. No question of the law's delays here.

So ended the Newport Rising, and with it collapsed, for the time being, all the other preparations for insurrection. The attention of the Chartist world was now concentrated upon the probable fate of Frost and his fellow-prisoners. Feargus O'Connor exerted himself to procure funds for the defence, and engaged Sir Frederick Pollock and Fitzroy Kelly, both men of considerable eminence, on behalf of Frost. He gave a week's profits of his paper to the fund, and swore to save the life of his colleague at all hazards. On the other hand, it appears that the idea of rescuing Frost and the others by an armed insurrection was quickly taken up, and preparations on an even wider scale were set on foot. A great revival of Chartist activity followed. Everywhere meetings were held, either to protest against the prosecution of the Newport rioters on the ground that the rising was the work of *agents provocateurs*, or to collect funds, or to concert plans of rescue. A kind of Convention met to organise the Frost rescue movement, but it accomplished nothing. The secret organisations flourished and grew apace.

From various evidence it seems that O'Connor was, perhaps on the strength of his promise to save Frost's life, regarded as the leader of this second insurrectionary movement. He was at least expected to provide funds. But O'Connor's conduct at this juncture was, to say the least, very unsatisfactory. It may safely be said that O'Connor was never at any time prepared to imperil either his life or his reputation by engaging in

any armed enterprise. By great dexterity, and by means of a month's visit to Ireland paid at this exceptionally dangerous moment, he managed to be the last of the earlier Chartist leaders to come under the ban of the law. There is every reason to believe he was suspected by the physical force extremists before the Newport affair,[1] and it is very probable that he was deliberately prevented from taking an active part in it. He afterwards denied all knowledge of it, which is absurd on the face of it, as Gammage argues.[2] Lovett declares that O'Connor put a stop to the affair except in Newport, and this is confirmed by William Ashton, who says that O'Connor could have stopped Frost's rising too, but preferred to sacrifice him out of jealousy.[3] This is scarcely to be believed, though O'Connor was not incapable of unscrupulous methods of eliminating rivals.

At any rate, O'Connor took this opportunity of quitting the country. He was engaged to lecture and agitate in Lancashire from October 7 to 12, but on October 2 he wrote to cancel this engagement on the ground that he was going to found Radical Associations in Ireland, and to array the people of Cork against the aristocracy in view of the next General Election.[4] He arrived in Dublin on October 6,[5] and was back in Leeds on November 6, two days after the events at Newport. On a later occasion he said that he went to Ireland to raise money on his property there.[6] Both versions appear equally unsatisfactory, and even if O'Connor was not really implicated in the plot, he must remain under the gravest suspicion of having run away and allowed his friends to engage in a futile and dangerous enterprise which a word from him could have stopped.[7]

Meanwhile preparations were going on for a second rising to take place in the event of Frost's condemnation. The Newport authorities were on the alert. About ten days after the rising, the presence of Beniowski, Cardo, and Taylor in the district was known or suspected. Cardo was actually arrested outside the Westgate Hotel on November 15, and his papers searched. He declared that " he did not believe that Mr. Frost headed the mob, and attributed the outbreak to Russian

[1] Parkes at Birmingham expressed his suspicions on October 30 (Home Office, 40 (49), Birmingham).
[2] *History*, ed. 1854, p. 282 *et seq.* [3] *Northern Star*, May 3, 1845.
[4] *Ibid.* October 5, 1839.
[5] *Ibid.* November 9, 1839 : account of his trip.
[6] *Ibid.* May 3, 1845.
[7] Cf. Lowery's statement in Gammage, ed. 1854, p. 287.

agency." So reports the Mayor—a curious corroboration of part of Urquhart's story from an apparently independent source, although Cardo may have picked up the idea from hearing Urquhart lecture in the course of a strenuous tour in the winter of 1839-40. When sending Cardo away by the mail on the 16th, the Mayor observed a stranger who was said to be Dr. John Taylor. The Mayor requested the Government to send down somebody who knew Beniowski by sight. He received an anonymous letter alleging that Beniowski had been sent with 138 lbs. of ball cartridge from London *via* Bristol. Three men were arrested on suspicion, but apparently no further proceedings were taken.[1]

About the same time the Bradford magistrates report secret proceedings. They managed to corrupt a Chartist, and obtained information of the intended rising. On December 17 they received a long report, probably through this channel. The rising was to take place on the 27th. A secret Convention would meet in London on the 19th and give the signal. There had been a meeting in Manchester the previous week, in which Taylor was the leading spirit. The soldiery were to be harassed by systematic incendiarism, and an attempt was to be made to assassinate the judges on their way to the trials at Monmouth.[2]

The Birmingham secret meetings continued, and there, too, there was talk of organising incendiarism. A memorandum describing the organisation is amongst the Home Office papers. The Chartist body there numbers some three or four hundred organised in lodges. The members are carefully selected. Each lodge is headed by a captain, who is a member of the General Committee. This body meets at private houses—a different one in each case. A password is given, and all precautions against surprise by the police are taken. It was intended to have a general rising in case of Frost's conviction. Some Chartists talked of proclaiming a republic,[3] whilst others declared that, if Frost were not released, the Queen's marriage would not take place.[4]

Similar reports of secret organisations of Chartists emanate from Loughborough and the hosiery villages in the neighbourhood. There the organisation in sections of ten, which seems to have been the general model, was in full swing. The project of a general rising was entertained, and the Newport men were blamed for being so hasty and premature. A similar organisa-

[1] Home Office, 40 (45), Monmouth. November 16, 17, 18, 19.
[2] *Ibid.* 40 (51), Yorks. [3] *Ibid.* 40 (49), Birmingham.
[4] Trial of Ayre (*Northern Liberator*, January 31, 1840).

tion existed in London. If Phillips's report on the Monmouth-shire Chartists is to be believed, this organisation in sections was for both military and administrative purposes.

In London the Chartist preparations were reported assidu-ously by spies and informants of various descriptions. One Robert T. Edwards, who was in the employ of Hetherington at 126 Strand, and, therefore, had opportunity of seeing and hearing what was going on, furnished information calculated to implicate all the Chartist leaders in the Newport affair, and warned the Government to keep an eye on the Bradford Chartists, and especially Pitkeithly. This, by the way, is almost the sole mention of Pitkeithly in this connection.[1] An anonymous informant made considerable revelations about the middle of November. He speaks of a council of three as directing the plot (a Bradford report speaks also of a council of three in London), and says, " Their Ame is to fire property, the shiping in the River and Docks, to kidnap the principal men of the State." " They have several thousands of fire arms to the account of Feargus O'Connor : the democratic association meet nightly at Mr. Williams (Baker) Brick Lane Spitalfields where they receive daily communications from Wales. Major Beniwisk (sic) went down to survey the country." The informer attended a meeting of over 300 " delegates " at the Trades Hall, Abbey Street, Spitalfields, where Cardo, Neesom, Beniowski, Williams the baker, and others addressed the audience with " very inspireing and highly dangerous language." This letter is dated the same day that saw Cardo hustled out of Newport by the Mayor, and must refer to some date considerably earlier, if it is true at all. This meeting appointed a Committee to raise funds which were to be handed over to the " Council of War." £500 was promised by Feargus O'Connor. A rising on the day previous to that fixed for Frost's execution was planned for London, Manchester, and Newcastle. A further report speaks of secret meetings at which members of the Convention are expected to be present. The Chartists (in London ?) are 18,000 strong.[2]

A report, dated November 12, was received by Wemyss at Manchester from Halifax.[3] The magistrates there say that the Chartists are continuing to meet, but in private houses. At one of these meetings a well-known leader was ordered to communicate with the local leaders as to the best means of

[1] Home Office, 40 (44), Metropolis. [2] Ibid.
[3] Ibid. 40 (43), Manchester.

"going to work, and to do it in better fashion than it had been done in Wales, where they consider it to have been badly mismanaged." Bradford is the objective of the would-be insurgents. Wemyss further reports meetings of similar character at Bolton, Todmorden, Manchester, Ashton-under-Lyne, Burnley, and Bury. The Ashton Chartists are known to have been in touch with the Newport leaders. He also relates that Feargus O'Connor was in Manchester at the time of the Newport rising,[1] and this is not impossible, as he may have stopped there on his way from Ireland to Leeds, which he reached, as we have seen, two days after the Newport failure. On December 22 Wemyss declares that there were very persistent rumours of a projected rising on the Lancashire-Yorkshire border for the end of the month. So serious was the news from Bradford that Napier went there in person. Bury is another centre specially mentioned in this connection, and another letter from Wemyss suggests that Fielden's mill at Todmorden was an important place of meeting. In spite of all these rumours, however, Wemyss reports that the general impression was that nothing would happen.[2]

And this is in fact the general impression made by all the secret reports, papers, and informations. Without going into the question as to how far these doings were prompted by *agents provocateurs*, it may be safely said that there was some real intention of doing something desperate in connection with the trial of Frost, but that the lukewarmness generated by the failure at Newport, the suspicions which were abroad as to the trustworthiness of the leaders, the presence of spies, and the wariness of the authorities, combined to cause the whole business to peter out in a rather ridiculous fashion! In the controversy which raged between O'Connor and his detractors in 1845, neither side denied the existence of a plot of some sort. O'Connor even mentioned that Dr. Taylor fitted out a vessel to waylay the convict-ship conveying Frost to Australia. Another story, related by Lovett, attributes the collapse of the plot to the cowardice of Bussey, who shortly afterwards fled to America. There was a plot and it came to nothing.

Two rather curious reports of Chartist doings in Manchester may be cited.[3] A Chartist committee of eight met on December 16, a police agent being concealed in the vicinity. They were discussing the collection of subscriptions for

[1] Home Office, 40 (43), Manchester. Is it possible that the Irish visit was merely a blind ?
[2] *Ibid.* 40 (43), Manchester. [3] *Ibid.*

Frost, and the whole tenour of the proceedings was one of depression and distrust. The balance sheet was read to the accompaniment of quarrelsome discussion, for scarcely anything had been collected. Another report relates that one member of the Manchester Chartist Council declared that not one in twenty of those who attended the meeting addressed by O'Connor and Cardo to raise funds for Frost, would be sorry if Frost were hanged. At Birmingham the Chartists could scarcely raise a penny for this purpose. One report shows that expenses of £2 : 17 : 4½ had been incurred to raise a subscription of £2 : 16 : 9, so that, as a speaker put it, Frost owed them 7½d. There was a quarrel with Cardo on December 31.[1] Cardo was accused of being in the pay of foreign and Tory agents, a charge to which he refused to reply. This charge, at least as regards Tory agency, was true. Cardo was apparently not a man of good character. Place thought him dishonest.[2] Cardo, Warden, Richards, Lowery, and others appear during 1840 as the paid agents of an anti-Russian, anti-Palmerston committee of which Attwood's brother and David Urquhart were the chiefs, facts which give still more colour to the latter's narrative of the Chartist plottings.[3] At Carlisle Cardo repeated his assertion that Frost was betrayed by Russian agents. As regards the rest of Urquhart's story, it may be admitted that he was correctly informed as to the nature of the plot which came partially to a head at Newport, and probably, too, the fantastic designs [4] which he describes may actually have been entertained. Apparently, too, he did win over Cardo and Warden and even others to his peculiar views, Cardo in fact within a short time of the rising. But whether the rising was so marvellously planned, and whether Cardo and Warden had the important rôles which he described, may well be doubted. These details were probably thrown in to justify Urquhart, who was a bit of a megalomaniac, in assuming the title of " the tamer of the English Democracy."[5]

Meanwhile the trial of Frost and his companions began. On December 14 the Grand Jury found a true bill for high treason, and the trial was fixed for the 31st. Geach, a relative of Frost and a solicitor, prepared the case for the defending counsel. Geach was a man of dishonest character, and does

[1] Home Office, 40 (49), Birmingham.
[2] *Northern Liberator*, February 21, 1840.
[3] *Ibid.* October 31, 1840. This paper gives most information about Urquhart's campaign.
[4] Except the Russian fleet !
[5] *Diplomatic Review*, July 1873.

P

not seem to have managed the case too well. He was in constant touch with O'Connor, who was supplying funds, and was even mentioned in connection with the proposed attempt to rescue Frost.

The unfortunate prisoners in Monmouth Gaol had no illusions as to their fate. Frost made over all his property to his wife (they had started inn-keeping) to avoid the confiscation which follows condemnation for high treason. On December 21 Geach transmitted a very pathetic petition from the prisoners, affirming that they "never entertained any feeling or spirit of hostility against your Majesty's sacred person, rights, or immunities, nor against the Constitution of your Majesty's realms as by law established." They beg for pecuniary assistance to enable them to employ counsel. There are twenty-two signatures, and sixteen sign with a cross. Frost's name is the last ; the hand of Zephaniah Williams is that of an educated man. The petition was refused, like some hundreds of others to the same purpose.[1] On January 16 sentence of death by drawing, hanging, and quartering was passed on the three chiefs, Frost, Williams, and Jones. A technical objection caused an appeal to the Court of Exchequer Chamber, which quashed it on the 28th. Four days later the sentence was commuted to transportation for life to Botany Bay, and by the end of February the hapless rebels were on their way to exile.

There were, after all, one or two small outbreaks in the interval between Frost's condemnation and the passing of the sentence. On the night of January 11 a number of Chartists attacked the police at Sheffield, and a large quantity of arms, ammunition, hand-grenades, fire-balls were seized from them. At Dewsbury on the same night the Chartists assembled and made signals by means of shots and fire-balloons. These were answered from Birstall and Heckmondwike, but nothing further took place. A similar affair occurred at Bradford, and in London preparations were made against extensive incendiarism. At Sheffield a number of Chartists were arrested and arraigned on a charge of high treason. It was stated that they intended to seize and hold the Town Hall, and that a similar attempt was to be made at Nottingham.[2] On January 16 a meeting of Chartists in Bethnal Green was rounded up by the police, and Neesom, Williams the baker, and others were

[1] Home Office, 40 (45), Monmouth.
[2] *Northern Liberator*, January 18, 1840 ; January 24, 1840.

arrested. Beniowski escaped. This meeting was an armed assembly, and Ashton afterwards declared that it was part of the intended rising in London.[1]

After this came another period of trials and imprisonments.[2] In March 1840 Richardson, O'Brien, W. V. Jackson, and others were tried at Liverpool and sentenced to imprisonment— O'Brien and Jackson to eighteen months, and Richardson to nine months. At Monmouth Vincent was condemned to a second imprisonment of a year. Holberry and the Sheffield Chartists were tried at York for conspiracy (not for high treason) and condemned to various terms of imprisonment. At York, too, Feargus O'Connor was tried for a newspaper libel. He called, or proposed to call, fifty witnesses to prove that he had never advocated physical force, though it does not appear that this point was at all material to the question. He was condemned to eighteen months' imprisonment, but actually served only ten, being released on account of bad health. From the gaol he contrived to smuggle out letters to the *Northern Star*, and his account of his sufferings there brought him unbounded sympathy. W. P. Roberts and Carrier were sentenced at Devizes in May to two years' imprisonment, and in July the two Sunderland leaders, Williams and Binns, were sentenced to six months' imprisonment at Durham Assizes. Many of the important leaders were thus accounted for. Frost, O'Connor, O'Brien, Lovett, Collins, Stephens, Richardson, Benbow, Roberts, Vincent were all in durance. Dr. Taylor was still at large, but was hurrying himself by his excesses to the grave, which received him in 1841. Bussey and Deegan fled overseas. Cardo and Warden were lost to the cause. Lowery ceased to take a very prominent part in the movement. Marsden, Harney, Rider, MacDouall—all prominent advocates of armed revolt—were still at large and lived to fight, or talk of fighting, another day. The Scottish Chartists in general took no part in these later proceedings, and pledged themselves at a Conference, held at Edinburgh in September 1839, to pursue the agitation only by peaceable and constitutional methods.[3] They never again entered into a thoroughgoing co-operation with the English Chartists. Nor did Wales play a prominent part in the movement after the fearful day of Newport. In fact, Chartism never again attained the extent and dimensions it possessed in 1839. It degenerated into sects and factions,

[1] Gammage, 1854, pp. 186 *et seq.*; *Northern Star*, May 3, 1845.
[2] *Ibid.* 1854, pp. 186 *et seq.*
[3] *Northern Liberator*, September 21, 1839.

deriving their importance from sources which were not within themselves.

Sufficient, it is hoped, has been said in the course of the narrative as to the causes which brought the first phase of Chartism from so promising a beginning to so futile an end. In spite of the appearance of unity which the movement exhibited at the beginning of the year 1839, Chartism was then far less of a homogeneous thing than at any time in its career. It never again included such heterogeneous elements. The movement in 1839 was a tumultuous upheaval of a composite and wholly unorganised mass. It was a disease of the body politic rather than the growth of a new member of it. The various sections of Chartism had been brought together upon the common but negative basis of protest against things as they were, but the positive fundamentals of unity were lacking. The protest against the Poor Law Amendment Act, the protest against the existing currency theory, and the vaguer but much more violent protest against poverty and economic oppression, had all been swallowed up in the general but doctrinaire protest against political exclusion and monopoly, and it was under the last standard that the Chartist legions marched. But the fundamental differences of outlook remained. One section, and that the largest, had been brought up on a strong diet of unreasoning sentimentalism by Stephens and Oastler, and hungry and starving men had long been inured to insurrectionary suggestion by Vincent, O'Connor, O'Brien, and other demagogues. The rude, half-barbarian ignorance of the miners and colliers in the North of England and in South Wales, and the famishing desperation of the poor weavers and stockingers, made these men very susceptible to such inflammatory teaching. They fell nominally under the leadership of intellectuals like Lovett and his friends, and of impractical fanatics like Attwood. Both Lovett and Attwood had come forward to build up organised parties, but Lovett had a permanent and Attwood only a temporary purpose. Both ideals came to grief through the dog-like attachment of the great mass of their nominal followers to their own local leaders —Harney, Bussey, Frost, Fletcher, MacDouall, O'Connor, and the rest. This destroyed all real organisation, for the organisation was concentrated in the persons of the leaders.[1] This was the "leadership" which Lovett so strongly condemned.

[1] This is shown by the complete collapse of the movement in 1840 when the leaders were in prison.

The fidelity of the rank and file was at once the strength and weakness of the movement. It was given to good and bad leaders with equal indiscriminateness, and produced an unprecedented amount of self-deception, which later so cruelly avenged itself.

These diversities of aims and outlook made effective co-operation in revolutionary action impossible. They were, in fact, the same fundamental divergencies of policy which had been, as we have seen, reflected in the Convention, which swayed constantly between the two extremes of French revolutionary [1] and English middle-class conceptions of political agitation. One section was for armed insurrection, and looked upon the Convention as a provisional government—a Committee of Public Safety *in posse*; another conceived it as a great agitating body, like the Anti-Corn Law League conferences; another, of which O'Connor was typical, was content to use the threats of the one and the methods of the other. To Lovett the Convention must have been a great tragedy—a long torture which his imprisonment brought to a welcome end. The futile boastings of would-be Marats and self-styled Robespierres, and the cowardly shufflings of irresolute babblers, who feared imprisonment more than they respected their own principles, must have thoroughly sickened him. It is not to be supposed that the delegates were generally cowards and rogues. The majority were quite sincere men, who in good faith had thoroughly deceived themselves and their followers, but who had not the moral courage to face the real facts, when they were finally undeceived, nor the mental dexterity of O'Brien and O'Connor to withdraw themselves from a false position without loss of prestige. On every material point the would-be insurrectionary leaders were wrong : they underestimated the strength of the Government and the influence of the middle classes, strengthened as these were by the upper strata of working people ; they underrated the military forces opposed to them ; but most of all, they attributed to English people that thoroughgoing lawlessness which had been inculcated in the French by generations of arbitrary government. For even Stephens thought it wrong to overturn a Government by arms, though it was right to oppose a bad law. According to O'Brien it was right to knock a policeman on the head, but wrong to destroy property.

[1] This without prejudice to the question whether these methods were not largely the invention of the middle class.

Thus in most of the delegates excitement and a new-found popularity amongst unreasoning followers produced exaggerated expectations and unbounded self-esteem ; experience brought disillusionment and shifty shufflings which robbed the Convention of its following long before it dissolved. Abandoning their leaders, the more desperate followers embarked upon projects of futile violence, ending in the imprisonment, transportation, and death of nearly 500 men.[1]

[1] Lovett, *Life and Struggles*, p. 238 : 443 persons were in prison alone for political offences in 1837–40. According to Rosenblatt's useful tables in his *Social and Economic Aspects of the Chartist Movement*, pp. 205-6 (*Columbia University Studies in History, Economics, and Public Law*, vol. lxxiii. 2, 1916), there were 543 individual convictions between January 1, 1839 and June 1840. The distribution of these, emphasised in Mr. Rosenblatt's table, is interesting.

CHAPTER XII

THE CHARTIST REVIVAL

(1840–1841)

FOR six months after the trial of Frost Chartism slept. The chief leaders were imprisoned and there was no organisation to keep alive the agitation. A few of the former leaders were still active. Harney was engaged in Scotland, apparently as a paid lecturer, in the employ of the Scottish Chartists. Some activity was called forth by the organisation of petitions on behalf of Frost. There was a delegates' meeting at Birmingham in September 1839, but there is no information as to its doings except that it discussed plans for organising the movement.[1] Three " Conventions " assembled at London, Manchester, and Nottingham in January, March, and April 1840. They were all concerned with Frost's case. The first was apparently connected with the futile outbreaks at Sheffield and elsewhere. The other two were of a milder character, though there was some bickering between the delegates, those representing the hosiery districts being still eager for violent courses.[2] The advocates of petitioning as a means of releasing Frost were able to carry the day, James Taylor taking a leading part in the discussions.[2] Petitions began to be extensively signed. In fact, more signatures were obtained on behalf of the three Newport victims than for the National Petition itself. Dr. Wade attended a levée on February 19, dressed in full canonicals, as etiquette required, and presented seven petitions on Frost's behalf.[3]

During the spring of 1840, however, the Chartist world was

[1] *Northern Liberator*, October 6, 1839.
[2] *Northern Star*, January 10, 1840 ; February 8, 1840 ; February 15, 1840 ; March 14, 1840 ; March 21, 1840.
[3] *Southern Star*, February 23, 1840.

deluged with suggestions for a reorganisation, or rather an organisation of the movement, for hitherto there had been singularly little machinery, except the Convention, for keeping together the rank and file and educating them in the principles and aims of the reformers. From this time onward the agitation took on a much sounder and more educational character. The Scots were the pioneers, though the original inspiration was due no doubt to the methods of the Anti-Corn Law League, and in a lesser degree to the London Working Men's Association.

The origin of the Scottish organisation is thus described by one of its authors: " In the autumn of 1839, when the cause of Liberty was suffering severely in England from the injudicious conduct of a number of its supporters and the persecution waged against it by an unprincipled Whig Government, who by spies and emissaries were endeavouring to excite the people to violence in order that every aspiration of freedom might be the more easily suppressed, the people of Scotland deemed it expedient to hold a great national delegate meeting for the purpose of devising a system of enlightened organisation and of suggesting such measures as might be considered necessary to promote sound and constitutional agitation in that critical period of the great movement." This meeting took place on August 15, 1839, at the Universalist Church, Glasgow. It was attended by seventy delegates, who represented fifty towns and populous places. It was recognised that the real line of advance lay in convincing public opinion, and two measures were decided upon to further this object. Firstly, paid lecturers—" missionaries "—were to be sent out to agitate in a more thorough fashion than hitherto ; and secondly, a series of small tracts, or pamphlets, was to be published to give a proper view of their grievances and demands. These tracts were to form " a complete body of sound political information, embracing in its scope the cause, nature, and extent of our wrongs, the rights which civilised society owes to us, and which we inherit from our Creator ; as also the appalling details of legislative misrule, the enormities which a reckless aristocracy have (sic) perpetrated on those over whom they have tyrannised, and the power which an organised nation would have in redressing its own grievances, so as to induce the people, by imbuing their minds with this knowledge, to concentrate their energies on the acquisition of their liberty." This was the origin of an excellent little publication which ran from

September 1839 to October 1841, under the name of the *Chartist Circular*. An elective Committee of fifteen members was constituted, with the title, "Universal Suffrage Central Committee for Scotland," and so the organisation got under weigh. Harney seems to have been one of its paid lecturers, having temporarily shelved his physical force ideas. In March 1840 he was recommending English Chartists to follow suit,[1] in a letter to the *Northern Liberator*.

Harney's letter is one of many which were communicated to the Chartist press about this time, all with the same object —organise, organise! They show how far the reaction from the exaggerated confidence of the previous year had gone, and suggest that there is some dim realisation of the necessity for hard spade work before the foundations of success can be laid. Harney relates how the failure of the late Convention had ruined the Chartist cause in the Border counties. He suggests a programme of organisation and systematic petitioning. He touches on a question which was to exercise many Chartist minds in the next few years—namely, the Free Trade agitation. He declares unremitting war upon it, and urges Chartists to attend Anti-Corn Law meetings in force to procure the rejection of all resolutions proposed there. His scheme of organisation includes a permanent paid central committee which shall sit at Manchester. There shall be local county leaders who will act as teachers of Chartism and as enemies of the people's enemies, especially of the priests. These men will in fact stand between people and patricians like the tribunes of the people at Rome.[2]

R. J. Richardson from his cell at Liverpool made public a scheme of organisation—a high-falutin affair culled from the Constitution of the United States, Freemasonry, Rousseau, archaeology, and R. J. Richardson.[3] It had all the essentials of a bad constitution. The Dumfries Chartists submitted another constitution in which an elective Convention played a part " to focus attention upon horrifying wrongs and oppressions."[4] Robert Lowery had another scheme in which the contesting of Parliamentary seats was the chief feature. Significantly enough, Lowery will hear no more of Conventions.[5] " Republican " wrote a series of articles in the *Northern Star* in support of a " permanent, secret, and irresponsible " directory, which would control the movement. He, too, will

[1] *Northern Liberator*. March 21, 1840.
[2] *Ibid.* March 21, 1840. [3] *Northern Star*, June 20, 1840.
[4] *Ibid.* April 25, 1840. [5] *Ibid.* May 2, 1840 ; May 16, 1840.

hear no more of Conventions. The old Convention was too large and heterogeneous. The members had not the necessary knowledge or integrity. All they did was to produce " puerile manifestos" and " the still more ridiculous National Holiday." Their imbecility had ruined the cause. He recommends a local organisation in small sections or classes with a county corresponding secretary and a " Great Central and Secret Directory " of seven to rule the whole. This scheme, strongly insurrectionary in aspect, " Republican " defended sturdily in the pages of the *Star*, complaining on one occasion that the attention of Chartists is too easily diverted from their main purpose to such things as Frost's trial and O'Connor's imprisonment.[1]

A very characteristic scheme was recommended by O'Connor. Nothing could exhibit more clearly the inferior calibre of O'Connor's mind than this effusion. He was perhaps the only leading Chartist who was devoid alike of idealism and of statesmanship. The first essential was the foundation of a daily newspaper. Just as he later transformed Chartism into a land gamble, so now he would transform it into a newspaper syndicate, flourishing on those profits which O'Brien so heartily detested. O'Connor wants 20,000 men to subscribe 6d. a week for forty weeks.[2] £6500 will be raised in subscriptions from readers, and £3500 he will provide himself. The paper will pay ten per cent upon the £20,000 share capital. For the first year, however, the profits will be devoted to other purposes. Twenty delegates were to sit in London from April 15 for eight weeks, receiving each £5 a week. As many lecturers would lecture, also for eight weeks, at the same rate of pay. Five prizes of £20 were to be given for essays on subjects selected by the Convention. £200 would be left in the hands of the proprietor for a defence fund, and the rest of the £2000 would be applied to miscellaneous purposes. The delegates and lecturers would be elected by show of hands and would be under the control of a " committee of review." The Convention would have a permanent Chairman and a Council of five to prepare all business for it. After a digression to show that he has spent £1140 in the people's cause, out of the profits of the *Northern Star* (which he later denied to exist), O'Connor concludes by showing how compact

[1] *Northern Star*, May 9, 1840 ; May 30, 1840 ; June 20, 1840.
[2] It is significant of the incoherence of O'Connor's mind that he allots only £5000 of capital to these weekly subscribers at a later stage of his article.

his machinery will be. The Convention will be the representative body of Chartism, the council its digestive organ, the lecturers its arteries, the people the heart, the *Morning Star* (the paper to be) its tongue, the committee of review its eyes, £2000 a year its food, and Universal Suffrage its only task.

That this scheme was put forward in all seriousness is indicated both by the general tenour of O'Connor's career and by the fact that it was published in the *Northern Star*,[1] a few days before the great delegate meeting at Manchester which was convened for the purpose of establishing a permanent organisation of the Chartist forces. It was apparently brought under review by that meeting. O'Connor's scheme would have established more effectively that quasi-Tammany organisation which he succeeded in establishing to a lesser degree through the *Northern Star*. As proprietor of the two papers O'Connor would have turned the Chartist movement into an extensive machine for booming his publications. He would have had lectures, delegates, council, and committee in his pocket. He would have debased the pure currency of Lovett, O'Brien, and Benbow by this scheme, just as he did by the Land Scheme later on.

Along with these various plans of reorganisation came the revival of local bodies which had been put out of action by the *débâcle* of 1839. We read in April of the formation of a Metropolitan Charter Union of which Hetherington was the leading figure.[2] It proposes the union of all Radical, Charter and similar associations into one great body, and hopes to proceed by the circulation of tracts and a penny weekly publication, by founding co-operative stores, coffee-houses, and reading-rooms. Its objects were " to keep the principles of the People's Charter prominently before the public, by means of lectures, discussions and the distribution of tracts on sound political principles, or by any other legal means which may be deemed advisable. To promote peace, union and concord amongst all the classes of people." . . . " *To avoid all private and secret proceedings,* to deprecate all violent and inflammatory language and *all concealment of the views and objects of this Association.*" This last suggestion was a very significant comment upon the recent events. Most of the names of the Committee of this society are new. It decided, perhaps for

[1] July 18, 1840. O'Connor actually appointed persons to collect subscriptions for the paper. [2] *Northern Liberator*, May 2, 1840.

lack of funds, not to send a delegate to the Manchester Conference in July, but did actually send Spurr, one of the old Democratic Association.[1]

In April, too, the Northern Political Union of Newcastle was reorganised for " the attainment of Universal Suffrage by every moral and lawful means, such as petitioning Parliament, procuring the return of members to Parliament who will vote for Universal Suffrage, publishing tracts, establishing reading rooms." Weekly lectures were also delivered, Lowery being the first speaker.[2] The Leeds Radical Association was re-established on the same lines.[3] In Lancashire there was no little activity, and the system of lecturers was in full swing in June. In June also the West Riding Chartists were meeting by delegates in preparation for the Manchester Conference in the following month.[4] The Carlisle Radical Association rose again.[5] All things considered, this revival in the spring of 1840 was a remarkable tribute to the vitality of Chartism. The movement was much more localised than in 1839, but within its narrower bounds it was stronger and healthier.

On July 20 twenty-three delegates met at the " Griffin," Great Ancoats Street, Manchester, to restart the Chartist movement. Lancashire and Cheshire districts were represented by eleven of the delegates ; Yorkshire had two, Wales one, Scotland one, London, Nottingham, Leicester, Loughboro', Sunderland, Carlisle, and one or two other places being also represented. Of ex-Conventionals only James Taylor, Deegan, and Smart were present. One or two names destined to be of some repute appear here for the first time. One was that of James Leach, a Manchester operative, whose forte was opposition to the Anti-Corn-Law agitation. Another was that of R. K. Philp of Bath, a man somewhat of the type of Lovett.

The first task of the delegates was to review the many plans of reorganisation and agitation which had been submitted to the Chartist public. O'Connor, Lowery, O'Brien, Richardson, Philp (who submitted a Press scheme, drawn up by W. G. Burns, intended to combat O'Connor's), Benbow (who sent a scheme too long to read), the West Riding delegates, and several anonymous individuals, including " Republican," had set forth their ideas in various schemes. Some were for no Convention, others were for annual Conventions, but nearly

1 *Northern Star*, June 20, 1840 ; August 29, 1840.
2 *Northern Liberator*, April 11, 1840.
3 *Ibid.* May 2, 1840. 4 *Northern Star*, June 27, 1840.
5 *Northern Liberator*, April 4, 1840.

all recognised the importance of regular subscriptions and of the machinery to collect and administer the funds so obtained. Pamphlets, tracts, lectures, and the organisation in small local bodies were also generally agreed on, and these were embodied in the final scheme of the National Charter Association, which, with the same title, but with varying purpose, held the field for a dozen years.

The object of the National Charter Association was " to obtain a full and faithful representation of the entire people in the House of Commons, on the principles of the People's Charter." None but peaceable and constitutional means, such as petitions and public meetings, were to be adopted. Members were to be admitted on signing a declaration of adhesion to the principles of the Charter, on paying twopence for a card of membership and a weekly subscription of one penny. All members were to be registered by the Executive. The local organisation was to be in " classes " of ten, a system which had been in use since 1830 amongst London Radicals, and which was based originally on the Methodist class organisation. The class leader was to collect subscriptions. These classes were to be combined into "wards " each with a ward-collector, and the wards again into a larger unit for each town. Each large town would have a Council with Secretary and Treasurer, and each county a similar Council. The whole was to be governed by an Executive of five with Secretary and Treasurer, to be elected on January 1 each year on the nomination of the counties. The executive members were to be paid 30s. a week, and the Secretary £2.

The measures recommended to the attention of Chartists were, first, the attending of political (*i.e.* Anti-Corn Law) meetings to move amendments in favour of the Charter ; second, sobriety ; and third, the adoption of O'Brien's election plan. This plan, which was a revival of the "legislative attorney " scheme which came to grief at Peterloo, consisted in proposing Chartist candidates at every Parliamentary election, regardless of the lack of qualification and other disabilities which afflicted poor men. These were to be elected by show of hands at the meetings, and afterwards, though they would not go to the poll, be regarded by all Chartists as their true representatives. It is difficult to say what O'Brien really intended by this scheme, though an article by him on the subject[1] suggests that an attempt might be made to constitute a rival Parlia-

[1] *Southern Star*, February 23, 1840.

ment to that at St. Stephen's, and even to uphold it by force.
The Chartists later made considerable use of the opportunity
which these bogus nominations offered to air their views at
election times, and Harney appears to have made a very
effective attack upon Palmerston at Tiverton by these
means.

The Manchester Scheme was afterwards drastically revised
so as to evade the vague and dangerous scope of the laws on
Corresponding Societies and Conspiracy. The publishers of
the *Northern Star* applied to Place for advice. Place certainly
regarded the scheme as illegal. "The people in the North,
some of them are organising on the Manchester Delegate
Assembly plan, by which every man of them makes himself
liable to transportation." [1] Place had written a pamphlet
on the law respecting political bodies of this description in
1831, and the *Northern Star* people evidently desired a copy
of it. Very likely as a result of Place's advice, various changes
were made. The election of local officials by their own
localities was dropped, as each district thereby assumed the
character of a branch, and the arrangement was therefore
illegal. Instead, the Chartists in any town where Chartists
reside should elect two or more members of a great General
Council, out of which local secretaries and treasurers would be
selected, as well as the Executive Committee. The General
Council would elect these various officers. Thus nominally
the suggestion of districts or branches was eliminated, and the
National Charter Association assumed the character of a single
undivided body with a Council of several hundred members.
As all declarations not required by law were illegal, the volun-
tary declaration of adhesion to the principles of the Charter
had to be omitted. [2] These details will suffice to illustrate the
difficulties which harassed political agitation in these times.
It is a tribute both to the shrewdness of the Chartists in evading
and to the scruples of the Government in administering bad laws
that no prosecution under the Acts 39 Geo. III. c. 79 and 57
Geo. III. c. 19 was instituted during the Chartist agitation.
The revised constitution of the Association was much more
cumbrous than the original, and for various reasons did not work
very well. Nevertheless even a bad constitution will help to
produce results if energetically worked, and the Chartists were
at least men of energy. The National Charter Association

[1] Place Collection, Hendon, vol. 55, p. 710.
[2] *Northern Star*, February 27, 1841 ; March 6, 1841.

proved an efficient agitating body and succeeded for many years in recruiting new men of zeal and ability, like Thomas Cooper, Ernest Jones, George Jacob Holyoake, and William James Linton.

The new organisation got under way rather slowly. James Leach and William Tillman, both of the Manchester district, acted as chiefs of a provisional Executive Committee. In August 1840 they issued an appeal for the prompt payment of subscriptions. Local Chartist organisations were dissolved and absorbed into the new Association, but owing to the belief that the Association was illegal, this went on very slowly. By February 1841 there were only eighty "localities" registered.[1] Another cause was operating to discourage recruiting, namely the provision that members' names should be registered. This was apparently necessary on account of the mysterious Acts of 1799 and 1817, but it aroused one Chartist to call the Association "the Attorney-General's Registration Office for Political Offenders."[2] This was no doubt the original intention of the clause in the Acts, and it apparently aroused no little doubts in the minds of many Chartists. In the spring of 1841 the revised constitution was promulgated, and a more rapid growth followed. By December 1841 there were 282 localities,[3] with apparently some 13,000 members. The membership is stated in April 1842 as 50,000. In the spring of 1841 the provisional Executive gave place to a regular elected Committee, consisting of MacDouall, Leach, Morgan Williams, John Campbell, George Binns, and R. K. Philp. Campbell, a Manchester man of no great ability or importance, also acted as Secretary.[4] Abel Heywood, the well-known bookseller, of Oldham Street, Manchester, acted as Treasurer until the removal of Campbell to London in 1842 caused that office to pass to Cleave, since it was convenient for both Secretary and Treasurer to live in the same place. But the treasurership of so impecunious a body was little more than a sinecure. The growing preponderance of Manchester in the movement is a noteworthy matter and indicates a further stage of localisation.

The Scottish and the Manchester reorganisations were by no means the only result of the Chartist revival, but they were

[1] *Northern Star*, December 4, 1841.
[2] *Northern Liberator*, November 28, 1840.
[3] *Northern Star*, December 11, 1841.
[4] *Ibid.* June 7, 1841, gives the number of votes recorded for each, ranging from 3795 to MacDouall to 1130 for Philp.

the two most important. Nothing is, in fact, more surprising
than the variety of enterprises which sprang up during this
phase of the movement, and nothing illustrates more clearly
the great moral revival which Chartism engendered than the
remarkable character of some of these movements. It is
worth while to consider those which are associated with the
names of Arthur O'Neill of Scotland and Birmingham, William
Lovett of London, and Thomas Cooper of Leicester.

On the one side the moral force Chartists relied for their
beliefs upon that faith in the omnipotence of human reason
which was characteristic of the earlier phases of the French
Revolution, and is conspicuous in the writings of Godwin and
Shelley. Reason was to them an irresistible moral force.
" How," asks Lovett, " can a corrupt Government withstand
an enlightened people ? " This was the principle on which
Lovett would have based the Chartist agitation. It is the
text of his pamphlet on Education and of his later book called
Chartism. Lovett, however, had come to divorce his moral
life from the teachings of Christianity. Arthur O'Neill, on
the other hand, a young enthusiast in his early twenties, made
no such distinction. The result was with Lovett, Educational
Chartism ; with O'Neill, " Christian Chartism "—two move-
ments which ran on in close kinship.

The Christian Chartist movement was in some measure a
protest against the exclusiveness and the Toryism of the
Established Church, and against the repellent narrowness of
some of the Dissenting bodies, notably of the Wesleyan
Methodists.[1] It was also partly due to a desire to base demo-
cratic principles upon the strong rock of Christian doctrine, and
partly to a genuine missionary zeal, a desire to brighten the
lives and minds of the poor, the ignorant, and the neglected.
Christian Chartism was always accompanied by educational
effort. The Church at Birmingham, the best-known and the
most famous of the Chartist churches, was run on purely volun-
tary lines by Arthur O'Neill and John Collins, with occasional
visits from Henry Vincent and others. It consisted of a
political association which studied democratic thought as laid
down in the works of Cobbett, Hunt, Paine, and Cartwright,
and a Church whose purpose was to further temperance,
morality, and knowledge. It had schools for children and
for young men, and a sick club.[2] O'Neill seems to have had no

[1] For Christian Chartism see H. U. Faulkner, *Chartism and the Churches*
in *Columbia University Studies in History, Economics, and Public Law*, vol.
lxxiii. 3, 1916. [2] *Northern Star*, August 28, 1841.

little success in the Birmingham area. He was on good terms with the working people and even with their employers. An iron-master in the district allowed him the use of a large room "which was crowded to suffocation every Sabbath afternoon from half-past two till a quarter past four." A Wesleyan minister, who was no friend to Chartism, describes O'Neill's methods thus:

O'Neill called himself a Christian Chartist and always began his discourse with a text, after the manner of a sermon ; and some of our people went to hear him just to observe the proceedings and were shocked beyond description : there was unmeasured abuse of Her Majesty and the Constitution, about the public expenditure and complete radical doctrines of all kinds. They have a hymn-book of their own and affect to be a denomination of Christians. This is the way they gained converts here, by the name. There were very few political chartists here, but Christian Chartist was a name that took. It is almost blasphemy to prostitute the name of Christian to such purposes.[1]

A Government Commissioner sent to inquire into the causes of the strike which engulfed Chartism in the Black Country in 1842, actually attended a " Christian Chartist Tea Party " at Birmingham, where O'Neill was the chief speaker. He thus reports O'Neill's sermon :

The necessity of their new Church was evident, for the true Church of Christ ought not to be split up into opposing sects : all men ought to be united in one Universal Church. Christianity should prevail in everyday life, commerce should be conducted on Christian principles and not on those of Mammon, and every other institution ought to be based on the doctrines of Christianity. Hence the Chartist Church felt it their duty to go out and move amongst the masses of the people to guide and direct them by the principles of Christianity. They felt it incumbent upon them to go out into the world, to be the light of the world and the salt of the earth. The true Christian Church could not remain aloof but must enter into the struggles of the people and guide them. The characteristic of members of a real Church was on the first day of the week to worship at their altar, on the next to go out and mingle with the masses, on the third to stand at the bar of judgment, and on the fourth perhaps to be in a dungeon. This was the case in the primitive Church and so it ought to be now.[2]

If this sermon is the worst which the Commissioner in spite of the " pain " which his attendance caused him can report, we may safely assume that the Wesleyan minister's account is

[1] *Parliamentary Papers*, 1843, xiii. p. cxxxii.　　　[2] P. cxxxiii.

not without bias. O'Neill was an opponent of insurrectionary methods, so that the Bible did not in his hands become the explosive force which Stephens had made it. He was, however, prominent in all local industrial movements; in the strike of colliers in 1842 he was one of the men's spokesmen, thus carrying out his own precepts even to the dungeon itself.

O'Neill was not the only Christian Chartist preacher. There was a similar church at Bath where Henry Vincent was a regular preacher. Vincent had forsworn his earlier insurrectionary views and was now a devoted preacher of temperance. In fact " temperance Chartism " was in the way of becoming a regular cult until, along with Christian Chartism and " Knowledge Chartism," it came under the ban of O'Connor, to whom knowledge and temperance were alike alien. Scotland was also the seat of Christian Chartism; Paisley and Partick were flourishing centres of it. But the strength of Christian Chartism at Paisley rested not so much on the Chartist Church itself as on the ardent partisanship of one of the parish ministers of the Abbey Church. Patrick Brewster, a strenuous opponent of O'Connor and a member of the Anti-Corn-Law League, held his charge at Paisley from 1818 to 1859, and to the horror both of the Presbytery of Glasgow and of the heritors, who had appointed him, preached Chartist sermons of astonishing vehemence. Here is a paraphrase of Ecclesiastes iv. 1 :

There is then one master grievance, one all-reaching, all-blasting evil : one enormous, atrocious, monstrous iniquity : one soul-blighting, heart - breaking, man - destroying, heaven - defying sin, which fills the earth with bondage and with blood, which aids the powerful and strikes the helpless, which punishes the innocent and rewards the guilty, which aggrandises the rich and robs the poor, which exalts the proud and beats down the humble, which decries truth and pleads for falsehood, which honours infamy and defames virtue, which pampers idleness and famishes industry : one GIGANTIC VILLAINY, the root and cause, the parent and protector of a thousand crimes . . . committing wrong and miscalling it right, committing robbery and calling it LAW, nay, in the sight of heaven, committing foul murder and calling it JUSTICE.[1]

Many men felt like Brewster in those days. Think of the poor religious stockinger's " Let us be patient a little longer,

[1] P. Brewster, *The Seven Chartist and Other Military Discourses libelled by the Marquis of Abercorn and Other Heritors of the Abbey Parish*, Sermon I. (Paisley, 1842.) Brewster was a younger brother of Sir David Brewster, the famous physicist.

lads. Surely God Almighty will help us soon," and the rejoinder, " Talk no more about thy Goddle Mighty ; there isn't one. If there was, he wouldn't let us suffer as we do ! " [1]

The Partick Chartists ran an evening school five nights a week,[2] whilst at Deptford there was established a " Working Men's Church," whose members were said to study the New Testament in Greek ![3] All these institutions were run on thoroughly democratic lines. The articles of the Paisley Church provided for belief in the Scriptures, in Christ, and the Atonement ; for the election of all officers, by universal suffrage and by the ballot ; for the repudiation of pew-rents, and for voluntary contributions only.

This Christian Chartist movement does not seem to have struck a deep root. It was but a protest in the name of democratic Christianity against the " oppressions that are done under the sun " on behalf of those " who had no comforter," and it died away with the approach of better times. Nevertheless the efforts of Vincent, O'Neill, Collins, and the like, who leavened the mass of Chartist doctrine with some moral ideals, ought not to be neglected by the student of the movement. It is the tragedy of Chartism that it came to be controlled by one whose influence was fatal to ideals.

The movement initiated by Lovett was of a somewhat different character, and needs perhaps more notice. In the latter months of their imprisonment Lovett and Collins had been allowed, as a result of strenuous efforts on the part of their friends and themselves, better diet and the use of pens, ink, and paper. Lovett kept up a brisk correspondence [4] with Place, defending his own conduct, and that of the Chartists generally, against the criticisms of the veteran politician.

Some of these letters are interesting enough to quote. On May 10, 1840, Place recommended the reinvigoration of the Working Men's Association, which he considered " was beyond all comparison a more important Association than any previous society of working men had ever been." It ought to be revived and extended into all parts, " but," says Place, " it may be objected that the plan of working-men's associations will be difficult—will move slowly—true, this is unfortunate, but moving a nation is a great work, it can go but slowly, it cannot be hurried." Place suggested that it was stupid not

[1] *The Life of Thomas Cooper*, p. 173.
[2] *Northern Star*, September 26, 1840. [3] *Ibid*. October 30, 1841.
[4] See volume 55 of Place Collection at Hendon, pp. 348, 538, 546, 550, etc.

to accept less than the Charter; for partial schemes, such as the repeal of the Corn Laws, might in the long run carry them further than the measure of justice embodied even in the Charter. Lovett replied on the 19th that he had no hopes of a repeal until a thorough reform of Parliament was accomplished:

And when I remember that the agitation for the alteration of the Corn Laws did not commence till after the people were actively engaged in contending for the suffrage, and when I know that a vast number of those who talk of giving the people cheap bread, spurn the idea of giving them the suffrage, I very much doubt the sincerity of their professions. . . . But after the great body of the Radicals in different parts of the country have resolved to give up their various hobbies of anti-poor-laws, factory bills, wages protection laws, and various others, for the purpose of conjointly contending for the Charter, I think I should be guilty of bad faith not to follow up the great object we began with.

Lovett, curiously enough, did not agree with Place as to the value of the working-men's associations. They were too poor to be effective. They excluded all but working men and were more literary than political in character. They were seldom able to get up public meetings or to attempt anything involving expense. They had no organ. The working-men's associations were but small knots of men and inadequate to carry through a great movement.[1] Consequently Lovett came to the conclusion that he must appeal to the middle class as well as to working people, if anything was to be accomplished. In spite of this the whole correspondence turns on the question whether the middle-class Radicals ought to come out for the Charter or the Chartists for Free Trade. Lovett was obdurate for the former, and Place for the latter.

It was in this state of mind that Place received from Lovett, some time in March 1840, a parcel containing a letter and a manuscript. The former was dated March 18, and related that both had been smuggled out of Warwick Gaol by way of a friend, as Lovett feared that the manuscript would be confiscated if despatched through the usual channels. The manuscript was a little book called *Chartism*, and had been written in the gaol by Lovett and Collins. In all probability Lovett wrote practically the whole of it. Lovett asked for Place's opinion on it. It was to be corrected according to his criticisms and amendments and published on the day of their

[1] Letter of May 19, 1840.

liberation. Lovett adds: "I have now resolved to write a memoir of my own life; perhaps you will think this a little bit of vanity." This resolve was not carried out till 1876. Place, however, was very unfavourable towards the book written in prison, and succeeded, consciously or otherwise, in delaying the publication till some time after the release of the two Chartists.[1]

The little work was an expansion of the tract on Education, published by the London Working Men's Association some four years before. It commences with a defence of democratic principles and an attack on the " exclusive " system then in vogue. This part is written with equal vehemence and ability. It gives vent to that throbbing and vibrating sense of injustice which is throughout characteristic of Lovett.

The black catalogue of recorded crimes which all history develops, joined to the glaring and oppressive acts of every day's experience, must convince every reflective mind that *irresponsible power*, vested in one man or in a class of men, is the fruitful source of every crime. For men so circumstanced, having no curb to the desires which power and dominion occasion, pursue an intoxicating and expensive career, regardless of the toiling beings who, under the forms of law, are robbed to support their insatiable extravagance. The objects of their cruelty may lift up their voices in vain against their oppressors, for their moral faculties having lost the wholesome check of public opinion; they become callous to the supplications of their victims.[2]

Incidentally Lovett gives his views upon the resort to force.

We maintain that the people have the same right to employ similar means to regain their liberties, as have been used to enslave them. . . . And, however we may regret, we are not disposed to condemn the confident reliance many of our brethren placed on their physical resources, nor complain of the strong feelings they manifested against us and all who differed in opinion from them. We are now satisfied that many of them experience more acute sufferings, and daily witness more scenes of wretchedness than sudden death can possibly inflict, or battle strife disclose to them.[3]

Lovett now proceeded to outline his scheme for a " new organisation of the people," which is what he conceives Chartism to be. This organisation is contained in the " Proposed Plan, Rules, and Regulations of an Association to be entitled ' The National Association of the United Kingdom for Promoting the Political and Social Improvement of the

[1] Lovett, *Life and Struggles*, p. 236. [2] *Chartism*, 1840, p. 4.
[3] P. 21.

People.'" The objects of the Association were tenfold.
First, "to unite in one general body persons of all CREEDS,
CLASSES, and OPINIONS who are desirous to promote the
political and social improvement of the people"; second, "to
create and extend an enlightened public opinion in favour of the
People's Charter and by every just means to secure its enact-
ment so that the industrious classes may be placed in possession
of the franchise, the most important step to all political and
social reformation." The third object was to erect Public
Halls and Schools for the people wherever necessary. There
were to be Infant, Preparatory, and High Schools; the halls
were to be used also for Public Lectures, Readings, Discussions,
Musical Evenings, and Dancing. Each school was to have
playgrounds for both sexes, gardens, baths, a museum, and a
laboratory. The establishment of Normal Schools, of Agri-
cultural Schools, the creation of travelling libraries, the
publication of tracts and pamphlets, the presentation of
prizes for essays on education, the employment of mission-
aries, and *the discovery of legal means whereby the members may
be able to control the Association in a democratic fashion* are
the remaining objects of this Association.[1] A vast system
of education on a purely voluntary basis was the object of
Lovett's speculations.

The funds for the scheme were to be raised by voluntary
contributions. Suppose, says Lovett, that everybody who
signed the National Petition would subscribe one penny a
week. This would give an income of £256,600 a year, devoted
to the following purposes:

Building of 80 schools or halls at £3000 each . . .	£240,000
710 travelling libraries at £20 each	14,200
20,000 tracts per week at 15s. per 1000 . . .	780
4 missionaries at £200 per year	800
Printing, postage, salaries, etc.	700
Surplus	120
	£256,600

No provision is made for the upkeep and staffing of the
schools.

Lovett now proceeds to explain the advantages of the
scheme. A people so organised "would not use its energies
in meeting and petitioning: it would not year after year be
only engaged in the task of inducing corruption to purify

1 Pp. 24 *et seq.*

itself : but it would be gradually accumulating means of instruction and amusement, and in devising sources of refined enjoyment to which the millions are strangers : it would be industriously employed in politically, intellectually and morally training fathers, mothers and children to know their rights and perform their duties : and with a people so trained, exclusive power, corruption and injustice would soon cease to have an existence." [1] He repudiates the notion that he agrees with those who say the people are too ignorant to be entrusted with the franchise. The franchise, in fact, would be the best means of education. Nevertheless an unenlightened electorate would never realise the full social consequences of its enfranchisement without education, which is, therefore, necessary to ensure complete freedom.[2] Lovett's thesis is this : the people ought to share completely in making the laws by which they are governed. They have even the right to use force to recover the liberties of which they have been deprived by force, but unless they are educated they will never realise the benefits which they seek to extort by their valour. By education and organisation they will become possessed of a moral force which no exclusive governing body can resist, and by their enlightenment they will use to the fullest extent and to the best effect the liberties they have won.

After a short dissertation upon the enfranchisement of women, a doctrine of which Lovett and some of his followers remained convinced champions,[3] Lovett plunges with evident satisfaction (for he was a born pedagogue) into a description of the kind of education he will have in his schools. It is crammed with knowledge and ideas. Lovett read nearly all the important English books on education and such of the German writers as were accessible in translations ; Combe, Pestalozzi, Wilderspin, Hodgskin, Dr. Southwood Smith all appear in the footnotes. Every aspect of education is treated, and much emphasis is laid upon the importance of hygiene, physical training, playgrounds, and gardens, as might be expected in the days of the Public Health Agitation. This little book may well be recommended to all students of English education. Hatred of State control of education, belief in the Lancasterian organisation, and thoroughgoing secularism are other features of the scheme.[4]

Such was the scheme on which Place's opinion was

[1] P. 47.
[3] Pp. 61-2.
[2] Pp. 55-60.
[4] Pp. 63 *et seq.*

requested. Place had outlived much of the enthusiasm which characterised his earlier attachment to the cause of education, for he was already in his seventieth year. He criticised the scheme as impracticable. He preferred the scheme outlined in the Address on Education published in 1837. The chief difference between the two schemes was that the former presupposed a grant from Government for the building of schools, whilst the second was entirely voluntary. Lovett replied that he was convinced that the people had a greater disposition to support the scheme than Place believed, and if it were once started the country would rally round it. Place, however, returned to the charge and called the scheme a " Chartist popedom "; he said it was " sectarian " as it was purely Chartist—which was of course exactly what it was intended to be. The Charter, says Place, would not be obtained within a quarter of a century, and so he returns to his old thesis, urging Lovett to support the agitation for the Repeal of the Corn Laws, which was more immediately necessary and practicable. Place can find no language strong enough to describe his contempt for the Convention of 1839 and for the " Big O's " of the North, in fact for the whole movement since May 8, 1838. The whole correspondence between the class-conscious and very sensitive enthusiast and the wire-pulling old politician is very instructive. The upshot was that Lovett published the work in spite of Place and felt some bitterness at the delay which the latter had caused.

Lovett was released on July 25, 1840. A great ovation was arranged for the two prisoners at Birmingham, and the plan of the National Charter Association was to be made public on this occasion. Lovett, however, declined to attend on the plea of ill-health, and Collins received the honour alone. James Leach spoke as temporary chairman of the new Association, and voiced the enthusiasm with which the new organisation had been conceived. Lovett went to Cornwall, but attended a dinner in his honour at the White Conduit House in London on August 3. After refusing the offer by Samuel Smiles of a good appointment on the staff of the *Leeds Times*, he settled down in London, where he started a book shop in Tottenham Court Road, and floated his National Association Scheme. The National Association was inaugurated in the spring of 1841, when an address was published and circulated throughout the country as in the case of the London Working Men's Association. A large number of

Chartists expressed their approval by signing the address—a step which caused them many pangs. The first meeting took place in November when a London branch of the National Association was started; Hetherington became Secretary; Vincent, Cleave, Watson, Mitchell, and Moore rallied round their old leaders. C. H. Neesom and R. Spurr, old opponents of Lovett and former advocates of insurrection, now joined hands with him. J. H. Parry, a barrister (afterwards Serjeant Parry) and a great advocate of women's enfranchisement, joined also, as did W. J. Linton, the artist and poet, who left interesting reminiscences of Lovett, Watson, and others. The National Association repudiated entirely the O'Brienite attitude towards the middle class, and the Chartist policy of spoiling Anti-Corn Law meetings. In 1842 it acquired a disused chapel in Holborn, renovated it at a cost of £1000, and so opened the first hall of Lovett's dreams. It was unfortunately the only one, and lasted but seven years. For reasons which will be given later, this movement obtained no root in the Chartist soil, and Lovett gradually drifted into that educational work in which his heart was, and so found a rest from political excitement.

The life of Thomas Cooper of Leicester, called "the Chartist"[1] (1805–1892), was in every way remarkable. The son of poor parents, robbed early of his father, Cooper passed rapidly through the varied rôles of shoemaker, teacher, musician, Wesleyan local preacher, newspaper reporter, Chartist lecturer and leader, Chartist prisoner, outcast and poet, teacher of morals and politics (a more educated though less forceful Cobbett), secularist, convert, anti-secularist, dying at the great age of eighty-seven. The mere recital gives a clue to the character of Cooper—an impulsive man but intensely loyal where his convictions or sympathies were enlisted—a hero-worshipper apt to turn iconoclast.

Cooper's career is an extremely interesting example of how Chartists were made. He was an entirely self-taught man. He acquired an incredible amount of learning under the most disadvantageous circumstances. Latin, French, Greek, Mathematics, Music, English Literature (especially that stand-by of the humble reader, *The Pilgrim's Progress*)—all came alike to him. Radical notions he acquired from some trade unionists of his acquaintance, though such ideas were beyond doubt the common possession of all the reflecting members of the working classes. Like most self-taught

[1] *The Life of Thomas Cooper*, 1872.

people, Cooper lacked that balance of judgment which comes largely by contact with other minds, and he was apt to act hastily upon half-truths. He also had no little opinion of himself, as a glance at his autobiography will show. A brilliant but impulsive intellect, Cooper flared up suddenly in the Chartist world, and as suddenly disappeared. But in the years 1841–42 there was no leader so successful as he.

Whilst acting as reporter for a Leicester paper, Cooper was requested near the beginning of 1841 to report a Chartist meeting in the town. It was to be addressed by John Mason, a shoemaker of Birmingham. It is remarkable how many shoemakers failed to stick to their lasts in those days ; Collins, Benbow, Cooper, Mason, Cardo are all cases in point. Cooper found some twenty ragged men in the room when he arrived, but the place quickly filled up with men and women, all equally poor and ragged. The speeches were sensible and temperate, and they told Cooper nothing new. On leaving the meeting, however, his attention was drawn to the clatter of the knitting-frames—and that at an hour approaching midnight. Inquiries revealed to him the fearful poverty which drove starving men and women to toil at such a time for such wages—less than a penny an hour. The crying injustice of the frame-rent system completed his conversion.[1] From that day he was a Chartist, and his Chartism grew more vehement daily. In our days revelations of this sort would at once produce an agitation for the reform of the frame-rent system, and it is very significant of the passionate and unpractical temper of those times that Cooper seems never to have thought of any such thing. The opposition which such a campaign would have to meet, and the poverty and recklessness of the poor employees themselves would have rendered its successful conduct all but hopeless. To men so situated as these stockingers (who had proved their own helplessness in many a futile strike) the Charter had become a kind of charm or fetish, through which every evil would be exorcised, and every social wrong be avenged. In the year 1841 every poor man with a real grievance tended to become a Chartist. Chartism was the grand, all-containing Cave of Adullam for men who were too poor to build up their own barriers against economic oppression.

So Cooper became a Chartist. His conversion was quickly followed by the loss of his situation, and he thenceforward

[1] *The Life of Thomas Cooper*, p. 179.

devoted himself wholly to the cause of the stockingers. He
ran several newspapers in succession, conducted innumerable
meetings, and rapidly acquired an immense following which
he proceeded to organise. He took a large hall of meeting,
and christened his flock the "Shaksperean Association of
Leicester Chartists." By the summer of 1842 he claimed 2500
members.[1] He divided them up into classes, which went
under such names as the "Andrew Marvell," "Algernon
Sydney," "John Hampden" class. He devised a kind of
uniform, gave to his adherents a pseudo-military organisation,
and proudly bore the title of "Shaksperean General." Is it
too far a cry to assume that Cooper was the originator of ideas
afterwards developed by William Booth at Nottingham? By
these means—the magic of uniform and badges—Cooper de-
veloped a really ferocious *esprit de corps* amongst his followers,
who idolised him. But he was not content with demonstra-
tions. He took pains to give his disciples education in an
adult school, and amusement of the right sort. Cooper has
preserved for us some Chartist hymns and songs of no little
merit which were composed by himself and some of his
Shakespereans. Through the comparatively prosperous days
of 1841 (there was a temporary revival of trade) Cooper kept
his following in hand. He kept their minds occupied, pre-
vented them from brooding, interested them in recreative
pursuits. A by-election provided excitement; visits from
various noted Chartists afforded variety, and in general
Cooper succeeded in brightening and cheering the lives of many
who would otherwise have fallen victims to despair. He
believed and taught his followers to believe in the vague and
vain promises of O'Connor that the Charter would yet be
carried.[2] Even this hope did not, however, remove the feeling
of desperation which began to grow during the terrible months
of 1842, when starvation knocked at every stockinger's door
with greater insistence than ever. The poor folk gradually
got out of hand; Cooper was equally carried away by the scenes
of terror and suffering, and was hurried into the catastrophe
which in August ruined Chartism for the second time.[3]

Thus the great movement got once more under weigh.
With new men and new methods, Chartism made great progress
during 1840 and 1841. The new organisation tended towards
much greater efficiency. It separated the wheat from the chaff,

[1] *Northern Star*, July 23, 1842.
[2] *The Life of Thomas Cooper*, p. 179. [3] Pp. 173 *et seq.*

those who applauded at meetings from those who worked
and subscribed for the cause. One sign of this greater effi-
ciency is the fact that a petition on behalf of Frost, handed in
in May 1841, received over two million signatures, far more
than the National Petition of 1839. Lecturers were hard at
work. Local newspapers again sprang up—such as those
published by Cooper in Leicester, by Philp at Bath, by Beesley
for North Lancashire, by Cleave in London, and by the Scottish
Chartists. Physical force was for the time being abandoned;
efforts were concentrated upon gaining steady adherents, and
upon preventing the spread of the Anti-Corn Law campaign.
In August 1841 O'Connor was released from York Gaol, six
weeks before his time, and a process of disruption at once began,
and did not cease until it had reduced the Chartist body to a
fanatical sect of unreasoning O'Connor-worshippers.

CHAPTER XIII

CHARTISM *VERSUS* FREE TRADE

(1842–1844)

REVIVED Chartism found itself competing, both for the attention of the public and the allegiance of working people, with a very powerful rival. This was the Anti-Corn Law League, whose agitation began almost simultaneously with the publication of the Charter and ran alongside it until 1846. The Chartists early discerned the danger to their cause which was threatened by the Free Trade agitation, and took up a definitely hostile attitude to it. But the earlier years of the Anti-Corn Law movement gave little promise that it would become a very serious rival to the Chartist propaganda. Its petitions and motions in the House of Commons were rejected with little ceremony, and the Chartists only saw in these non-successes further proofs of their belief that without political reform no important social improvement could be achieved. During 1839 the working classes were preponderatingly on the side of the Charter, but the ignominious collapse of Chartism, the imprisonment of the leaders, and the temporary abandonment of agitation, gave the Anti-Corn Law League an opportunity which it did not let slip. With large funds, able and eloquent leaders, and unswerving purpose, the Free Traders made great headway. The solid mass of the middle class was behind them, and this was the class which had the preponderating influence in the majority of the electorates which returned the reformed House of Commons. Moreover, it probably required no great persuasion to bring over all the better-paid and more educated artisans and operatives, who were beginning more and more to share the political and economic ideas of the Radical middle class. The extent of the Free Trade

forces in 1842 may be gauged from the fact that in the Parliamentary Session of that year 2881 petitions, signed by 1,570,000 persons, were presented ; and this was repeated year after year.

When the revival came the Chartists took up with vigour the task of counteracting the Free Trade Campaign. By debates, polemics, and the smashing of meetings they carried on for three years the hopeless struggle, until in August 1844 a personal meeting between O'Connor and Cobden destroyed the Chartist case and ended the feud.[1] The Chartist arguments against the rival agitation were derived largely from James O'Brien. It was detested as a middle-class movement, started to suit the interests of the manufacturers—a charge to which Cobden pleaded guilty. The repeal of the Corn Laws would simply hand over the working class to the manufacturers and money-lords. The ruin of agriculture, which was inevitable if the laws were repealed, would drive thousands of agricultural labourers to the towns, there to compete and reduce wages. High prices meant high wages, they argued ; therefore, if the manufacturers cried " cheap bread " they meant " cheap labour." Furthermore, if prices were so reduced, the chief benefit would go to those who lived upon fixed incomes— the " tax-eaters," fund-holders, clergy, and sinecurists. The reduction in prices would be equivalent to an enormous increase in the National Debt, and thus benefit the public creditor at the expense of the labourer who has to pay the taxes. Unless, therefore, as O'Brien argued, there were some readjustment of the currency and of contracts for debt, the result of the repeal of the Corn Laws would be disastrous to the industrious classes.

These were the theoretical grounds of opposition. There were other reasons, too, which appealed to Chartists. Some few, like James Leach and West of Macclesfield, were convinced Protectionists, and tried to answer the Free Traders with arguments in kind. Other Chartists regarded the Anti-Corn Law League as an insidious middle-class attack upon their own agitation, as a movement deliberately devised to turn attention

They debated at Northampton on August 5, 1844. O'Connor's case was so feebly stated as to set rumours circulating among his own followers to the effect that he had been bribed to allow Cobden to enjoy a stage victory. O'Connor's own account in the *Northern Star*, August 10, has the merit of including a generous testimony to Cobden's ability. " He is decidedly a man of genius, of reflection, of talent, and of tact. . . . He has a most happy facility of turning the most trivial passing occurrence to the most important purpose. I am not astonished that a wily party should have selected so apt and cunning a leader." Gammage, *History of the Chartist Movement*, p. 255, says that the debate was the greatest victory ever won by the League over the Charter.

from the Factory and Poor Law questions, on both of which Cobden took an unpopular view. The Free Trade agitation was claimed by the Chartists as originally a working-man's agitation. It certainly figured largely in the agitation connected with the name of Hunt, and " No Corn Laws " was a cry at Peterloo. The middle classes, it was argued, had refused to aid in the agitation then, but were now ready to take it up in opposition to another propaganda, which threatened their own newly acquired political dominion. Unfortunately for Chartist solidarity, however, there was no complete unanimity in the opposition to the Anti-Corn Law League. Not every Chartist was opposed to the League, and not every Chartist was hostile to Free Trade. Some were quite prepared to leave the League alone to press the one question while they agitated for the Charter ; others were afraid that the League would swallow up their own movement. Some believed that the Corn Laws were an atrocity which ought to be removed ; others were Protectionists, like Feargus O'Connor. Some believed that the League was wasting its time, since Free Trade would never be attained without the Charter, and were therefore anxious to gain middle-class support for a joint programme of Charter and Free Trade. In fact every variety and combination of views existed amongst the Chartists upon this question. If there was a definite line of demarcation amongst them, it was between the agriculturists and the industrialists. Many Chartists, whose views are represented by O'Connor and O'Brien, regarded the industrial system as a whole as something unnatural, and they therefore harked back to a purely agricultural society, which O'Brien visualised as communistic and O'Connor as individualistic. Others accepted the industrial system and tended to be Free Traders. From other evidence, of which more will be said later, it appears likely that the most ardent followers of O'Connor's later " back-to-the-land " cry were the unfortunate industrialists who had been crushed by the competition of steam—the handloom weavers and stockingers. These men had long been crying for Protection—protection of wages and protection for their handicraft. Free Trade and Competition had no attractions for them.

A few samples of Chartist argumentation may here be cited. The Free Traders at Sunderland had called upon the Chartists there to aid in their agitation. Williams and Binns were the Chartist leaders ; they were sensible and moderate men who

agreed that the Corn Laws were an intolerable evil, but they replied that they could not agree to co-operate merely upon the merits of the question. " What," they ask, " is our present relation to you as a section of the middle class ? It is one of violent opposition. You are the holders of power, participation in which you refuse us ; for demanding which you persecute us with a malignity paralleled only by the ruffian Tories. We are therefore surprised that you should ask us to co-operate with you." They proceed to describe how the middle class press had denounced them as low adventurers, and their schemes as impracticable ; how it had ignored their proceedings except to pour contempt and ridicule upon them. The middle class had urged the prosecutions for treason and sedition, had hounded on the police and imprisoned the people's leaders. The people cannot co-operate with them, for their failings will not permit them to do so. Nor will their principles, for Chartism aims at something higher than the repeal of a tax. It aims at the stoppage of tyranny and slavery at their source.[1] So the attitude of the local magistrates, mill-owners, and gentry in the summer of 1839 was resulting in its natural consequences. The " asking-for-troops " face, which Napier so graphically describes, gave place to the prosecution-for-sedition face. The terror of July and August was avenged with a carnival of arrests, trials, and imprisonments which only embittered the relations of Chartists and the higher classes. The whole odium was thrown on to the middle class, and we cannot be surprised if leaders like Williams and Binns, smarting under imprisonment, vented their feelings in bitter denunciations of the whole body which they vaguely felt to be the cause of their failures and misfortunes.

The arguments of James Leach speak for themselves. In a debate with a Free Trader at Manchester he laid down seven propositions. First, that the workers had been duped by the middle class over the Reform Bill, and might therefore be duped over the Repeal of the Corn Laws. Second, that the evils of which the workers complained were due not to agricultural protection and the consequent depression in trade, but to machinery. Third, that the increase of trade which the League promised as a result of repeal would not be of any benefit to the labourer, for as the cotton trade had increased the wages of the handloom weavers had decreased. The argument here is, more trade more machinery, more machinery

[1] *Northern Star*, May 23, 1840.

less wages. Fourth, that England would not be able to compete with foreign countries through the export of manufactures, partly because the foreign countries would raise protective tariffs and partly because wages were very low in foreign countries, and we should have to reduce wages accordingly. Fifth, that the reduction of wages was the real object of the masters who took part in the agitation. Sixth, that no good could be done until the profit-mongers were deprived of their monopoly of political power. Seventh, that the real solution of the problems of unemployment and surplus population was the land. It may be said that, even allowing for garbled reporting, the Free Trader's arguments were hardly good enough to convince a less prejudiced opponent than Leach.[1]

The *Northern Star* of course took a prominent part in the controversy. In January 1842 it produced the following argument to prove that the extension of foreign trade, so ardently desired by the Manchester men, was no matter for which the working classes should show enthusiasm. It gives the following statistics of foreign trade :

	Official value of exports.	Real value.	Taxation.
1798 . .	£19,000,000	£33,000,000	£16,000,000
1841 . .	£103,000,000	£51,500,000	£53,000,000

Thus the extension of foreign trade meant that we had to give five times as much labour and raw materials to produce one and a half times as much goods in 1841 as in 1798. The labourer had to give five times as much labour for one and a half times as much wages. In addition to this he had to pay over three times as much in taxation. Arithmetically considered, the labourer was paying proportionately ten times as much taxation in 1841 as in 1798.

Suppose now, the argument proceeds, we abolished all our foreign trade, what then ? We should lose fifty-one and a half millions a year. But we could easily reduce taxation by forty-eight millions, and our loss would only be three and a half millions. On the other hand, we should gain all the vast stores of food and clothing which are now annually exported ; these would be divided out at home instead.[2]

Truly political economy was no mystery to the leader-writer of the *Northern Star*.

A very terse analysis is given by T. J. Dunning. The National Income as a whole is divided into Wages, Profit,

[1] *Northern Star*, October 3, 1840. [2] *Ibid.* January 29, 1842.

Rent, Taxation, falling respectively to the Labourer, Capitalist, Landlord, and Tax-receiver (fund-holders, clergy, pensioners, civil servants, sinecurists, army, navy, etc.). The prices at which goods are sold must be sufficient to allow each of these his share. In order that corn may yield this price a duty is imposed upon cheaper foreign corn ; the repeal of these duties will lower the price of corn, which reduction will have to be borne by some or all of the above classes.

I apprehend it cannot affect the labourer for he is already ruined, nor the farmers, unless the cultivation of corn is to be stopped, for they are said to be on the brink of ruin : it must therefore fall upon the landlord or the tax-receiver or both : but these have the making and repealing of the laws. It is highly probable, therefore, that unless these men are in perfect ignorance of the matter, which by the way is not unlikely, these laws will still be unrepealed.[1]

In this controversy, therefore, the Chartists were hopelessly out-argued by Cobden, Bright, W. J. Fox, and the rest. Both in theory and methods the League was far superior. Nevertheless those who follow Place in condemning as futile and foolish the opposition of the Chartists to the League forget that the opposition was one of passion and sentiment rather than of dialectics. The Chartists feared that the cause for which they had struggled and suffered would be smothered in the dust of a conflict between two factions which they considered to be equally inimical to it. They hoped, through their new organisation, to win to their side the large body of the industrious classes, and they hated the Leaguers for queering their pitch. When the two agitations began, there was no reason to suppose that the one would be any more successful than the other. No one described Chartism as " the wildest and maddest scheme that had ever entered into the imagination of man to conceive," as Melbourne described the repeal of the Corn Laws. The Chartists, therefore, had as much right to expect co-operation from the middle class in the Charter campaign as the middle class from the Chartists in the Free Trade campaign. The opposition was perfectly natural. It was indeed futile and foolish. By the system of upsetting League meetings the Chartists accomplished little, and they only brought themselves into bad odour. When they debated, they often had to beat a ridiculous retreat. But poor, uneducated men, stirred by passion and resentment, are poor debaters in any case, and the disturbance of opposition meet-

[1] *Charter*, January 27, 1839.

ings was as much a symptom of helplessness as of anything else. It was a counsel of despair, and it is unfortunate that the *Northern Star* writers, who ought to have known better, should have encouraged this vain and absurd practice by declaiming in big headlines about " triumphant victories " over the League, " the Plague " as they were pleased to call it, and by assuming to believe that such " victories " were rendering service to their cause.

CHAPTER XIV

O'CONNORISM

(1841–1842)

On August 30, 1841, Feargus O'Connor was released from York Gaol, six weeks before the period of his imprisonment was complete. With this event the Chartist Movement commences another phase. It is the period of the development of the absolute personal supremacy of O'Connor. It is interesting to see how this supremacy was attained. There are several factors in the process, the personal gifts of O'Connor himself, the *Northern Star*, which ruthlessly manufactured and exploited opinion, the ignorance of his followers, and the fact that leaders inclined to independence of opinion were at work in separate organisations, and so left the National Charter Association at the mercy of O'Connor.

Of O'Connor's personality something has already been said. A jovial, tactful, obliging person, to whom no exertions were wasted which procured one more adherent, a boon-companion of a highly entertaining character, suiting his conduct exactly to the standards of his company, a racy and not too intellectual speaker, a master-hand at flattery and unction, a *poseur* of talent and resource, O'Connor was well equipped to gain the affections of uneducated men to whom sympathy with their hard lot was more than dissertations upon democratic freedom and exhortations to self-culture. Social antipathy, not political bondage, was at the bottom of Chartism, and the immense exertions of O'Connor, a member of the favoured classes, in the cause of the poor, vain, futile, and self-glorifying as those exertions were, were nevertheless a passport to the fidelity and affection of many thousands of followers.

There is a repulsive aspect to this relationship in the manner

in which O'Connor exploited this intense loyalty. That this
exploitation did not exhaust the sources of affection is a witness
alike to the intensity of the feeling and the blind ignorance of
the followers. O'Connor had that rare commercial instinct
which enabled him to derive profit from the most unlikely
sources. Nothing escaped his notice—the *Northern Star*, his
imprisonment in York Gaol (though only remotely connected
with Chartism), and the bad memories of his followers, were
alike sources of profit and power. A few samples may be
given.

On the eve of his commitment to York Castle O'Connor
penned an article of Napoleonic arrogance [1] to his followers.
It is a farewell message :

Before we part, let us commune fairly together. See how I
met you, what I found you, how I part from you, and what I leave
you. I found you a weak and unconnected party, having no
character except when tied to the chariot wheel of Whiggery to
grace the triumphs of the Whigs. I found you weak as the mountain
heather bending before the gentle breeze. I am leaving you strong
as the oak that stands the raging storms. I found you knowing
your country but on the map. I leave you with its position engraven
upon your hearts. I found you split up into local sections. I have
levelled all those pigmy fences and thrown you into an imperial
union. . . .

Early in 1841 he produced a long recital of his political
career and addressed it to the English People.[2] It culminates
in the amazing assertion :

Now attend to me while I state simple facts. *From September
1835 to February 1839 I led you single-handed and alone.*

In this way O'Connor, in true Napoleonic fashion, succeeded
in throwing a haze of legendary magnificence about the early
dubious venturings of his post-Parliamentary career. The
last statement was a master-stroke. When he wrote, February
1839 was but two years past and memories reached back to it ;
it was not safe to allegorise the career of the Convention. Nor
was it expedient, for by giving up his leadership at that
moment, O'Connor divested himself of responsibility for the
futilities which followed. He followed up this bold step a
week later by presenting a version of his career as a Conven-
tional. He had always opposed physical force. In fact, in the
Convention he had *alone opposed* the idea of a Sacred Month,
and had succeeded in putting a stop to it. He had always

[1] *Northern Star*, April 25, 1840. [2] *Ibid*. January 16, 1841.

opposed the talk about arms, not as illegal, but as inadvisable.[1]
The truth was, that having steadfastly shouted with the
larger crowd, O'Connor could safely claim to have supported
and opposed every policy which the Convention discussed.

Along with this process of self-glorification, O'Connor en-
deavoured successfully to enlist sympathy for his sufferings
in gaol.[2] From the first week of his imprisonment O'Connor
was able to publish in the *Northern Star* long accounts of his
evil plight, his ill-health, the despondent verdicts of the doctors,
the ruthless tyranny of governor and Government. These
accounts were followed by multitudinous meetings of protest.
A fortnight after his commitment to gaol the reports of these
meetings occupy six closely printed columns on the front page.
On July 11, 1840, O'Connor's article upon the subject occupied
eight columns. These whinings, which aroused the contempt
of Lovett and others, were not the sentimental drivelling of
cowardice, but the manœuvres of a diplomat who knew what
he was about. He was establishing a claim to Chartist martyr-
dom. His imprisonment was for a serious libel upon the
Warminster Guardians, and was therefore not a Chartist affair,

[1] *Northern Star*, January 23, 1840.
[2] No more extraordinary example of self-glorification can surely be
found than the stanzas written by O'Connor in York Gaol and intended
to be recited by Lovett and Collins at the reception in Birmingham.
There are thirty-one in all.

> 1. From East to West, from North to South,
> Let us proclaim the Charter !
> We'll send all tyrants right about
> Who dare oppose the Charter.
>
> 3. In England's name her own King John
> Once tried to sell her Charter.
> But England's sons now dead and gone
> All rose for England's Charter.
>
> 5. Will Lovett, Collins, and the rest
> Who suffered for the Charter,
> In old St. Stephen's shall be placed
> To rule us by the Charter.
>
> 7. *O'Connor is our chosen chief,*
> *He's champion of the Charter :*
> *Our Saviour suffered like a thief*
> *Because he preached the Charter.*

As the poem progresses the quality declines, but stanzas 24 and 25 are
interesting :

> 24. The sons of men must have their field
> Protected by the Charter.
> The earth will then profusion yield,
> Made fertile by the Charter.
>
> 25. The gaols are full; the Whigs did bribe
> To damn the People's Charter.
> But for their wives we will subscribe
> In honour of the Charter.

except in so far as he had later become a Chartist. But he affected to believe that the case had only been pressed to get him out of the way, just as his release was supposed to be dictated by craft and fear.[1] So the O'Connor legend grew. The mere fact that O'Connor was able, nearly every week, to write long articles to his paper, does not encourage belief in his sufferings. Nor does the remarkable energy which he displayed from the moment of his release support such belief. That the confinement did cause some discomfort is beyond doubt, but whether, as a result, O'Connor could, like John Collins, stick his hard felt hat inside the waistband of his trousers [2] may be doubted.

From the gaol, too, O'Connor was able to take no little part in the conduct of the National Charter Association. His plan for the reorganisation of the movement had already received attention. In the early part of 1841 a project was on foot for a second Petition, combining the requests of the National Petition with one for the release of various prisoners, especially Frost, Williams, and Jones. O'Connor proposed that a Convention of ten should be elected to supervise the Petition. He suggested a list of twenty persons who might be elected. When the election was complete nine out of ten of his nominees were elected. The tenth was Collins, who raised a great storm in the Convention.[3] The proceedings of this body show that even careful selection of delegates was not an antidote to disunion. O'Connor followed up this manœuvre with another of the same kind. He drew up a list of eighty-seven individuals whom he described as Chartists who may be trusted. All the Lovett men are omitted, as well as Collins and the Christian Chartists. It was a purely partisan selection. Thomas Cooper, for the time a blind follower of O'Connor, is described as a host in himself. O'Brien and Benbow find places, but Rider and Harney do not, being on the staff of the *Star*, and therefore not available for organising and delegate work. The obvious intention was to ensure the selection of these men in the choice of officials and representatives. The list was joyfully accepted and resolutions of confidence passed in the " old list " and " the 87." [4]

In this development of O'Connorism, in which personal loyalty to O'Connor was at least as requisite as sound Chartism, the *Northern Star* played a great and decisive part. It was

[1] *Northern Star*, August 28, 1841, Leading Article.
[2] See the account in Lovett's *Life and Struggles*.
[3] *Northern Star*, May 8, 15, 22, 29, 1841.
[4] *Ibid.* April 24, 1841 ; May 1, 1841.

the only really prosperous Chartist paper, and stood head and shoulders above its struggling contemporaries. The great collapse of 1839 dragged down many rival newspapers, and those which took their places were Chartist pamphlets rather than newspapers, for they were unable to publish " news," being unstamped.[1] The Chartist body was unable to support more than one journal of any size, and so the *Northern Star* shone alone in the firmament. It was almost the sole source of Chartist news, and it was the chief channel of communication. Its able and unscrupulous editor, William Hill, employed it exclusively to further the despotism of its proprietor. He suppressed news and garbled it. He allowed attacks upon suspected individuals and prevented replies. He made and unmade reputations in his columns. Through the *Star* the policy of Chartism was made and directed. Not that the rank and file were unable to obtain a hearing in its columns, far from it; but preference was given to particular persons, and opinion was overridden by the *ipse dixi* of editor or proprietor.

Not merely on the journalistic side was this newspaper a potent O'Connorising instrument, but its commercial side was exploited, too, for the same purpose. A newspaper must have agents, distributors, reporters, and so on, and O'Connor and his staff had built up an efficient body of news-collectors and news-distributors. Naturally none but Chartists were eligible for this purpose. O'Connor, however, was not content with this perfectly legitimate employment of Chartists; he strove deliberately to turn his employees, reporters, and agents into instruments for furthering his personal supremacy. We have seen how he offered to pay a Convention, and how he offered to turn Chartism as a whole into a newspaper syndicate under his control. These projects came to naught, but he attained part of their purpose by the use of the *Star*. He turned Chartist leaders into paid reporters,[2] and paid reporters into Chartist leaders, and he used them, as in the case of Philp at Bath, to eliminate from the movement men of independence.[3] He ruthlessly exploited financial obligations, as in the case of O'Brien.[4] He allowed his newspaper agents to fall into debt if he thought he could keep a hold on them thereby.[5] So

[1] A list of eleven Chartist papers in the *Northern Star*, October 23, 1841. Few were of importance as compared with the *Star* itself.
[2] George White, Harney, Rider, Griffin, Cooper, Lowery, and others were connected in this way with the *Star*.
[3] *Northern Star*, March 12, 1842; March 19, 1842.
[4] See below, pp. 236-7.
[5] Case of R. Lowery, *Northern Star*, February 13, 1841.

great became the power of the newspaper that a new species of *lèse majesté* became possible. Deegan was solemnly tried at Sunderland on the charge of speaking evil against the *Northern Star*; he was mercifully acquitted.[1] Cases of Anti-Northern-Starism became possible and not infrequent. Thus, as Place relates: " O'Connor obtained supremacy by means of his volubility, his recklessness of truth, his newspaper, his unparalleled impudence, and by means of a body of mischievous people whom he attached to himself by mercenary bonds." [2]

There is, however, another side to the matter. Says Thomas Cooper:

Feargus O'Connor, by his speeches in various parts of the country and by his letters in the *Northern Star*, chiefly helped to keep up these expectations (*i.e.* that the Charter would soon be obtained). The immense majority of Chartists in Leicester, as well as in many other towns, regarded him as the only really disinterested and incorruptible leader. I adopted this belief because it was the belief of the people : and I opposed James Bronterre O'Brien and Henry Vincent and all who opposed O'Connor or refused to act with him.[3]

Nothing shows more clearly the strength of O'Connor's influence than that a leader of Cooper's calibre should unhesitatingly follow the crowd of which he was supposed to be leader, in its blind adoration of that famous demagogue. It would be idle to suppose that O'Connor in no wise deserved this fidelity ; men do not gain such homage without cause or merit. But O'Connor's character was such that no man of independence, talents, and integrity could long co-operate with him. O'Brien, Cooper, William Hill, Gammage, Harney, Jones, and a crowd of others served him with zeal and quitted him with contumely. Yet there was something gained by the supremacy of O'Connor. The disunion which had been so disastrous in 1839 was avoided, and the National Charter Association stood as a very enthusiastic and very hopeful compact body. The ruthless and unsparing ostracism of the anti-O'Connorite leaders is a tribute to the desire for solidarity in the rank and file as well as to the jealousy and power of O'Connor. But within the association movement was restricted, criticism was gagged, and initiative discouraged. Chartism became the faith of a sect rather than the passionate cry of half a nation.

On his release from prison O'Connor at once jumped into the saddle. He was greeted with tremendous ovations. The

[1] *Northern Star*, February 13, 1841.
[2] Additional MSS. 27,820, p. 3. [3] *Life*, p. 179.

great Huddersfield demonstration deserves special mention. The following is a list of the banners and mottoes:

1. Full-length portrait of O'Connor.
2. Banner setting forth the points of the Charter.
3. "We demand Universal Suffrage."
4. Justice holding the scales with Equal Rights balanced against the People's Charter.
5. "The Charter our Right."
6. "Equality of All before the Law."
 "Taxation without Representation is Tyranny and ought to be resisted."
7. "The Right of every Man to Liberty is from God, from Nature, from Birth, and from Reason."
 "The whole of the principles contained in the People's Charter we demand."
8. "God save the Queen, for we fear no one else will."
 "The Glorious Republic of America, and soon may England imitate that country: its people happy and contented."
9. "England expects every man to do his duty."
 "God helps those who help themselves."
10. "The Land, the Land, the right of every living man."
 "The Rights of Labour, soon may they be acknowledged throughout the world."
11. "Every man his own Landlord."
 "Down with the accursed factory system, the school of immorality, profaneness, wickedness, and vice of every description."
12. "England, Home, and Liberty."
 "No Bastilles: the Right of every man to live upon his native land."
13. "Equal Representation.
 "No distinction before the Law."
14. "Honesty is the best policy: No Humbug: No Corn Law Fallacies: the full rights of all we ask, no more we demand, this we will have."
 "God gave the earth for man's inheritance: a faction have taken it to themselves. Justice, Justice, Justice!"
15. "Universal Suffrage."

Then came:

Operatives sixteen abreast
The Carriage
drawn by four greys; postillions, scarlet jackets, black velvet caps and silver tassels; containing the People's Champion

FEARGUS O'CONNOR, ESQUIRE,

along with Messrs. Edward Clayton, Robert Peel, and other friends.

Transparent lamps on each side.
Green silk flags on each side of the carriage.
Operatives sixteen abreast.[1]

Apart from their variety, which embraces everything from opposition to the League to overthrowing the monarchy, the aspirations blazoned on the banners are remarkable for the significance already attached to the land as a factor in national regeneration. O'Brien, Leach, O'Connor, Hobson (publisher of the *Northern Star*), and many other leaders were in various ways agitating the question, and a movement was already on foot which was destined to swallow up the Chartist movement itself.

Another example of O'Connor worship may be quoted :

Working Men of Huddersfield and vicinity Arouse, Arouse! and join the ranks of Freedom. Shake off the chains of servile bondage. Be Men, Men determined no longer to be serfs, or wear the galling mark of Slavery. Up then in your wonted might, and show to your oppressors, you know how to estimate such men as O'CONNOR, who will be in Holmfirth at Noon on Saturday, December 4, 1841.[2]

As a matter of fact the arrangements for O'Connor's reception fell far short of what was intended, on account of his unexpected release. Special demonstration committees were set on foot in Lancashire and Yorkshire, and demonstrations were arranged for York, Leeds, Sheffield, Manchester, Colne, Keighley, Halifax, Bradford, Todmorden, Bolton, Stockport, Huddersfield, Dewsbury, Barnsley, Rochdale, Middleton, and Blackburn.[3] These demonstrations were of course intended to be a great recruiting tour, but unfortunately the fates decided against them. O'Connor showed himself, however, perfectly indefatigable. Early in November he made a successful tour throughout Scotland where, in spite of his declarations against physical force, he took pleasure in attacking Brewster and his Chartist " Synod " at Glasgow. His report on this journey is written in a style strongly suggestive of megalomania.[4] A few days later he was quitting London for a tour in Lancashire and Yorkshire, visiting Stockport, Ashton, Oldham, Rochdale, Heywood, and Bolton in five days. At Stockport there was so large a crowd that the floor collapsed.[5] He then visited Dews-

[1] *Northern Star*, December 11, 1841.
[2] *Ibid*. November 27, 1841.
[4] *Ibid*. November 13, 1841.
[3] *Ibid*. August 21, 1841.
[5] *Ibid*. December 4, 1841.

bury, Bradford, and Halifax. If O'Connor attained supremacy within the National Charter Association, it was partly because he worked for it, for none of his followers, Cooper perhaps excepted, could compare with him in activity. He rejoiced in the work; he enjoyed the excitement and the applause. Controversy he almost welcomed, as if politics were a great Donnybrook. Year after year his herculean frame enabled him to continue, but the malady which was slowly unseating his reason caused his feats of endurance to be less and less controlled as the years went on. Chronic incoherence characterised his later activities. But in these earlier years O'Connor's ubiquity and superhuman energy were invaluable to the cause. He brought in recruits wherever he went. He kept the agitation alive through good report and evil report. So far as Chartism spurred on governments and public opinion to a more sympathetic treatment of the poor and the industrious classes, O'Connor must not be denied some of the praise for the good which indirectly ensued from his immense activities.

From the moment of O'Connor's release the policy of the National Charter Association took on a firmer shape. Much had been done since the Manchester Delegate Assembly of July 1840. A lively agitation was organised; a Convention had been held, and a petition, very successful in point of signatures at least, had been presented in May 1841 by T. S. Duncombe to the House of Commons, praying for the release of the Chartist convicts. Duncombe's motion that the Queen be requested to reconsider the cases of all political prisoners was lost only on the casting vote of the Speaker, who declared that the motion was an interference with the Royal Prerogative.[1] On the occasion of an O'Connor demonstration at Birmingham in the September following, MacDouall, as one of the Executive, put forward a programme of agitation which included another National Petition and Convention.[2] All efforts were to be concentrated upon these objects and the Petition was to be presented in 1842. The organisation was strung up to a higher degree of activity. Delegate meetings, representative of large areas, were called to supervise the arrangements.[3] In October 1841 the Executive published the programme outlined by MacDouall. The Convention was to meet on February 4,

[1] *Northern Star*, June 5, 1841. For, 58; against, 58.
[2] *Ibid*. September 25, 1841.
[3] See the cases of Bath (*Northern Star*, October 16, 1841), and Birmingham (*Ibid.* November 6, 1841).

1842, and to sit for four weeks. The Petition was to be presented without any delay such as occurred in 1839. The Convention was to consist of twenty-four delegates, for each of whom a sum of £15, exclusive of travelling expenses, must be furnished by the constituents. The representatives would be nominated by ballot and elected in public meetings. The Executive would stand for election and the " parliamentary candidates " would have a prior claim to the suffrages of the Chartist body.[1] Thus the intention was to bring the renewed agitation to a climax early in 1842. Nothing was specified as to the subsequent proceedings, and there was no foolish talk about ulterior measures. But before the Convention met or the Petition was presented, much water flowed under the bridge, and in it many Chartist hopes foundered.

[1] *Northern Star*, October 9, 1841.

CHAPTER XV

(1841–1842)

(1) O'CONNOR'S BREACH WITH LOVETT (1841)

WHILST striving, with energy and success, to establish his supremacy over the National Charter Association, O'Connor was carrying on a vigorous campaign against all rival and parallel organisations within the Chartist world. In this warfare he had the enthusiastic and unquestioning support of the great mass of the members of the Association, who were anxious above all to avoid the schisms and disunion which had been so devastating in 1839. Even allies were not tolerated if they aspired to independence ; there must be one army and one leader. Thus the personal desires of O'Connor and the intolerant notions of his followers worked together for the same ends.

The first rival scheme to come under O'Connor's ban was the National Association for Promoting the Improvement of the People, which, as we have seen, was being inaugurated by Lovett and Collins. The opposition between Lovett and O'Connor was the opposition of two completely different personalities. Lovett was a thin, delicate, nervous, retiring, serious, and ascetic man to whom life was a tragedy, made bearable only by self-abnegation and devotion to the welfare of others. O'Connor was a great, burly, bouncing, hail-fellow-well-met, to whom the essence of life was political agitation, involving crowds, excitement, applause, and authority, the end and purpose of the agitation being but secondary. The two were totally incompatible. Lovett lacked the saving grace of a sense of humour, and O'Connor jarred on

him, whilst to O'Connor the intellectual and moral purposes of Lovett were foreign and unintelligible. All these things were against any hearty co-operation from the very beginning. Lovett detested the personal ascendancy of O'Connor; it was against his principles. He also suspected O'Connor's sincerity in the people's cause. O'Connor no doubt returned these feelings with interest. He took no further notice of Lovett and Collins when they were incarcerated, and their appeals for better treatment in prison were totally ignored by the *Northern Star*,[1] which found space for many columns of O'Connor's whinings. Lovett fell into an intense detestation of the great Northern demagogue, and from the moment of his release nothing could induce him to bury his resentment and co-operate with the National Charter Association. Lovett carried with him many sincere and able men, but they were officers without companies. The rank and file marched with the Irishman, whose controversial methods may be gauged from the following.

Even before Lovett's new Association had been launched these incompatibilities were threatening Chartism with a new schism. Lovett was designing his National Association to supplement rather than to supersede the National Charter Association. But as the latter fell more and more under O'Connor's control, Lovett's refusal to work with it had the inevitable consequence of suggesting that he was dividing the Chartist forces at a moment when unity was especially necessary. O'Connor took full advantage of his enemy's mistake and attacked him and his friends with unrestrained violence. The onslaught began with an article, written by O'Connor, in July 1840, denouncing the refusal of the London Radicals to take part in the Manchester delegate meeting, a refusal, dictated partly by lack of funds, which was afterwards rescinded. The worst enemies of the suffering multitudes, says O'Connor, are the better-paid members of their own order. " Of all parts of the kingdom the masses have least to expect from the leaders of popular opinion in the Metropolis. The fustian jackets, the unshorn chins, and the blistered hands are as good there as here, but the mouthpieces which undertake to represent them appertain, generally speaking, to an altogether different class." [2] A week later O'Connor tersely declared that " London is rotten."

[1] Place Collection, Hendon, vol. 55, p. 580.
[2] *Northern Star*, July 4, 1840.

This particular article contains one of the earliest references to the Land Scheme of the future, a scheme which was more alien than ever to Lovett's Chartism. In this fashion was O'Connor leading Chartism away from the original ideas of its founders, among whom he could in no wise claim to be. Not content with O'Brien's denunciation of the middle class, he still further narrowed the appeal of Chartism by his denunciation of the higher ranks of the working class. The great working-class party which Lovett conceived of, and still more the possible co-operation of the more liberal of the middle classes, became more and more impossible of realisation. The truth was that for really intelligent working men O'Connor had no appeal. Hence his dislike of London and his preference for the factory and handloom-weaving areas.

These attacks upon Lovett provoked a reply from W. G. Burns, who averred with some asperity that " so long as Feargus O'Connor connects himself with any agitation, the object of which is to benefit the masses, that benefit will never be enjoyed, and he does not wish they should enjoy it." [1]

Soon afterwards Lovett's book *Chartism* appeared, and was very loudly praised by the more sympathetic London press. The *Northern Star* contented itself with sarcastic comments.[2] When, however, in March 1841 the " Address of the National Association to the Political and Social Reformers of the United Kingdom " was published, the storm of obloquy broke. This Address was circulated throughout the Chartist world. It set forth the objects of the National Association, as already described in *Chartism*, and it was accompanied by a dissertation in the true Lovett style.

In addressing you as fellow-labourers in the great cause of human liberty, we would wish to rivet this great truth upon your mind : *you must become your own social and political regenerators or you will never enjoy freedom.* For true liberty cannot be conferred by Acts of Parliament or by decrees of princes, but must spring up from the knowledge, morality, and public virtue of our population. . . . If therefore you would escape your present social and political bondage and benefit your race, you must bestir yourselves and make every sacrifice *to build up the sacred temple of your own liberties.* . . .
Tracing most of our social grievances to class legislation, we have proposed a political reform upon the principles of the People's Charter. . . . Believing it to have *truth for its basis and the happiness of all for its end,* we conceive that it needs not the violence of passion, the bitterness of party spirit, nor the arms of aggressive warfare

[1] *Northern Star,* July 18, 1840.　　[2] *Ibid.* October 3, 1840.

for its support : its principles need only to be unfolded to be appreciated and being appreciated by the majority will be established in peace.

But while we would implore you to direct your undivided attention to the attainment of that just political measure, we would urge you to make your agitation in favour of it more efficient and productive of social benefit than it has been hitherto. We have wasted glorious means of usefulness in foolish displays and gaudy trappings, seeking to captivate the sense rather than inform the mind, and apeing the proceedings of a tinselled and corrupt aristocracy rather than aspiring to the mental and moral dignity of a pure democracy. Our public meetings have on too many occasions been arenas of passionate invective, party spirit, and personal idolatry . . . rather than schools for the advancement of our glorious cause by the dissemination of facts and the inculcation of principles.[1]

This last paragraph is in every way worthy of attention. It is a splendid utterance of an idealist of democracy. Nor is its praise of " the mental and moral dignity of a pure democracy " more remarkable than the attitude Lovett betrays towards agitation. It is the agitation itself, not the attainment of the Charter, which will bring freedom. But this agitation must be far different from that which has hitherto been conducted ; it must be based upon education, self-sacrifice, self-activity, not upon wild talk of insurrection, arms, and violence, leading to cowardly desertions and imprisonments. In Lovett's mind the Charter has ceased to be a bill to be introduced into Parliament, but has become a democratic ideal which will realise itself through the strivings of the people for self-culture. Chartism is the organisation of an enlightened people ; with class-war, land schemes, conventions, petitions, and Parliaments it has simply nothing to do. It is in the hearts and minds of the people, which, when they are properly attuned one to the other, will produce the mighty song of freedom.

On April 17 there appeared the *Northern Star's* reply to this address. It took umbrage at the references to " gaudy trappings," and made the inevitable reply " as to personal idolatry, we shall only add in addition to what has already been said ' sour grapes.' " It denounced the notion of forming a separate association. Were the " six " who were responsible for the new Association more entitled to public confidence than the Executive of the National Charter Association ?

[1] Place Collection, Hendon, vol. 55, pages following 710 not indexed.

Was the London move not in fact a scheme of O'Connell, Roe-buck, and Hume to split the Chartist body and gain over a part to Household Suffrage ? Had not Roebuck pronounced the National Charter Association illegal ?

O'Connor through his deputy, Hill,[1] now proceeded to pour scorn upon Lovett's educational scheme.

Will some good fellow furnish us next week with an appropriate dialogue between one of the architects laying the foundation stone of the first Hall—the new Temple of Liberty—and a handloom weaver with nine children awaiting its completion as a means of relief ?

How would O'Connor use the quarter of a million annually raised under the scheme ? He would subsidise a hundred " independent " members of Parliament at £1500 a year each ; a Parliamentary committee at £1750 a year ; one hundred missionaries at one hundred pounds a year each ; and a balance of £74,730 would still be available for other purposes.

Now what would our friends think of such an appropriation clause, the enactment of which would, we fancy, put us in less than two years in joint possession of all the Town Halls, Science Halls, Union Halls, Normal and Industrial Schools, Libraries, Parks Pleasure Grounds, Public Baths, Buildings and Places of Amusement in the kingdom, ready built, furnished, stocked, and raised to our hands ?

The writer of the article alleged that it would be perfectly easy to buy dozens of members of Parliament at the price offered. This from an enemy of " corrupt " legislation !

Hill wrote the article, he tells us, with great pain. It was evident that those who had signed their names to the document had been deceived, and he adjured these misguided friends to confess their error and " manfully to ask pardon." " But should it be otherwise and should the sword be drawn, why then, we throw away the scabbard." [2]

This is a fair sample of this journal's controversial style. The generally low tone, allegations of treachery, sowing of suspicion, bludgeon-like satire, and the mixture of cozening and threats are thoroughly typical. It was unfortunately all too effective. The very next week a number of letters and resolutions appeared in the *Northern Star* from various persons and societies begging pardon, or echoing the *Star's* denunciations. Lovett had certainly not erred on the side of tact in his method

[1] The Trowbridge Chartists attributed this to Hill.
[2] *Northern Star*, April 17, 1841.

of propagating his new scheme. He sent copies of his address
to various Chartist leaders in person, selecting of course those
likely to be favourable or those whom he knew. They were
requested to sign if they approved and return it to Lovett,
who thereupon published the address with their signatures
under the title of the National Association. Thus many
members of the National Charter Association found them-
selves approving of another body which was now pronounced
to be a secret Whig-Radical dodge to smash the Chartist body.
But even though Lovett had been a little sharp in his dealings,
the tone of some of the recantations was sufficiently disgusting.
They were collectively described by the *Star* as " rats escaping
from the trap," and the National Association became the
" new move." The " new move " was described as " the
selfish and humbugging scheme of Lovett and Co." who were
" a Malthusian clique," " milk-and-water patriots " into whose
eyes gold-dust had been thrown. One resolution spoke of the
" base, cowardly, and unjustifiable conduct of the unprincipled
leaders of the new move in their continued efforts to heap
odium and discredit upon that tried man of principle and un-
ceasing advocate of the people's rights, Feargus O'Connor,
Esq." Leach at Manchester solemnly burned a presentation
portrait of Collins. In towns where one single Chartist had
signed the document the whole body of Chartists there hastened
to dissociate themselves from him and it, as if from a fatal
contagion. Some who recanted explained that they had never
read the document but took the signatures as a sufficient
guarantee. M'Crae, Craig's successor in Ayrshire, begged his
country to forgive him for signing. George Rogers, the bold
tobacconist of 1839, actually alleged that his signature was
used without his consent, and the *Northern Star* hinted that
there might be others similarly deceived. A very curious
sample of recantation is furnished by the Trowbridge Chartists,
once the favourite henchmen of Vincent and his physical force
notions. After sending to the paper a very temperate remon-
strance on the subject of its invective and mischief-making,
they nullified this by sending a letter immediately afterwards,
in which they withdrew all their charges and roundly de-
nounced Lovett's scheme as a Whig plot. It would be interest-
ing to know what wires were pulled to produce these contra-
dictory results.[1] Week after week the campaign went on.
The more the respectable newspapers praised Lovett's address,

[1] *Northern Star*, May 1, 1841.

the more the *Northern Star* denounced it. It was " a new mode of canvassing for support for Mechanics' Institutes, and the Brougham system of making one portion of the working classes disgusted with all below them." [1] Lovett replied to these attacks, but in the nature of things his arguments could have little effect.[2] Not all those who signed the address were cowardly enough to desert. Vincent and Philp claimed to be at once members of the National Association and of the National Charter Association. They were powerful in the Bath area, and special measures had to be taken by O'Connor and his followers to eliminate them. Vincent boldly defended his position, while Cleave, Hetherington, and Neesom engaged in fierce controversy with O'Connor and Rider.[3] It must be confessed, however, that the victory rested with the large battalions. Lovett found no general support amongst the Chartist ranks. He was compelled more and more to seek middle-class support, and outside London he gained few adherents.[4] His Association became a society of political and educational *virtuosi*. It was among other things an avowed supporter of the enfranchisement of women, a policy which alone sufficed to put it out of the pale of practical politics. So the leaven of idealism was ejected from the Chartist mass.

(2) THE ELIMINATION OF O'BRIEN (1841–1842)

O'Brien was also to be eliminated. For years he had been regarded as the friend and mentor of Feargus O'Connor, who had bestowed upon him the title by which he became honourably remembered, " the Chartist Schoolmaster." His articles in the *Northern Star* during 1838 had done not a little both for Chartist theory and for the reputation of that journal. In the Convention of 1839 O'Brien and O'Connor were generally faithful allies, but it is probable that the seeds of disagreement were already sown. O'Brien seems to have been as devoid of business acumen as O'Connor was rich in it. None of his independent journalistic ventures were successes. His personal habits seem to have been very irregular. He was a somewhat cranky, uncertain-tempered individual, impatient of restraint— in short, a man whose intellectual genius was crippled by un-

[1] *Northern Star*, April 24, 1841. [2] *Ibid.* May 1, 1841.
[3] *Ibid.* May 1, 1841; May 8, 1841. Neesom lost all his bookselling business on account of his support of Lovett.
[4] The Christian Chartists were on his side, but they did not count for much. O'Neill and Lowery signed the Address.

favourable circumstances, and whose temper was fretted by troubles which ensued from instability of will and conduct. He was reckless always, especially in money-affairs, inclined to fits of moroseness, occasionally gloomy and splenetic, a difficult character indeed. Financial difficulties seem to have put him into O'Connor's hands,[1] a situation which O'Brien's temper could ill brook. O'Brien further conceived that O'Connor had behaved treacherously to him on the occasion of his trial in April 1840.[2] For eighteen months O'Brien was incarcerated at Lancaster. Towards the end of his imprisonment he was able to contribute to the pages of the *Star*, so that the breach was by no means complete. The newspaper had every reason to desire a continuation of the connection with so able a writer, and one upon whose authority its anti-middle-class teaching was largely based. In April 1841 an article appeared which showed that O'Brien's views on this point were undergoing a significant change.[3] He put forward the thesis that the enormous political power of the middle class is as nothing compared with their social power. In fact political power is a consequence of the social power, which is derived from wealth, position, and social functions. Clearly O'Brien was turning his former teaching upside down.[4] He had hitherto taught that the power of legislation was the basis of social power, and the instrument of social improvement.

This reversal was too sudden for O'Brien himself, and he began to hedge a little. He succeeded after all in coming to the conclusion that the middle class was still the most implacable enemy of the working class, but he was clearly wobbling. The statement that the Reform Act of 1832 was a consequence of the social influence of the middle class, paved the way for the co-operation with part of that class, a policy which O'Brien advocated in 1842, as a means of gaining another and greater Reform Act.

Thus O'Brien, like Lovett, was drifting from the old Chartist moorings now occupied by the National Charter Association. In the summer of 1841 came the General Election which returned Peel to power and began the great financial revolution which ended in the Repeal of the Corn Laws. The Chartists were much agitated by the question as to what policy they ought to pursue in the party conflict. Some time previously

[1] *Northern Star*, May 30, 1840, case of Mrs. O'Brien and the *Southern Star*.
[2] Gammage, 1854, p. 270. [3] *Northern Star*, April 17, 1841.
[4] O'Brien recanted somewhat of this argument later in the same year (*Northern Star*, November 20, 1841) at Whitechapel.

they had endorsed the suggestion of O'Brien that Chartists should help neither party, but that Chartist candidates should be put forward at each nomination and carried at the hustings on the show of hands. But on May 29 and June 19, 1841, O'Connor came along with the advice to Chartists to support the Tories rather than the Whigs in the actual polling. On this O'Brien joined issue with his wonted vehemence. Unless, he said, fifty real Chartists are elected to the House of Commons or two or three hundred, elected by show of hands, are summoned to a great national council, there would be a bloody revolution. Such a council would be a means of rescuing the people from desperate courses. How, it is not clear. O'Brien denounced O'Connor's advice to vote Tory as madness. It would mean the annihilation of Chartism if the Tories were returned.[1] He further objected to O'Connor's habit of assuming to speak for the whole Chartist body, and of regarding his (O'Brien's) views as those of an individual.[2] He said that O'Connor's paper ought to have been moving in the election campaign three months before, instead of coming with its Chartist-Toryism at the last moment. O'Connor replied that he was advocating election plans as early as 1835 and referred to an article of September 1839 on the subject. He defended his advice. If, he said, the Whigs were re-elected they would have another seven years in which to exercise their callousness. The Tories were bound to be weaker than the Whigs, so that the latter would not be badly defeated, but adversity would tame them into accepting the alliance of the Chartists in future. O'Brien replied that O'Connor had favoured him with eight columns, when half a column would have said enough to show him that O'Connor would never convince him that it was right for Chartists to vote Tory.[3] In controversy O'Brien was more than a match for his opponent.

In the ensuing election, neither O'Connor nor O'Brien seems to have carried the day with the Chartists. Certainly the Tories won, and it is possible that Anti-Poor Law feeling, which was at the bottom of a good deal of Chartism, induced many Chartists to go with the Tories. It certainly was so at Leicester, as Cooper relates. So far O'Connor's advice was the feeling of a great part of the Chartists. The Salford Chartists on the other hand, after careful consideration, decided to support Brotherton, a prominent Anti-Corn Law man,[4] who, perhaps

[1] *Northern Star*, June 19, 1841. [2] *Ibid.* June 26, 1841.
[3] *Ibid.* July 3, 1841. [4] *Ibid.* July 10, 1841.

through their support, secured his election. It is clear that cross-currents of opinion were already influencing Chartist policy. At Northampton the intervention of MacDouall, who went to the poll, actually prevented the return of a Tory.[1]

O'Brien himself stood for Newcastle-on-Tyne. His election address is perhaps the first ever written in a prison. It is worth quoting. The candidate calls himself a " Conservative Radical Reformer in the just and obvious meaning of the words." He advocates unqualified obedience to the laws even where they are bad and vicious, so long as the people have an opportunity of altering them in accordance with the will of the majority. He stands for the inviolability of all property, both public and private, but amongst public property he includes church rates, public endowments, and unappropriated colonial lands which the aristocracy are appropriating just as they seized the land of this country. He also considers that the State has a right to interfere with private property where the public weal is at stake, but compensation ought to be given in just measure. He will oppose all monopolies, whether of wealth, power, or knowledge. He will therefore oppose the Bank of England monopoly and take away from the other banks the right to issue notes. A really National Bank under public control would be substituted if he had his way. He will equally oppose all restrictions upon trade, commerce, and industry, especially the Corn Laws, which, with the concentration of landed property through enclosure, are the chief causes of the present distress. He will vote for total and immediate repeal, provided that there is an equitable readjustment of public and private obligations in accordance with the increased purchasing power of money. He will demand the abolition of all further restrictions upon the Press, the disestablishment and disendowment of the Church of England, the adoption of a system of direct taxation of property, the reduction of indirect taxation, and the exclusion of placemen of every description from the House of Commons.[2]

With the exception of a few words this address might have been written by Cobbett. It was a good and sensible document, but it was scarcely a distinctively Chartist pronouncement at all. It only had one reference to the Charter, for O'Brien no doubt wanted to appeal to a wider public than the Chartists of Newcastle. Not many election addresses, issued

[1] Figures were: Whig, 981; Whig, 970; Tory, 884: MacDouall, 170 (*Northern Star*, July 3, 1841). [2] *Northern Star*, July 10, 1841.

in that election, one ventures to think, contained as much good sense as the one composed in Lancaster Gaol. It shows, however, how much O'Brien was drifting from the somewhat Ishmaelite standpoint of O'Connorite Chartism.

The Newcastle Election gave rise to a curious legal point. O'Brien and two other candidates stood for two seats. Though absent, O'Brien carried the day on the show of hands; he did not go to the poll, and the other two were declared elected. O'Brien's committee decided to petition on the ground that the two had been elected neither by show of hands nor by the poll. Counsel actually thought O'Brien was the person elected, though, of course, he had not the requisite financial qualification. The cost of petitioning was, however, prohibitive and no further steps were taken.[1] It stirs the imagination to think of O'Brien in the Corn Law debates. How he would have laid about him !

O'Brien was to be released in October 1841. His popularity was still great in the Chartist world, and a movement was at once set on foot to give him a great ovation, and to raise a fund to enable him to start a newspaper.[2] He refused the demonstrations; they would cost money; working men would lose employment and wages by attending. Let Chartists give O'Connor an expensive ovation if they liked.[3] The "press fund," however, went on with the result that O'Brien became part owner and editor of the *British Statesman*,[4] a Radical weekly which started in March 1842. The *Statesman* was at first largely an Anti-Corn Law journal, but O'Brien gave it a somewhat different complexion. It was never a Chartist paper in the O'Connorite sense. Like all the rest of O'Brien's ventures, it died an untimely death. In the latter months of 1841 O'Brien was still very active as lecturer and agitator, but in the early part of 1842 events occurred which brought to a head the various enmities and rivalries which the policy or person of O'Connor had aroused.

(3) THE COMPLETE SUFFRAGE MOVEMENT (1842)

In 1842 the focus of Chartist interest once more shifted to Birmingham, which, since the riots of July 1839 had not figured very prominently in Chartist affairs. The Chartists of that town were divided in allegiance between Arthur O'Neill

[1] *Northern Star*, July 31, 1841; August 14, 1841; August 7, 1841.
[2] *Ibid*. October 9, 1841; October 16, 1841.
[3] *Ibid*. August 14, 1841. [4] *Ibid*. July 16, 1842.

and the official leaders, like George White, a *Northern Star* reporter, and John Mason, whose eloquence had helped to convert Cooper at Leicester. The old Birmingham Political Union was of course dead and buried in oblivion. A " Birmingham Association for Promoting the General Welfare," with T. C. Salt for a chairman, was in existence in October 1841, but no more seems to be known about it than the notice recorded by Place.[1] In 1842, however, Birmingham was the centre of a movement which at first bade fair to carry Chartist or Radical principles into regions which O'Connor never knew, a movement in fact which carried no less a person than Herbert Spencer in its train.

This was the Complete Suffrage Movement. It was a kind of middle-class Chartism. There are two distinct aspects to Chartism as generally conceived down to 1840, and as conceived after that date by the National Charter Association. On the one hand, it is an agitation for the traditional Radical Programme ; on the other, it is a violent and vehement protest from men, rendered desperate by poverty and brutalised by excessive labour, ignorance, and foul surroundings, against the situation in life in which they found themselves placed. This protesting attitude had been brought, by the teachings of leaders and the prosecutions of authority, to a pitch of bitterness hardly now conceivable. In this second aspect alone was Chartism an exclusively working-class affair, and in this respect alone could there be no middle-class Chartism, for such a thing would be a contradiction in terms. At the same time there was nothing to prevent middle-class people from supporting the principles of the Charter (which had successively been favoured by every social class from the Duke of Richmond to Richard Pilling, cotton operative), or to prevent them from sympathising, in the name of humanity, with the sufferings of the working folk. Such middle-class sympathisers, however, found it difficult, in the year of grace 1842, to give their opinions practical expression. They found the field of political and social reform agitations more than comfortably occupied. On the radical side there were the Anti-Corn Law League and the various Chartist organisations ; on the conservative side Factory Legislation and Repeal of the Poor Law of 1834 were still the stand-by of social reformers. For Radicals the claims of the League or of Chartism were naturally paramount, but between the two there was a great

[1] Additional MSS. 27,821, p. 315

gulf fixed. However much they sympathised with Chartism, middle-class leaders could scarcely hope to find any great following amongst their own class for the Chartist programme. Preoccupation with Free Trade, the class-war teachings of some Chartists, and the futile excuses of others, prevented that. Nor could middle-class leaders find a place within the National Charter Association. The predominance of O'Connor prevented that, except they were prepared to occupy a very subordinate position.

The Complete Suffrage Movement was a well-meant, ill-conceived, but not wholly unsuccessful attempt to solve this difficulty. Its author was Joseph Sturge (1793–1859), a Quaker corn-miller and alderman of Birmingham, a zealous and prominent anti-slavery advocate, and now an adherent of the Free Trade Movement. Sturge was a typical Quaker, honest, upright, and benevolent. Prosperity in business had not blinded his eyes to the distress and poverty of thousands of his fellow-citizens, and it was this which moved him along the path of political agitation.[1] Sturge was hardly a deep-thinking man and, being a little pig-headed and hasty-tempered, had few special gifts for dealing with men more addicted than he to disputations and contentions. Rectitude and sympathy were his qualifications for leadership, and though they carried him far, it was not far enough.

Sturge, like many other Quakers and Radicals, had taken a part in the work of the Anti-Corn Law League, but he had apparently come to the conclusion that the Repeal of the Corn Laws could never be attained, "except by first securing to the people, a full, fair, and free representation in the British House of Commons." [2] He had also, as a true Quaker, been much disturbed by the growing alienation between the middle and the working classes, which he traced, like the Chartists, to the evils of class legislation. During 1841 he published in the *Nonconformist*, which periodical became the organ of the Complete Suffrage Movement, a series of articles afterwards reissued under the title "Reconciliation between the Middle and Working Classes." This reconciliation was to be accomplished by a combined agitation for "full, fair, and free" representation of the people in Parliament. In recommending the "Reconciliation" to his readers Sturge writes: "The

[1] Sturge visited the West Indies and America in the cause of Abolition (*Brief Sketches of the Birmingham Conference,* published by Cleave, 1842).
[2] Letter to Chairman of A.C.L. Conference, *Sun,* July 28, 1842.

Patriot and the Christian fail in the discharge of their duty, if they do not by all peaceable and legitimate means strive to remove the enormous evil of class legislation. . . . I earnestly recommend these conclusions to the candid and impartial consideration of those who wish to be guided in their political as well as religious conduct by the precepts of the Gospel." [1] Sturge's political ideas were, therefore, very much like the Christian Chartism which flourished at Birmingham. He entirely adopted the Chartist point of view with regard to the Free Trade agitation. Though many other middle-class people adopted the class-legislation theory, they did not apply it in the same way as Sturge did.

The Complete Suffrage Movement originated at an Anti-Corn Law Convention, held in Manchester on November 17, 1841. The delegates had met and the main business of the Convention was over, when Sturge commenced an informal talk about the " essentially unsound condition of our present parliamentary representation." The other delegates expressed their agreement with these sentiments, and requested Sturge and Sharman Crawford, M.P., to draw up some sort of a manifesto on the subject. This was done, and a number of the delegates, including a majority of the Manchester Council of the Anti-Corn Law League, put their signatures to the document, which became widely known as the " Sturge Declaration." In December the Declaration was printed and circulated, mainly amongst middle-class Radicals, and in January 1842 a number of the Birmingham signatories united under the name of the Birmingham Complete Suffrage Union. This body, following the lines laid down by Sturge in the " Reconciliation," decided to appeal to the industrious classes. This was done by circulating the Declaration and inviting signatures from those who approved. The Declaration reads thus :

Deeply impressed with the conviction of the evils arising from class legislation and of the sufferings thereby inflicted upon our industrious fellow subjects, the undersigned affirm that a large majority of the people of this country are unjustly excluded from that full, fair and free exercise of the elective franchise to which they are entitled by the great principle of Christian equity and also by the British Constitution, " for no subject of England can be constrained to pay any aids or taxes, even for the defence of the realm or the support of the Government, but such as are imposed by his own consent or that of his representatives in Parliament." [2]

[1] *Reconciliation*, Introduction. [2] Quotation from Blackstone.

Signatories were also asked to express their approval of a motion upon the subject to be introduced into the House of Commons by Sharman Crawford. Approval of the Declaration carried the right to be invited, either in person or by delegacy to a Conference at Birmingham where the question of future proceedings was to be discussed.[1]

Such was the origin of the Complete Suffrage Movement. It progressed rapidly for it had very influential support, especially from philanthropically disposed men like Sturge himself. Benevolence and peace-making were in fact the chief motives which drove Sturge into the agitation, and the character which he gave to the movement attracted ministers of religion, especially those of the Dissenting Churches. The newly founded *Nonconformist*,[2] ably edited by Edward Miall, became the organ of the movement. Josiah Child of Bungay, a clerical rebel of some note, Scottish theologians like John Ritchie and James Adam, Methodist Unitarians like James Mills of Oldham, Quakers like John Bright and others, betray the Radical Nonconformity which was at the bottom of a great deal of English political agitation. Even the Anglican clergy who sympathised with the movement, such as the Rev. Thomas Spencer, incumbent of Hinton Charterhouse, near Bath, uncle of Herbert Spencer, the Synthetic Philosopher,[3] and the advanced Radical, Dr. Wade, vicar of Warwick, with whom we have made acquaintance already, had very much of the Nonconformist in them. Complete Suffrage Unions were rapidly started in every important town, and by the end of March 1842 some fifty or sixty were in course of formation ; places as far apart as Aberdeen and Plymouth being included in the list.[4]

What the connection between the Free Traders and the Complete Suffrage Movement exactly was, is difficult to say. Certainly between the League and the Sturge unions there was no connection of an official kind. Nor was the Sturge movement an outgrowth of the Free Trade agitation ; it had an independent origin in the mixture of philanthropy and Radical theory which was not uncommon in those days. Sturge himself was of opinion that the Free Trade movement was likely to be

[1] For all preceding see *Report of Proceedings of the Middle and Working Classes at Birmingham, April 5, 1842, and Following Days*, London, 1842, pp. iii. *et seq.* [2] Sturge was one of the founders.
[3] Herbert Spencer, then a youth of twenty-two, who had been taught by his uncle at Hinton Charterhouse, took some part in the Complete Suffrage agitation, being honorary secretary of the Derby branch. See also later, p. 264. [4] *Report of Proceedings*, etc., p. 6.

futile in view of the existing state of Parliamentary representation, but there is little or no evidence that his middle-class followers shared this view. The Complete Suffrage Movement did receive the support of large numbers of Corn Law Repealers, and even of men actively engaged in the work of the League—men like John Bright, Charles Cobden,[1] Archibald Prentice, ex-Chartist and later historian of the League, and Francis Place, who placed his vast stores of political wisdom at the disposal of Free Traders and Sturgeites alike. These men were all Radicals and supported Sturge because they were Radicals, though it is not too much to suppose that many of the rank and file of the Free Traders were not sorry to have a kind of second string in the Radical movement initiated by Sturge. The Complete Suffrage leaders acted totally independently of the Free Trade movement, and if they sought support, they sought it on the common basis of radical beliefs. When they began to recruit working-class support, it was on the same basis. In short, the Complete Suffrage Movement was an honest attempt to organise a single Radical body without distinction of class or interest. The suspicions of the Chartists that it was a dodge of the League to draw off support from Chartism were quite unfounded.

The appeal of the Complete Suffrage Union to the working classes was answered almost exclusively by those Chartists who, for various reasons, were at loggerheads with O'Connor and his friends. Lovett saw in the Declaration an opportunity for that co-operation of all classes which he so much desired, and he no doubt looked forward to a revival of the agitation for the Charter upon the idealistic lines laid down in *Chartism*. O'Brien also began to sympathise with the Sturge movement, but his motives are less easy to discover ; pique and a growing personal dislike for O'Connor were probably the chief. O'Brien could not stand the patronage of one so inferior to himself. He found allies in the Bath Chartists, and their exceptionally able leaders, R. K. Philp, Henry Vincent, and W. P. Roberts, all of whom were rapidly falling away from their allegiance to the National Charter Association, no doubt for the same reason which made it impossible for any man of independence and spirit to tolerate for long the yoke of O'Connor. The Christian Chartists, to whom Sturge and his pietist ways appealed strongly, rallied round the new movement. Arthur O'Neill, John Collins, Robert Lowery,

[1] Brother of Richard.

R. J. Richardson, and Patrick Brewster, a bitter opponent of O'Connor, fell into line with Lovett, Vincent, O'Brien, and Collins. Thus the Sturge movement was rapidly becoming a rallying-ground for all the ablest anti-O'Connorite Chartists. A goodly proportion of the moral force leaders of the 1839 Convention were now arrayed under the banner of " Reconciliation." The forthcoming Conference was likely much more to resemble a great Chartist Convention than any of the assemblies which the National Charter Association could muster.

This was a prospect which O'Connor and his followers could hardly face with equanimity, and a strenuous counter-campaign was at once organised. The first steps were taken against those members of the National Charter Association who were suspected of sympathising with the rival movement. Of these R. K. Philp and James Williams of Sunderland were the chief. Philp was actually a member of the Executive and Williams was a very able and influential leader in his district. The attack on Philp was carried on with unparalleled virulence. His speeches were falsified, resolutions garbled, letters of denunciation were printed, and letters of defence suppressed, in the pages of the *Northern Star*. No effort was spared to make Philp appear a traitor and a schismatic, and all the arrangements which a well-devised Tammany system could invent were put into operation, with a view to securing his rejection at the next election of the Executive.[1] Philp, however, was scarcely happy in his defence. He said he had only signed the Declaration so as to have an opportunity of persuading the Complete Suffrage leaders to accept the Charter—an explanation which was scarcely satisfactory to either side. The excommunication of Philp brought about a great schism in the Bath district, and the Chartists of Wootton-under-Edge actually elected O'Brien to sit in the coming Conference at Birmingham. In Sunderland Williams showed fight and disregarded O'Connor's threats. He declared that he had signed the Declaration because he approved of its vindication of the people's right to the franchise. If O'Connor wanted to denounce him, Williams was ready to take up his challenge.[2]

The next step was to attack the Sturge movement in set terms. It was a dodge of the Anti-Corn Law League, and the Chartist cause was doomed to be lost if it was in any manner

[1] R. K. Philp, *Vindication of his Political Conduct*, 1842. I am bound to say that I believe Philp with some little reservation.
[2] *Northern Star*, April 9, 1842. Philp, *Vindication*, etc

mixed up with that of the League.[1] Complete Suffrage was
denounced because it apparently did not involve the other
five " points " of the Radical Programme,[2] and a comparison
was drawn between the " Charter Suffrage " and Complete
Suffrage.

The Charter Suffrage would not rob any man while it would
protect and enrich all : while Complete Suffrage would merely
tantalise you with the possession of a thing you could not use,
and would entirely prostrate labour to capital and speculation.
The Charter Suffrage would, firstly, more than treble our production
now locked up, restricted, and narrowed, while it would cause a
more equitable distribution of the increased production. Complete
Suffrage would not increase the production while it would monopolise
all that was produced. Repeal of the Corn Laws without the
Charter would make one great hell of England, and would only
benefit steam producers, merchants, and bankers without giving
the slightest impetus to any trade, save the trade of slavery, while
it would from the consequent improvement and multiplication of
machinery,[3] break every shopkeeper and starve one half of our
population. On the other hand the Charter would *in less than
six months* from the date of its enactment, call forth all the industry,
energy, and power of every class in the State.[4]

This was followed by an article from O'Connor who de-
nounced Complete Suffrage as " Complete Humbug," and said
that Sturge, being a banker and corn-merchant, was striving,
for interested reasons, to draw Chartists into the Anti-Corn
Law Movement.[5] Nothing could have been more unjust or
untrue than this charge.

Meanwhile the plans for the Conference at Birmingham
were being elaborated, and it was fixed for April 5 and the
following days. O'Connor thereupon ordered a meeting of
delegates and others at the same place and on the same days.
Every delegate was to bring with him as much money as his
constituents could collect.[6] The delegates were apparently to
sit as long as the money lasted.

Thus on April 5, 1842, two rival conferences met at Birming-
ham. The Complete Suffrage Conference consisted of 103
members. The majority of these were representatives of the
middle-class supporters of the movement, but the workers were
represented by Vincent, Lovett, O'Brien, Neesom, John Collins,

[1] *Northern Star*, March 12, 1842.
[2] These suspicions were not at first unfounded. See below.
[3] For trade which is not improving !
[4] *Northern Star*, March 26, 1842.
[5] *Ibid.* [6] *Ibid.* April 2, 1842.

James Mills, Robert Lowery, R. J. Richardson, and Dr. Wade, all ex-members of the 1839 Convention. Besides Vincent, the Bath Chartists had a champion in the Rev. Thomas Spencer. Miall, Bright, and Prentice were present. The National Association was represented also by J. H. Parry, a barrister of great ability and a pungent controversialist.

The proceedings commenced with the usual formalities. Sturge was elected to the Chair. A committee was appointed to examine the credentials of delegates. Parry and Vincent were on this committee, which rejected the credentials of several adherents of O'Connor who tried to obtain admission.[1] Five avowed, but apparently not extremist, members of the National Charter Association were actually admitted. How they came to escape the censure and earn the adulation of O'Connor is a mystery, but such was the fact. Various other formalities were despatched, and the real proceedings commenced with the presentation of the report of the Birmingham Complete Suffrage Union.

The important proceedings took a rather significant course. Down to the Conference, no specific statement of the nature of the political programme involved in Complete Suffrage had ever been issued. It is very probable, judging from the discussions in the Conference, that the originators of the movement were not prepared to adopt as complete a scheme as the Chartists. Some " modified Charter " was probably what they had in view. The Chartists present had evidently come with the express intention of moving the adoption of the Charter *in toto*, and they placed a motion to that effect, in Lovett's name, upon the order paper. So far Philp's declaration was supported by fact. The result was surprising. One after another the six points of Chartism were carried. All attempts to cut away anything from the abstract completeness of the Radical Programme failed. The original resolution, making representation coextensive with taxation, was abandoned in favour of one basing the franchise on natural, original, or inherent right. A resolution in favour of freedom of elections was displaced in favour of an explicit demand for the ballot. Bright's preference for Triennial Parliaments was shared by a small minority only of the delegates. There was an inordinate passion for unanimity until the delegates found themselves committed to the Charter in all except name and associations. Sturge was by no means pleased with the result

[1] *Northern Star*, April 16, 1842.

of the discussions. He thought the first four points carried ought to be sufficient,[1] but he hoped for the best. He disliked the Charter because of its association with violence and terrorism. Nevertheless Lovett brought forward his motion in favour of the adoption of the Charter. It merely pledged the Complete Suffrage leaders to call a second Conference, in which there would be more working-class delegates, at which the Charter would at least be taken into consideration. He made a good speech, urging that the adoption of the Charter would be a guarantee of sincerity, and would enlist on their side the support of the millions. Edward Miall seconded the motion, though he spoke very strongly against the unwisdom of the Chartists in pressing their claims so far. O'Brien violently declared himself on the side of Lovett, and the debate was long and excited. During the evening session Lovett and his Chartist colleagues agreed to abandon the exclusive claims of the Charter, and merely insisted that it should be considered along with other similar documents. It is clear that much feeling was aroused by the victory of the extremists, and very great distaste was expressed of the Charter and its associations. Many delegates thought that, having conceded the contents, they might reasonably refuse the name; the Chartists, on the other hand, thought it silly to strain at that gnat after having swallowed the camel. However, the amended resolution was carried unanimously.

The conflict was thus put off till a future date. The Chartists truly had reason on their side. They were men who had done honour to the Chartist creed, and who had little or no part in the evil associations attached to the name. They were proud of their exertions in the cause, and their sacrifices had brought them honour and influence amongst their fellow-workmen. To surrender the name, because some had made it a by-word, was to them unthinkable, for their purpose was to cleanse Chartism from its evil associations, a purpose which might be accomplished if their middle-class friends would adopt the name. These, on the other hand, had to consider whether they would achieve more by making a fresh appeal to the Radicals of all classes, or by adopting an older cry which was still potent. In short, the problem was whether they would lose more middle-class support than they would gain of working-class support, if they adopted the Chartist programme. This conflict of sentiment

[1] Omitting Annual Parliaments and payment of M.P.'s.

T

and policy was left to be decided later. Meanwhile the Chartist were no doubt satisfied with their gains ; their principles had been adopted and their Charter not rejected. With the people of Birmingham they were still popular, for at the great public meeting with which the Conference closed, Lovett, O'Brien, Vincent, Mills, Richardson, Neesom, and Lowery were the speakers. It was a Chartist meeting with Sturge in the chair,[1] but all the speakers, O'Brien included, spoke in favour of union with the middle classes in the great cause of political and social regeneration.

Following the Conference the Complete Suffrage Petition was drawn up. It was dated in good Quaker fashion on the 5th of the fourth month, and contained all the " six points " now so familiar. But the struggle between the old Chartists and the Complete Suffragists had resulted in a final split between them, and the O'Connorites pursued their independent action for the whole Charter, regardless of the rival movement. When the Suffrage Petition came before the House of Commons, Sharman Crawford, member for Rochdale, moved on April 21 that the House should discuss in Committee the question of the reform of the representative system. His motion was of course rejected, the figures being 67 for and 226 against. All the Radicals and Free Traders voted for it.[2]

So matters stood in the Chartist world in the spring of 1842. The National Charter Association, active and virulent, was still organising its Petition and, like certain celestial bodies we read of, giving off in its convulsions an ever-increasing ring of detached fragments. The other Chartists were endeavouring to gain a new support in the Complete Suffrage Movement. Popular Radicalism was organised into three distinct sections under O'Connor, Lovett, and Sturge, and the outcome of the triangular struggle was doubtful.

[1] *British Statesman*, April 16, 1842. For the best report of the Conference see *Report of Proceedings*, etc., above cited.
[2] *British Statesman*, April 24, 1842.

CHAPTER XVI

THE NATIONAL PETITION OF 1842

In spite of the diversions caused by Sturge, Lovett, O'Brien, and its various other rivals, the National Charter Association continued to push on its preparations for a great demonstration. What the strength of the Association exactly was is difficult to say. Duncombe, in presenting its Petition to the House of Commons in May 1842, said it had 100,000 members who paid a penny a week to carry on the agitation.[1] Had this been so, the National Charter Association would have been a more powerful body than the Anti-Corn Law League itself, even in its best days. No official of the Association claimed more than half that number of members, and judging from the balance sheets, published by the Executive, only a small percentage even of the smaller number paid its pence with any regularity. So low were the funds that the Executive could not find the wherewithal to finance the Conference which was called to counteract the Sturge Conference at Birmingham.[2] Out of 401 " localities " 176 paid nothing to the central funds during the quarter April-July 1842. Manchester was one of these. The falling-off of trade may account for this decline of the finances, but carelessness and laxity were also complained of by the Executive. In spite of this manifest disadvantage (which drove MacDouall into the quack medicine trade [3]) the Association did not abate one jot of its activities. Lecturers were hard at work ; new tracts, pamphlets, and small periodicals saw the light. Cooper's *Illuminator, Rushlight,* and *Extinguisher,* and Beesley's *North Lancashire and Teetotal Letter Bag,*[4] were some of the results of this newspaper enterprise. Much of this activity was carried on with small

[1] *Hansard,* 3rd ser. vol. lxiii. p. 13.
[2] *Northern Star,* April 11, 1842. [3] *Ibid.* April 2, 1842.
[4] *Ibid.* January 1, 1842.

resources, fickle support, and astonishing self-sacrifice, for, as the year 1842 wore on to the summer, the growth of distress made propagandist work terribly difficult and trying. It was so hard to restrain passion and preach patience in those days. Lecturers had to go without their pay ; journals circulated at a loss, but enthusiasm and hope were not yet extinguished. Strenuous were the efforts made to enlist the support of the organised trades whose sympathies were Chartist, but whose policy was more cautious. The decline of employment made these efforts more hopeful as the weeks passed by. MacDouall was especially active in this branch of agitation,[1] and Leach was endeavouring to persuade Manchester trade unionists that Trade Unionism was a failure.[2] O'Connor was as energetic and ubiquitous as usual. He was bent on making the Petition a great success : 4,000,000 signatures would be hurled at the House of Commons, and make a way thither for the people's true and democratic representatives.[3]

It had originally been intended that the Convention should meet and the Petition be presented as early as possible after Parliament reassembled in February 1842, but various causes intervened to postpone these events for over two months. The chief of these was the fact that the Scottish Chartists refused to support the National Petition because it included a demand for the Repeal of the Union, and of the Poor Law Amendment Act of 1834.[4] Later on they added a demand for the Repeal of the Corn Laws, which was not included in the Petition.[5] In January 1842 a Scottish delegate assembly decided, on the casting vote of its chairman, to reject the Petition on these grounds. O'Connor was present at the discussion and went out of his way to praise the conduct of the delegates, who decided to draw up a new petition. A week later his journal poured scorn on the " morbid sensitiveness of a few thin-skinned individuals " who had caused the rejection of the Petition, regardless of the fact that they were the majority. MacDouall followed with a more conciliatory remonstrance, and finally O'Connor boxed the compass by a vigorous denunciation of the majority which voted the National Petition down.[6] Negotiations were opened up with the Scots, who seem to have come to terms, for they sent delegates to the Convention which met on April 12, 1842, in London. Owing to lack of funds, it was only to sit for three weeks.

[1] *Northern Star*, May 14 and 21, 1842. [2] *Ibid.* March 26, 1842.
[3] *Ibid.* November 13, 1841. [4] *Ibid.* November 27, 1841.
[5] *Ibid.* January 8, 1842. [6] *Ibid.* January 8, 15, 22, 1842.

The Convention met on the date appointed, but no business was done until the 15th. It consisted of twenty-four members, including Philp, O'Brien, W. P. Roberts, R. Lowery (now a Scottish leader), all more or less under suspicion of being rebels against O'Connor, and sympathisers with Sturge. Lowery, Thomason, A. Duncan, M'Pherson, and Moir represented the Scots. All the Executive members were present. O'Connor was of course a delegate, and had a goodly " tail," including George White, Pitkeithly, Bartlett, and others.

The first business was to arrange for the presentation of the National Petition. Thomas S. Duncombe, member for Finsbury, agreed to present it early in May, and Sharman Crawford was therefore requested to put off his Complete Suffrage motion, which was down for April 21, until a later date. Crawford refused, and we have already heard how summarily it was rejected. O'Connor took the opportunity of this debate to say a few uncomplimentary words upon the Sturge movement as a whole. The delegates, with a few noteworthy exceptions, gave glowing accounts of the prosperity of the cause in their several districts. The proceedings were enlivened by somewhat lively exchanges between Philp and Roberts on the one side and O'Connor and his friends on the other. A few delegates, like Beesley and John Mason, gave support to the rebels, and the bickering proceeded to such a point that a formal discussion was opened by Thomason as to the best means of allaying such discussions. A farcical reconciliation took place between O'Brien and O'Connor, and the fact was sealed by a motion, proposed by O'Connor and seconded by O'Brien, urging all Chartists to abstain from private slander and schism. Two whole days were thus occupied. The fact was that the Convention had nothing to do, and it amused itself by proposing resolutions about co-operation, teetotalism, and various other more or less irrelevant matters, and then postponing them. One resolution which met this fate deserved it :

" To take into consideration the best means for protecting labour against the influence of those employers who apply it to artificial production, and for insuring to the working classes a supply of all the necessaries of life independent of foreign countries or mercantile speculations."

Its author was O'Connor and its secret small holdings and spade-husbandry.[1]

[1] For accounts of these discussions, *Northern Star*, April 23 and 30, 1842. *British Statesman*, April 24, 1842, May 1, 1842.

An Address of the old kind was drawn up and published by the Convention. The usual resolution not to petition any more was placed in the forefront, but it had lost its quondam character of an ultimatum. It was interpreted to mean that the existing House of Commons would not be petitioned again : instead memorials and remonstrances would be employed. A clause expressing sympathy and friendly feeling towards Unions and Associations professing similar opinions was actually carried by the efforts of the Scottish delegates, Philp's friends, and one or two more orthodox O'Connorites, a fact which indicates that O'Connor was not even now able to command the allegiance of all Chartists. O'Connor himself was not present at the debate.

Meanwhile May was drawing near. The Petition itself contained fourteen classes. It recited the usual theory of democracy ; it described the various well-known anomalies of representation, complained of bribery " which exists to an extent best known by your honourable house " ; it described the grievous burdens of debt and taxes and the rigours of the Poor Law ; it spoke feelingly of the great inequality of riches between those who produce and those " whose comparative usefulness ought to be questioned," such as the Queen, the Prince Consort, the King of Hanover, and the Archbishop of Canterbury. The quasi-abolition of the right of public meeting, the police force, the standing army, the state of the factory and agricultural labourers, and the Church Establishment all found places in the catalogue of grievances. Then came the praises of the Charter, and the final demand " that your Honourable House . . . do immediately, without alteration, deduction, or addition, pass into law the document entitled the People's Charter." It was indeed a tremendous and comprehensive document.[1]

The arrival of the Petition at the House of Commons was in keeping with its tremendous import. It had 3,317,702 signatures, said the *Northern Star*. It was to be delivered at the House of Commons on May 2. At very early hours of that morning detachments of Chartists assembled in various parts of London, and marched to the rendezvous in Lincoln's Inn Fields. At noon the Petition arrived, mounted on a huge wooden frame, on the front of which were painted the figures " 3,317,702 " above the legend " The Charter." At the back appeared the same figures and " Liberty." On the sides were set forth the

[1] *Northern Star*, October 16, 1841.

" six points " of the Charter. The Petition was just over six miles long. The great bobbin-like frame was mounted on poles for the thirty bearers. The journey to the House began. MacDouall and Ruffy Ridley, a London Chartist worthy, headed a procession on horseback. Then came the Petition, next the Convention, headed by O'Connor himself, and followed by a band. Delegates from various towns, and Chartist rank and file brought up the rear of what, if the *Northern Star* is to be credited, was an uncommonly long column. It took a devious route, and the head reached the House when the rear was at Oxford Circus, a length of nearly two miles. When the Petition reached the Houses of Parliament, the huge framework was found much too large to enter, and it had to be broken up. The Petition was carried in in lumps and bundles and strewed all over the floor of the House. It looked as if it had been snowing paper. Nevertheless the Petition made a very impressive show.[1]

Next day, May 3, Duncombe brought forward his motion, that the petitioners should be heard at the bar of the House by themselves, their counsel or agents. He spoke of the great authority such a petition must possess. He traced the Charter to its aristocratic origin in order to vindicate its respectability. The Chartists were but the Radicals of former days, and, like the Whigs themselves, were the inheritors of the tradition of the Duke of Richmond, Major Cartwright, and the other early advocates of Radical Reform. He described, in language borrowed largely from Chartist sources, the great distress in the manufacturing districts, distress which was due partly at least to the fact that the interests of the industrious classes were not represented in Parliament. Leader, Bowring, and Fielden supported the motion. Sir James Graham opposed. Then arose Macaulay to make one of the last great Whig utterances ever delivered in Parliament. Macaulay's chief objection was to universal suffrage. " I believe that universal suffrage would be fatal to all purposes for which Government exists, and for which aristocracies and all other things exist, and that it is utterly incompatible with the very existence of civilisation. I conceive that civilisation rests upon the security of property.... I will assert that while property is insecure, it is not in the power of the finest soil, or of the moral or intellectual constitution of any country, to prevent the country sinking into barbarism." A government elected by persons who had no

[1] *Northern Star*, May 7, 1842.

property would of course give no guarantee for the security of those who had. The petition was a clear indication of this. National Bankruptcy and the expropriation of landed property would follow inevitably if the petitioners were enfranchised. Macaulay quite believed that unparalleled distress had driven them to adopt such disastrous remedies. Education would perhaps teach them better, but till then it would be madness to give the petitioners power to enforce their legislative infatuations. The result of enfranchising such persons would be one huge spoliation. Distress, famine, and pestilence would ensue, and the resultant confusion would lead again to military despotism. England would fall from her high place among the nations, her glory and prosperity would depart, leaving her an object of contempt. Of her it would be written that "England had her institutions, imperfect though they were, but which yet contained within themselves the means of remedying all imperfections. Those institutions were wantonly thrown away for no purpose whatever, but because she was asked to do so by persons who sought her ruin. Her ruin was the consequence, and she deserves it."

Not less extraordinary was the outburst of Roebuck who spoke nominally in favour of the Petition. Government, said he, was constituted to counteract the natural desire of every man to live upon the labour of others. Therefore, to exclude a majority of citizens from the control of public affairs was in effect to allow the minority to oppress the majority. Roebuck denied that the petitioners were hostile to property, which was as essential to their welfare as it was to its owners'. They were not so infatuated as to destroy their own livelihood.

Roebuck said he was not concerned with the Petition, or with its trashy doctrine, which was drawn up by a malignant and cowardly demagogue. The great fact was that three millions had petitioned, and he believed they ought to be admitted within the pale of the Constitution. It would be the best guarantee for the security of property, and it would give to every man the proceeds of his own labour, subject only to the payment of his just share of the public burthens. This was one of the chief of the people's grievances, that, because they were unrepresented, they were unfairly taxed. A change in the representation would remedy this injustice. It would not dethrone wealth and eminence altogether, but would cut off their over-great preponderance.

Roebuck's reference to O'Connor did tremendous damage.

In spite of his thoroughly Chartist sentiments he had ruined the whole case. Let us hear Lord John Russell. Lord John had as great a respect for the petition as abhorrence of its demands. Even to discuss such demands would bring into question the ancient and venerable institutions of the country. It would drive capital out of the country by throwing doubts upon the rights of property and of the public creditor. The fund out of which the working people are supported would be reduced and much distress would follow.

If, as the member for Bath had told them, the Petition was drawn up by a malignant and cowardly demagogue, was that not a serious reflection upon the petitioners ? Might they not, if the Petition were granted, elect the said demagogue to Parliament ? That being so, were measures of spoliation totally out of the question ? Electors would require more circumspection than that. Property, intelligence, and knowledge were the qualifications for a constituency. Citizens, moreover, had no natural and inherent right to the franchise, for the franchise was granted by the laws and institutions of the country in so far as the grant was considered conducive to better government. The grant of universal suffrage was not so conducive. Though the petitioners were not actuated by motives of destruction and spoliation, yet in the present state of education there was great danger that elections under universal suffrage would give cause for much " ferment." Revolutionary-minded persons might be elected, and such a thing could not be beneficial, considering how delicate and complex the institutions and society of the country were. There were very old institutions, such as the Church and the Aristocracy, which hold property. These might be offered as prizes to a people in distress, yet to touch these institutions, which held society together, would be disastrous.

Peel spoke much in the same strain. What was the question before the House ? Was it that the petitioners should be heard at the bar ? Now the whole constitution was impeached by the petition, and could the impeachment be despatched by a few speeches at the bar ? And who would speak at the bar but the foolish, malignant, and cowardly demagogue who drew up the trashy petition, and who was not the real leader of the people ? As to the granting of the Charter, he believed that it was incompatible with that mixed monarchy under which they lived and which had secured one hundred and fifty years of greater liberty and happiness than had been enjoyed

by any other country, not excepting the United States of America.

There was little more to be said. The " malignant and cowardly demagogue" haunted the debate. Forty-nine members voted with Duncombe, and 287 against him. Macaulay and Roebuck had slain the great Petition.[1]

[1] *Annual Register*, 1842, pp. [152-]160, summarises the debate; the full report is in Hansard's *Debates*, 3rd series, lxiii. 13-91.

CHAPTER XVII

THE DECLINE OF CHARTISM

(1842–1853)

(1) The Plug Plot and its Consequences (1842–1843)

CHARTISM stood helpless when the combination of Whigs and Tories had thrown out of Parliament the National Petition of 1842. The autocrat of Chartism had staked everything on a false move. Once more " moral force " had failed to convince the representatives of the middle - class electorate. Once more there only remained the trial of " physical force." But, however much he might bluster, O'Connor was neither willing nor able to fall back upon the alternative policy of the hot-bloods whom he had so often denounced. And O'Connor still dominated the movement to such an extent that a course of action of which he disapproved was condemned to futility. Hence the tameness with which organised Chartism bore the destruction of its hopes. Hence the weakness and incoherence of the measures by which the stalwarts of the party strove to maintain the Chartist cause after the failure of the Petition. Hence, too, their eagerness to adopt as their own any passing wave of discontent and claim the storm as the result of their own agitation.

The collapse of the Petition was followed by a few protests, much violent language in the *Northern Star*, and a few public meetings, notably in Lancashire, where the speaking was even more unrestrained than were the leading articles of the Chartist organ. A notable instance of these assemblies was the great gathering held on Enfield Moor, near Blackburn, on Sunday, June 5. Its business was " to consider the next steps to be taken to obtain the People's Charter." Marsden of Bolton put before the crowd the fatuous proposal that the people

should collect arms and march in their thousands on Buckingham Palace. "If the Queen refuses our just demands, we shall know what to do with our weapons."[1] But nothing came of this or any other similar manifestations of Chartist statesmanship. It looked as if the leaders could no longer carry on an effective agitation.

The outbreak of a widespread strike in August added a real element of seriousness to the situation in the North. Here again Lancashire was the storm-centre, but the strike movement broke out simultaneously in other districts, ranging from Glasgow and Tyneside to the Midlands, where the colliers in the Potteries and in the South Staffordshire coal-field went out. It is very doubtful whether the strike had much directly to do with Chartism. Its immediate cause was a threatened reduction of wages, which was answered by the workmen in the Lancashire mills drawing the plugs so as to make work impossible.[2] For this reason the operatives' resistance to the employers' action was called in Lancashire the Plug Plot.

Whatever the origin of the strike, the Chartist leaders eagerly made capital out of it. They attributed the proposed reduction to the malice of the Anti-Corn Law manufacturers, anxious to drive the people to desperation, and thus foment disturbances that would paralyse the action of the Protectionist Government.[3] In a few days the country was ablaze from the Ribble to the confines of Birmingham. At a great meeting of the Lancashire and Cheshire strikers on Mottram Moor on August 7 it was resolved that "all labour should cease until the People's Charter became the law of the land." A similar resolution was passed at Manchester[4] and in nearly

[1] *Annual Register*, lxxxiv. ii. 102.

[2] *The Life of Thomas Cooper*, pp. 190-91. Compare T. E. Ashworth, *The Plug Plot at Todmorden*, p. 16. "The 'turn-outs' visited every mill in the Todmorden valley, first raking out the fires from beneath the boilers and then knocking the boiler-plugs out."

[3] This is Cooper's view, *Life*, pp. 190-91. That it was widely spread is clear from the *Manchester Courier*, August 13, 1842, and still more from *The League Threshed and Winnowed*, *League Hypocrisy*, *The Treachery of the League*, and other contemporary pamphlets, collected in Manchester Free Reference Library (P. 2507). A foolish speech of Cobden in the House of Commons on July 8, threatening outbreaks, is often quoted as a proof. Dolléans' *Chartisme*, ii. 210-25, elaborately discusses the origin of the strike and inclines towards connecting both Chartists and Anti-Corn Law League with it. But it would be safer to assume that the League, like the Chartists, made what capital it could out of the situation. The Machiavellian policy attributed to it is hardly credible. But none of these interrelated movements worked independently of the other. Their isolation only exists in the narratives of their historians. It is remarkable, however, how both the political and the free trade writers ignore the very existence of Chartism. Even Morley's *Life of Cobden* is not exempt from this reproach.

[4] *Manchester Guardian*, August 13, 1842, gives its terms.

all the great towns of Lancashire. On August 15 the same resolution was passed at a meeting on Crown Bank at Hanley, at which Thomas Cooper presided.[1] Despite his exhortations to observe peace and order, serious rioting broke out.

The Chartists' leaders now gathered together at Manchester, where the Executive Council of the National Charter Association was joined by delegates from the Manchester and West Riding areas. It first assembled on August 12, but members came in by slow degrees. It met in Schofield's chapel and was dignified by the *Northern Star* with the name of a conference.[2] In this MacDouall took the lead, and was not displaced from it even when O'Connor, Campbell the Secretary, and Thomas Cooper, hot from his stormy experiences in the Potteries, joined the gathering. Cooper has left a vivid account of his escape from Hanley by night, and of his vacillation between his desire to stay with his comrades in the Potteries and his wish to be in Manchester, where he rightly felt the real control of the movement lay. He trudged along the dark roads from Hanley to Crewe, a prey to various tumultuous and conflicting thoughts. But he was sustained by the noble confidence that O'Connor would be at Manchester and would tell everybody what to do. At Crewe he took the train and found Campbell the Secretary in it. Campbell, now resident in London, was anxious to be back in his old home and see how things were going there. As soon as " the city of long chimneys " came in sight and every chimney was beheld smokeless, Campbell's face changed, and with an oath he said, " Not a single mill at work ! Something must come out of this and something serious too ! "[3]

The conference speedily resolved that the strikers should be exhorted to remain out until the Charter became law. To procure this end, MacDouall issued on behalf of the Executive a fierce manifesto appealing to the God of battles and declaring in favour of a general strike as the best weapon for winning the Charter.[4] But divided counsels now once more rent asunder the party and made all decisive action hopeless. Even in the delegates' meeting it had been necessary to negative an amendment denying any connection between the existing strike and Chartism. At Ashton-under-Lyne the strikers declared that they had no concern with any political questions.[5]

[1] *Life of Thomas Cooper*, pp. 191-9.
[2] *Northern Star*, August 20, 1842. [3] *Life of Thomas Cooper*, p. 206.
[4] *Ibid.* pp. 210-11. *The Times*, August 19.
[5] *The Times*, August 15.

The fatal blow came from O'Connor, to whom simple men like Thomas Cooper had gone as to an oracle for guidance. Even in the Convention his puppets had supported dilatory tactics. In a few days O'Connor fiercely attacked MacDouall in the *Northern Star,* for " breathing a wild strain of recklessness most dangerous to the cause." [1] Good Chartists were advised to retire from a hopeless contest, reserving their energies for some later season when their organisation should have been perfected. The strike, far from being a weapon of Chartism, was a crafty device of the mill-owners of the Anti-Corn Law League to reduce wages and divert men's minds from the Charter. [2]

Riots and disturbances further complicated the situation. Cooper had fled from the burning houses of Hanley and the fusillade of soldiers shooting men dead in the streets. Now the trouble spread northwards into Lancashire and the West Riding. Shops were looted, gas-works attacked, trains were stopped, two policemen were killed in the streets of Manchester. Troops were rapidly poured into the disaffected districts. There were over two thousand soldiers with six pieces of artillery in Manchester alone. [3] At Preston and Blackburn the soldiers fired on the crowd ; [4] Halifax was attacked by a mob from Todmorden. Widespread alarm was created, but there is little evidence that the disorders were really dangerous. O'Connor strongly urged peaceable methods in a public letter. " Let us," he said, " set an example to the world of what moral power is capable of effecting." His violent pacifism was largely attributed to lack of personal courage.

The vigorous action of the Government soon re-established order. Then came the turn of the leaders to pay the penalty. The panic-stricken authorities put into gaol both those who had advocated rebellion and those who had spoken strongly for peaceable methods. O'Connor himself was apprehended in London, while William Hill, the editor of the *Northern Star,* was taken into custody at Leeds. Cooper was arrested soon after his return home to Leicester. But there was long delay before the trials were concluded, and many were released on bail, among them Cooper and O'Connor. The most guilty of all, MacDouall, evaded, by escape to France, the consequences of his firebrand manifesto. [5] In the course of

[1] *Northern Star,* August 27. [2] *Ibid.* August 20.
[3] *Times,* August 17. [4] *Ibid.*
[5] *Northern Star,* January 25, 1845.

September the strike wore itself out. The workmen went back to the mills and coal-mines without any assurances as to their future wages. The economic situation was as black as was the course of politics. With a falling market, with employers at their wits' end how to sell their products, there was no chance of a successful strike. The appeal from the Commons to the people had proved a sorry failure. Once more the Chartists had mismanaged their opportunities through divided counsels and conflicting ideals.

The discomfited remnant that was still free fiercely quarrelled over the apportionment of the blame for the recent failure. There was a strong outcry against the old Executive. It was denounced for insolence, despotism, slackness, wastefulness, and malversation. A warm welcome was given to a proposal of Cooper's that the Association should receive a new constitution which dispensed with a paid Executive.[1] As a result of an investigation at a delegates' meeting towards the end of the year, the Executive either resigned or was suspended.[2]

MacDouall was made the scapegoat of the failure. He it was who had given the worst shock to the credit of Chartism.[3] How many tracts might have been published and distributed with the money lavished upon MacDouall.[4] In great disgust the exile renounced his membership of the Association.[5] However, he came back to England in 1844, and at once made a bid for restitution. His first plan was to drive home the old attack on O'Connor by an attempt to set up a separate Chartist organisation for Scotland independent of the English society.[6] At the same time he denounced O'Connor for his ungenerous exploitation of his pecuniary obligations to him in the hope of binding him to him and gagging him.[7] It was O'Connor, too, who had advised him to run away in 1842 in order to throw upon him the whole responsibility for the Plug Riots. Both accusations are only too credible, but no trust can be given to MacDouall's statements. His veracity and good faith are more than disputable, and his constant change of policy was at least as much due to self-interest as to instability. He was one of the least attractive as well as most violent of the Chartist champions.[8] It is startling after all this to find that

[1] *Northern Star*, December 10, 1842. But compare *ibid.* December 3.
[2] *Ibid.* January 7, 1843. [3] *Ibid.* December 10.
[4] *Ibid.* December 17, 1844. [5] *British Statesman*, December 17.
[6] *Northern Star*, February 17, 1844. Compare *ibid.* November 23 and December 28. [7] *Ibid.* February 15, 1842.
[8] For a very frank view of the morality and motives of MacDouall, " the doctor," as he calls him, see Alexander Somerville's *Autobiography*

in 1844 O'Connor was welcoming MacDouall back to the orthodox fold and that the Glasgow Chartists raised the chief difficulties in the way of the ostentatiously repentant sinner.[1] There was no finality in the loves and hates of men of the calibre of O'Connor and MacDouall.

Though its prospects were increasingly unhopeful the Complete Suffrage agitation was not yet dead. At Sturge's suggestion a new attempt was made to bridge over the gulf between Suffragists and Chartists, which was found impossible to traverse at the Birmingham Conference. With this object a second Conference met on December 27, 1842, also at Birmingham. Sturge once more presided over a gathering which included representatives of both parties. The Suffragists were now willing to accept the Chartist programme, but they were as inveterate as ever against the use of the Chartist name. To the old Chartists the Charter was a sacred thing which it was a point of honour to maintain. Harney thus puts their attitude :

Give up the Charter ! The Charter for which O'Connor and hundreds of brave men were dungeoned in felons' cells, the Charter for which John Frost was doomed to a life of heart-withering woe ! ... What, to suit the whim, to please the caprice, or to serve the selfish ends of mouthing priests,[2] political traffickers, sugar-weighing, tape-measuring shopocrats. Never ! By the memories of the illustrious dead, by the sufferings of widows and the tears of orphans he would adjure them to stand by the Charter.[3]

The Conference was carefully packed by the O'Connorites, but there was more than O'Connorism behind the pious enthusiasm that clung to the party tradition. Nor can the Sturgeites be acquitted of recourse to astute tactics to outwit their opponents. Knowing that they were likely to be in a minority, they got two lawyers in London to draft a new Bill of Rights which they laid before the conference in such a way

of a Working Man (1848), pp. 474-8. It is only fair to say that Somerville was bitterly prejudiced against MacDouall as a violent and cowardly apostle of physical force. In the time of the 1839 riots Somerville had written his dissuasive *Warnings to the People on Street Warfare.* He was now quite out of sympathy with Chartism and a strong critic of O'Connor's Land Scheme. Cobden in 1849 suggested him to Bright as the best man to write a " temperate and truthful " history of Chartism, " reviewing with advantage the bombastic sayings and doings of Feargus and his lieutenants." " It would be certain to elicit a howl from the knaves who were subjected to the ordeal of the pillory " (Morley's *Life of Cobden,* ii. 54).

[1] *Northern Star,* August 1 and 8, 1846.

[2] An allusion to Thomas Spencer, Herbert Spencer's uncle. Herbert Spencer himself was a " Sturgeite " delegate for Derby at the Conference. *Ibid.* December 24, 1842.

[3] *Ibid.* January 14, 1843. Harney was a representative of Sheffield at the Conference along with three like-minded colleagues.

that they burked all discussion of the Charter in its old form. The New Bill of Rights embodied all the " six points " of the Charter, but the old Chartists bitterly resented the tactics which gave priority to this new-fangled scheme. Lovett came out of his retirement to move that the Charter and not the Bill of Rights should be the basis of the movement. He sternly reproached the Sturgeites for their lack of faith. O'Connor himself seconded Lovett's proposal and strove, though with little effect, to conciliate with his blandishments the stubborn spirit of his old adversary. But even their momentary agreement on a common policy united for the time the old Chartist forces. In the hot debate that followed, the doctrinaire tactlessness of the Sturgeite leaders added fuel to the flames of Chartist wrath.[1] " We will espouse your principles, but we will not have your leaders," said Lawrence Heyworth, the most offensive of the Sturgeite orators. Years afterwards Thomas Cooper voiced the general Chartist feeling when he declared " there was no attempt to bring about a union—no effort for conciliation—no generous offer of the right hand of fellowship. We soon found that it was determined to keep the poor Chartists at arm's length." [2]

In the end Lovett's resolution was carried by more than two to one. Thereupon Sturge and his friends retired, and the Conference broke up into two antagonistic sections, neither of which could accomplish anything that mattered. The failure practically put an end to the Complete Suffrage Movement, which was soon submerged in the general current of Radicalism. No doubt the dispute in the form in which it arose was one of words rather than things, but it was no mere question of words that brought Chartists of all sorts into a momentary forgetfulness of their ancient feuds to resist the attempt to wipe out the history of their sect. The split of the Conference arose from the essential incompatibility of the smug ideals of the respectable middle-class Radical, and the vague aspirations of the angry hot-headed workman, bitterly resenting the sufferings of his grievous lot and especially intolerant of the employing class from which Sturge and his friends came. The deep gulf between the Complete Suffragist and the Chartist is symbolised in the extreme contrast between the journalism of the *Nonconformist* and that of the *Northern Star.*

[1] *Nonconformist*, December 31, 1842. This paper gives good accounts of the proceedings from the Sturgeite point of view. It should be compared with the opposite standpoint expressed in the *Life of Thomas Cooper.*
[2] *Ibid.* pp. 222-44.

U

The Birmingham failure was another triumph for O'Connor. He had dragged even Lovett into his wake and could now pose more than ever as the one practical leader of Chartism. It was to little purpose that Lovett, shocked at the result of his momentary reappearance on the same platform as his enemy, withdrew, with his friend Parry, from the O'Connorite Conference. The remnant went to a smaller room and finished up their business to their own liking. If Chartism henceforth meant O'Connorism, it was because O'Connor, with all his faults, could upon occasion give a lead, and still more because, lead or no lead, it was O'Connor only whom the average Chartist would follow.

The failure of this last effort at conciliation was the more tragic since it was quickly followed by the conclusion of the long-drawn-out trials of the Chartists, accused of complicity in the abortive revolt of the summer of 1842. Some of the accused persons, notably Cooper and O'Connor, were still on bail at the Conference and went back to meet their fate. Their cases were dealt with by special commissions which had most to do in Staffordshire and Lancashire. The Staffordshire commission had got to work as early as October, and had in all 274 cases brought before it. Thomas Cooper was the most conspicuous of the prisoners it dealt with. Acquitted on one count, he was released on bail before being arraigned on another charge. He finally received a sentence of two years' imprisonment, which he spent in Stafford Gaol. In prison he wrote his *Purgatory of Suicides*, a poetical idealisation of the Chartist programme, which won for him substantial literary recognition.[1] Most of the Staffordshire sentences were much more severe than that of Cooper, fifty-four being condemned to long periods of transportation.[2] In Lancashire and Cheshire the special commission was presided over by Lord Abinger, Chief Baron of the Exchequer, whose indiscreet language gave occasion for a futile attack on him by the Radicals in Parliament.[3] But the actual trials do not seem to have been unfairly conducted, and the victims were much less numerous than in Staffordshire. O'Connor was found guilty, but his conviction, with that of others, was overruled on technical grounds. His good fortune in escaping

[1] See, for instance, the testimony of Thomas Carlyle in *Life of Thomas Cooper*, pp. 282-3.
[2] The statistics are in *Annual Register*, lxxxiv. ii. 163.
[3] A vote of censure was moved on February 21, 1843, by T. Duncombe and lost by 228 to 73. Most of the free traders, including Cobden and Villiers, voted with the majority (*Northern Star*, February 25, 1843).

scot-free, while other Chartist leaders languished in gaol or in exile, still further increased his hold over the party. It was another reason why O'Connorism henceforth meant Chartism.

(2) O'CONNOR'S LAND SCHEME AND THE CHARTIST REVIVAL (1843–1847)

We have now seen the process by which O'Connor was established as the autocrat of Chartism. But the desperate struggle for supremacy had not only eliminated O'Connor's enemies ; it had almost destroyed the Chartist movement itself. It was not only that the Complete Suffragists had been ejected from the movement, that Lovett was permanently alienated and O'Brien brutally silenced ; that Cooper and scores of the rank and file were in prison and MacDouall in dishonourable exile. Even within the depleted ranks of the Chartist remnant there was now a deplorable lack of interest and activity.

The sluggishness, which sapped the prosperity of the whole movement, extended even to the inner circle of agitators and organisers who stood round O'Connor's solitary throne. It is best evidenced in the postponement of the Chartist Convention, which, first summoned for April 1843, did not assemble until September 5, when it met at Birmingham. The list of delegates present contained but few of the famous names of earlier Chartist history, but O'Connor himself represented the London Society, while of the rest Harney was perhaps the best-known of the delegates.[1] During the months of waiting, O'Connor had been thinking out plans of reorganisation which, while professing to give a much-needed stimulus to the decaying cause, aimed grossly and obviously at the promotion of the interests of the autocrat. Accordingly the object of the Convention was pompously given out as " to consider and devise a PLAN for the organisation of a society to enforce upon public attention the principles of the People's Charter and to devise means for their practical accomplishment." [2] With this motive two schemes were laid before the assembly. One was a device for the stiffening up and centralisation of the existing machinery of the National Charter Association. The other was the enunciation of a new policy of Land Reform with which all the future history of Chartism is closely bound up.

[1] See the list of delegates present in *Northern Star*, September 9, 1843. O'Connor was the only London representative.
[2] *Ibid.* August 26.

A new Executive had to be chosen for the Association. Up to now O'Connor had proudly stood aloof from it, preferring to control the machine from the outside. He was now so anxious to get everything under his own direct control that he condescended to accept office. He announced his acquiescence in characteristically grandiose terms :

I am now about to enter into a reacknowledgement of a Solemn League and Covenant with the working classes during that period for which they have imposed upon me duties and a responsibility which nothing but their own good conduct would have induced me to undertake.[1]

Humbly accepting the patronage of the descendant of Irish kings, his meek followers promptly elected O'Connor as their Treasurer, hoping, no doubt, that the rents of his mythical Irish estates and the more certain profits of the *Northern Star* would fill up the emptiness of their coffers. As Secretary of the Executive the defaulting John Campbell was replaced by T. M. Wheeler, a member of the staff of the *Northern Star*, and a dependent of O'Connor. The effect was to put the Executive in the hollow of the autocrat's hands. O'Connor, in fact, was responsible for the whole scheme ; he had set it forth in the *Northern Star* so far back as the previous April.[2] It involved much more than mere changes of personnel, for the crowning new proposal now was to establish the headquarters of the organisation in London.

The change was easily agreed upon, but its motives and results deserve some consideration. There were obvious motives of convenience in favour of establishing the Chartist machine in the political centre. London had in the days of the Working Men's Association been the birthplace of the movement, and it was only gradually that its centre of gravity had shifted towards the industrial North. Meanwhile the current of London Radicalism had begun to drift into very different channels, and there were few representative leaders in the South save those with whom O'Connor had quarrelled. Harney voiced the higher argument for the change when he declared that transference to London was necessary to "regenerate" the capital. But for O'Connor himself the chief motive was that he himself now lived in London and his simple wish was to exercise control with a minimum of trouble to himself. Perhaps one object was to get away from the Anti-

Corn Law League, whose offices were in Manchester. But how-
ever these things may be, the result was to cut off O'Connor
and his following from the fierce democracy of the West Riding
and Lancashire, which had hitherto been his whole-hearted
support. It left the field free for the Anti-Corn Law agi-
tators, and left them in triumphant possession. It did little
to open up new areas of propaganda. But for the rest of
Chartist history the centre of interest becomes once again
the South, and the South was so little converted that the net
result could only be regarded as loss.

Rather more than a year after the removal of the Executive
to London, the southward trend was further emphasised by
the transference to the capital of the *Northern Star*, the one
supremely successful journalistic venture of the Chartist
movement. Even the *Northern Star* had suffered from the
lethargy which in 1843 and 1844 had fallen upon every aspect
of Chartism. It lost its editor when Hill quarrelled with
O'Connor and threw up his post in disgust. It fell off seriously
both in circulation and influence. In the palmy days between
1839 and 1842 the *Star* had been not only the oracle of northern
industrial discontent, but a veritable gold-mine to its pro-
prietor, and the source of the lavish subventions with which
he sustained the tottering finances of the cause. But the
greatest prosperity of the *Star* had been in the early days
of its identification with Chartism. Founded in 1837 before
the Charter had been devised, it was not before 1839 that it
had grown into the position of the leading Chartist organ. It
was in the great year 1839 that the *Star* had attained the
highest point of its prosperity. But after the great year 1839
the sales of the *Star* had steadily declined. Even in 1840 it
had only half the circulation of the previous year : each
succeeding year was marked by a further drop, and by the
summer of 1843 the state of affairs was becoming critical.[1]
It was the logical consequence of the establishment of the
Executive in London in 1843 that the organ of the party should
follow on the same road. Accordingly in the autumn of 1844
the office of the paper was transferred from Leeds to London.
Specious reasons for the change were given. The *Star* was not

[1] In 1839 it was said that the *Star* sold 35,559 copies a week. But
compare above, p. 173, note 1, for an even more extravagant estimate
for part of that year. The returns of the stamps issued show that its
average weekly circulation in 1840 was 18,780, in 1841, 13,580, and in 1842,
12,500 (*Parliamentary Papers*, 1843, xxx. 544). In 1843 the circulation
from July to September averaged 9700, and from October to December
9000 a week (*Ibid.*, 1844, xxxii. 419).

a local but a national paper ; news came later to Leeds than to London ; O'Connor's residence in London interposed constant difficulties in the way of publication in Leeds; London was the centre of Government and faction, and the *Star* must be there in order to fight the enemy on the spot.[1] But if the step had been undertaken in the hope of reviving its sales, the result finally was the completion of its ruin. The *Star*, which first came forth from its London office on November 30, 1844, was something very different from the old Yorkshire newspaper. It was now called the *Northern Star and the National Trades Journal*, and a desperate effort was made to win new readers by appeals to the Trades Union element which in earlier days had seemed of little account. Before long it almost ceased to be a Chartist paper at all. The methods and spirit of the old *Star* had been nurtured in the fierce and democratic atmosphere of the West Riding and Lancashire, and the transplanted organ retained enough of its traditions to fail in making a strong appeal to the south-country readers on whose support it was henceforth mainly dependent. And it was a bad day for O'Connor's influence upon the most blindly devoted of his adherents when he removed from their midst their favourite organ. Even eighty years ago north-country opinion was inclined to resent the dictation of " metropolitan " journalism.

We must now return to the Birmingham Convention of 1843. There the crowning triumph of O'Connor was the somewhat reluctant acceptance by its obsequious members of the grandiose schemes of land reform which were now taking a superficially definite shape in the brain of the agitator, and to which he was to devote his main energies for all that remained of his tempestuous life. How these plans originated in his mind will demand an even further retrospect.

Despite incoherencies and insincerities O'Connor remained possessed by certain fundamental principles or prejudices during the whole of his public life. His hatreds were as sincere as they were fierce, and chief among them was his deep-rooted hostility to modern industrialism and all its works. His abhorrence of machinery, the factory system, the smoke and squalor of the factory town, the close-fisted and selfish employers with their eagerness for cheap labour, sprang not only from his real sympathy with the down-trodden weavers and colliers

[1] *Northern Star*, October 19, 1844, the date of the public announcement of the impending change. The last number published at Leeds was issued on November 23.

whose cause he voiced, but also from the country gentleman's enthusiasm for agriculture and the land, and the Irish landlord's appreciation of the advantages of small spade cultivation. His remedy for the evils of the factory system, as shown in the northern towns, had persistently been to bring the people back to the land. Against the horrors of Manchester and Leeds, as he knew them, he set up the ideal of the Irish land system, not as it was, but as it might be, if the huge rents drawn from the toiling cotters were to be diverted to the benefit of the cultivating class and to buying up fresh estates to be divided into small farms. So early as 1841 he had beguiled his imprisonment in York Castle by writing a series of *Letters to Irish Landlords,* which must have afforded strange reading to the operatives who devoured the *Northern Star.*[1] In them he ingenuously exposed to the men of his own class his anxiety to preserve the estates of the landlords from the grasp of the manufacturers, who would soon, he was convinced, use the political monopoly, conferred on them by the Reform Act of 1832, to lay hands upon the landed property of the country gentry. He advised the Irish landlords to provide against this danger by abandoning the system of large farming and high rents, and by allocating a sufficient portion of their estates to peasant holdings. To get the peasant to work zealously at the intensive cultivation of his little plot, he must have security and freedom ; but so great are the virtues of the system that the prosperous and active cottier can not only earn a good living but pay a high rent, provided that this rent is yielded in corn actually grown, and not in fixed money payments. If this system is good for Ireland, it is equally good for Britain. Within twenty years of its general adoption twenty million landholding peasants, entrenched on the soil and living in contentment and comfort, tempered only by the idyllic simplicity of happy village life, would form an army able to save Ireland and Britain from the domination of cotton-spinners and iron-masters, and give the land and the gentry their true place in controlling the destinies of a free nation. It is a strange phase of a novel New Englandism ; a new physiocracy wherein the land yields its *produit net* for the benefit of the community.

Between 1841 and 1843 the same note is repeatedly struck with the difference in tone required for an audience of opera-

[1] They appeared in the *Northern Star* between July 10 (No. 1) and August 7 (No. 5), 1841.

tives rather than for one of landlords. The workmen them-
selves must unite and by subscribing small sums allow some
happy members of their order to make a start. Three or four
acres are enough. Cultivated by the spade, and producing
crops of potatoes, roots, and cabbages, these little plots will
yield such profits, over and above the farmers' support, that
they will form a fund which will enable other comrades to
forsake the mill and the mine for the invigorating labours of
the field.[1] The result will be that the greedy mill-owners
and colliery proprietors will find their looms and mills deprived
of labour. Then their only way to carry on their trade will
be to bribe their hands not to remove to the land by wages
so ample that town and country alike will enjoy the blessings
of opulence. The security for all this to the poor man will
of course be the People's Charter. When the Charter is won,
his vote will secure him the permanent possession of his pro-
sperity.[2] Even before the Charter is secured, and that will not
be a long time, the champions of the good cause can organise
the resources which will enable a beginning to be made in this
most beneficent social revolution.

We now see what O'Connor meant by declaring at Birming-
ham that something practical must be adopted to save the
declining Chartist cause, and how in his megalomania he built
up his new Tammany Hall in London, where as chief boss
he could pull the wires that were to win the Charter, restore
the golden age, make unnecessary the new Poor Law, and
turn the artisan classes from their misguided faith in Bright,
Cobden, and Free Trade. On the incoherencies of the system,
as O'Connor expounded it, it is needless to dwell. They are
written large in every detail of the scheme. But there is no
need to doubt the sincerity of the strange mind which could
convince itself and others of the practicability of such a plan.
After all there were sound elements in O'Connor's principles
which have appealed, and will continue to appeal, to social
reformers of many types and ages. But the fantastic details
were as vivid to the agitator as was the honest repugnance to
the black sides of industrialism on which his weird calculations

[1] See, for instance, O'Connor's extraordinary argument in *Northern
Star*, May 15, 1843, that a man with four acres under potatoes, cabbages,
and turnips could *clear* £100 a year at a moderate estimate by spade
cultivation. O'Connor's figures worked out to £305, and he allowed only
£100 surplus to show his moderation. The *Leeds Mercury* replied that at
this rate all landlords would raise their rents twentyfold.
[2] See O'Connor's answer to the *Leeds Mercury* in *Northern Star*, June 3,
1843. It is simply that the *Mercury* leaves the magic effects of the Charter
out of the question.

were based. His cry was now, " The Charter and the Land " ; and he extolled the " Real Chartism which is the Land as a free market for labour, and the Vote to protect it." [1] From the moment he had made the Land Scheme his own, he could talk of nothing else.

Despite the enthusiasm of O'Connor, both the Chartist cause and the Land Scheme still languished. Even in the Birmingham Convention the warning note was feebly sounded. In the Manchester Convention of 1844, held, unlike that of 1843, at its proper time in April, the final touches were given to the reorganisation scheme. The organisation was henceforth to be the " National Charter Association of Great Britain," and its object was " to secure the enactment of the People's Charter by peaceful legal and constitutional means." Membership was proved by possession of a card, which cost 3d. and was to be renewed annually. There was also a subscription of a penny a week to the General Fund. There was an Executive Committee of five, elected by the annual Convention, and a General Council, chosen by the Executive. The old officers were renewed, and O'Connor was unanimously re-elected by the grateful Convention.[2] But the resolution of the Convention, not to proceed with the Land Scheme on account of the difficulty involved in enrolment,[3] must have brought him face to face with the insecurity of his position. Most of the delegates declared in favour of separating the Land Scheme from the agitation for the Charter.

The apathy, discernible in 1844, was somewhat lessened in 1845. At the National Convention, held on April 21 at London, there was more feeling in favour of the Land Scheme, though there were still good Chartists who were afraid lest it should swallow up Chartism. A committee drew up a scheme for a " Chartist Land Co-operative Society," whose shares of £2 : 10s. each could be purchased in weekly instalments of 3d. and upwards, and whose design was to " show the working classes the value of land as a means of making them independent of the grinding capitalist," and " the necessity of securing the speedy enactment of the People's Charter, which would do for them nationally what this society proposes to do for them sectionally "[4] But up to the end of the year the net subscriptions available for the purchase of land

[1] Northern Star, September 16, 1843. [2] Ibid. April 27, 1844.
[3] Ibid. April 20. [4] Ibid. April 26 and May 5, 1845.

amounted to less than £2700.[1] It seemed then that, however much O'Connor might flog the twin steeds of the Charter and the Land, their pace remained terribly slow, and even at that pace they could not keep step with each other.

The real sincerity of Chartism had always been its cry of want, its expression of deep-felt but inarticulate economic and social distress. Chartism was the creed of hard times, and it was unlucky for O'Connor and his plans that between 1842 and 1845 there was a wave of comparative prosperity that made those who profited by it forget the distress that had been so widespread between 1836 and 1842. It was only in Ireland that misery still grew apace until its culmination in the potato famine, and in Ireland there never had been any Chartism to speak of. But in England and Scotland it was becoming clear that better times were at hand. The harvests were good, though bread remained dear ; there was a great impetus in railway construction ; the textile trades, notably the cotton industry, were rapidly increasing. The Chartists themselves recognised the improved outlook, and they were hardly convincing when they warned their following that prosperity would not last long without the Charter.[2] The gross fact remained that the return of economic progress was cutting away the very foundations of the Chartist movement.

The ebb and flow of prosperity and misery largely depend on causes deeper seated than the operations of Governments. Yet the unheroic but effective administration of Sir Robert Peel had already begun to teach the ordinary man that substantial benefits might accrue even from an upper-class Ministry, kept in power by a middle-class House of Commons. This was notably the case with their factory legislation, their successive readjustments of the national finances, and their legal and administrative mitigations of the doctrinaire harshness of the New Poor Law, as carried out by convinced Benthamites. The result was that men, who, a few years earlier, had been ready converts to Chartism, found more immediate and practical ways of working out their salvation. Unemployment was becoming less common ; wages were tending towards the up grade ; many of the worst scandals of the factory system were being grappled with. A moderately prosperous artisan discovered a new outlet for his energies in aiding in the great development of trades unionism that was now beginning.

[1] *Northern Star*, December 13 and 20, 1845. Report of Land Conference at Manchester. [2] *Ibid*. May 3, 1845.

Emigration to rich and undeveloped lands beyond the ocean began to afford a more hopeful outlook to surplus population than the doubtful experiments of O'Connor's Land Scheme. For those who still clung to panaceas there were rival Land Schemes which seemed as attractive, and were as unsound, as that of O'Connor himself.[1] And there were still orthodox adherents of the old Chartist political programme who complained that O'Connor's Land Scheme was but a device to divert the attention of the people from the vital " six points." [2] To this O'Connor's only answer was that he brought in the land question, before they won the Charter, to show to what purpose the Charter was to be applied when obtained.[3]

The return of prosperity was neither general nor deep-seated, but it had the more profound effects in diminishing Chartist zeal, since the constant dissensions and jealousies, that had repeatedly rent asunder the party, had spread among the rank and file a widespread distrust of the leaders which often amounted to complete disillusionment. Not only was the failure of Chartism due to the decrease of misery ; it was also brought about by the decrease of hopefulness.[4]

The results of O'Connor's unscrupulous treatment of his foes within the party now came home to roost. Nowhere was there fiercer opposition to the Land Scheme than from the malcontents whom the dictator had drummed out of the Chartist army. O'Brien bitterly denounced the Land Scheme from the point of view of doctrinaire Jacobinism. If the Land Scheme succeeded, he declared, it would set up a stolidly conservative mass of peasant holders who would make all radical change impossible. " Every man," said the *National Reformer*, " who joins these land societies is practically enlisting himself on the side of the Government against his own order." [5]

[1] See, for instance, the rival scheme of Carpenter in *Lloyd's Weekly Newspaper* for 1845, and O'Connor's answer to it in *Northern Star*, June 21 and 28, 1845. Compare the Land Scheme, mooted at a conference at Exeter, 1845, in conjunction with a project for a general union of trades (*Ibid.* July 12, 1845).

[2] *Northern Star*, May 20 and June 24, 1843, Letter of Thomas Smith of Liverpool : " According to this new light of Mr. O'Connor all our efforts to obtain what we have called our rights, all negotiation on behalf of the Charter, now prove to have been but superfluous and mischievous impertinence."

[3] *Ibid.* July 15, 1843. Speech of O'Connor at Manchester on July 8.

[4] See the valuable suggestions on the relative value of material and moral forces in the falling away of Chartism, and generally the whole of the chapter in Dolléans, ii. 317. Compare Slosson, *The Decline of the Chartist Movement*, pp. 115-38, ch. iv., "The Improvement in the Condition of the Working Classes after 1842."

[5] *National Reformer*, quoted in Slosson, *Decline of the Chartist Movement*, p. 88. It was O'Brien's own organ.

As time went on, even O'Connor felt the need of trimming his sails to meet the new breezes of opinion. He began to hedge in his attitude to the Corn Law question, and henceforth generally spoke of Cobden with some measure of respect. In a Chartist Convention held on December 22, 1845, at Manchester the party abandoned its opposition to the repeal of the Corn Laws on account of the threatened scarcity.[1] O'Connor now sang the praises of Peel. Under his administration Toryism had become progressive.[2] A Chartist meeting at Ashton, presided over by O'Connor, unanimously declared in favour of Peel as against Russell. O'Connor was more than wavering in his ancient opposition to Trades Unionism. The *Star*, now removed to London, gradually posed as a trades union organ. Yet a few months earlier it had spoken contemptuously of " the pompous trades and proud mechanics who are now willing forgers of their own fetters."[3] But O'Connor still sought out any new source of discontent, hoping to bring new recruits to his cause by adopting their principles. Thus a proposal of the Government to reorganise the militia resulted in another new departure. This was a Chartist " National Anti-Militia Association," which was announced as " established for the protection of those who have a conscientious objection to the service and who will not pay others to do for them what they object to themselves.[4] " No vote ! No musket ! " now became a Chartist cry.[5] Their sensitive consciences revolted against the not very martial obligation of taking their turn in the militia ballot, or of paying a substitute in the event of the lot being adverse.

It was another sign of O'Connor's conciliatory temper that he attempted to re-establish friendly relations with Thomas Cooper, who was released from Stafford Gaol on May 4, 1845.[6] Cooper was more anxious at the moment to secure the early publication of the *Purgatory of Suicides* than to take up his old propaganda. He was, however, clearly flattered when O'Connor sought out his society, listened with interest to the poet's readings from the *Purgatory,* and offered to bear the expense of printing the work at the office from which the *Star* was issued. His acceptance at once opened the way to renewed friendship, but O'Connor soon dropped poetry for

[1] *Northern Star*, December 27, 1845.
[2] *Ibid.* December 20. [3] *Ibid.* November 1, 1845.
[4] *Ibid.* February 7, 1846. [5] *Ibid.* January 17, 1846.
[6] *Life of Thomas Cooper*, p. 258. Compare *ibid.* chapters xxiv. and xxv. for Cooper's subsequent relations with O'Connor.

politics. " Occasionally," wrote Cooper, " I called on O'Connor and conversed with him; and he invariably expounded his Land Scheme to me and wished me to become one of its advocates. But I told him that I could not, and I begged him to give the Scheme up, for I felt sure it would bring ruin and disappointment upon himself and all who entered into it." [1] At first the patrician kept his temper at the workman's presumption; but he soon grew haughty, and denied Cooper his door. Thus the ill-assorted pair drifted back into coolness, and from coolness to the " real and fierce quarrel " which finally ended Cooper's relations to O'Connor and Chartism.[2]

The Land Scheme still required further advertisement if it were to hold its own against the bitter hostility and the widespread indifference which it encountered. The Land Society underwent a further reconstitution; it was " provisionally registered " in October 1846, and early in 1847 reached its final status as the National Land Company. Its capital was to be £130,000 in 100,000 shares. Branches were to be set up all over the country, and a Land Bank was to be started to facilitate its operations. But O'Connor was to be the Chairman of the Board of Directors of the Land Company with absolute control over its operations. Its object was to buy estates in the open market and divide them up into small holdings. All persons anxious to become landed proprietors were to buy as many shares in the Company as they could afford. To encourage the poorest not to despair of owning his plot of ground, a low minimum of weekly subscription for shares was fixed, and a single share could be purchased for 26s. The proprietor of two shares might hope to receive a house, two acres of land, and an advance of £15 to stock it. The holder of one share had a claim on one acre and an advance of £7 : 10s. The order in which the share-holder was to participate in these benefits was to be determined by ballot. As soon as the fortune of the lottery gave the lucky investor his chance, it was the Company's business to find the land, prepare it for cultivation, erect a suitable cottage, and advance the loans which would start the new proprietor in his enterprise. In return the tenant had simply to pay to the Company a rent of 5 per cent per annum. With this rent the Company was to go on buying and equipping more land, until every subscriber to its capital was happily established on his little farm.

[1] *Life of Thomas Cooper*, pp. 273-4
[2] *Ibid.* pp. 277-8. Cooper himself refers to Gammage's *History of the Chartist Movement* for details of the final rupture.

The impossibility of carrying out such a scheme need hardly be indicated. How could the "surplus hands," the outcasts of the factory system, find the money to buy even one share in O'Connor's Company? How could the town-bred artisan cultivate his little holding without knowledge, capital, equipment, or direction? Could such tiny plots, unskilfully tilled by amateur farmers, be made capable of supporting even the most industrious and capable of the new owners? How could such ill-equipped amateurs compete successfully against the capitalist farmer, skilled in his trade and provided with all the machinery and tools required for modern farming? If this were impossible, how was the Company to get back its "rent" without which it could not extend its operations? How could a sufficient supply of land be procured in a country where great capitalist landholders looked with jealousy upon an independent and self-sufficing peasantry? Moreover, the cotton lords and the railway kings, the successful heads of the professions, the thrifty landholders with a traditional title were all eager to become purchasers of any land offered for sale, and were able and willing to pay a price far beyond the economic value of the land, on account of the social and political prestige still associated with a proprietary estate. Even had this not been the case, the inevitable result of the operations of a great land-purchasing company was bound to speedily raise the already inflated price of land, to the extent of making commercial investments in estates extremely difficult. And so small a sum as £130,000 would do little towards setting up a peasant proprietary in the teeth of a thousand obstacles.

The difficulties of the new enterprise were complicated by O'Connor's extraordinary indifference and ignorance in all matters of business. His own finances were a mystery. At one time he boasted of his estates and capital, and posed as running the movement and financing the *Star* out of his own pocket. At others he appeared in his truer colours as a reckless and extravagant spendthrift, unable to find funds for the most necessary purposes. Under his later management the *Star*, once a mine of wealth, had become less and less prosperous. He kept no accounts; he could not make the simplest calculations; he destroyed balance-sheets; he took no trouble to give his Company a legal position; he gave himself the airs of a prince. Moreover, his incapacity to transact business was no longer a mere matter of temperament. Reckless living, a constant whirl of excitement, heroic but futile exertions had

undermined his constitution and sapped his faculties. The seeds of insanity were already sown, and the Chartist autocrat was rapidly ceasing to be responsible for his actions.

If a shocking man of affairs, O'Connor had still enough wit left to be an ideal Company promoter. His plausibility, his sanguine temperament, his driving force, his rare command over words, his power over his followers, his magnificent assurance, his reckless unscrupulousness, his extraordinary and ubiquitous energy were still adequate to give his Company a good start. The greater part of the capital asked for was subscribed; six small estates were purchased in the open market and broken up into small allotments. The first of these, an estate of about one hundred acres near Watford, was rechristened O'Connorville, and eager artisans set to work to prepare it for its tenants. No device of advertisement was neglected. There was a cricket match on Chorleywood Common, where O'Connor captained a team of bricklayers against an eleven of carpenters and sawyers, employed in getting O'Connorville ready for the Chartist settlement. In this the bricklayers won by twenty-eight runs. "The workmen," says the enthusiastic *Star* reporter, "having proclaimed a half-holiday, appeared as respectable and much more healthy than the Oxford and Marylebone boys." [1] A Chartist cow, named Rebecca in compliment to the South Welsh destroyers of turnpikes, supplied milk for the needs of the workmen.[2] There was later a ceremonial inauguration of O'Connorville on August 17, for which Ernest Jones, O'Connor's latest recruit, wrote a rather commonplace poem :

> See there the cottage, labour's own abode,
> The pleasant doorway on the cheerful road,
> The airy floor, the roof from storms secure,
> The merry fireside and the shelter sure,
> And, dearest charm of all, the grateful soil,
> That bears its produce for the hands that toil.[3]

The settlers soon flocked in, proud to be the pioneers of a great social experiment. One of the allottees was a hand-loom weaver from Ashton-under-Lyne, who brought his loom with him and employed the time not required for cultivating his allotment in weaving ginghams from yarn supplied from Manchester.[4] Nor did the Hertfordshire settlement stand alone. Within less than two years four other estates were

[1] *Northern Star*, July 11, 1846. [2] *Ibid.* August 1.
[3] *Ibid.* August 22. [4] *Manchester Examiner*, December 5, 1846.

purchased, each covering a wider acreage and commanding a higher price than O'Connorville. There were two sites near Gloucester, one at Minster Lovel near Witney, and another at Dodford near Bromsgrove. A fifth purchase near Gloucester was never completed. It is characteristic of the change that came over Chartism that all these sites were in the South and West Midlands. But the shareholders came largely from the North, and in one week it was boasted that a quarter of the subscription contributed was drawn from Lancashire.[1]

O'Connor found a capable and energetic lieutenant for carrying out his Land Schemes in Ernest Charles Jones (1819-1869). Like O'Connor, Jones was a man of family, education, and good social position. His father, Major Jones, a hussar of Welsh descent, had fought bravely in the Peninsula and at Waterloo, and became equerry to the most hated of George III.'s sons, Ernest, Duke of Cumberland, after 1837 King of Hanover. The godson and namesake of the unpopular duke, Ernest Jones was born at Berlin, brought up on his parents' estate in Holstein, and educated with scions of Hanoverian nobility at Lüneburg. He came to England with his family in 1838, but his upbringing was shown not only in his literary tastes and wide Continental connections, but by his very German handwriting and the constant use of German in the more intimate and emotional entries in his manuscript diaries.[2] He entered English life as a man of fashion, moving in good society, assiduous at court, where a duke presented him to Queen Victoria, marrying a lady " descended from the Plantagenets " at a " dashing wedding " in St. George's, Hanover Square. He was gradually weaned from frivolity by ardent

[1] *Northern Star*, November 21, 1846. In one week Lancashire contributed £292 : 17 : 8 out of a total subscription of £1331 : 4 : 9½. There was much rejoicing over these large totals.

[2] For instance, the long entries in his diary under September 2, 1839, and more shortly in the remark under September 10. " Bought a pair of boots. *Mein Herz bricht !* " Jones's manuscript diary is preserved with much other material for his biography in the Manchester Free Reference Library [MSS. 312 A 17, 18]. Its two volumes range from July 3, 1839, to May 9, 1847. For other diaries and note-books of Jones, see later, note 1 on page 299 The diary has been used to some extent by David P. Davies in his *Life and Labours of Ernest Jones* (Liverpool, 1897). Among the numerous Jones tracts in the Manchester Library is a curious pamphlet, *Ernest Jones Who is He ? What has He Done ?* It was an attempt to justify his career when he stood for Manchester in 1868, and is not unskilfully done, though in too apologetic a strain. Some statements are demonstrably false, notably that he never had any connection with O'Connor's Land Campaign. The pamphlet excited critical rejoinders, such as *Mr. Ernest Jones and his Candidature* by G. W. Mason, which accuses Jones of having written *Who is He ?* himself. However this may be, it was clearly drawn up under his inspiration Both pamphlets are merely electioneering. No one can read his diary without being convinced of Jones's fundamental sincerity despite many weaknesses and affectations.

literary ambitions, but was soon terribly discouraged when publishers refused to publish, or the public to buy, his verses, novels, songs, and dances.[1] In 1844 he was called to the Bar, but hardly took his profession seriously. Domestic and financial troubles soon followed. His father and mother died and his speculations failed. In 1845 there was an execution in his house; he was compelled to hide from his creditors and pass through the bankruptcy court. He had now to seek some sort of employment, but apparently failed to find anything congenial to his mystic, dreamy, enthusiastic temperament.[2] He does not seem to have been destitute, but he lived in a fever of excitement and alternating hope and depression. He felt cut away from his bearings, living without motives, principles, or ambitions, until he began to find a new inspiration in attending Chartist meetings.[3] He was soon so fully a convert that, when his first brief came from the solicitors, it gave him far less satisfaction than the applause with which his Chartist audiences received his vigorous recitation of his poems, and the honour of dining four or five days running with O'Connor. Yet many years later he could inspire the boast that he had " abandoned a promising, professional career and the allurements of fashionable life in order to devote himself to the cause of the people."[4] He assiduously attended committees and rushed all over the country to make speeches at meetings. He offered himself as a candidate for the next Convention because he wished to see " a liberal democracy instead of a tyrannical oligarchy."[5] He reveals his sensitive soul in his diary.

I am pouring the tide of my songs over England, forming the tone of the mighty mind of the people. Wonderful! Vicissitudes of life—rebuffs and countless disappointments in literature—dry toil of business—press of legal and social struggles—dreadful domestic catastrophes—domestic bickerings—almost destitution—hunger—

[1] A few entries from the diary illustrate this. " I played a *walzer* of my own composition ; " " I have now three songs being set to music by Benedict ; " " I went to the Queen's grand birthday drawing-room ; " " married to Jane [Atherley], June 15, 1841, dashing wedding ; " " offered a poem to thirty-two different publishers." Under November 3, 1842, he records that five plays of his and one novel, besides numberless minor pieces, had been refused by publishers.

[2] On September 20, 1845, he was appointed secretary to the Leek and Mansfield (Macclesfield ?) Railway at a salary of four guineas a week, and began work at once.

[3] He was gazetted bankrupt in January 30, 1846 (*London Gazette*, January 30 and February 2, 1846). His first recorded attendance at a Chartist meeting was on January 28 of that year, where he " spoke over the Chartist organisation."

[4] *Ernest Jones. Who is He ?* [5] *Northern Star*, May 9, 1846.

X

labour in mind and body—have left me through the wonderful Providence of God as enthusiastic of mind, as ardent of temper, as fresh of heart and as strong a frame as ever ! Thank God !

I am prepared to rush fresh and strong into the strife or struggle of a nation, to ride the torrent or to guide the rill, if God permits." [1]

Jones was altogether composed of finer clay than O'Connor. His real sincerity and enthusiasm for his cause were quite foreign to the temperament of his chief. But there were certain obvious similarities between these two very different types of the " Celtic temperament." Not only in sympathetic desire to find remedies for evil things, but in deftness in playing upon a popular audience, in violence of speech, incoherence of thought, and lack of measure, Jones stood very near O'Connor himself. Henceforth he was second only to O'Connor among the Chartist leaders. For the two years in which he found it easy to work with his chief, Jones's loyal and ardent service did much to redeem the mediocrity of O'Connor's lead. In his political songs he set forth, always with fluency and feeling, sometimes with real lyrical power, the saving merits of the Land Scheme. Nor was he less effective as a journalist and as a platform orator. Not content with the publicity of the *Northern Star*, whose twinkle was already somewhat dimmed, O'Connor set up in 1847 a monthly magazine called *The Labourer*, devoted to furthering the work of the Land Company. In this new venture Jones was O'Connor's right-hand man. And both in prose and verse no perception of humour dimmed the fervour of his periods :

> Has freedom whispered in his wistful ear,
> " Courage, poor slave ! Deliverance is near ? "
> Oh ! She has breathed a summons sweeter still,
> " Come ! Take your guerdon at O'Connorville."

A modest but undoubted Chartist revival flowed from all this strenuous effort. O'Connor now sought a place in Parliament, and in 1846 offered himself for election in Edinburgh against Macaulay, who had vacated his seat on taking office in Lord John Russell's new ministry. His address is noteworthy for throwing over one of the " six points " of the Charter. Vote by ballot, hitherto a Chartist panacea, was rejected because it " put a mask on an honest face." [2] O'Connor did not, however, go to the poll, transferring his

[1] *MS. Diary*, October 8, 1846. [2] *Northern Star*, March 7, 1846.

electoral efforts to Nottingham, where he was beaten in the poll by Sir John Cam Hobhouse, the sometime Radical friend of Byron and Francis Place, but now shut up in the straitest school of Whiggery as one of the tamest of Cabinet ministers of the Russell Government.

The Chartist cause fared better at the general election of 1847. It was one of the surprises of that election that O'Connor was chosen member for Nottingham while Hobhouse was put at the bottom of the poll.[1] There were a good many other Chartist candidatures, but most of them were not persevered in beyond the public nomination at the hustings, and the inconclusive verdict of the popular show of hands. But the few Chartists who went to the poll did not share the leader's good fortune. Ernest Jones was badly beaten at Halifax,[2] and the nearest approach to a second Chartist victory was at Norwich, where J. H. Parry nearly defeated the Marquis of Douro, the eldest son of the great Duke of Wellington.[3] It was, however, a new thing to have even one Chartist able to voice the party's point of view in the House of Commons, the more so since its representative was the vigorous personality who stood for the cause in the public mind. Even in the heyday of Chartism, it had only been through the benevolence of some sympathetic Radicals, like Thompson and Crawford, that the Chartist standpoint could be indirectly expounded in Parliament.

O'Connor did not make much of his position in Parliament. He talked of bringing in a bill to legalise his Land Company, which the experts had already pronounced to be illegal. But he was as much an Irish Nationalist as he was a Chartist, and the House of Commons after O'Connell's death offered an irresistible temptation to him to revert to the first rôle he had ever played in politics. His chief work in Parliament was now in obstructing and denouncing the Whig ministers' Irish Coercion Bill. It almost looks as if he had ambitions to oust John O'Connell from his uneasy succession to his father as the Irish leader.[4] But his eccentricities were now verging towards insanity, and his language had become extraordinarily

[1] The numbers were Walter (of the *Times*) 1830 ; O'Connor, 1340, elected ; Gisborne, 1089 ; Hobhouse, 974, not elected (*Northern Star*, July 31, 1847).
[2] Jones only got 279 votes, while the lowest successful candidate obtained 506.
[3] The numbers were Peto, 2414 ; Douro, 1723, elected ; Parry, 1648, not elected.
[4] *Northern Star*, December 4, 1847, called J. O'Connell " a lick-spittle spaniel only fit to be kicked." His crime was wishing to keep on terms with the Whig ministry.

violent.[1] His methods went down on Chartist platforms, but he never gained the ear of the House of Commons.

(3) CHARTISM AND THE REVOLUTION OF 1848

In 1848 a new impetus was given to the Chartist movement by the revolutionary disturbances which broke out in nearly every country of western Europe. The example of the foreign proletariat in revolt, and particularly the expulsion of the monarchy of July in favour of a French Republic with a social policy of national workshops, stirred up British malcontents to imitate the glorious doings of the Parisian revolutionaries.

Up to this point Chartism has presented itself to us mainly as a particularly British manifestation of specifically British grievances. But the problem of misery and its remedies had its universal as well as its insular aspect, and from the early days of the Working Men's Association, from which Chartism sprang, the cosmopolitan side of the common cause had not been lost sight of. The Chartist pioneer, Lovett, made it the pride of the Working Men's Association that, as early as 1836, it had introduced to Europe the mode of international addresses between working men of different countries.[2] For a decade the workers of the West, wrestling with legitimism, and the fruits of the Holy Alliance, and finding no salvation in the bourgeois rule which seemed the only alternative to traditional class domination, had looked for guidance from the comparative freedom of English political and social development. While Chartism stood in revolt against the middle-class ascendancy, established by the Reform Bill, the French Revolution of 1848 marked the triumph of the opposition to the similar principles of bourgeois ascendancy which had come in with the citizen king of the French. Thus the Continental democratic leaders hoped for assistance from the Chartist pioneers of proletarian revolt, while the Chartists themselves rejoiced to find brethren and allies among the workers beyond seas.

[1] Thus he addressed the *Weekly Despatch* : " You unmitigated ass ! You sainted fool ! You canonised ape ! There is not a working man in England who has not more confidence in me than in any banker in the world, and so he ought, you nincompoop ! " (*Northern Star*, September 25, 1847).
[2] Lovett's *Life and Struggles*, pp. 98-100. In that year the W.M.A. sent an address to Belgian workers and received an answer from them. In 1844 Lovett joined in forming a society of the " Democratic Friends of all Nations," largely composed of refugees, which aimed at promoting international brotherhood by pacific addresses.

One link between Chartism and the Continent had always existed in the family connections of Feargus O'Connor. His uncle, Arthur O'Connor, a priest-hating aristocrat, who had taken a leading part among the United Irishmen, had done his best to induce Lazare Hoche to effect the liberation of Ireland by bringing a Jacobin army across the Channel. On his release from prison in 1803, Arthur O'Connor had settled down in the land of Revolution, had been made a general by Napoleon, had become a French citizen, and had married a daughter of the philosopher Condorcet. He was still living in a country house that had once belonged to Mirabeau, and, though over eighty years of age, remained active enough to send home furious attacks on O'Connell and his clerical following. Thus the French Revolutionary tradition had almost as much to do in moulding O'Connor's policy as had his Irish nationalist antecedents. Lesser apostles of Chartism had drunk deeply in the French Revolutionary spring. James O'Brien had glorified the Jacobinism of Robespierre and the Communism of Babeuf in writings which had been widely read in Chartist circles. If O'Brien were now virtually lost to the party, Harney's Jacobinical sentiments, MacDouall's exile in France, and Ernest Jones's German upbringing and relations with German revolutionaries, had all multiplied the dealings between the Chartist leaders and the Continent. There was now in England a considerable band of foreign exiles, chief among whom was Giuseppe Mazzini. Thus it was that the revolutionary movements on the Continent were closely followed in Chartist circles, while Continental rebels repaid the compliment by studying the methods of Chartism in England. The Chartist outlook was no longer merely local.

In 1845 Feargus O'Connor made a tour in Belgium and came home full of a desire to emulate the Flemish methods of small intensive farming, which he held up for admiration to those who wished to participate in his Land Scheme. Were England cultivated like Flanders and Brabant, it would, he declared, be able to maintain a population of three hundred millions.[1] But O'Connor did not simply go to Belgium to study its agriculture. At Brussels he had treaty with a band of German democratic communists then in exile in the Belgian capital. This body welcomed him with a congratulatory address, signed among others by Karl Marx and Friedrich

[1] *Northern Star*, September 20, 1845. With characteristic incoherence O'Connor wrote in the *Star* of September 27 that the Belgian peasants were in terrible tribulation through a failure of the harvest.

Engels.[1] These men, young and little known at the time, had just begun that long association which was to be of such significance in the later history of socialistic theory and practice. Engels had already become during his earlier residence in England the chief link that bound to English Chartism the extremists of the German revolt against the social order.

Friedrich Engels (1820–1895), the son of a well-to-do cotton-spinner at Barmen, was brought to Manchester in 1842 in the interests of a branch of his father's firm, established in the cotton area of south-east Lancashire. His residence in this country between 1842 and 1844 bore as its chief fruit an elaborate study of the condition of the English working classes at that period, which was first published in 1845.[2] It also resulted in Engels being brought into relation with English Chartists and Socialists, from whom he learnt a more concrete method of dealing with economic problems than had prevailed among his German teachers. He wrote for the *Northern Star*, and became friendly with O'Connor and Jones. On leaving England for Paris, Engels began there his intimacy with Karl Marx (1818–1883), a young doctor from Trier, whose Jewish origin and Radical views made an academical career impossible for him in Prussia. Marx was now, under Engels's guidance, sitting at the feet of the French social reformers. He gladly widened his reading to include the pioneers of English socialism and profited much by it, learning, for instance, from Hodgskin some of the characteristic doctrine which he set forth to the world twenty years later in *Das Kapital*. Expelled from Paris at the request of the Prussian Government, Engels and Marx next took up their quarters at Brussels, where O'Connor found them. At Brussels they were free to think and write as they chose, while awaiting the upheaval which they foresaw to be imminent in their native country. When even orthodox Radicalism denied Marx a hearing, he was sure of publicity for his views in the friendly pages of the *Northern Star*. Thus, when he was forbidden to denounce Free Trade in a conference at Brussels, O'Connor printed his written speech for him in that organ.[3] A "League of the Just," reorganised by Marx and Engels as a "League of Communists," took up under their guidance an open educational propaganda. With

[1] *Northern Star*, July 25, 1847.
[2] F. Engels, *Die Lage der arbeitenden Klassen in England* (Leipzig, 1845), translated by F. K. Wischnewetzky as *The Condition of the Working Classes in England in 1844* (London, 1892).
[3] *Northern Star*, October 9, 1847. The conference was on September 17-19.

branches in London, Paris, and Brussels, it became a powerful body.

London, as the chief haven of refuge for the exiled revolutionary, furnished more abundant opportunities than even Brussels for fraternal relations between the Chartists and their foreign allies. Thus Harney and Jones attended, on July 14, 1846, the celebration of the anniversary of the fall of the Bastille by a Democratic Society of French exiles. At this gathering Jones made a terrific speech on behalf of the fraternity of nations, while Harney drove home his moral by urging the French to forget Fontenoy and the English to forget Waterloo.[1] Moreover Harney and Jones were both members of an international society of German origin called the *Deutsche Bildungsgesellschaft für Arbeiter.* Jones was an active member of a committee for the regeneration of Poland, and Harney energetically got up meetings in favour of the Poles.[2]

There was a danger lest absorption in international schemes of revolution might not limit the directness of the Chartist appeal to the British proletariat. In the early months of 1848 the conflict between the older and newer Chartist ideals was already making itself felt. There was the natural impulse to profit by the recrudescence of interest in the movement to carry on an agitation on the good old lines that had so often been tried and found wanting. A new National Petition had already been arranged for, and it was another proof of the ascendency of O'Connor that his aristocratic dislike of the ballot was allowed to prevail over the sacred traditions of the Six Points, consecrated by ten years of agitation. The Petition asked for the Charter, but henceforth the Charter was a Charter of Five Points. The Sixth Point, the Ballot, was quietly dropped. Yet it must have been a real stimulus to men, who had long lived in a backwater, conscious, despite their own assertions to the contrary, that the general public was little heedful of their doings, to learn that crowds were flocking on every side to sign the Petition, and that there was every prospect of making a braver show than even in the glorious days that preceded the collapse of the Petition of 1842. With February came the news of the ignominious flight of Louis Philippe and the supersession of the citizen king by a Radical Republic with socialistic leanings. The *Northern Star* rejoiced in the triumph of the " Paris proletarians," and declared that " as France had secured for herself her beloved

[1] *Northern Star*, July 18, 1846. [2] *Ibid.* March 21 and 28, 1846

Republic, so Ireland must have her Parliament restored and England her idolised Charter." [1] It scathingly compared the glories of the national workshops of revolutionary France with the miserable " bastilles " of the English Poor Law.[2] Something more novel and drastic than mass meetings and petitions was necessary, if the men of England were to follow effectively the example of the heroic sovereign people of France.

In March disturbances broke out all over the country. On March 6 there were food riots in Glasgow. A mob paraded the town, looting the shops and crying " Bread or Revolution," " Vive la République." [3] Everywhere great damage was done and keen alarm excited. At Bridgeton, an eastern suburb of Glasgow, the soldiers fired on the crowd and shot five men dead. On March 7 there was a less formidable movement at Manchester, a feature of which was the attempt of the mob to clear the workhouse " bastille " in Tib Street of its inmates. There was also wild rioting at Aberdeen, at Edinburgh, and in many other places. In London a meeting, called for Trafalgar Square on March 6 to protest against the income tax, was, owing to its injudicious prohibition by the police, turned into a Chartist demonstration. George M. W. Reynolds, a journalist who had long upheld the claims of foreign revolutionaries, took the chair, and motions were passed sending congratulations to the French Republic, and declaring the adherence of the meeting to the Charter. The police sought to disperse the assembly, but were driven into Scotland Yard. Towards nightfall there ensued slight disturbances, the breaking down of the railings round the Nelson Column and the smashing of lamps in front of Buckingham Palace. The dispersal of the crowd by the palace guard showed that there was not much danger in the outbreak. Where there were not riots, there were meetings to demonstrate sympathy with the French Republicans. At a gathering of Fraternal Democrats, who cheered the French Republic and the Charter, Ernest Jones declared that " the Book of Kings is fast closing in the Bible of Humanity." He was sent with Harney and McGrath to Paris to convey in person the Chartists' congratulations.[4] There was another demonstration on March 13 on Kennington Common.

The Convention met on April 3 in London, where forty-four representatives came from about thirty-six towns. On

[1] *Northern Star*, March 25, 1848. [2] *Ibid*. March 18.
[3] *Ibid*. March 11. [4] *Ibid*. March 4.

April 4 serious business began with a proposal from Bronterre
O'Brien, whose revolutionary enthusiasm now brought him
once more to a meeting controlled by O'Connor. But he came
not to bless but to curse, and poured abundant cold water on
the ardent schemes of the executive. Bronterre upheld the
view that, as the Convention only represented a small fraction
of the nation, it should limit its action to presenting the new
petition, and that a larger assembly should be summoned to
consider ulterior measures. By this dilatory measure time
would be gained to prepare for revolution. In opposition to
this the executive moved resolutions that in the event of the
petition being rejected, a National Assembly should be con-
voked. This body was to draw up a memorial to the Queen
to dismiss her Whig Ministers and choose others who would
make the Charter an immediate Cabinet question. Reynolds,
the hero of the Trafalgar Square disturbances, had stepped into
some prominence as a Chartist leader. He now moved an
amendment to this, proposing that on the rejection of the
Petition the Convention should declare itself in permanent
session, and proclaim the Charter the law of the land.

In the end the Convention decided in favour of the convoca-
tion of a National Assembly, consisting of delegates appointed
at public meetings, and empowered to present a National
Memorial to the Queen and to remain in session until the
adoption of the Charter. Elaborate plans for the constituting
of the Chartist Commonwealth of the future were now in the
air. The aim before the zealots was a Revolutionary assembly
that would secure the extension of the Republic from France
to England. Even before the Convention had met, O'Connor
had sketched in the *Star* an ideal polity which had many
affinities with the French Constitution of the Year Three, and
included a House of Commons, elected after the Chartist
fashion, a Senate or House of Elders, rather of the pattern
of the *Conseil des Anciens*, and an Executive Council of five,
like the Executive Directory, but with a President chosen
for life. Local government was to be provided for by each
electoral district choosing twelve justices of the peace, whose
mandate was to magnify their office by overthrowing all
centralisation.[1] Projects of this sort show how the Chartist
leaders had widened their platform. Unluckily they could
not agree on the same plan, and events soon made their
deliberations abortive.

[1] *Northern Star*, April 1.

The National Petition was now ready for presentation, and, according to O'Connor and Jones, had been signed by something approaching six million persons. The Convention publicly announced that it was to be handed in to Parliament on Monday, April 10, and convoked for that day a mass meeting of sympathisers on Kennington Common. The plan was for the Petition to be carried solemnly to Westminster, accompanied by an imposing procession. The great multitude of Chartists, reinforced by any friends of the cause who cared to join, was to convince the timid aristocrats of the strength of the people's cause and terrorise them into the immediate concession of the Charter. In other cities sympathetic demonstrations were to show that zeal for the Charter was not limited to the capital.

The greatest alarm was created by the proposed action of the Chartists, and the publicity chivalrously given to the proposed meeting gave the administration the opportunity of taking adequate precautions to deal with the threatened disorder. The Government lawyers discovered a law of the Restoration period which forbade the presentation of a petition by more than ten individuals. An Act was hurried through Parliament making certain seditious deeds felony. Among such acts were " seeking to intimidate or overawe both Houses of Parliament," and " openly or advisedly writing or speaking to that effect." An army of special constables approaching 170,000 in strength was hastily levied, among their number being Louis Napoleon, the future Emperor of the French. The Duke of Wellington, still Commander-in-chief though on the verge of his eightieth year, was entrusted by the Cabinet with the direction of all the measures necessary for defence, and the Tory veteran appeared in the Whig Cabinet to deliberate with it on the steps to be taken. His plans were judicious and promptly carried out. All available troops were collected, and carefully massed at certain central points from which they could be easily brought to defend the bridges over the Thames, and watch the two miles of road that separated Kennington Common from Westminster Bridge. But they were carefully hidden out of sight and few suspected the strength of the forces reserved for emergencies. The discipline of the streets, even the control of the passage over the bridges, was left to the new police and to the civilian special constables who were everywhere in evidence. In Kennington and Lambeth peaceable citizens carefully barricaded their houses and kept within doors.

On April 10 a great crowd assembled on the open space of rough grass then known as Kennington Common. No attempt was made to stop the bands of Chartist processionists who marched from all parts of London to the rendezvous. Soon the Chartists were there in force, and with them were many adventurous spirits, attracted by curiosity or love of excitement. But the alarm as to what might happen was so real and widespread that the assembly was far smaller than the organisers of the demonstration expected. While O'Connor boasted of a gathering of half a million, more impartial observers estimated the crowd as something in the neighbourhood of 20,000. O'Connor drove up in a cab, and was ordered by the chief commissioner of police, Mr. Richard Mayne, to come and speak to him. He looked pale and frightened, and was profuse in thanks and apologies when Mayne told him that the meeting would not be stopped but that no procession would be allowed to cross the bridges over the Thames. He then harangued the assembly, advising it to disperse. The leader was followed by Jones, Harney, and other popular orators. Small as the mob was, it consisted of spectators quite as much as sympathisers. It listened good-humouredly to the speeches and scattered quietly after they were over.[1] The processionists, however, were no longer allowed to cross the bridges in force, and a few heads were broken before they accepted the inevitable and made their way home in small detached groups. Meanwhile O'Connor had driven to the Home Office, where he reported to the Home Secretary, Sir George Grey, that the danger was over, and repeated the thanks and assurances that he had already made to the commissioner. The Petition duly reached Parliament in three cabs, and the day of terror ended in the shouts of laughter that greeted its arrival in the House of Commons. Meanwhile similar precautions had been attended with similar results in the other great centres where Chartist violence had been expected. When April 10 dawned in Manchester, cannon were found planted in the streets, and dragoons patrolled the chief thoroughfares with drawn swords. Thousands of miners and factory hands marched out from Oldham, Ashton, and the other manufacturing towns to the east, and many of them bore pikes and other implements of war. As they approached

[1] A letter of Lord John Russell to the Queen, dated 2 P.M., giving a useful summary of the events of the morning, is in *Letters of Queen Victoria,* ii. 168-9. There is a coloured but very accurate account in *Annual Register,* xc. ii. 50-54 (1848).

the city, they were warned of the danger that confronted them and were persuaded to return to their homes.[1]

Chartism never recovered from the tragic fiasco of April 10, 1848. The panic fears that had preceded it were now turned into equally unthinking and more provocative ridicule. The Petition came out badly from the scrutiny of the Commons Committee on Petitions. The gross number of signatures was somewhat less than two millions, and many of these were in the same handwriting. The Committee solemnly drew attention to the fact that among the signatories were " the names of distinguished individuals who cannot be supposed to have concurred in its prayer," such as " Victoria rex, 1st April," Prince Albert, the Duke of Wellington [who was supposed to have signed seventeen times], and Sir Robert Peel. " We also," continued the Committee, " observed another abuse equally derogatory of the just value of petitions, namely the insertion of names which are obviously altogether fictitious." " Mr. Punch," " Flatnose," " Pugnose," and " No Cheese " were examples of this reprehensible tendency. Even including such efforts of the practical joker, there were fewer signatures to the Petition of 1848 than to the Petition of 1842. It was to no purpose that O'Connor blustered in the House of Commons and declared the great things that he proposed to do. The Petition was dead and was never resuscitated.

A few stalwarts still insisted on the summoning of the National Convention which was to take the " ulterior measures threatened if the Petition were disregarded." Accordingly a National Convention met on May 1. O'Connor opposed its meeting, and took no part in its proceedings. The half-hearted and irresolute assembly set up a new Executive, in which Jones and MacDouall were the leading spirits ; but neither Convention nor Executive could decide on any practical steps to secure the acceptance of the Charter in Parliament. Within a fortnight the Convention broke up for good. Lack of funds and a more paralysing lack of interest effectively stayed the hands of the Executive.

A further diminution of O'Connor's reputation now came from the collapse of his Land Scheme. The promises of 1846 and 1847 had not been realised ; the little groups of land settlers were very far from earning their living and providing

[1] See the interesting reminiscences of the old Chartist, William Chadwick, quoted from the *Bury Times* of February 24, 1894, in Slosson, p. 100. Russell had reported to the Queen that " at Manchester the Chartists are armed and have bad designs " (*Letters of Queen Victoria*, ii. 109).

the surplus of profit to the funds from which new lands could
be bought; the allotment holders of O'Connorville and its
like were in many cases reduced to dire distress. Many were
in danger of having to fall back on the cruel charity of the
New Poor Law. Rumours of incompetence and malversation
were so rife that there was a great outcry against the whole
plan. Finally the House of Commons took the matter up and
appointed a committee of investigation, which reported in
August strongly against the National Land Company and all
its works. The Company was an illegal scheme; it could
not fulfil the expectations held out by the directors to the
shareholders; its books and accounts had been most imper-
fectly kept; the original balance sheets signed by the auditors
had been destroyed, and only those for three quarters were
producible in any form. One point only in the damning
catalogue of error could in any wise be construed in O'Connor's
favour. The Committee reported that the confusion of the
accounts was not attributable to any dishonesty on O'Connor's
part. The irregularity had been against him, not in his
favour, and a large sum of money was due to him at the
moment. The conclusion of the Committee was that power
should be given to wind up the undertaking, and relieve the
promoters of the scheme from the penalties to which they
might have incautiously subjected themselves.[1] In September
Parliament accepted the report. It dealt such a blow to
O'Connor's diminished prestige that the strongest of men could
hardly have recovered from it. The Land Scheme, like the
Petition, had ended in ridicule and contempt. It was small
consolation to the fallen leader that his colleagues regarded
him as a fool rather than as a rogue.

A minimum of disturbance and protest followed the collapse
of April 10. As after the failure of 1842, there was a certain
amount of agitation and rioting, but the disorders of the spring
of 1848 fell as far short of those of the summer of 1842 as the
Petition of 1848 fell short of the Petition of 1842. There were
tumults in Aberdeen in April, occasioned by the election of a
delegate to the Convention.[2] In May there were several suc-
cessive disturbances in London on Clerkenwell Green, now a
favourite meeting-place of Chartists; and at Bishop Bonner's
Fields in the Tower Hamlets.[3] In Manchester the vigilance

[1] The conclusions of the Committee are quoted in Slosson, pp. 91-92.
The evidence and report are set forth at length in *Parliamentary Papers,
1847-8*, xix.
[2] *Annual Register*, xc. ii. 59.　　　　　[3] *Ibid.* p. 80.

of the police prevented any outbreak, but on July 14 there was a collision at Ashton-under-Lyne between a mob, armed with pikes, and the special constables, supported by a small military force. In the course of it the mob did to death a policeman, who was wrongly identified with a constable who had given evidence against MacDouall, who had long plied his trade as an unqualified medical practitioner at Ashton, and was something of a local hero.[1] In London several secret deposits of arms and weapons were discovered by the police in August.[2]

These circumstances gave some justification to the numerous arrests and trials which vindicated the dignity of the law. Ernest Jones was sentenced to two years' imprisonment for his share in the troubles at Clerkenwell Green and Bonner's Fields. In August MacDouall received a similar punishment, while in September William Cuffey and others were condemned to transportation for life.[3] The most chilling circumstance for the last victims of Chartism was the profound indifference shown to their threats and sufferings. But their foolish schemes of impracticable rebellions no less than the eagerness with which they incriminated each other might well have disgusted a public less attuned to anti-Revolutionary panic than the disillusioned men of 1848.

(4) THE LAST STAGES OF CHARTISM (1849–1858)

After the Chartist collapse of 1848 there remains nothing save to write the epilogue. But ten more weary years elapsed before the final end came, for moribund Chartism showed a strange vitality, however feeble the life which now lingered in it. But the Chartist tradition was already a venerable memory, and its devotees were more conservative than they thought when they clung hopelessly to its doctrine. It is some measure of the sentimental force of Chartism that it took such an unconscionably long time in dying.

O'Connor had survived with difficulty the double catastrophe of the National Petition and the Land Scheme. But he still remained member for Nottingham, and, though his parlia-

[1] *Annual Register*, p. 103. [2] *Ibid.* p. 104.
[3] Cuffey, a notorious London Chartist, is perhaps the Chartist leader most often mentioned in *Punch*, whose attitude to the men of 1848 was much less sympathetic than it had been to the heroes of 1842. Cuffey, for instance, is never spoken of without ridicule. But the change of tone in this widely read paper reflects the change of sentiment in its middle-class readers with regard to the Chartist movement.

mentary activity was now rapidly declining, he still spoke
and voted upon occasion. There was a last flash of the old
O'Connor spirit when, in 1849, he indignantly denounced the
severity of the treatment meted out to Ernest Jones, when the
Chartist captive incurred the wrath of the prison authorities
by refusing to pick oakum. But it was a sign of failing power
or interest when he delayed bringing forward until that same
session of 1849 his long-promised motion in favour of the
principles of the National Petition. He was, however, voted
down by 224 to 15, and, when in 1850 he once more revived
his proposal, he suffered the ignominy of a count-out. It was
O'Connor's nature to shout with the crowd, and these deadening
experiences led him to seek parliamentary notoriety in other
channels. Early in 1852 he sold the *Northern Star* to new
proprietors, who forthwith dissociated it from the Chartist
cause. His last parliamentary appearances were when he
spoke on Irish subjects. If this were no new experience for a
politician who never swerved in his allegiance to the Irish
national idea, it showed demoralisation that he should make
overtures to the Cobdenites, and worship the gods whom he
had of old contemned. But O'Connor's career was now nearly
run. The shadow of insanity had long been brooding over
him and the end came the more quickly by reason of his
intemperate habits. At last he was removed from the House
of Commons under deplorable circumstances. In 1852 he
outrageously insulted a brother member and was committed
to the custody of the sergeant-at-arms. Next day he was
pronounced insane and placed in an asylum. He died in 1855,
and the huge concourse that attended his funeral at Kensal
Green showed that the last years of failure and sickness had
not altogether destroyed the hold he had so long possessed
over his followers.

Ernest Jones gradually stepped into O'Connor's place.
His imprisonment between 1848 and 1850 had spared him the
necessity of violent conflict with his chief, and after his release
he had tact enough to avoid an open breach with him. His
aim was now to minimise the effects of O'Connor's eccentric
policy, and after 1852 he was free to rally as he would the
faithful remnant. He wandered restlessly from town to town,
agitating, organising, and haranguing the scanty audiences
that he could now attract. His pen resumed its former
activity. He sought to replace the fallen *Northern Star* by a
newspaper called *Notes to the People*. Jones was an excellent

journalist, but there was no public which cared to buy his new venture. It was in vain that he furiously lashed capitalists and aristocrats, middle-class reformers, co-operators, trades unionists, and, above all, his enemies within the Chartist ranks. He reached the limit when, under the thin disguise of the adventures of a fictitious demagogue called Simon de Brassier, he held up his old chief to opprobrium, not only for his acknowledged weaknesses, but as a self-seeking money-grabber and a government spy. It was in vain that Jones denied that his political novel contained real characters and referred to real events. Simon de Brassier's sayings and doings were too carefully modelled on those of O'Connor for the excuse to hold water. But however great the scandal excited, it did not sell the paper in which the romance was published. After an inglorious existence of a few months *Notes to the People* came to an end, and the *People's Paper*, Jones's final journalistic venture, was not much more fortunate. It dragged on as long as sympathisers were found to subscribe enough money to print it. When these funds failed it speedily collapsed.

The scandal of Simon de Brassier showed that Jones was almost as irresponsible as O'Connor. In many other ways also the new leader showed that he had no real gift for leadership. He was fully as difficult to work with, as petulant and self-willed, as O'Connor had ever been. He threw himself without restraint into every sectional quarrel, and under his rule the scanty remnant of the Chartist flock was distracted by constant quarrels and schisms. Meanwhile the faithful few still assembled annually in their Conventions, and the leaders still met weekly in their Executive Committees. But while each Convention was torn asunder by quarrels and dissensions, the outside public became stonily indifferent to its decisions. Jones himself retained a robust faith in the eventual triumph of the Charter, but he soon convinced himself that its victory was not to be secured by the co-operation of his colleagues on the Chartist Executive. He now grew heartily sick of sitting Wednesday after Wednesday at Executive meetings where no quorum could be obtained, or which, when enough members attended, refused to promote " the world's greatest and dearest cause," because minding other matters instead of minding the Charter. He was one of the last upholders of the old Chartist anti-middle-class programme ; but he preached the faith to few sympathetic ears. In 1852 he withdrew in disgust from the Executive, but came back again when the Man-

chester Conference of that year adopted a new organisation of his own proposing. This Conference, however, made itself ridiculous by persisting in the old policy of refusing to co-operate with other parties pursuing similar ends, and after 1853 no more Conventions were held. The release in 1854 of the martyrs of the Newport rising—Frost, Jones, and Williams—showed that in official eyes Chartism was no longer dangerous. For the five more years between 1853 and 1858 Jones still lectured on behalf of the Charter, and could still, in 1858, rejoice with his brother Chartists on his vindication of his character against the aspersions of Reynolds. With his passing over to the Radical ranks the Chartist succession came to a final end.

During its long agony many attempts were made to re-vivify Chartism on lines independent of the official organisation. Now that O'Connorism was no more, Chartist pioneers, whom the agitator had driven from the field, came back with new schemes for saving the Charter. But in all of these the Charter was but an incident in a long programme of social reconstruction. In effect politics were to be relegated to the background, and the Charter was to be a symbol of Radical reforms.[1] The first proposals came from William Lovett, who, in May 1848, a month after the failure on Kennington Common, started the People's League, which was to combine with the Charter national economy, the abolition of indirect taxation, and a progressive tax on property. Lovett found so little response that in a few months the new society was wound up. Even more discouraging was the reception of a half-hearted attempt of Thomas Cooper to start in 1849 a new form of Chartist agitation by way of individual petition. Jones would have nothing to say to it, and Cooper so completely gave up the idea that he does not so much as allude to it in his autobiography.

Other plans came from more Radical-minded Chartist seceders. Conspicuous among these was a scheme set up by Bronterre O'Brien with the goodwill of G. W. M. Reynolds. These two established a National Reform League which aimed at combining with the political programme of the Chartists large measures of social reform, notably the national-isation of the land, which had always been a leading principle of O'Brien. It kept on good terms with the National Charter

[1] Dierlamm, *Flugschriften literatur der Chartistenbewegung*, pp. 9-10, brings out this new tendency very clearly.

Association, Reynolds forming a link between them. Yet this compromise between political Chartism and the visions of abstract Socialism never prospered, and O'Brien soon transferred his support to another equally abortive society. And even in the thin ranks of orthodox Chartism there was still schism. In 1850 a National Charter League was founded by Thomas Clark in open opposition to the Charter Association. This advocated a more moderate programme and an alliance with the " Manchester School," and had the ambiguous advantage of the secret backing of Feargus O'Connor. Nevertheless it died in infancy. A final attempt to combine the various projected organisations in a single body proved equally abortive. The fewer the Chartists the more they were divided. Harney, Jones's ally in fierce attacks on the Charter League, soon quarrelled himself with Jones and fell into schism. Later on, Reynolds assailed Jones with even greater fierceness, accusing him of malversation of funds and of other gross acts of dishonesty. At last in 1858 Jones was compelled to vindicate his honour in a libel action, from which he emerged absolutely triumphant. It was sheer despair of such allies that at last led Jones to drop the Chartist cry.

Individual Chartists survived the Chartist organisations for another generation. Down almost to the latter years of the nineteenth century there was hardly a populous neighbourhood where some ancient Chartist did not live on. He was generally in poor, often in distressed circumstances, but he enjoyed the respect and esteem of his neighbours, was brimful of stories of the hard struggles of his youth, and retained amidst strangely different circumstances a touch of the old idealism which had ever shone with a purer flame among the rank and file than among the leaders. Some of the older Chartists had still work before them which had been suggested by their earlier struggles. Some of the younger Chartists made names for themselves in new directions.

Of the last Chartist leader, Ernest Jones, there is still something to say. In 1858 he initiated a National Suffrage Movement and accepted the presidency of the organisation established for that end. It became, under his guidance, one of the forces which, after a few years of lethargy, renewed the agitation for reform of Parliament, and was a factor in bringing about the second Reform Act of 1867. In 1861 he transferred himself from London to Manchester, where he resided until his death, writing plays and novels, agitating for reform,

watching the movement of foreign politics, and winning a respectable practice at the local bar. Here his greatest achievement was his able defence of the Fenian prisoners, convicted in 1867 of the murder of Police Sergeant Brett. He remained poor, but obtained a good position in Radical circles, contesting Manchester in 1868, when, though unsuccessful, he received more than ten thousand votes. He died in January 1869, and the public display which attended his burial in Ardwick cemetery was only second to that which had marked the interment of O'Connor.[1]

Jones's bitter enemy, George W. M. Reynolds (1814–1879), survived for another ten years. He ended as he had begun, as a journalist, and *Reynolds' Weekly Newspaper*, started by him in 1850, and still published, early obtained a position as the organ of republican and extreme labour opinions. Three of O'Connor's enemies still had much work before them. Robert Gammage, the historian of Chartism, found, after the collapse of the movement, a new occupation in the practice of medicine at Newcastle and Sunderland, from which he only retired shortly before his death in 1888. Lovett survived until 1877, mainly absorbed in his declining years in the work of popular education, which had always seemed to him the most essential condition of social progress. Cooper lived on until 1892, even more divorced from politics than Lovett, and finding consolation in his last years in upholding in his lectures the evidences for Christianity. Frost, the Newport rebel, after his return to England, lived quietly near Bristol, where he died in 1877 when over ninety. Notable among the younger men, who could still strike out fresh lines, was George Jacob Holyoake (1817–1906), the young Birmingham Chartist whose long public life ranged from the Bull Ring Riots of 1839 to his many battles for co-operation and secularism, continued until a very advanced age. Even more noteworthy was the career of William James Linton (1812–1898), who, after he had thrown off the trammels of O'Connorism, won reputation as an ardent political reformer, a true poet, and, above all, as the most distinguished wood-engraver of his time.

The great band of Chartist patriarchs show that the reproaches of mediocrity and ineffectiveness, often levelled

[1] See for Jones's later years the remarkable collection of pamphlets and manuscripts about him preserved in the Manchester Reference Library. The election of 1868 produced a good deal of biographical literature, both for and against him. His " business diary " shows that between 1860 and 1862 [MSS. 312 A 19], he had a good many briefs, and another note-book (*ibid.* A 21), that he devoted some attention to his legal studies.

against the movement, must not be pressed too far. Nearly all of them beguiled their old age by setting down in writing the reminiscences of their youth, or in treating in some more or less general fashion of the history of the Chartist movement. Their memoirs share fully in the necessary limitations of the literary type to which they belong. There are failures of memory, over‑eagerness to apologise or explain, strong bias, necessary limitation of vision which dwells excessively on trivial detail and cannot perceive the general tendencies of the work in which the writers had taken their part. But, however imperfect they may be as set histories of Chartism, we find in most of them that same note of simplicity and sincerity that had marked their authors' careers. If these records make it patent why Chartism failed, they give a shrewder insight than any merely external narrative can afford of the reasons why the movement spread so deeply and kept so long alive. They enable us to understand how, despite apparent failure, Chartism had a part of its own in the growth of modern democracy and industrialism.

(5) THE PLACE OF CHARTISM IN HISTORY

Contemporaries, whether friendly or hostile to Chartism, had no hesitation in declaring the movement fruitless. The initial failure to gain a hearing for the National Petition was complicated by unending faction among the Chartists, and culminated in the great fiasco on Kennington Common. Then, after a few frenzied efforts had been made to keep the cause alive, it slowly perished of mere inanition. The judgment of its own age has been accepted by many later historians, and there has been a general agreement in placing Chartism among the lost causes of history.

That there is some measure of truth in the adverse judgment can hardly be gainsaid. The Chartist organisation failed ; the individual Chartists were conscious of the wreck of their hopes. But how many of the greatest movements in history began in failure, and how often has a later generation reaped with little effort abundant crops from fields which refused to yield fruit to their first cultivators ? A wider survey suggests that in the long run Chartism by no means failed. On its immediate political side the principles of the Charter have gradually become parts of the British constitution. If on its broader social aspects there was no such complete and obvious

vindication of the Chartist point of view, this is due partly to the fact that the Chartists had no social policy in the sense that they had a political platform, and partly to the obvious truth that it is harder to reconstitute society than it is to reform the political machinery of a progressive community. Yet even here Chartism may claim to have initiated many movements which are still with us, both in Britain and on the Continent. Accordingly we shall take a much truer view of the place of Chartism in history, if we disregard the superficial judgments of despairing agitators and contemptuous enemies, and look rather at the wider ways in which Chartism has made its influence felt upon succeeding generations. From this point of view Chartism deserves a much more respectful consideration than it has generally received. Hard as it is to study it in isolation from the other tendencies with which it was brought into close relations, either helpful or hurtful, it is not impossible to dissect out the Chartist nerve and trace its ramifications into regions of the body politic which, though apparently out of relation to Chartism, were yet unconsciously amenable to its stimulus. Let us work out this point of view in somewhat greater detail.

We may begin with political Chartism, for though Chartism was in essence a social movement, yet, for the greater part of its active existence, it limited its immediate purpose to the carrying out of a purely political programme. Here the consummation of its policy was only deferred for a season. Its restricted platform of political reform, though denounced as revolutionary at the time, was afterwards substantially adopted by the British State without any conscious revolutionary purpose or perceptible revolutionary effect. Before all the Chartist leaders had passed away, most of the famous Six Points became the law of the land. A beginning was made in 1858, the year of the final Chartist collapse, by the abolition of the property qualification for members of Parliament. Next followed vote by ballot, established in 1872. More tardily came the accomplishment of a third point, when in 1911 members of the House of Commons voted themselves pay for their services. If the other three points have not been carried out in their entirety, substantial progress has been effected towards their fulfilment. Two great strides were made in the direction of universal suffrage by the Reform Acts of 1867 and 1885, which extended the right of voting to every adult male householder, and to some limited categories

beyond that limit. In 1917, in the midst of the Great War, Parliament is busy with a third wide extension of the electorate which, if carried out, will virtually establish universal suffrage for all males, and, accepting with limitations a doctrine which Lovett considered too impracticable even for Chartists, will allow votes to women under a fantastic limitation of age that is not likely to endure very long. The changes of 1867 and 1885, with the more drastic ones under discussion in 1917, will bring about something as nearly approximating to equal electoral districts as geography and a varying increase of population make possible. Its effect will be the greater since the drastic limitation of plural voting, and the abolition of the freeholder's time-honoured qualification, make voters, as well as votes, more nearly equal in value. One only of the Six Points has been regarded as undesirable, namely the demand for annual parliaments. Yet even here the recent curtailment of a normal Parliament's life from seven years to five is a step in that direction.

Even minor articles of the Chartists' programme, not important enough to be included in the Six Points, are either adopted or in course of adoption. The payment of returning officers for their services, the relegation to the rates of the necessary expenses of elections, the shortening of the electoral period, with the view of concentrating elections on a single day, are now approved, and it will be a short step from a maximum of two votes to the Chartists' veto of all plural franchises. Thus as far as political machinery goes the Chartists have substantially won their case. England has become a democracy, as the Chartists wished, and the domination of the middle class, prepared for by the Act of 1832, is at least as much a matter of ancient history as the power of the landed aristocracy.

In the light of the adoption by the State of the whole of its positive programme it is hard to reproach Chartism with failure. But let us not overstress its success. Against it we must set the fact that not a single article of Chartist policy had the remotest chance of becoming law until the movement had expired. It was only when Chartism ceased to be a name of terror that the process of giving effect to its programme was taken up by the middle-class Parliaments of the later Victorian age. The pace only became quick when, after 1867, Parliament, with each extension of the franchise, grew more susceptible to working-class pressure. But the Chartist

programme was only the first step towards the consummation of the Chartist ideal. The most optimistic of Chartist enthusiasts could hardly have believed that a new heaven and a new earth would be brought about by mere improvements in political machinery. Behind the restricted limits of avowed Chartist policy lay the vision of social regeneration that alone could remove the terrible evils against which Chartism had revolted. The latest phases of Chartism after 1848 fully recognised this fact, but the machine, which had failed at the moment to work out its political programme, could not be reconstructed by its discredited makers for the discharge of still more difficult tasks. Accordingly the social ideals of Chartism attained even a scantier degree of realisation through direct and immediate Chartist action than did its political programme.

In estimating the measure of success won, when the time was ripe, for the Chartist social programme we must apply the same tests that we have used in studying the execution of its political reforms. We must determine the extent to which its social and economic ideals have been taken up, and made practical, in the sixty years that have elapsed since the extinction of the movement. The real difficulty before us is, however, to discover what were the broader visions of the Chartists. They were well agreed in the diagnosis of the obvious social diseases of their time ; they could unite in clamouring for the political reforms which were to give the mass of the people the means of saving themselves from their miseries. Beyond this, however, the Chartist consensus hardly went. It was impossible for them to focus a united body of opinion in favour of a single definite social ideal. The true failure of Chartism lay in its inability to perform this task. Political Chartism was a real though limited thing ; social Chartism was a protest against what existed, not a reasoned policy to set up anything concrete in its place. Apart from machinery, Chartism was largely a passionate negation.

The Chartists need not be severely reproached for their lack of a positive policy. It was a fault which they shared with the chief English parties of the time. It was a limitation which was inevitable in the existing circumstances. The new Britain, in which we still live, had been slowly arising out of the old England which had preceded the Industrial Revolution. The forms and trappings of the old system still cumbered the ground, though the reasons for their existence were rapidly

passing away. There was no prospect of such sweeping changes as those which, after 1789, rudely destroyed the mediaeval survivals in government and in society which had been much more noticeable in eighteenth-century France than in nineteenth-century England. There was the less need for political revolution in England since her political institutions, unlike those of France, were still sufficiently sound to be capable of legal adaptation to their new social environment. It was necessary then that the first reforms should be political, and that both these, and such social ameliorations as were immediately possible, should be rather the removal of restrictions than the establishment of positive principles. The first business of every reformer was to clear away evil survivals that could no longer justify themselves. Thus it was that within twenty years it was practicable to abolish the excessive cruelties of the criminal code, to initiate the first timid attempts to mitigate the brutalities of the factory system, to remove the more glaring disabilities imposed on Nonconformists and Roman Catholics, to repeal the anti-combination laws, which had made the healthy development of Trades Unionism impossible, and to cut away unworkable and harmful restrictions on freedom of trade between the United Kingdom and the rest of the world. It was thus that the Benthamites, the only reformers who acted upon principle, could erect the very practical test of utility into a philosophical doctrine, and preach the unrestrained freedom of the individual as the panacea for all the evils of society.

Chartism then was the union of men who agreed in a negative policy of protest against restrictions which were the source of infinite misery and unrest, but whose positive policy was narrowed down to a sensible but limited political programme which, when realised, left the root of social evils hardly touched. That this should be so was unavoidable, since Chartists were profoundly disagreed as to what use should be made by the proletariat of the political power which they claimed for it. Every conceivable wave of doctrine flowed from some portion or another of the Chartist sea. Ideas the most contradictory, dreams the most opposite, were strongly and passionately expressed from one section or other of the Chartist ranks. Many Chartists were, like O'Brien and Harney, frank revolutionaries, who wished a complete breach with a rotten and obsolete past and desired a thoroughgoing reconstruction of the social order. But even these

differed among themselves. Some desired the erection of an autocratic and Jacobinical state which would dragoon the individual into progress on socialist lines. Others, even among those who shared the socialist ideal, were as suspicious of state control as the Benthamites or as Robert Owen, and believed that their goal could best be attained by free voluntary association. Another school, headed by Lovett, was brought by the rude teaching of experience to modify its original abstract doctrine in the direction of a practical compromising individualism. Its final faith was that all would be well when positive restraint on freedom was removed, and when the spread of popular education, organised by private associations, untrammelled by state or clerical interference, had been secured. While all these varied types looked to the future, there were many Chartists who gazed back with such longing to a mythical golden age that they were not so much conservative as reactionary. Men like Joseph Stephens of Ashton, the Tory-Protectionist, the ally of Oastler and Sadler, made a much more direct appeal to the industrial North than did Jacobins like O'Brien and Harney. O'Connor himself in his sincerer moments was much more akin to Stephens than to the revolutionary crew which he inspired to battle. Thus Chartism represented not one but many social ideals. Two essentially divergent Chartist types struggled unhappily in a single Chartist organisation.

Much has been written about the various schools of Chartism. There have been many superficial attempts to divide Chartists, both in their own time and later, into the partisans of moral and physical force. But the dispute between O'Connor and the physical force men was a mere difference as to method; it did not touch the fundamental problem of the Chartist ideal; it corresponded to what is found in one shape or another in the history of every revolution. Moreover, there was little sincerity in the physical force party. To a large section of it, notably to the Birmingham Political Union, the appeal to arms was a game of bluff calculated to terrorise the governing classes into submission. To another section it was even less than this; it was simply a blatant device to attract attention. There was little depth then in the physical force cry. Even more superficial than the division between the champions of moral and physical arms is the attempt to split up Chartism into schools, arising from the miserable personal rivalries that did so much to wreck the movement as a force in practical politics. The clearest

way of dividing the Chartists into schools is to group them into two sections, a reactionary and a progressive section. While men like Stephens and O'Connor looked back to the past, and strove to bring back those good old days which all history proves never to have existed, Chartists of the type of Lovett and Cooper turned their eyes to the future and sought the remedy for past evils in a reconstruction of society which frankly ignored history.[1]

These schools correspond roughly to the agrarian and the industrial schools. The past which Stephens and O'Connor wished to reconstitute was the rural England, as they imagined it to have been, before the Industrial Revolution. A nation of small farmers, a contented peasantry, rooted to the soil, and capable by association of controlling its own destinies, was to replace the sordid industrialism of the factory system, which to men thus minded was so hopelessly bad as to be incapable of improvement and was to be ended as soon as practicable. On the other hand, the school of Lovett and Cooper accepted the Industrial Revolution and tried to make the best of it. These men saw that the country had necessarily to remain preponderatingly industrial and commercial, and sought to recast society in the interests of the industrial classes, exploited by the capitalists. From these efforts came the most idealistic school of Chartism which recognised that the first step in all improvement was the moral and intellectual regeneration of the workers. At the other end of the scale were the coarsely material Chartists, whose object, narrowed by their miserable conditions, was limited to palpable and tangible benefit for themselves. There were further cross divisions. The northern crowd of factory hands and miners had a spirit very different from that of the south-country Chartists who looked for guidance to the London artisans and agitators. The midland movement, centring round Birmingham, was conspicuous for the part played in it by the " respectable " middle class. To some extent, but not by any means universally, the northerners tended towards physical force and the southerners towards moral force. Then, again, there was the line of demarcation between the individualists and the socialists, also to some extent following the local division of south and north. It was the socialistic wing that had the more clearly cut policy, and the one which carried on most fruitfully the Chartist tradition to the next

[1] Dierlamm, pp. 8-9, has some excellent remarks on these heads.

generation. The great Chartist following had, we may safely say, no policy at all. It followed its leaders with touching devotion into whatsoever blind alleys they might go. The plain Chartists had nothing to contribute to Chartist doctrine. A moving sense of wrong, a fierce desire to remedy the conditions of their daily life, were the only spurs which drove them into agitation and rioting. Hence the incoherence as well as the sincerity of the whole movement.

It followed from the contradictory tendencies within their ranks that Chartists could agree in little save in negations, whether in their social or in their political activity. Nothing kept Chartists together long, save when they made common cause against some obvious and glaring evils. Thus they united their forces easily enough when they fought manfully against the New Poor Law or for factory legislation and declared in chorus their abhorrence of the Manchester Radicals, like Bright and Cobden, who opposed it in the interest of the manufacturers. When a more positive remedy was sought, the divergent schools parted company. We have seen this when the agrarian proposals of O'Connor were opposed, not only in detail but on principle, within the Chartist ranks. A stolid and prosperous peasant democracy was hateful to Jacobin Chartism, because it would be hostile to all change as change, and would therefore stop any idealistic reconstruction of society.

Whatever else it was not, Chartism certainly was an effort towards democracy and social equality. Nowadays the gulf between classes is bad enough, but it is difficult for the present generation to conceive the deeply cut line of division between the governing classes and the labouring masses in the early days of Victoria. It was the duty of the common man to obey his masters and be contented with his miserable lot. This had been the doctrine of the landed aristocracy of the past ; it was equally emphatically the point of view of the capitalist class which was using the Reform Act to establish itself in an equally strong position. Against the autocracy both of the landlord and of the capitalist Chartism was a strong protest. Every Chartist was fiercely independent and eager that the class for which he stood should work out its own salvation. It is this which makes the most reactionary Chartist idealisation of the past differ from the Young England-ism which was expressed most powerfully in Disraeli's *Sybil*. The Chartists rejected the leadership of the " old nobility,"

of the landed aristocracy and the priest, almost as hotly as they resisted the patronage of the plutocrat and the capitalist. In finding no place for the independence of the worker the Young England scheme of salvation parted company from all Chartism.

There was the same conflict in the Chartist social outlook as in their ideals of reconstruction. To some Chartists the war of classes was the necessary condition of social progress, and their characteristic attitude was the refusal of all co-operation between working men and those who did not gain their bread by manual labour. To others of a more practical temperament experience showed that it was wise to unite the proletariat with the enlightened middle classes in common bonds of interest and affection. Yet even the straitest zealots for class war could not dispense with the guidance of men of higher social position, " aristocratic " deserters from their own class, and middle-class men, like the preachers, barristers, apothecaries, shopkeepers, and journalists who were so numerous that they left but few positions of leadership open to real working men. And it is typical of the deep-rooted habit of dependence and deference in early Victorian society that the men who resented the patronage of Young England lords and cotton kings should have been almost entirely unconscious of the blatant condescension involved in O'Connor's supercilious attitude to his followers. But it would be bewildering to develop still further the varieties of social type included within the Chartist ranks.

The religious outlook of Chartists was as varied as their social ideals. To the timid folk who trembled at Chartism without even trying to understand it, Chartism meant irreligion even more than it meant revolution. And it is clear that to most Chartists organised middle-class religion was anathema. " More pigs and fewer parsons " was a famous cry of Chartism on its most material side. Chartist leaders, like Hetherington and Cleave, handed on to Lovett and Holyoake the uncompromising free-thought of revolutionary France, until, under the latter's auspices, it crystallised into the working-class " secularism " of the later nineteenth century. Yet a strain of exalted mysticism gave force and fervour to many Chartists. We have seen how many Chartist leaders were ministers of religion. Even among the doubters there were elements of spiritual emotion, sometimes extinguished by environment, but at other times kindled into flame by favourable conditions. Thomas Cooper, a Methodist preacher in his youth, the mis-

sionary of free-thought in his mid-career, the unwearied vindicator of the Christian faith in his old age, belonged at one time or another to all the chief religious types of Chartism. There was, too, a serious movement for the formation of so-called Chartist churches, though these never comprehended all the religious fervour of the Chartist fold.[1]

The differences of general ideal and social status, the contrasts in method, faith, and conduct explain to some extent the constant feuds which made it hard for the Chartist organisation to follow up a single line of action. The utter inexperience of the Chartist leaders in the give-and-take of practical affairs, their abhorrence of compromise, the doctrinaire insistence on each man's particular shibboleth still further account for their impotence in action. We must not complain overmuch of these deficiencies; they, too, flowed inevitably from the conditions of the time. The working-men leaders had had no opportunity of learning how to transact business one with another. The law denied them any participation in politics, central or local. The still-enduring Six Acts threw all sorts of practical difficulties in the way of the most harmless associations. No political society could lawfully have branches or correspond with kindred organisations or impose on its members a pledge to any categorical policy. Even the right of association in the interest of their own trades had been a boon of yesterday for the British workman, and, when given, it was hampered by many restrictions and limitations. There was never more danger of the plausible tongue prevailing over the shrewd head. Men with little education and untrained in affairs moved in an atmosphere of suspicion, the more so as they were exacerbated by real suffering and inevitably prone to class jealousy and intolerance. The leaders of higher social position taught them little that conduced to moderation, business method, or practical wisdom. The men who most easily won their confidence were the windbags, the self-seekers, the intriguers. Yet there was a better type of Chartist leader, and the touch of complacent self-satisfaction, the doctrinaire impracticability, and the limited outlook of a Lovett or a Cooper must not blind us to their steady honesty of purpose, to their power of learning through experience to govern themselves and others, to their burning hatred of injustice and to their passion for the righting of

[1] For Chartism in its relations to organised religion see H. U. Faulkner's "Chartism and the Churches" in *Columbia University Studies in History, etc.* lxxiii. No. 3 (1912), and M'Lachlan's *Methodist Unitarians* (1920).

wrongs. Yet, making all allowances, Chartism as an organisation was ineffective, just as Chartism as a creed possessed no body of coherent doctrine.

In tracing the influence of Chartism on later ideals we must look to the individual rather than the system, to the spirit rather than the letter. But it would be unjust to deny the variety and the strength of the stimulus which the Chartist impulse gave towards the furtherance of the more wholesome spirit which makes even the imperfect Britain of to-day a much better place for the ordinary man to live in than was the Britain of the early years of Victoria. The part played by the Chartists in this amelioration is not the less important because, as with their political programme, the changes to which they gave an impetus were effected by other hands than theirs. At first their efforts were mainly operative by way of protest. They were seldom listened to with understanding, even by those who sincerely gave them their sympathy. As early as 1839 Thomas Carlyle's *Chartism* had shown his appreciation of the social unrest and burning sense of wrong that underlay the movement, but Carlyle understood the mind of Chartism as little as he understood the spirit of the French Revolution. His remedy of the strong saviour of society was as repulsive to the Chartist as was the sham feudalism of Disraeli's *Sybil*. It was a time when the mere attempt to describe social unrest was looked upon with disfavour by the respectable, when a book so conservative in general outlook as Mrs. Gaskell's *Mary Barton* (1848) could be denounced for maligning the manufacturers, and when the chaotic fervour of Kingsley's *Alton Locke* (1850) could be interpreted as the upholding of revolutionary principles. But the setting forth by men of letters of the social evils, first denounced by Chartists, spread knowledge and sympathy, and at last some efforts at improvement. The complacent optimism of a Macaulay, the easy indifference of a Palmerston to all social evil in the best of all possible Englands became tolerable only to the blind and the callous. Men of the younger generation, too young to take active part in the Chartists' work, gratefully recognised in after years the potency of the Chartist impulse in the formation of their views.[1]

The Chartists first compelled attention to the hardness of the workmen's lot, and forced thoughtful minds to appreciate

[1] See, for instance, the pleasant story of the " conversion " of Anthony John Mundella, then a boy of fifteen, by Cooper's earnestness at a Leicester meeting (*Life of Thomas Cooper*, p. 170).

the deep gulf between the two "nations" which lived side by side without knowledge of or care for each other. Though remedy came slowly and imperfectly, and was seldom directly from Chartist hands, there was always the Chartist impulse behind the first timid steps towards social and economic betterment. The cry of the Chartists did much to force public opinion to adopt the policy of factory legislation in the teeth of the opposition of the manufacturing interests. It compelled the administrative mitigation of the harshness of the New Poor Law. It swelled both the demand and the necessity for popular education. It prevented the unqualified victory of the economic gospel of the Cobdenites, and of the political gospel of the Utilitarians. If the moderate Chartists became absorbed in the Liberal and Radical ranks, it gave those parties a wider and more popular outlook. In a later generation rival political organisations vied with each other in their professions of social reform. The vast extension of state intervention, which has been growing ever since, was a response on thoroughly Chartist lines for the improvement of social conditions by legislative means. A generation, which expects the state to do everything for it, has no right to criticise the early Chartist methods on the ground that one cannot interfere with economic "laws" or promote general well-being by act of parliament. The whole trend of modern social legislation must well have gladdened the hearts of the ancient survivors of Chartism.

In the heyday of Chartism public opinion dreaded or flouted the Chartist cause. In the next generation the accredited historians of political and parliamentary transactions minimised its significance and dealt perfunctorily with its activity. Yet Chartism marks a real new departure in our social and political history. It was the first movement of modern times that was engineered and controlled by working men. Even its failures had their educational value. Its modest successes taught elementary lessons of self-discipline and self-government that made the slow development of British democracy possible without danger to the national stability and well-being. Its social programme was, like its political doctrine, gradually absorbed into current opinion. It helped to break down the iron walls of class separation, and showed that the terrible working man was not very different from the governing classes when the time came for him to exercise direct power.

Nor was the Chartist message for Britain only. The crude experiments of Chartism were watched at the time with keen interest by reformers from other lands, and have been studied in later days with much more curiosity in Germany, France, and America than in the island of its birth. It was the first genuinely democratic movement for social reform in modern history. It was the first stage of the many-tongued movement which transferred the *bourgeois* demand for liberty, equality, and fraternity from the purely political and legal to the social sphere, and was thus the unconscious parent of Continental social democracy. Hence its anticipation of the cry for a universal proletarian brotherhood which was to cut across national lines of division by organising the laborious classes of all lands in a great confederation of all workers. The first efforts towards international brotherhood came from the Chartist leaders, and their methods were studied by the revolutionaries of the Continent and adapted to the conditions of their own lands. Thus a movement, which was only to a limited extent socialistic at home, became an important factor in the development of abstract socialism abroad. It is strange that in the evolution of Continental socialism the Chartists should have played a more direct part than did Robert Owen and the whole-hearted pioneers of the British socialist movement. It was from the Chartists and their forerunners that Marx and Lassalle learned much of the doctrine which was only to come back to these islands when its British origin had been forgotten. Europe is still full of " the war of classes " of the " international " and other disturbing tendencies that can in their beginnings be fathered on the Chartists. There is no need to discuss here the value of these points of view. However they may be judged, their importance cannot be gainsaid. As a result of such tendencies our own generation has seen a much nearer approach to the realisation of Chartist ideals than the age of our fathers. It need not be afraid to recognise that, with all their limitations, the Chartists have a real place in the development of modern English politics and society. In stumbling fashion they showed to the democracies of the West the path which in our own times they have first striven seriously to follow. Many of the problems which still vex the reformer were first attacked by the Chartist pioneers.

BIBLIOGRAPHY

(A) MANUSCRIPT SOURCES

(i.) *At the British Museum*

The Place Collection. (British Museum, kept at the Hendon Repository.)

Set 56, *Reform*, 1836–47. 29 vols. Set 66, *The Charter and Chartists*, January 1839–March 1840. 1 vol.

[Mainly newspaper cuttings, but containing much manuscript material, and substantially continuous with the collections at Bloomsbury.]

The Place Manuscripts. (British Museum.) *Collections on Working Men's Associations*, eighteenth and nineteenth centuries. Additional MSS. 27,819–27,822, 27,835. *Narratives of Political Events in England*, 1830–35. Additional MSS. 27,789–27,797.

Correspondence and Papers of the General Convention of the Industrious Classes, 1839. 2 vols. Additional MSS. 34,245, A and B.

London Working Men's Association Minutes. 2 vols. Additional MSS. 37,773 and 37,776.

(ii.) *At the Public Record Office*

Home Office Papers, 1839–40.

(iii.) *At the Manchester Free Reference Library*

Ernest Jones's Manuscript Diaries, Notebooks, and Account Books.

(B) BOOKS AND PAMPHLETS

The Annual Register. 1838–49.

ASHWORTH (T. E.). *The Plug Plot at Todmorden.*

BAMFORD (SAMUEL). *Passages in the Life of a Radical.* **2** vols. London, 1893. [First published in parts at Heywood, Lancs, 1839–1842.]

BAXTER (G. R. W.). *The Book of the Bastilles. History of the New Poor Law.* 1841.

BEER (M.). *Geschichte des Sozialismus in England.* Stuttgart, 1913. (English translation. 2 vols. London, 1919–20.)

BENBOW (WILLIAM). *Grand National Holiday and Congress of the Productive Classes.* London, 1831.

BRAY (J. F.). *Labour's Wrongs and Labour's Remedy: or, the Age of Might and the Age of Right.* Leeds, 1839.

BRENTANO (LUJO). *Die christliche-sociale Bewegung in England.* Leipzig, 1883.

——— *Die englische Chartistenbewegung; Preussische Jahrbücher,* Bd. 33 (1874).

BREWSTER (P.). *The Seven Chartist and Military Discourses, ordered by the Assembly's Commission to be libelled by the Paisley Presbytery.* Paisley, 1842.

Brief Sketches of the Birmingham Conference. London, 1842. [In Manchester Free Library.] Compare *Report of the Proceedings at the Conference of Delegates of the Middle and Working Classes at Birmingham,* April 5, 1842, etc.

CARLYLE (THOMAS). *Chartism* (1839). *Past and Present* (1843).

CARTWRIGHT (Miss F. D.). *The Life and Correspondence of Major Cartwright.* 2 vols. London, 1826.

CLARKE (W.). *The Clarke Papers,* 1647–49, 1651–60, edited by C. H. Firth. 3 vols. Published by the Camden Society, now included in the Camden Series of the Royal Historical Society. London, 1891, 1894, and 1899.

COBBETT (WILLIAM). *Cobbett's Legacy to Labourers.* In Six Letters. London, 1834.

COLQUHOUN (PATRICK). *A Treatise on the Population, Wealth, Power, and Resources of the British Empire.* 1814.

COOPER (THOMAS.) *Life of Thomas Cooper.* London, 1872.

——— *The Purgatory of Suicides.* London, 1845.

DAVIES (DAVID P.). *Life and Labours of Ernest Jones.* Liverpool, 1897.

Dictionary of National Biography. Edited by Leslie Stephen and Sidney Lee. London, 1885–1912.

DIERLAMM (GOTTHILF). "Die Flugschriftenliteratur der Chartistenbewegung und sein Wiederhall in der öffentlichen Meinung," in *Münchener Beiträge zur romanischen und englischen Philologie.* Leipzig, 1909.

DISRAELI (BENJAMIN). *Sybil* (1845).

DOLLÉANS, (E.). *Le Chartisme, 1830–48.* 2 vols. Paris, 1912–13.

——— "La Naissance de Chartisme, 1830–37," in *Revue d'histoire des doctrines économiques et sociales,* No. 4. Paris, 1909.

ENGELS (FRIEDRICH). *Die Lage der arbeitenden Klassen in England* (1845). Translated by F. K. Wischnewetzky as *The Condition of the Working Class in England in 1844.* 1892.

FAULKNER (HAROLD U.). "Chartism and the Churches," *Columbia University Studies in History, etc.* lxxiii. No. 3. New York, 1916. (With good bibliography.)

FROST (THOMAS). *Forty Years' Recollections.* 2 vols. London, 1880.

GAMMAGE (ROBERT G.). *History of the Chartist Movement.* 1854. (2nd edition, 1894.)

GARDINER (S. R.). *The Constitutional Documents of the Puritan Revolution, 1625–1660.* 1906.

GONNER (E. C. K.). "The Early History of Chartism," in *English Historical Review,* iv. 625-644 (1889).

HALL (CHARLES). *Effects of Civilisation on the Peoples of European States.* 1805.

HANSARD'S *Parliamentary Debates.*

HELD, A. *Zwei Bücher zur socialen Geschichte Englands.* Leipzig, 1881.

HODGSKIN (THOMAS). *Labour defended against the Claims of Capital: or, the Unproductiveness of Capital proved.* 1825.

HOLDEN (JOSHUA). *A Short History of Todmorden.* Manchester University Press, 1912.

HOLYOAKE (G. J.). *Life of Joseph Rayner Stephens.* London, 1881.
—— *History of Co-operation.* 1875–76. Revised ed. 1906.
—— *The Life and Character of Henry Hetherington.* London, 1849.

HUNT (HENRY). *Memoirs of Henry Hunt, Esq.* (Written by himself in Ilchester Jail.) 2 vols. London, 1820–22.
—— *The Green Bag Plot.* London, 1819.

JONES (ERNEST C.). *The Wood Spirit,* 1841.
—— *Ernest Jones. Who is He? What has He Done?* Manchester, 1868.
—— *Chartist Songs and Fugitive Pieces.* London, n.d.

KAY (J. P.). *The Moral and Physical Condition of the Working Classes employed in the Cotton Manufacture in Manchester.* 1832.

KINGSLEY (CHARLES). *Yeast* (1848–51). *Alton Locke* (1850).

LOVETT (WILLIAM). Pamphlets by, bound in one volume, formerly the author's property. British Museum (8138a55).
—— *Life and Struggles of William Lovett.* London, 1876.
—— and COLLINS (JOHN). *Chartism, a New Organization of the People.* London, 1840.

LINTON (W. J.). *Memories.* London, 1895.
—— *James Watson: a Memoir* (privately printed, London, 1879). Manchester, 1880.

MACKAY (THOMAS). *History of the English Poor Law, 1834–98.* London, 1904.

MARX (KARL). *Das Kapital.* 1 vol. (1867. English Translation, 1886.)

MASON (G. W.). *Mr. Ernest Jones and his Candidature.* Manchester, 1868.

MENGER (A.). *Das Recht auf den vollen Arbeitsertrag.* 1891. Translated by M. E. Tanner, as *The Right to the whole Produce of Labour,* with Introduction by H. S. Foxwell. 1899.

MORLEY (Viscount). *Life of Richard Cobden.* London, 1881.

NAPIER (Sir W. F. P.). *Life and Opinions of General Sir C. J. Napier.* 2 vols. London, 1857.

NIEHUUS. *Englische Bodenreformtheorien.* Leipzig, 1910.

OGILVIE (WILLIAM). *An Essay on the Right of Property in Land.* 1782.

PAINE (THOMAS). *Agrarian Justice* (1797).

—— *Rights of Man* (1791–92).

PHILP (R. K.). *Vindication of his Political Conduct.* 1842. [In Manchester Free Library.]

PODMORE (FRANK). *Life of Robert Owen.* 2 vols. London, 1906.

PORRITT (E. and A. G.). *The Unreformed House of Commons. Parliamentary Representation before 1832.* Cambridge (University Press), 1903.

RICARDO (DAVID). *Principles of Political Economy and Taxation* 1817.

ROSENBLATT, FRANK F. "The Chartist Movement in its Social and Economic Aspects," *Columbia University Studies in History, etc.* lxxiii. No. 1. New York, 1916.

SPENCE (THOMAS). *The Rights of Infants.* 1797.

SLOSSON (PRESTON W.). "The Decline of the Chartist Movement," *Columbia University Studies in History, etc.* lxxiii. No. 2. New York, 1916.

SOMERVILLE (ALEXANDER). *Autobiography of a Working Man.* London, 1848.

—— *Warnings to the People on Street Warfare.* 1839.

STEFFEN (G. F.). *Studien zur Geschichte der englischen Lohnarbeiter. Übersetzt von M. Langfeldt.* 3 vols. Stuttgart, 1901–5.

THOMPSON (WILLIAM). *An Inquiry into the Principles of Distribution most conducive to Human Happiness.* London, 1824; reprinted 1850.

TILDSLEY (JOHN). *Die Entstehung und die ökonomischen Grundsätze der Chartistenbewegung.* Jena, 1898.

VEITCH (G. S.). *The Genesis of Parliamentary Reform.* London, 1913.

WALLAS (GRAHAM). *The Life of Francis Place, 1771–1854.* London, 1898.

WEBB (S. and B.). *History of Trade Unionism.* London, 1894. New ed. 1911.

WEST (JULIUS). *History of Chartism.* London, 1920.

(C) PARLIAMENTARY PAPERS

1837–38. Vol. VIII. *Reports from the Select Committee on Combinations of Workmen.*

Vol. XLV. *Reports of Inspectors of Factories, and Memorial of the Short Time Committee of Factory Operatives of Manchester.*

1839. Vol. XLII. *Factory Returns, Reports of Factory Inspectors, and Reports from the Assistant Handloom Weavers Commissioners.*

1840. Vol. XXIV. *Reports on Handloom Weavers.*
1842. Vol. XI. *Report from the Select Committee on Payment of Wages.*
 Vol. XV. *Children's Employment Commission.* (Report on Mines.)
1843. Vol. XIII. *First Report of the Midland Mining Commission and Children's Employment Commission.* (Report on Trades and Manufactures.)
1844. Vol. XVI. *Report on the State of the Population in the Mining Districts, and of the South Wales Inquiry.* (Rebecca Riots.)
1845. Vol. XV. *Report of the Commissioners appointed to inquire into the Condition of the Framework Knitters, with Appendixes.*
1848. Vol. XIX. *Reports on the National Land Company.*
Various dates. *Reports of Poor Law Commissioners.*

(D) PERIODICALS

The Birmingham Journal. Birmingham (from 1825).
The British Statesman. (Bronterre O'Brien's.) London, 1842–43.
The Charter. London, 1839–40.
The Chartist Circular. Glasgow, 1839–41.
The Diplomatic Review. (See the *Free Press.*)
The Dispatch. (Hetherington's Twopenny.) London, 1836–39.
The Free Press. London, 1855–65. Continued as the *Diplomatic Review,* 1866–77. (Edited by David Urquhart.)
The Labourer. Edited by F. O'Connor and Ernest Jones, 1847–48.
The Leeds Mercury. Leeds.
Lloyds' Weekly Newspaper. London (from 1843).
The London Mercury. (Bronterre O'Brien's.) 1836–37.
The Manchester Guardian. Manchester (from 1821).
The Morning Chronicle. London.
The National Reformer. (Bronterre O'Brien's.) London, 1837.
The Nonconformist. London (from 1841).
The Northern Liberator. Newcastle-on-Tyne, 1837–40.
The Northern Star. (O'Connor's.) Leeds, 1837–44, then London to 1852.
Notes for the People. (Edited by E. Jones.)
The People's Paper. (Edited by E. Jones.)
The Poor Man's Guardian. (Hetherington's.) London, 1831–35.
Punch. London, 1841 and later.
The Republican, 1831.
The Southern Star. London, 1841.
The Times. London.

[Bibliographical Note to the 1950 Impression, p. 318.

BIBLIOGRAPHICAL NOTE TO THE
1950 IMPRESSION

Professor G. D. H. Cole's *Chartist Portraits* (1941) has a bibliography (pp. 359-366), which contains references to much of the material published on Chartism and the early English socialists since December 1924. To these should be added:

(a) Alfred Plummer: *The place of Bronterre O'Brien in the working-class movements* (*Economic History Review*, January 1929, Vol. II, No. 1, pp. 61-80).

(b) M. F. Jolliffe: *Fresh light on John Francis Bray* (*Economic History*, February 1939, Vol. III, No. 14, pp. 240-4).

(c) *The reminiscences of Thomas Dunning, 1813-1894* (Trans. Lancashire and Cheshire Antiquarian Society, Vol. lix (1947), pp. 111-22).

(d) C. E. Raven: *Christian Socialism 1848-1854* (1920).

(e) Alexander Gray: *The Socialist Tradition: Moses to Lenin* (1946), pp. 262-96 (The pre-Marxians).

(f) Cecil Driver: *Tory Radical: the Life of Richard Oastler* (1946).

INDEX

Aberdeen, 35, 133, 138, 244, 288, 293
Abergavenny, 178, 180
Abinger, Lord, 266
Accrington, 14
Adam, James, 244
Address of the National Association to the Political and Social Reformers of the United Kingdom, 232
Address to the Queen on Political and Religious Monopoly, 68
Address to Reformers of Great Britain and Ireland, 69
Address to Reformers on the Forthcoming Elections, 71
Agreement of the People, the, 4
Alison, Archibald, 72
America, 184, 312
Annual Parliaments, 1, 3, 302
Anti-Combination Laws, 30, 45, 304
Anti-Corn Law Agitation, 123, 193, 196, 204, 208, 209, 213-219, 237, 239, 241-246, 252, 276
Apprentices, Act of 1562, 11
Apprenticeship, 11-12
Ashley, Lord, 140
Ashton-under-Lyne, 88, 90, 121, 122, 145, 151, 158, 170, 171, 184, 227, 261, 279, 291, 294, 305
 Parish Church, 158
 Stephens's chapel at, 88
Ashton, William, of Barnsley, 176
Ashworth, T. E., his *The Plug Plot at Todmorden,* 260
Attwood, Thomas, 100-110, 118, 134-135, 154-161, 188
Australia, 184
Ayr, 154

Babeuf, 31, 285
" Bagmen," 18
Ball, John, 30, 85
Ballot, vote by, 2, 282, 287, 301
Bamford, Sam, 91, 138
Barnsley, 66, 138, 176, 227
Bartlett, 253
Bastille, anniversary celebrations of fall of, 287
Bastilles, workhouses so called by Chartists, 82
Bath, 75, 169, 196, 202, 212, 228, 244, 246, 257

Bath, the Chartist Church at, 202
Baxter, G. R. W., his *Book of the Bastilles,* 82, 83
Beaumont, Augustus Harding, 66, 92, 97, 103
Beer, Max, 32, 91
Beesley, 212, 251, 253
Belgium, 285
Bell, John, 65, 66, 69
Benbow, William, 49, 91, 138, 155, 170, 187, 195, 196, 210, 223
Beniowski, 176, 177, 181-183, 187
Benthamites, 304-305
Bernard, J. B., 65, 66
Bible, the, 85, 89, 202
Bill of Rights, the new, 264-265
Bilston, 27, 129
Binns, George, 64, 199, 215
Birkbeck College, 49
Birkbeck, Dr., 48
Birmingham, 22, 71, 75, 76, 85, 98-117, 120, 132, 135, 140, 144-159, 165, 170, 177, 178, 182, 185, 191, 200, 201, 208, 228, 240-251, 264-267, 270, 272, 273, 299
 Association for Promoting the General Welfare, 241
 Bull Ring at, 122, 145, 147, 156, 157, 166, 299
 Chartist Church at, 200-202
 Complete Suffrage Movement at, 243-250
 Conference (1842), 264
 Duddeston-cum-Nechells, 147
 Golden Lion Hotel, 156
 Holloway Head, 156
 Nelson Monument at, 166
 Newhall Hill, 107
 Political Union at, 72, 99-115, 305
 Public Office, 166
 Reform Association, 100, 101
 Rural Dean of, 26
 St. Martin's Church, 122, 156
Birstall, 186
Black, John, 59, 61
Blackburn, 14, 227, 259, 262
 Enfield Moor near, 259
Bolton, 14, 81, 111, 120, 133, 159, 165, 184, 227
Booth, William, 211
Botany Bay, 186

319

Brabant, 285
Bradford, 91, 111, 119, 120, 138, 140, 150, 182, 184, 186, 227
 Hartshead Moor, 119
 Peep Green, 111
Brassier, Simon de, Jones's, 296
Bray, J. F., 31, 44, 47
 His *Labour's Wrongs and Labour's Remedy, or the Age of Might and the Age of Right*, 44
Brett, Police Sergeant, 299
Brewster, Sir David, 202
Brewster, Patrick, of Paisley, 120, 202, 227, 246
 His *The Seven Chartists and Other Military Discourses libelled by the Marquis of Abercorn and Other Heritors of the Abbey Parish*, 202
Bright, John, 218, 244, 248, 272, 307
Brighton, 67, 76
Bristol, 75, 119, 122, 128, 136, 182
British Association for Promoting Co-operative Knowledge, 50
Bromsgrove, 280
Bronterre, *see* O'Brien, James
Brotherton, Joseph, 238
Brough, a brewer, 179
Brown, Birmingham delegate, 144, 145, 171, 178
Brussels, 286, 287
Bryant, William Cullen, his *Thanatopsis*, 59
Buonarotti, 31
Burnley, 184
Burns, W. G., 146, 196, 232
Burslem, 131
Bury, Lancs, 87, 91, 111, 113, 120, 121, 128, 184
Bussey, Peter, 91, 122, 134, 187, 188
" Butty " system, the, 23-24
Byron, Lord, 283

Cade, Jack, 85
Cambridgeshire, 65, 80
Campbell, John, 199, 261
Canterbury, Archbishop of, 254
Capital, 42, 43
Capitalism, rise of, 8-11
 revolt against, 31
Cardo, William, 122, 130, 174, 181-183, 185, 210
Carlile, Richard, 49, 53, 135
Carlisle, 14, 15, 81, 196
 Radical Association at, 196
Carlyle, Thomas, his *Chartism*, 310
Carmarthen, 76
Carpenter, William, 76, 122, 146, 164, 275
Carrier of Trowbridge, 130, 154, 187
Cartwright, F. D., Miss, her *Life of Major John Cartwright*, 6
Cartwright, Major John, 6, 200, 255
 His pamphlet, *Take your Choice*, 6
Chadwick, Edwin, 78
Chadwick, William, 292
Chatham, William Pitt, 1st Earl of, 5
Cheltenham, 122
Cheshire, 80, 81, 196
Chester Castle, 171
Child, Josiah, 244

Christian Chartism, 200-203, 309
Clark, Thomas, 298
Class War, the, 9, 52, 74, 108-109, 123, 142, 163, 232
Clayton, Edward, 227
Cleave, John, 53, 59, 60, 67, 71, 73, 76, 122, 146, 149, 199, 209, 212, 236, 242, 308
Cobbett, J. P., 87, 122, 124, 125
Cobbett, R. B. B., 87
Cobbett, William, 36, 41, 81-86, 200, 239
 His *Legacy to Labourers*, 82
 His *History of the Reformation*, 82
Cobden, Charles, 245
Cobden, Richard, 214, 215, 218, 272, 276, 307
Colchester, 76
Collins, John, 100, 105, 106, 113, 144, 157, 166, 171-172, 203, 208, 210, 230, 235, 245-247
Colne, 14, 168, 227
Colquhoun, Patrick, 40
 His *Treatise on the Population, Wealth, Power and Resources of the British Empire in every Quarter of the World*, 40
Combe, George, 207
Combination Laws, the, 30, 45, 304
Communism, 31-32, 44-47, 306, 312
Complete Suffrage Movement, the, 240-250, 253, 264
Complete Suffrage Petition, the, 250
Congleton, 131
Condorcet, 285
Conseil des Anciens, the, 289
Convention of the Industrious Classes (1839), 75, 106, 121, 116-135, 189, 194, 195, 208
 At London, 121-147
 Meetings to elect delegates, 119
 Members of, 122
 Rules and Regulations, 126
 Discussion on right of people to possess arms, 132
 Resignations, 131-159
 At Birmingham, 147-159
 Manifesto, 147, 159
 At London, 159-173
 Debate after Rejection of Petition, 164-169
 Adjournment, 170
 Dissolution, 172-173
Convention 1842 at London, 252-254
 1843 at Birmingham, 267
 1844 at Manchester, 273
 1845 at London, 273
 1845 at Manchester, 276
 1848 at London, 288-289, 292
Conventions, 296
Cooper, Thomas, 199, 200, 209-211, 223, 224, 225, 228, 238, 241, 251, 261-263, 265-267, 297, 299, 306, 308-310
 His *Purgatory of Suicides*, 265-267 276-277
 His *Life of Thomas Cooper*, 21, 203, 209-211, 260, 261, 277, 310
Cork, 92, 93, 181
Cornwall, 129, 208

Corresponding Societies Acts, 102, 107, 198, 309
Coventry, 9, 12, 13, 168
Craig, James, of Ayrshire, 123, 128, 154
Crawford, Sharman, 70, 73, 243, 244, 250, 253, 283
Cray, Richard, 60, 62
Crewe, 261
Criminal Code, the, 304
Croydon, 176
Cuffey, William, 294
Cumberland, Ernest, Duke of, 254, 280
Cupar, 106
Currency Scheme (Attwood's), 100-103, 109, 114-115, 118

Darlaston, 129
Davenport, Allan, 66
Davies, David P., his *Life and Labours of Ernest Jones*, 280
Dean, Christopher, 154
Deegan, Chartist delegate, 169, 187, 196, 225
Democratic Society of French Exiles, 287
Democratic Association, the London, 65, 67, 126, 150
Deptford, Working Men's Church at, 203
Derby, 18, 80, 150
Deutsche Bildungsgesellschaft für Arbeiter, 287
Devizes, 130, 171, 187
Devonshire, 130
Dewsbury, 82, 106, 177, 186, 227
Dierlamm, G., his *Flugschriftenliteratur der Chartistenbewegung*, 297, 306
Disraeli, Benjamin, 161-163, 307, 310
 His *Sybil*, 24, 307, 310
Dixon, Peter, 81
Dodford, near Bromsgrove, 280
Doherty, John, 22
Dolléans, E., his *Le Chartisme*, 260, 275
Domestic System of Industry, 8-11, 18, 29
Donaldson, Birmingham Chartist, 144
Dorchester, 52, 58, 72, 92, 117
 Labourers, the, 52, 75, 117
Dorset, 122
Douglas, R. K., 76, 100, 103, 111-112, 113, 123
Douro, Marquis of, 283
Dublin, 93, 181
 Trinity College, 93
Dudley, 27
Duke, James, 145
Dumfries, 193
Duncan, A., 129, 168, 253
Duncombe, Thomas S., 228, 251, 253, 255, 258
Dundee, 106
Dunfermline, 106
Dunning, T. J., 217
Durham, 25, 169

Edinburgh, 76, 106, 109, 120, 127, 136, 187, 282, 288
Edmunds, George, 65, 104, 105, 113
Educational Chartism, 200, 202, 203-209

Edwards, Robert T., 151, 183
Elliott, Ebenezer, 76, 119
Enclosures, revolt against, 31
Enfield Moor, near Blackburn, 259
Enfranchisement of women, 70, 207, 209, 236, 259, 302
Engels, Friedrich, 285-286
Equal Electoral Districts, 4, 6, 302
Essex, 80

Factory Act, 1833, 30
 Legislation, 241
 System, 11, 17, 22-23, 31, 304
Farmers' Association, the Cambridge-shire, 65
Faulkner, H. U., his *Chartism and the Churches*, 200, 309
Fenian Prisoners, 299
Fielden, John, 47, 86-87, 114, 134, 161, 164, 184, 255
Flanders, 285
Fletcher, Matthew, Dr., 91, 128, 153, 168, 173, 188
Fontenoy, 287
Fox, Charles James, 6
Fox, W. J., 61, 218
France, 37, 45, 93, 128, 262, 312
Freeholder's qualification, abolition of, 302
Free Trade, 73, 119, 193, 204, 213, 242, 244-245
French Revolution, 4, 6-7, 28, 30, 144, 200
 of 1848, 284-285, 288
Frost, John, 117, 127, 174, 175, 177, 180, 185, 188, 191, 212, 223, 264, 297, 299
Frost, Thomas, 176
Fussell, Birmingham Chartist, 144, 145, 178

Gammage, Robert G., 176, 181, 187, 214, 225, 277, 299
 His *History of the Chartist Movement*, 214, 277
" Gang " System, the, 23
Gast, John, 60
Geach, solicitor, 185
Germany, 312
Glasgow, 66, 72, 75, 76, 104-106, 109, 117, 119, 120, 136, 153, 202, 227, 260, 264, 288
 Bridgeton, 288
 Cotton spinners, prosecution of, 72, 103, 106, 117
 Universalist Church at, 192
Gloucester, 280
Gloucestershire, 17
Godwin, William, 30, 31, 200
Goulburn, Serjeant, 172
Graham, Sir James, 255
Gray, Charles, 31, 47, 49
Grey, Sir George, 291
Griffin, journalist, 224

Hadley, Benjamin, 100, 105, 122, 132, 144
Halifax, 137, 138, 140, 227, 228, 262, 283
Hall, Charles, 17, 31, 36-38

Hall, Charles, his *Effects of Civilisation on the People in European States*, 36-37
Halley, 132, 146, 147, 149, 154
Hammersmith, 93
Hanley, 262
 Crown Bank, 261
Hanover, Ernest, King of, 254, 280
Hansard's Parliamentary Debates, 164, 166, 251, 258
Harney, George Julian, 66, 126, 149, 154, 174, 178, 187, 191, 193, 198, 223, 225, 264, 267, 268, 287, 288, 291, 298, 304
Hartwell, Richard, 60, 75, 76, 146, 174
Heckmondwike, 186
Hendon, Place Collection at, 77, 172, 198, 203, 231, 233
Hertfordshire, 279
Hetherington, Henry, 38, 53, 56-58, 60, 66, 67, 71, 73, 75, 76, 107, 146, 150, 195, 209, 236, 308
Heywood, Lancs, 227
Heywood, Abel, 199
Heyworth, Laurence, 265
Hibbert, Julian, 58
Higgins, Timothy, 158, 170
Hill, William, 96, 224, 225, 234, 262
Hinckley, T. P., 20
Hindley, Member of Parliament, 70, 73
Hinton Charterhouse, near Bath, 244
Hoare, Citizen William, 65
Hobhouse, Sir John Cam, 283
Hobson, Joshua, 96, 227
Hoche, Lazare, 285
Hodgskin, Thomas, 31, 39, 41-44, 49, 207, 286
 His *Labour Defended against the Claims of Capital*, 41-44
Holberry, Sheffield Chartist, 187
Holden, J., his *Short History of Todmorden*, 87
Holy Alliance, the, 284
Holyoake, George Jacob, 199, 299, 308
 His *Life of J. R. Stephens*, 90
 His *Life of H. Hetherington*, 58
Hosiery trade, the, 18-21
Household Suffrage, 101, 160, 234
Huddersfield, 87, 152, 153, 169, 226, 227
 Fixby Hall, near, 87
Hull, 67, 122, 141
Hume, David, 35
Hume, Joseph, 70, 163, 234
Hunt, Henry, 49, 94, 138, 153, 200, 215
 His *Memoirs*, 91
Hyde, Cheshire, 137, 139, 154, 169

Individualism, 54-55, 305, 306
Industrial Revolution, the, 8-27, 28, 45, 303, 306
Instrument of Government, the, 3
Ipswich, 76
Ireland, 271, 285, 288
Ireton, Henry, 4
Irish Coercion Bill, 283
Irish immigrants, 14, 80, 81

Jackson, W. V., 187
Jacobinism, 285

Jamaica, 143
Jenkins, Samuel, 20
Jones, Ernest Charles, 199, 279-283, 285, 290-292, 294-298
 His *Diary*, 280-282
 Ernest Jones. Who is He? What has He Done? 280
Jones, John Gale, 49, 53
Jones, Major, 280
Jones, William, 180
Junius, 5

Kay, J. P., his *Working Classes in Manchester* (1832), 104
Keighley, 227
Kelly, Fitzroy, 180
Kenilworth, 129
Kensal Green, 295
Kilmarnock, 106
Kingsley, Charles, his *Alton Locke*, 310
Kirriemuir, 138
Knox, Robert, 169
Knutsford Gaol, 171

Labour Exchange Scheme, Robert Owen's, 50, 54
Lanarkshire, 72
Lancashire, 14, 18, 25, 46, 80, 81, 84, 87, 88, 90, 98, 106, 107, 111, 112, 119, 139, 150, 151, 196, 212, 227, 259, 260, 266, 280
Lancaster, 171, 237, 240
Lancaster, Joseph, 69
Land Scheme, O'Connor's, 32, 232, 267-280, 292-293
 Theories, 32-36
 Values, 35
Lane End, Staffordshire, 131
Lassalle, Ferdinand, 312
Leach, James, 196, 199, 208, 214, 216, 227, 235, 252
Leader, 73, 255
League of Communists, 286
League of the Just, 286
Leamington, 168
Leeds, 58, 76, 93, 106, 118, 130, 141, 181, 227, 262, 270, 271
 Great Northern Union, 118
Leeds Radical Association, the, 196
Leek, 131, 281
Leicester, 18, 80, 137, 196, 200, 209, 212, 262
Lincolnshire, 80
Linton, William James, 199, 209, 299
 His *Memories*, 55, 56, 59
Liverpool, 153, 167, 170, 193
Llanidloes, 150, 151, 171
Locke, John, 33
London, 12, 47, 48, 52-77, 85, 98, 106, 116, 119, 120, 144, 146, 177, 182, 183, 191, 196, 199, 200, 212, 231, 232, 252, 262, 264, 268-276, 287
 Abbey Street, 183
 Bethnal Green, 186
 Bishop Bonner's Fields, 293-294
 Blackfriars Bridge, 49
 Bolt Court, 121
 Brick Lane, 183
 British Hotel, Cockspur Street, 121
 Brompton, 73

London—*continued*
Buckingham Palace, **288**
Bunhill Fields, 49
Charing Cross, 48, 49, 121
Clerkenwell Gaol, 58
Clerkenwell Green, 293-294
Crown and Anchor Tavern, the Strand, 69, 70, 125, 127, 132
Fleet Street, 48, 49
Gray's Inn Lane, 48, 67
Holborn, 48, 59, 209
Kennington Common, 288, 290, 291, 297, 300
Kensal Green, 295
Lincoln's Inn Fields, 254
Lumber Troop's Hall, 121
Marylebone, 122
Nelson Column, 288
Oxford Circus, 255
Palace Yard, 75, 76
St. George's Church, Hanover Square, 280
St. Stephen's, 198
Scotland Yard, 288
Seven Dials, 48
Shoe Lane, 59
Soho, 48
Spitalfields, 48, **60**, 62, 183
Strand, 69, 183
Tavistock Street, Covent Garden, 60
Tottenham Court Road, 48, 208
Tower Hamlets, 293-294
Tower of London, 139
Trades Hall, 183
Trafalgar Square, 288, 289
Westminster, 49, 75, 76, 125, 290
Whitechapel, 237
White-Conduit House, 208
London artisans, condition of, 47-51
Co-operative Trading Association, 50, 52, 54
Corresponding Society, 49
Democratic Association, 65, 67, 126, 150
Mechanics' Institute, 48, 50, 53
Working Men's Association, 48, 52, 77, 102, 103, 203 ; Leading members, 53-59 ; Objects, 60 ; Membership, 61 ; Proceedings, 62 ; Address and Rules, 62 ; Propaganda, 67 ; Publications, 64-71 ; Publication of " People's Charter," 74 : Meeting at Palace Yard, Westminster, 75
Lothians of Scotland, 25
Loughborough, 137, 171, 182, 196
Loveless, George, 122
Lovett, William, 38, 47, 49, 53-56, 59-60, 67, 68, 73, 76, 118, 123, 146-149, 155, 157-158, 166, 171-172, 176-177, 187, 188, 195, 203-209, 230-236, 245-251, 265-267, 284, 297, 299, 302, 306, 308
His *Address on National Education*, 68, 200
His *Address and Rules for the London Working Men's Association*, 62
His *Chartism*, 68, 200
His *Life and Struggles*, 60, 61, **176**, 190, 223, 284

Lowery, Chartist, 129, 146, 172, 181, 193, 196, 224, 236, 245, 248, 250, 253

Mably, 30
Mackay, J., his *History of the English Poor Law*, 91
Macaulay, T. B., 255-256, 258, **282**, 310
Macclesfield, 12, 81, 214, 281
M'Crae, Ayrshire delegate, 235
M'Culloch, Politician Economist, 41
MacDouall, P. M., 91, 125, 138, 145, 154, 155, 168, 171, 187, 188, 199, 228, 239, 251, 252, 255, 261-264, 267, 285, 292, 294
M'Grath, Chartist, 288
M'Nish, James, 106
M'Pherson, Scottish delegate, 253
Macerone, Italian revolutionary, 138
Malthus, T. R., 37, 44, 64, 89, 91
Malton, 58
Manchester, 12, 14, 15, 75, 91, 111, 117, 118, **121**, 122, 132, 138, 140, 141, 151-154, 165, 195-199, 216, 227, 228, 235, 243, 251, 260-262, 269, 271, 273, 276, 286, 291, 292, 298-299
Ardwick Cemetery, 299
Ashton Road, 151
Free Reference Library, 280, 299
Grammar School, 87
Griffin, the, Great Ancoats Street, 196
Kersal Moor, 118-119, 153
New Bailey Gaol, 121
Oldham Street, 199
Schofield's Chapel, 261
Stephenson Square, 154
Tib Street, 288
Manchester, Convention at, **273**, **276**
Political Union, 118
Manifesto of July 12, 1839, 159
Marat, 66
Marcus, anonymous writer, 91
Marsden, Richard, of Preston, 111, 122, 126, 150, 164, 187
Marsden of Bolton, 259
Marshall, A., his *Principles of Economics*, 39
Marvell, Andrew, 6
Marx, Karl, 31, 285-286
Mason, G. W., his *Mr. Ernest Jones and his Candidature*, 280
Mason, John, 210, 241, 253, 291
Matthew, Scottish delegate, 133
Mayne, Richard, 291
Melbourne, Lord, 100, 102, 143, 218
Menger, A., 32
Merthyr Tydfil, 137
Methodism, 5, 88-89, 122, 308
Metropolitan Charter Union, **195**
Miall, Edward, 244, 249
Middleton, Lancs, 138, 168, **227**
Midlands, the, 27, 280
Mill, John Stuart, 41
Mills, James, of Oldham, 244, **248**, **250**
Mining Industry, the, 24-27
Minster Lovel, 280
Mitchell, Chartist, 209
Moir, Scottish Chartist, 107, 130, 155, 253
Molesworth, Sir William, **70**

Monmouth, 137, 151, 152, 178, 179, **180**, 182, 186, 187
Monmouthshire, 25, 27, 141, 151
Moore, Richard, 60, 73, 76, 209
Morelly, 30-31
Morley, John, his *Life of Cobden*, **264**
Mottram Moor, 260
Mundella, Anthony John, 310
Muntz, George Frederick, 100
Muntz, P. H., 76, 100, 103, 105, 107
Murphy, Chartist delegate, 106

Napier, Sir Charles J., 136, 139-142, 151-153, 184, 216
Napier, Sir W. F. P., his *Life and Opinions of Sir Charles J. Napier*, 136, 158
Napoleon Buonaparte, 285
Napoleon, Louis, 290
National Association for Promoting the Political and Social Improvement of the People, 205-208, 230
 Charter Association, 197, 198, 208-209, 225, 228, 246, 250, 261, 298
 Charter League, 298
 Holiday, 158, 164-167, 170, 194
 Land Company, 295
 Land Society, 297
 Memorial to the Queen, 289
 Reform League, 297
 Suffrage Movement, 298
 Union of the Working Classes, 50, 52
Neesom, Chartist, 66, 168, 186, 209, 236, 247, 250
Newcastle-on-Tyne, 76, 92, 97, 120, 122, 137, 141, 152, 154, 170, 183, 239, 240, 299
 Northern Political Union of, 196
Newhall Hill, Birmingham, 107
New Lanark, 31, 38
Newport, Monmouthshire, 26, 117, 122, 127, 137, 138, 175-181, 187, 191
 Westgate Hotel at, 180, 181
Newtown (Montgomery), 122, 150, **178**
Nonconformists, 304
Northampton, 214
Norwich, 111, 283
Nottingham, 18, 80, 93, 141, **151**, **171**, 186, 191, 196, 283, 294
Nuneaton, 13

Oastler, Richard, 22, 74, 83, 87-91, 93, 188, 305
O'Brien, James (Bronterre), 23, 31, 32, 33, 40, 61, 65, 66, 94, 96, 109, 125, 138, 146, 150, 164, 167, 168, 169, 187, 188, 189, 195-197, 214, 215, 223-225, 227, 236-240, 245-251, 253, 267, **275**, 285, 289, 297-298, 304
 His *Election Address*, 239
O'Connell, Daniel, 66, 70-71, 72, 73, 93, 95, 163, 234, 283, 285
 His *Correspondence*, 93
O'Connell, John, 283
O'Connor, Arthur, 92, 285
O'Connor, Feargus, 33, 61, 65, 67, 69, 71, 74, 76, 82, 92-96, 107, 111, 112, 118-121, 133, 150, 153, 164, 173, **180**, 181, 187, 188, 189, 194-196,

202, 211-215, 220-229, 252-259, 261-287, 289-296, 298, 305-308
O'Connor, Feargus, his *Letters to Irish Landlords*, 271
O'Connor, Roger, 92
O'Connorville, 293, 297
Ogilvie, William, 31-35
 His *An Essay on the Right of Property in Land*, 35
Oldham, 25, 26, 82, 86, 106, 120, 227, 291
O'Neill, Arthur, 200-203, 236, 240, 245
Owen, Robert, 31, 32, 38, 39, 44, 45-47, 49-50, 54, 57, 58, 61, 87, 305, 312
 His *New View of Society*, 38

Padiham, 120
Paine, Thomas, 30-33, 36, 171, 200
 His *Agrarian Justice*, 36
 His *Rights of Man*, 36
Paisley, 202-203
 The Abbey Church, 202
 The Chartist Church, 202-203
Palmerston, Lord, 198, 310
Pamphlets—
 History of the Reformation, 82
 Labour defended against the Claims of Capital, 41-44
 Legacy to Labourers, 82
 Rights of Infants, 33-34
 The Rotten House of Commons, 62-64, 74
 Take your Choice, 6
Pare, William, 32
Paris, 111, 141, 144, 286, 287
Parkes, Birmingham Chartist, 178, 181
Parry, J. H., 209, 248, 266, 283
Partick, 202
Payment of Members of Parliament, 6, 70, 101, 301
Peasants' Revolt, the, 85
Peel, Sir Robert, 227, 237, 257, 274, 276
Pennine Districts, 25
Penzance, 53
People's League, the, 297
People's Parliament. *See* Convention
Perth, 106
Pestalozzi, 207
Peterloo, 91, 111, 140, 153, 197, 215
Petition to the House of Commons, 1839, 69, 117, 160-164
 Extract from Preamble, 69
 Six Points, 69 70
 1841, 228
 1842, 251-258
Pettus, Mr., 4
Periodicals—
 Birmingham Journal, 113, 122, 126
 British Statesman, 240, 250, 253, 263
 Bury Times, 292
 Champion, 87
 Charter, 76-77
 Chartist Circular, 193
 Destructive or People's Conservative, **57**
 Extinguisher, 251
 Illuminator, 251
 Labourer, 282
 Leeds Mercury, 272
 Leeds Times, 118, **208**

Periodicals—*continued*
 Lloyds' Weekly Newspaper, **275**
 London or *Twopenny Dispatch,* **54,**
 57, 150, 154, 168
 Mercury, 65, 66
 Gazette, 281
 Manchester Courier, 260
 Examiner, 279
 Guardian, 139, 155, 170, 175, **260**
 Morning Chronicle, 59, 128, 179
 Star, 195
 National Instructor, 93
 Reformer, 275
 Nonconformist, 242, 244, 265
 *North Lancashire and Teetotal Letter
 Bag,* 251
 Northern Liberator, 71, 92, 103, 193
 Star, 71, 93-96, 103, 111, 120, 173,
 176, 187, 217, 219, 220, 222, 231-
 237, 241, 246, 247, 254, 255, 259,
 261, 262, 265, 268-271, 279, 286,
 287, 289, 295
 Notes to the People, 296
 People's Paper, 296
 Poor Man's Guardian, 51, 57
 Punch, 294
 Republican, 57
 Reynolds' Weekly Newspaper, 299
 Rushlight, 251
 Southern Star, 191, 197, 237
 Times, 67
 Weekly Dispatch, 284
 Weekly Police Gazette, **59**
 Western Vindicator, 75
Philippe, Louis, King of the French, **287**
Phillips, Sir Thomas, 137, 179
Philp, R. K., 196, 199, 212, 224, 236,
 245, 246, 248, 253
 His *Vindication of his Political Con-
 duct,* 246
Pilgrimage of Grace, the, 85
Pilgrim's Progress, the, 209
Pilling, Richard, 241
Pitkeithly, Chartist, 122, 144, 253
Place, Francis, 49, 53, 55, 56, 59, 60, 61,
 63, 64, 68, 73, 74, 75, 76, 101, 110,
 114, 129, 133, 143, 146, 149, 172,
 175, 185, 198, 203, 204, 205, 207,
 208, 218, 225, 241, **245, 283**
Plug Plot, the, 259-264
Plural voting, 302
Plymouth, 244
Podmore, Frank, 20, 32
Pollock, Sir Frederick, 180
Pontypool, 137
Poor Law Amendment Act, 1834, 16,
 21, 36, 64, 71, 78-98, 188, 241, 252,
 274, 288, 293, 307, 311
Poor Relief, 13, 80, 81
Poor Rate, 13, 36
Porritt, E., his *Unreformed House of
 Commons,* 3, 5
Potteries, the, 130-131, **169,** 260
Powell, Birmingham Chartist, 144, **151**
Power looms, introduction of, **15**
Preamble of the Charter, 2
Prentice, Archibald, 245, 248
Preston, 111, 120, 168, 262
Prince Consort, the, 254

Property Qualification for Members of
 Parliament established, 5
 abolished, 301
Prussia, 286
Purdie, Scottish delegate, **107**
Putney, 5

Rainborough, Colonel, **4**
Ramsbottom, 91
Ravenstone, Piercy, 31
Rebecca Riots in Wales, 117
Reform Act, 1832, 45, 50-52, **60,** 216,
 237, 271, 284, 302, 307
 1867, 298, 301-302
 1885, 301-302
 Parliamentary, its history, 1647-1838,
 3-7
Registration Act, 1837, 91-92
Reports, Government, 10, 11, 19, 20, 23,
 24, 26
Revil, Thomas, 20
Reynolds, G. W. M., 288, 289, **297-299**
 His *Reynolds' Weekly Newspaper,* 299
Ricardo, David, 30, 36, 38-40
 His *Principles of Political Economy
 and Taxation,* 38
Rich, Colonel, 4
Richards, John, 130-131, 169
Richardson, R. J., 91, 107, 130, 132, 138,
 154, 167, 171, 187, 193, 196, 246,
 248
Richmond, Duke of, 6, 241, 255
Rider, William, 91, 174, 223, 224, **236**
Ridley, Ruffy, 255
Rights, natural, 32-33
Riot Act, the, 145
Risca, Monmouthshire, **179**
Ritchie, John, 244
Roberts, W. P., 130, 187, 245, 253
Robespierre, M., 285
Rochdale, 111, **120,** 122, 164, 168, 227, 250
Roebuck, John Arthur, 70, 71, 73, **76,**
 234, 256, 258
Rogers, George, 76, 127, 235
Rosenblatt, F. F., his *Social and Eco-
 nomic Aspects of the Chartist Move-
 ment,* 190
Rotherhithe, 60, **144**
Rousseau, J.-J., **30,** 36, 37
Rural Police Bill, 128
Rushton, William, 154
Russell, Lord John, 139, 140, **161, 177,**
 179, 257, 276, 282
Ryder, Chartist, 126, 155

Sacred Month, the, 159, 164-165, 221
Sadler, Michael Thomas, 22, 87, 305
Salford, 91
Salt, T. C., 100, 105, 112, 126, 129, **241**
Sandbach, 131
Sankey, Dr., 127, 132, 146
Sawbridge, Alderman, 5
Scholefield, Joshua, 100, 105
Scholefield, William, 145, 156
Schools of Chartism, 305-307
Schools, Sunday, 26
Scotland, Chartism in, 167, 191-193, **196,**
 252
Septennial Act, the, **5**

Shakesperian Association of Leicester Chartists, 211
Sheffield, 76, 119, 130, 168, 186, 191, 227
Shelley, Percy Bysshe, 200
Short Parliaments, 4, 5, 6, 63, 101, 160
Silk Trade, the, Coventry, 11-13
Six Acts, the, 98, 146, 309
Six Points of the Charter, 2, 301-302
Skevington, Chartist, 168
Slosson, P. W., his The Decline of the Chartist Movement, 275, 292, 293
Smallwood, Birmingham Chartist, 178
Smart, Chartist, 144, 196
Smith, Adam, 35, 37
Smith, J. B., 168
Smith, Dr. Southwood, 207
Smith, Thomas, 275
Socialism, 30-39
Society for National Regeneration, 47, 87
Somerville, Alexander, his Autobiography, 263
His Warnings to the People on Street Warfare, 264
Spence, Thomas, 31, 32, 33-34, 35
His Rights of Infants, 33-34
Spencer, Herbert, 241, 244
Spencer, Thomas, 244, 248
Spring Rice, Thomas, 102
Spurr, R., 209
Stafford Gaol, 276
Staffordshire, 22, 24, 260, 266
Stamp duty on newspapers, abolition of, 53
Stanhope, Lord, 6
Steffen, G. F., his Geschichte der Englischen Lohnarbeit, 15
Stephens, George, 88
Stephens, Joseph Raynor, 71, 74, 87 91, 93, 97, 111, 118, 120, 121, 171, 187, 188, 189, 202, 305, 306
Stirling, 106
Stockholm, 88
Stockport, 227
Stoke-on-Trent, 131
Stone, Staffs, 151
Stourbridge, 129
Strutt of Derby, 150
Sturge, Joseph, 242-250, 251, 253, 264, 265
His Reconciliation between the Middle and the Working Classes, 242-243
His Declaration, 243
Suffolk, 80
Sunderland, 64, 169, 196, 246, 299
Mechanics' Institute, 64
Sutton-in-Ashfield, 124, 128

Taylor, James, of Rochdale, 122, 164, 169, 191, 196
Taylor, Dr. John, 120, 133, 153, 154, 156, 164, 173, 174
Thomason, Chartist delegate, 253
Thompson, Colonel Perronet, 73, 283
Thompson, William, 17, 31, 39, 32, 44, 47, 49
His Distribution of Wealth, 39, 65
Tillman, William, 199
Tiverton, 198

Todmorden, 14, 86-87, 91, 184, 227, 260, 262
Trade Collapse, 1815, 8, 12, 15, 16, 99
Societies—attitude towards Chartism, 169
Trades Union Movement, 43, 45, 46, 52, 71, 72, 252, 274, 276, 304
Trades Union, Grand National Consolidated, 46, 53
Trier, 286
Tristan, Flora, 121
Trowbridge, 75, 154, 234
Truck, 10, 17, 20, 24
Tyneside, 269

Ulterior Measures, 105, 134, 148-149, 159
Unearned Increment, the, 33, 35
Union, Repeal of the, 252
United States, 99
Universal Suffrage, 255-256
Central Committee for Scotland, 193
Urquhart, David, 175-185
Utopia, More's, 30

Veitch, G. S., 5, 6
Victoria, Queen, 103, 182, 254, 280, 307
Letters of, 291, 292
Vincent, Henry, 33, 64, 71, 75, 76, 107, 117, 129, 130, 133, 151, 187, 188, 200, 203, 209, 235, 236, 245-250

Wade, Dr., Vicar of Warwick, 38, 49, 61, 75, 106, 109, 131, 191, 244, 248
Wages, 12-18, 20, 21, 81
Wales, 25, 117, 138, 139, 196
Wallas, Graham, 50, 52, 102
His Life of Francis Place, 52, 73
Warden, Chartist, 185, 187
Warminster Guardians, libel on, 222
Warwick, 171
Gaol, 166
Waterloo, Battle of, 8, 287
Watson, James 38, 49, 53, 58-59, 73, 209
Weavers, Cotton, 13-16
silk, 13-15
wool, 17-18
Webb, S. and B, their History of Trade Unionism, 130
Wellington, Duke of, 283, 290
Welshpool, 171
Wemyss, Colonel, 141, 151, 153, 158, 174, 184
West, of Macclesfield, 214
Westrapp, Chartist, 176
West Riding, Yorkshire, 17, 87, 134, 196, 261
White, George, 224, 241, 253
Whittle, James, 111, 150
Wigan, 112
Wigton, 158
Wilderspin, educational writer, 207
Willenhall, 27, 129
Williams, Hugh, 117

Williams, James, 246
Williams, Morgan, 64, 199, 215
Williams, Zephaniah, 180, 186, 223, 297
Wischnewetzky, F. K., his *The Condition of the Working Classes in England in 1844*, 286
Wolverhampton, 27, 129
 Vicar of, 26
Wood of Bolton, 133

Worcester, **76**
Wootton-under-Edge, 246

York, 187, 227
York Castle, 212, 220, 221, 271
Yorkshire, 18, 25, 67, 81, 88, 90, 98, **106,** 107, 111, 112, 119, 141, 196, **227.**
 See also West Riding
Young Englandism, 307-**308**

THE END

Printed in Great Britain by R. & R. CLARK, LIMITED, *Edinburgh.*